SIGMUND FREUD

His Life in Pictures and Words

Ernst Freud, Freud's younger son died in 1970. Together with his widow, Lucie Freud, Ilse Grubrich-Simitis has completed the work of compiling this book. The well-known New York psychoanalyst K. R. Eissler has contributed a masterly biographical sketch, and Dr Christine Trollope has translated those sections of the text where an English translation was not already available. The layout and the assembly of the original German edition was done by the distinguished German designer Willy Fleckhaus.

SIGMUND

FREUD

His Life in Pictures and Words
Edited by Ernst Freud, Lucie Freud
and Ilse Grubrich-Simitis
With a biographical sketch
by K. R. Eissler
Translation by Christine Trollope
Design by Willy Fleckhaus

ERRATA

Sigmund Freud: His Life in Pictures and Words
edited by
Ernst Freud, Lucie Freud, and Ilse Grubrich-Simitis

The following notice was inadvertently omitted from the
copyright page: Plates 127, 128, 129, and 325 of Berggasse 19
© 1976 Edmund Engelman. Photo credit: Edmund Engelman,
New York.

W·W· NORTON & COMPANY
New York · London

First published by Harcourt Brace Jovanovich, Inc. 1978
First published as a Norton paperback 1985
Published simultaneously in Canada by Penguin Books Canada Ltd,
2801 John Street, Markham, Ontario, Canada L3R 1B4

Printed and bound in Italy by New Interlitho SPA

ISBN 0-393-30285-7

W. W. Norton & Company, Inc., 500 Fifth Avenue, New York, N.Y. 10110
W. W. Norton & Company Ltd, 37 Great Russell Street, London WC1B 3NU

1 2 3 4 5 6 7 8 9 0

Contents

Ernst Freud died on April 7, 1970, long before this book was finished. After his death the material gathered by him had to be put in order and in various ways supplemented in collaboration with his widow, Lucie Freud. The object was to put into effect ideas which he had been developing since the middle Sixties: pictures were to tell the story of Sigmund Freud's life, and extracts from his works and letters were to form the accompanying text.

In supplementing the pictures we have tried to widen their scope; whereas at first the aim was predominantly to illustrate the family scene, we have placed it in the context of such things as political events, cultural influences, aspects of Freud's work, and his associations with the first generation of his pupils. At the same time we deliberately retained the character of a picture record concentrated on Freud himself and his immediate environment, a pattern that seems commensurate with the secluded life he led, dedicated to the treatment of his patients and to research. It should be clear that it is not our intention fully to illuminate the contemporary background against which psychoanalysis was developed and then became effective in thera- peutics and education, the visual arts and literature, the social sciences, and simply in our capacity to understand ourselves. This principle of selection, biographical in the narrow sense, has made us include some illustrations that are technically imperfect, but are nevertheless important for the story of Freud's life.

In supplementing and editing the text, we also used Ernst Freud's original plans as a guideline. Pictures and texts were to be juxtaposed and fitted together like a mosaic to form a sort of illustrated autobiography. Editorial comments are restricted to those passages in which fragments of the mosaic are missing. Here brief explanations are added to the pictures. More de- tailed biographical information and additional references can be found in the "Notes to the Picture Section" in the appendix. The notes complete the text attached to the pictures, and so form a continuous chronological account of Freud's life. K. R. Eissler's biographical sketch at the beginning gives a preliminary survey. The volume is thus both a picture book and a reading book; many pictures are elucidated only in conjunction with their text.

We should like to draw the reader's attention to two observations we made in the course of our work.

It is well known that the so-called autobiographical writings, particularly "On the History of the Psycho-Analytic Movement" (1914) and *An Autobi- ographical Study* (1925), are primarily scientific history concerned with the development and content of psychoanalysis. All information on childhood experiences, infantile fantasies, the results of self-analysis—hence, his own unconscious material–Freud reserved for his letters, which he never thought of publishing. In the books he intended for publication, especially those written at the turn of the century, *The Interpretation of Dreams* (1900) and *The Psychopathology of Everyday Life* (1901), he allowed such information to appear only in fragmentary, incidental, unobtrusive fashion, oc- casionally disguised. He revealed it only for its scientific interest, in order to illustrate the complicated mental mechanisms which give rise to dreams, symptoms and parapraxes. If, as we have done in this book, one places some of these scattered autobiographical comments in chronological sequence, it becomes evident that Freud has left us very personal statements relating to almost every phase of his life and many aspects of his character—the elements of a more intimate autobiography. In this book of pictures we can, "in consideration of representability," take from all this wealth of testimony only texts for which we have pictures. Some central characters from Freud's

childhood and youth, his brother Julius, scarcely a year younger than himself, who died early, the children's nurse, his nephew John and niece Pauline, almost exactly his own age, his grown-up half brother Philipp, his friend Silberstein, cannot be shown. Where appropriate, mention of them is made in the notes.

The second observation is that the simultaneous perception of texts and pictures affords the opportunity to check directly certain descriptions Freud gave of visual sense impressions. Some of the combinations of text and pictures (*e.g.*, numbers 67, 69, 100, 190) show us how precisely Freud observed, how accurately he could look at external reality and translate it into language. Perhaps this can convey to us an inkling of how carefully he approached the inner reality of man, his special field of work, that, being invisible, cannot be shown in a pictorial record.

The book's difficult birth has left its noticeable marks. At best this might well be a protection against that "task of idealization" of which Freud once spoke when expressing his deep scepticism concerning the approach of biographers towards a great man: "[. . .] they obliterate the individual features of their subject's physiognomy; they smooth over the traces of his life's struggles with internal and external resistances, and they tolerate in him no vestige of human weakness or imperfection. They thus present us with what is in fact a cold, strange, ideal figure, instead of a human being to whom we might feel ourselves distantly related."[1]

For tireless, inestimable help during the years of preparation we are grateful to Dr. Anna Freud, London, and Dr. K. R. Eissler, New York. Without them the book could not have been finished. The editors received constant support from Mark Paterson, Sigmund Freud Copyrights, London. Dr. Eva Laible, Vienna, in the course of a detailed correspondence, contributed many valuable suggestions as well as information and pictures to the book. At the beginning of our work after Ernst Freud's death, Dr. Harald Leupold-Löwenthal, Vienna, also gave us encouragement and material. Frau Ingeborg Meyer-Palmedo, Frankfurt, helped us with proofreading and research; we are in addition indebted to her for the index. Finally, the publishers spared no pains in the production of the book. Our special thanks are due to Professor Willy Fleckhaus for the graphic form which his inspiring collaboration has given to the book.

For the Anglo-American edition we are indebted to Dr. Christine Trollope, who has translated texts which do not exist in authorized English texts, and who has also translated the Preface, Biographical Sketch and other editorial matter. We are also grateful to Dr. Trollope and to Mrs. Pat Marsden for their hard work on the establishment of the text. Mrs. Helen Wolff of New York gave us the benefit of her great experience in publishing which was of invaluable assistance in the editorial work.

[1] *Leonardo da Vinci and a Memory of his Childhood, S. E.,* **11**, p.130.

K. R. Eissler
Biographical sketch
Translated from the German

On May 6, 1856, Sigmund Freud was born in Freiberg, Moravia, the first child of Jacob Freud's third wife. It is noteworthy that thirty-four years earlier another child had been born in this region who was also to play an outstanding part in the history of science. Gregor Mendel (1822–1884), pioneer of modern genetics and discoverer of the basic law of heredity later named after him, came from Heinzendorf, only twenty kilometers away from Freud's birthplace.

We shall more easily place the year of Freud's birth in history if we remember the following facts: Charles Darwin's book *On the Origin of Species* appeared three years later, and Karl Marx's *Das Kapital* eleven years after that. Goethe had been dead for twenty-four years. Heinrich Heine, one of Freud's favorite authors, had died two and a half months earlier in Paris. The Austrian Empire, 620,000 square kilometers in extent, with 35 million inhabitants, still stretched as far as Italy; under the leadership of the young Emperor Franz Josef it appeared, eight years after the suppression of the Revolution, to be an established power. A mere decade later its decline was to begin with the loss of the Italian provinces and the defeat, at the hands of Prussia, at the battle of Königgrätz. Austria was on the threshold of industrialization. About a decade before Freud's birth the first telegraph line had been inaugurated, and two decades earlier the railway had begun to develop. As many years were to pass before the first electric light was ceremonially switched on in Vienna. There were neither telephones nor cars. The Jews had not been emancipated until 1848.

When Freud died in London eighty-three years later, Austria had dwindled to a minor state and temporarily lost its independence. The Second World War had broken out three weeks before. The Jews of Central Europe were being robbed of their civic rights, persecuted and murdered. The whole of Europe was industrialized, and mankind was only three decades away from the first flight to the moon. European culture and civilization had altered beyond recognition. Freud himself had in his own way made a vital contribution to this revolutionary change.

The small East Moravian town of Freiberg, today Příbor, is about 240 kilometers from Vienna. In the year of Freud's birth it had 628 houses and 4,596 inhabitants. The house where he was born is still standing, its original shape almost unaltered. It is a simple two-storied house; the side fronts on the street which has since been named after Freud. In the two ground floor rooms was the locksmith's shop of the Zajíc family, which had carried on its trade there already for five generations. The family name can still be seen over the front door. One flight up were the living quarters of the Freud and Zajíc families. Legend, which may very well reflect a historical truth, shows us the child as lively, well developed and cheerful; he is said to have liked spending time in the workshop, fashioning toys from sheet metal with skill and imagination.

Freud's paternal ancestors had lived in Cologne and had fled a long way eastward in the fourteenth or fifteenth century because of persecution of the Jews. In the nineteenth century they came westward again from Lithuania through Galicia to Austria. Freud's father, Kallamon Jacob (1815–1896), had moved to Freiberg in 1840. He came from the small Galician town of Tismenitz (now Tysmenica). At sixteen he had married Sally Kanner in Tismenitz. They had two sons: Emanuel (1834–1915) and Philipp (1838–1912); both went to Freiberg with their father. In 1852 Freud's wife died. Of his second wife we know only that she was called Rebekka.[1] She must have died soon after the marriage, for in 1855 Freud was married in Vienna to Amalie Nathanson (1835–1930), Sigmund Freud's mother.

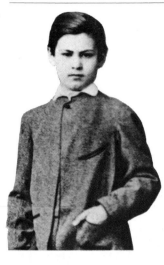

Freud was born at six thirty in the evening, and circumcised a week later; his father recorded this in the family Bible. Jacob's own father had died two and a half months earlier, which lent particular importance to his son's birth; to mark this the newborn baby received, besides his German name, the Jewish name Salomon (or Schlomo, from *schalom*, peace) after his grandfather. When he was born, his mother was twenty-one years old and his father forty-one. The combination of a young mother and an aging father appears to be particularly favorable to some children; there was a wide age gap between Goethe's parents too. The particular structure of the family may also have contributed to the happy circumstances of the child's first years of life in the little town surrounded by forests, as Freud hinted seventy years later in a letter to the Mayor of Příbor[2] when a commemorative tablet was unveiled on the house where he was born.

Freud had seven siblings. A brother was born when he was still less than a year old, but died eight months later. The youngest child, Alexander (1866-1943), was born when Freud was ten. Between the two brothers there were five sisters.

When Jacob Freud moved to Freiberg, he followed his grandfather, who for years had been carrying on a lucrative business there, buying woollen cloth in Freiberg, dyeing and finishing it, and exporting it to Galicia from whence he imported Galician farm produce to Freiberg. During the Fifties, however, the economic conditions for this branch of commerce began to deteriorate considerably. Manufacture of textiles by machinery was threatening handmade products everywhere. In addition, Freiberg had hitherto owed its prosperity to the fact that it lay on one of the most important trade routes; when the northern railway route was built through the countryside at a great distance from Freiberg, there were shattering consequences to the economic life of the small town, which was now cut off from important markets.

Jacob Freud thus found himself compelled to look for another source of income. When Sigmund was three years old, the family left Freiberg. The father tried first to get a foothold in Leipzig, but he made his way to Vienna only a few months later. So at four years of age Freud, with his parents and his sister Anna, entered the great city where he was to stay for seventy-eight years, until the occupation of Austria by Hitler forced him to go into exile in England, to which his two half brothers had emigrated as early as 1859.

The ritual circumcision and Jacob Freud's Hebrew entries in the family Bible may lead us to suppose that Freud was brought up as an orthodox Jew. This, however, was not the case. His father himself, it is true, most probably had this sort of upbringing, and Jacob Freud appears to have kept his faith for a long time; however, he seems to have become a freethinker as he grew older. He had no success in his profession, and was almost constantly obliged to call on others for financial help, but he spent a great deal of time in the study of Jewish writings in Hebrew.

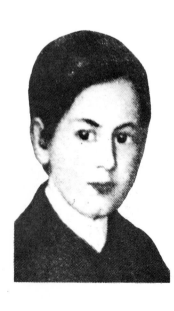

Freud was familiar with Jewish festivals and customs, but while still young he took up a nonreligious attitude to life. In early childhood, however, his children's nurse, who was a Roman Catholic, had often taken him to Mass with her. He also immersed himself in Biblical history "almost as soon as I had learnt the art of reading." This reading obviously had a lasting effect on him, as he recognizes in his *Autobiographical Study*.[3] Nevertheless he remained averse to all religious rites and ceremonies for the whole of his life, and adhered rigorously to atheist thought. At the same time he never lost his intense feeling of Jewish identity.

The boy received his first instruction from his mother. Then his father

became his teacher, until, according to the recollection of his eldest sister, his parents sent him to a private school, the name of which is still unknown. At the age of nine he passed the entrance examination to the Leopoldstadt *Communal-Realgymnasium*, which in 1867, that is during Freud's schooldays, was renamed the Leopoldstadt *Communal-Real- und Obergymnasium*. In six out of the eight years he spent there he was first in his class; at seventeen he passed the final examinations with distinction.

We are very well informed as to Freud's experience of the written part of the examination, as a letter has been preserved in which he enlarges on his fears and successes as well as on smaller incidents.[4] What really makes this letter remarkable is the beauty of style and language achieved by this seventeen-year-old boy. His teachers too noticed this gift, and with the adolescent irony very characteristic of this letter, Freud tells us: "My professor told me—and he is the first person who has dared to tell me this—that I possess what Herder so nicely calls an *idiotic* style—i.e., a style at once correct and characteristic."[5] His remarkable early development of linguistic fluency goes with a heightened interest in language and in literature in general; he tells us that the passage from Virgil and the thirty-three lines from *Oedipus Rex*, which he had to translate for the examinations, were already familiar to him from his own private reading.

His boyhood friendship with Heinrich Braun, who later became a sociologist, aroused in Freud a wish to go into politics, and he very nearly chose law as his subject. When, however, at a lecture by Carl Brühl, he came across the essay "Nature," debatably attributed to Goethe, he felt deeply impressed by it and decided to study medicine. He enrolled at the University of Vienna in the autumn of 1873, but did not graduate until March 30, 1881. Friends and relatives thought he was lazy not to take his examinations after five years, but to let three more years go by before passing his finals. In view of the normal length of studies in those days it was in fact remarkable that a student as gifted and industrious as Freud should have postponed his graduation for such an unusually long time. In a letter written in 1888 we find a passage which throws some light on his motives: "Apart from that, the habit of research, to which I have sacrificed a good deal, dissatisfaction with what the student is offered, the need to go into detail and exercise the critical faculty, are obstacles to the study of text-books."[6] This "habit of research" must have played a part in causing procrastination even in the early years; Erna Lesky believes that at that time Freud was "more a researcher than a student."[7] As soon as Freud himself finally saw it as imperative, he was capable of immense efforts to reach his goal. He got through the three examinations for his medical degree in the space of ten months, although during the whole time he was preparing for them he was constantly occupied with other work at the Physiological Institute.

At this point we have to recognize that Freud's father showed deep understanding for his son. During the whole of his period as a student the family was in economic difficulties, for the father had lost his small fortune in the financial crisis before 1873 and was no longer earning. At first, then, he had understandable hopes that his son might take up a career in business. Despite this he never put any obstacle in the way of his son's plans, financially unpromising though they might be; he did not even try to influence him when he was delaying the completion of his studies.

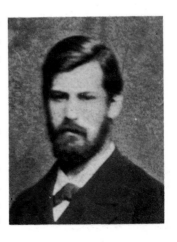

Freud wrote his first independent scientific work at the suggestion of his zoology professor Carl Claus. Twice, in 1875/76, the Ministry of Education awarded him grants amounting to 180 gulden altogether, so that he could complete a study on male river eels at the Zoological Station in Trieste. The

result of these researches appeared in print in 1877. The study is remarkable from two points of view. No layman can imagine the endurance and self-discipline needed to dissect, with the cumbersome methods of the time, the 400 eels, the histological study of which form the basis of Freud's work. And Freud was the first to approach the idea of intersexuality, proposing the possibility that sexual differentiation in the eel is not genetically prede-termined. This was not confirmed by experiment until later. Neither the twenty-year-old student nor his teacher was aware of the far-reaching consequences of this idea.[8]

Obviously disappointed in his researches—he considered them a failure—Freud changed at this point from the Zoological to the Physiological Institute, directed by Ernst Wilhelm von Brücke. Freud was to say of him later that he was the greatest authority ever to influence him.[9] Brücke was one of the leading representatives of the new antivitalistic school of phys-iology which, with Hermann Helmholtz and Emil Du Bois-Reymond at its head, sought to explain all vital phenomena by the action of physical-chemical forces.

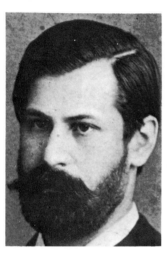

Freud spent six years, 1876 to 1882, at the Physiological Institute. Impor-tant neuro-histological studies from this period show that he was on the threshold of a brilliant career in this field. He gave it up, however, when he fell in love with Martha Bernays (1861–1951) and, not long after their first meeting, became engaged to her in June 1882. As he could not expect rapid promotion at the Physiological Institute, and yet saw financial inde-pendence as his highest priority, he began to prepare to open a medical practice, and spent the next three years, up to August 1885, at the Vienna General Hospital. These years, however, were not devoted exclusively to hospital work and the acquisition of practical experience. There was still time for scientific research, which he continued when his years of apprentice-ship at the General Hospital were over. Besides Freud's studies in brain anatomy and clinical work based on the observation of patients suffering from neurological illnesses, mention must be made of the so-called cocaine period.

In April 1884 Freud began to engage in research on this drug. Cocaine, an active constituent of coca leaves, was known to be used by Indian races to make physical stresses easier to bear. Freud, at considerable financial sacrifice, had a gram of cocaine sent to him by the firm of Merck, and soon discovered, by experiments on himself, the reinvigorating effect of the substance. He also observed its influence on friends, and was able shortly afterwards to write a monograph in which he gave a general survey of the effects of the drug and the stage research had reached, and promised further experiments.[10] The work was finished in June 1884; two months later he visited Martha Bernays in Wandsbek. When he returned to Vienna after four weeks, his colleague Carl Koller had in the meantime made the sen-sational discovery that cocaine had an anesthetizing effect on the eye. Koller became internationally famous overnight, for thanks to him eye surgery could now be carried out painlessly. Freud was then very anxious to win rapid fame so as to be able to marry soon and to free his family from their financial straits; this time he had come so close to the fulfilment of his ambitions, only to see success pass him by at the last moment.

Cocaine brought him yet another deep disappointment. His friend and teacher Ernst von Fleischl-Marxow, at one time assistant at Brücke's In-stitute, had become addicted to morphine; he had contracted an infection while dissecting a corpse, and painful neuromas, which proved intractable to surgery, were continually forming on the stump of his amputated thumb.

Freud hoped to succeed in weaning his friend from morphine with the help of cocaine, never suspecting that cocaine can lead to an even worse addiction. Two years later Freud was openly accused of having unleashed upon mankind "a third scourge" besides alcohol and morphine.

Two more events dating from this period are worthy of mention. The first concerns Freud's academic career, the second a definite reorientation in his scientific work. On January 21, 1885, he applied for a *Dozentur*, or lectureship, in neuropathology at the University of Vienna. The *Dozentur* was then considered the highest target which a young doctor could set himself, and an applicant had to show above-average performance before he could hope to attain to such an honor. Freud's admission as lecturer was supported by his old teacher Brücke as well as by Professors Hermann Nothnagel and Theodor Meynert. Nothnagel, one of the great specialists in internal Medicine of the Vienna medical school, had been called to Vienna in 1882, and in the same year Freud had worked for about six months as clinical assistant in his Department of Internal Medicine. Meynert, of whom Freud later said: "the great Meynert, in whose footsteps I had trodden with such deep veneration,"[11] was a specialist in brain anatomy and Professor of Psychiatry. Freud had acted as Junior Resident at the Psychiatric Clinic for five months and had carried out important research in the laboratory for brain anatomy. He immediately fulfilled the complicated conditions involved in an application for the lectureship, and on September 5 of the same year, scarcely more than six months after his application, the Ministry confirmed his appointment. Freud's future career appeared secure. The appointment promised a flourishing practice with guaranteed standing, and allowed him to hope for further scientific advancement.

It was, however, the second event, following a little later, which gave his life an unexpected turn. In the academic year 1885/86 it was the turn of the medical faculty to allot a University Jubilee Travel Scholarship which had been founded in 1865 and was awarded yearly. Freud applied for the grant and on June 20 the College of Professors approved his application. Once more he owed it to Brücke, who had spoken very strongly in his favor, that he had been chosen from the three applicants.

Freud stayed in Paris from October 1885 to February 1886. He worked at the Salpêtrière, the famous hospital where Jean-Martin Charcot, probably the greatest neuropathologist of his time, carried on his research and gave lectures. It is hard to say which made the stronger impression on Freud, the fascinating personality of this innovator and man of genius, or his teaching. At any rate Charcot had finally succeeded in giving hysteria, at that time a widespread form of neurosis, the place it deserved in scientific medical thinking; up to then the hysteric had as a rule been regarded with mistrust and even contempt. Charcot showed that the phenomena of hypnosis had the character of reality, and for the first time put the bewildering diversity of hysterical symptomatology into comprehensible clinical order. By demonstrating how hysterical symptoms can be artificially created in patients under hypnosis, he showed ways of investigating their origin.

In Paris, then, a new world opened to Freud. It could be said that there, under Charcot's influence, he discovered the psychological side of neuropathology, which was soon to become his exclusive interest. When the travel grant was unexpectedly awarded to him in June 1885, he wrote exuberantly to his fiancée: "Oh, how wonderful it will be ! I [will] [. . .] come back to Vienna with a huge, enormous halo, and then we will soon get married, and I will cure all the incurable nervous cases [. . .]."[12]

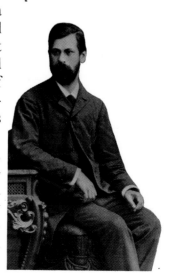

But events moved differently. Instead of the hoped-for success, Freud unexpectedly met with harsh rejection when, after his return in October 1886, he expounded Charcot's doctrines to the *Gesellschaft der Ärzte* (Medical Society) in a lecture "On Male Hysteria." For the time being mental patients appeared, as ever, incurable.

Freud now started his private practice in the Rathausstrasse. On three mornings a week he worked as a neurologist in Professor Max Kassowitz' Pediatric Institute. And six months later he was able at last to marry Martha Bernays; an aunt of the bride, by a generous gift of money, had enabled the couple to set up house.

That he could finally marry Martha must have seemed a great triumph to Freud, for at first everything seemed to conspire against a happy end to their engagement. Martha Bernays, who was born near Hamburg, came from a culturally eminent German-Jewish family. Her grandfather, Chacham Isaac Bernays, was Chief Rabbi of the Hamburg Congregation; he had played a prominent part in the synagogue dispute of 1841; he was well educated and was a follower of Schelling's philosophy. Although he opposed the efforts toward the reform movement by a considerable section of the Hamburg Congregation, he was the first orthodox Rabbi to preach in the vernacular. Two of Martha's uncles, Jacob and Michael Bernays, were also well-known figures. Jacob was Professor of Classical Philology and Chief Librarian at the University of Bonn; he had worked especially on the Greek philosophers, and his book *Die Grundzüge der verlorenen Abhandlungen des Aristoteles über die Wirkung der Tragödie* (1857) had caused a considerable sensation. Michael, who had accepted baptism, taught the history of German literature in Munich; his professorship had been especially created for him by Ludwig II of Bavaria, and his best-known work bears the title *Zur Kritik und Geschichte des Goetheschen Textes* (1866).

Martha's father Berman had come to Vienna in 1868. Ten years later he died suddenly, leaving his family penniless. The mother Emmeline (née Philipp) was a highly educated, intelligent woman of Scandinavian origin. Like her late husband, she was orthodox Jewish. To Freud's great distress she insisted, after her husband's death, on moving to Hamburg with her daughters, thus inflicting on the engaged couple a separation that lasted for years.

Considering the customs of the time, Freud's choice was thus most unconventional and complex. He was, in fact, seeking the hand of a girl whose family, from the point of view of tradition and social rank, could set their sights high, but at the same time were unable to offer the suitor an appropriate dowry. As in many other spheres of life, however, Freud fought relentlessly for Martha.

After their marriage the couple moved into an apartment in the Sühnhaus, then newly built. This building stood on the site of the Ringtheater, which had burned down in 1881. Three hundred people had died in the disaster. Their relatives were now to be supported by the rents from the Sühnhaus. Freud did not share in the superstition, widespread among the populace, that the building was haunted because it held memories of the tragedy.

The marriage marked the end of a decisive period in Freud's life. The engagement, which lasted more than four years, is probably to be regarded as the hardest trial he ever faced. Separated from his fiancée, suffering financial hardship, with an uncertain future before him, involved in exhausting training, working on difficult scientific problems, now coming close to great success, now plagued by disappointments, he had to muster the full force of his will in order not to succumb to the pressure of all these stresses

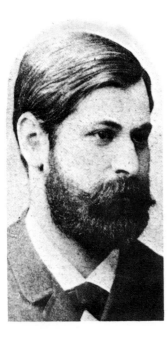

Yet he succeeded at last in founding a family and achieving the *Dozentur*. His reputation also won him the respect of his colleagues; the practice at first proved lucrative beyond expectations. The sorrows and privations of the last four or five years appeared to be abundantly compensated. In 1887 the first child was born; five more followed in the next few years. Freud's life seemed to be moving along clear and predictable paths. But once again events turned out differently.

To begin with he seemed quite ready to give up his earlier ambitious plans and confine himself to his medical practice to support his family. As he had been professionally trained in neuropathology, he was soon consulted chiefly by patients suffering from nervous diseases. For more than a year and a half he used the curative methods generally accepted for such complaints: electrotherapy, massage and therapeutic baths. However, the improvements, or even cures, promised in the textbooks frequently did not happen. For that reason Freud turned finally to hypnosis, which, although rejected by many authorities, was beginning at that time to be a popular therapy. The doctor put the patient into a hypnotic trance, and made all kinds of suggestions concerning his symptoms, hoping to bring about in this way the disappearance of the neurotic disturbances. As this method did in fact achieve gratifying cures in many cases, Freud at first thought that the failures or relapses which he was constantly meeting in his patients were due to his own inadequacy. Therefore, in 1889 he went to Nancy, then the stronghold of dynamic therapy, in order to perfect his hypnotic technique under Auguste Ambroise Liébeault, the founder of the Nancy school, and his famous pupil Hippolyte Bernheim. All this bore little fruit, and he had few successes. It seemed useless to suggest to the patient under hypnosis that he was well, when he still insisted after waking that he was ill.

In this situation a man whose friendship he had long enjoyed became very important to Freud. This was Josef Breuer, at that time probably the most highly reputed specialist in internal medicine and a general practitioner in Vienna. Warm-hearted and generous, he had come to Freud's assistance with advice and financial support in the years of emotional crises and material poverty. Breuer was in addition an important researcher. For his work on the autonomic control of breathing and on the organ of equilibrium he was elected a corresponding member of the Vienna Academy of Sciences. We may well say that Breuer was extraordinary as a scholar, as a doctor, and as a man.

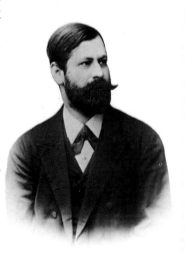

For years Breuer had been treating, in his practice, a woman patient who suffered from very severe hysterical symptoms. In medical literature she goes under the name of "Anna O." We know today that this pseudonym hid the identity of Bertha Pappenheim, later to become famous as one of the first fighters for women's rights and social welfare.

An observation which Breuer made by chance had led him to an important discovery: when under hypnosis the patient remembered in detail the original situation in which the hysterical symptom had arisen, and gave expression to the emotion which had been repressed at the time, the symptom in question disappeared. Breuer had already told Freud at an earlier date about this illuminating case and the unusual observations connected with it, and Freud had evidently been deeply impressed by Breuer's reports, although he did not follow up this important clue at once. "I determined to inform Charcot of these discoveries when I reached Paris, and I actually did so. But the great man showed no interest in my first outline of the subject, so that I never returned to it and allowed it to pass from my mind."[13] Now, when Freud found himself powerless against his patients' suffering, he remembered what he had heard from Breuer, and himself tried Breuer's

method, called "catharsis." Breuer and Freud published the findings of this experiment, which had some surprising clinical results, together with the case-history of "Anna O.," in *Studies on Hysteria*.[14] This is the book from which psychoanalysis emerged. The revolutionary first chapter, "The Psychical Mechanism of Hysterical Phenomena," had appeared as early as the beginning of 1893 as a "preliminary report."

Breuer had used his cathartic method only with this one patient. Freud now took it as his exclusive technique for treatment. In doing so he made the observation, as unexpected as it was portentous, that the original traumas leading to the formation of psychoneurotic symptoms were regularly concerned with sex. Breuer received this discovery with scepticism, and the two scholars became increasingly estranged one from the other, leading to the final break.

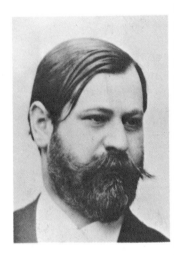

While Breuer's influence was weakening, the importance of another man in Freud's life was growing. This was Wilhelm Fliess, a Berlin ear, nose and throat specialist, who was interested in problems of general biology. Fliess became famous for two discoveries: the role of periodicity in the life of the organism, and the doctrine of bisexuality. He believed he had discovered, in the life of both sexes, two effective periods, one of 28 days in women, and one of 23 days in men. These hypotheses have few adherents left today, although the logical conclusions of the bisexuality theory, that the physical and mental makeup of human beings contains elements of the opposite sex, continues to be accepted as correct. Aside from the value of his scientific research, however, Fliess was evidently an extremely fascinating personality—one of those people who, without being geniuses, yet give the impression of genius. Whoever met him seemed to fall under his spell. The friendship between Freud and Fliess began in 1887, but was already cooling off by 1900. Yet without a doubt it answered a deep-seated need for Freud.

Unfortunately, of the letters the two friends wrote to each other in these years, only those written by Freud have been preserved. *The Origins of Psycho-Analysis*[15] is the only record of the significant processes that went on in the mind of a scientist of genius during one of his most productive phases. Let us visualize Freud's situation: Every day the treatment of neurotic patients led him to discover new problems needing elucidation. The multiplicity and novelty of these problems must have had a completely bewildering effect on him, especially as it became clearer and clearer that he had touched upon facts which contradicted all established ways of thinking and traditional concepts.

Let us look, for example, at the role of repressed sexuality in the causation of neurotic symptoms. Freud, who grew up in a strictly conventional middle-class family, must have needed to overcome great inner resistances before he could gradually acknowledge the contents of repressed material, that is to say without minimizing or glossing over it. At that time nothing was known about the dynamics and structure of neuroses. First of all Freud had to find and define basic concepts like "repression" and "projection."

In the letters to Fliess we can see the cautious forward groping, the sudden gleam of an insight that slips away as abruptly as it came, returns and slips away again, until at last it becomes a new understanding to be grasped and firmly held. The reader experiences the researcher's doubts and fears, and knows the disappointment he feels when what appeared to be a firm, basic scientific fact unexpectedly turns out to be wrong. In such a situation it was most important for Freud to have a correspondent to whom he could always turn, and who, for the very reason that he was engaged in other fields of research, offered a kind of background of friendly neutrality. It is

questionable whether Freud, left to himself, could have held out, as in the meantime his situation in Vienna had considerably worsened.

The unfavorable reaction of the Medical Society to his lecture on the experiences in Paris had hurt him. His former chief Meynert barred him from the laboratory of brain anatomy, and wrote an article in violent opposition to him. At the General Hospital, Professor Franz Scholz, who had also been a superior of his, refused him the case material he needed for his lectures. The reason was ostensibly an old quarrel from the period when Freud was working in Scholz's department. Whenever Freud advanced his clinical discoveries, which appeared to clash so violently with the laws of sanity and common sense, his audience melted away. Word was put about that he probed for details of his patients' sexual lives, which gave rise to horrified amazement and meant that no more patients were referred to him.

This serious financial worries were added to the almost unbearable inner tensions which his research inevitably caused. Freud had now to live through an extremely painful period of isolation; apparently this experience of being excluded is the unavoidable fate of great innovators. In those years, at any rate, Freud made one of his great discoveries: the Oedipus complex. According to this concept every child goes through a phase of conflict in his relationship with his parents. At that time Freud specified this conflict only for the male child, who, he said, competed with his father and wanted to get rid of him in order to fulfill his daydreams and wish impulses and possess his mother. Thus every boy at a certain period of his life is a little Oedipus, and on a smaller scale and in a different form, his story is that of the king immortally dramatized by Sophocles. The resistance and indignation which Freud aroused with this discovery, and which psychoanalysis often meets even today, are well known.

The year 1899 is an important one in the history of European thought; in this year Max Planck gave his lecture on the quantum theory, which represents the watershed between classical and modern physics, and Freud published his book on *The Interpretation of Dreams*.[16] There is a certain savor in the thought that Thomas Mann was writing his *Buddenbrooks* in the same years, 1896 to 1900, in which Freud was engaged on his dream book.

Freud had come upon the problem of the dream through the remarkable observation that his patients regularly told him about their dreams and that there was an obvious connection between their dreams and symptoms. This necessitated a systematic investigation into the psychology of dreams, in the course of which Freud also studied his own dreams.

At the beginning of his great book Freud gives a survey of all the frequently contradictory statements that had been published about dreams up to that point. He subsequently shows that there is a place for almost all these findings in his comprehensive theory. On the foundation of his revolutionary insights, the accuracy of which had been confirmed by dream analysis, he then built up his new general theory of the emotional life of man. It is contained in the famous seventh chapter, and marks a radical turning point in psychology, comparable to the revolution in physics effected by Planck's quantum theory.

Freud was aware of the great importance of his discovery. He meant it as a joke, of course, but there was an element of seriousness in the question he threw out in a letter to Fliess, written during the summer holiday in Bellevue, a little mansion in the Vienna woods where, years before, he had achieved the first complete analysis of a dream: "Do you suppose that some

day a marble tablet will be placed on the house, inscribed with these words: 'In this house on July 24, 1895, the Secret of Dreams was revealed to Dr. Sigmund Freud'? At this moment I see little prospect of it."[17] Without a doubt *The Interpretation of Dreams* counts among the great books of our civilization. The material treated in it is varied and complex. It is written in a masterly style and argued with compelling logic. Step by step, Freud develops his new theories. Nobody could have told, from its unity and beauty of form, the pains that attended its birth.

It had long been clear to Freud that he would have to delve into his own unconscious if he wished really to understand his patients. He had moved away, step by step, from the cathartic technique and its attendant exertion of influence on the hypnotized patient, and turned to the method of free association which he had developed himself; this now smoothed the way to his self-analysis. In this method of free association the patient is fully conscious and yet is encouraged not to influence his thought processes, but to let himself go uncritically with the flow of his thoughts; he is asked to tell the doctor everything that occurs to him, in as uncensored a form as possible. The free associations which his patients conveyed to Freud, using the individual dream elements as a starting point, led him into unexpected depths in their mental lives which had not yielded to Breuer's cathartic method.

Another advantage of this method was that Freud could also use it on his own dreams. Since the free associations which are released by the day's residues represented in the dream lead to very painful thoughts, fantasies, memories and impulses which have been forgotten, or, psychoanalytically speaking, "repressed," an almost unimaginable self-discipline was needed if the chain of these associations was not to be prematurely broken. In psychoanalytical treatment it is the analyst who helps the patient to overcome his resistance against the free associations. Freud, however, stood alone in the struggle with his unconscious. It is an unsolved psychological enigma where he found the strength to expose himself voluntarily to the anguish which is unavoidable when someone calls to memory all the tragic events and experiences of childhood which usually lie repressed in the innermost depths of the mind. And there is more to come. In the cause of science Freud made public not only his patients' dreams, but first of all his own, together with their associations and interpretations. In so doing he had to admit openly what other people "would never even dream of," because the dream reproduces the impulse rejected by consciousness in so distorted a form that the unconscious contents encoded in the dream-representation are unrecognizable when the dream is remembered in waking life.

Imagine the horror that a well-bred conventional man, who loves and respects his father, must feel when he learns, on analyzing his dreams, that many of his unconscious thoughts treated this recently (1896) dead father with great disrespect, and, indeed, that intensely hostile and belittling impulses lay hidden behind the veneration perceived by the conscious mind. Freud's self-analysis and the unsparing publication of the most intimate, usually shameful, details, must be regarded as the extraordinary sacrifice of a great idealist, practically unparalleled in scientific history.

In a relatively short space of time, between 1901 and 1905, there followed the publication of yet more epoch-making works, including "Fragment of an Analysis of a Case of Hysteria,"[18] *The Psychopathology of Everyday Life,*[19] *Three Essays on the Theory of Sexuality.*[20]

At the turn of the century the isolation gradually lessened. The prime factor

in this was not so much the fact that in March 1902 Freud was appointed titular Professor Extraordinarius (full professor), after the Ministry had failed to implement an earlier application by the Faculty for his promotion. A much more decisive factor was that since 1902 four doctors, Alfred Adler, Rudolf Reitler, Max Kahane and Wilhelm Stekel, had been meeting regularly every Wednesday evening in Freud's home in order to discuss his work with him. The circle soon widened. In 1903 they were joined by Paul Federn, who was later to replace Freud as the chairman of the Vienna Psycho-Analytical Society and to make important contributions to group psychology, educational questions and the psychoanalytical treatment of schizophrenia, in which he was the first in the field.

Eduard Hitschmann, a successful internist, was brought in by Federn in 1905. He wrote the first textbook on psychoanalytical teaching about neuroses, and also published important contributions to the application of psychoanalysis to biography. He became head of the psychoanalytical outpatient clinic in Vienna.

Otto Rank, before he founded his own school, was a favorite pupil of Freud's. In his youth he had introduced himself to the little group with a manuscript that revealed his particular talent. He was encouraged to pass the entrance examinations and attend the University. Later Rank made some important contributions to the psychology of the artist and the application of psychoanalysis to mythology.

Hanns Sachs, a Viennese lawyer, had been so impressed by *The Interpretation of Dreams* that he gave up his profession. He joined the group in 1910. He possessed a very highly developed capacity for empathy, and was particularly interested in literature and art. He played a decisive part in the founding of the periodical *Imago*, which published mainly contributions on psychoanalysis as applied to the humanities.

In 1908 the group already had twenty-two members. Gradually visitors from abroad began to appear, ready to make psychoanalytical treatment and research their life's work. Sándor Ferenczi, later the leader of psychoanalysis in Hungary, of whom Freud remarked at a time when there was as yet no psychoanalytical association in Budapest, that he alone made up for a whole society,[21] soon became his friend and even accompanied him on his travels. Ferenczi developed into one of the most productive and original analysts, and there is scarcely a sphere of psychoanalysis in which he did not have a fruitful influence.

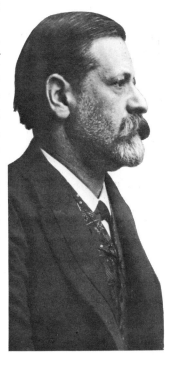

In May 1908, on Freud's birthday, two visitors from the English-speaking world appeared: Abraham A. Brill, a successful representative of psychoanalysis in the United States, and from London Ernest Jones, who became one of the most important analysts, and crowned his many contributions to psychoanalysis with the three-volume biography of Freud.[22] It was he who, after the occupation of Austria in 1938, immediately travelled to Vienna to arrange for the Freud family's emigration, and who approached the British government to allow them to settle in England.

Ludwig Jekels concerned himself with analysis in Poland before settling in Vienna. He too belonged to the circle of early pupils and collaborators whom one might call the "old guard." His biographical contribution to the life of Napoleon and acute analysis of complicated mental situations are worthy of note.

Karl Abraham first met Freud in 1907 before opening his practice in Berlin, where he founded, in 1910, the Berlin Psycho-Analytical Society. He was the leading representative of psychoanalysis in Germany, and his work included important contributions to the psychoanalytical study of mental illness, and also to the understanding of the development of libido. Not

least, Abraham became a faithful and reliable counsellor to Freud on questions touching the administration of the psychoanalytical movement. His moral integrity, combined with a highly original mind, made him an irreplaceable support for Freud.

I end this list with Max Eitingon, who should really have been mentioned at the beginning, for in 1907 he was the first visitor to come to Vienna from abroad to consult Freud about a particularly difficult case. He was the only one of the group to have considerable financial means. It was due to his generosity that the Berlin Institute and out-patient department could be opened in 1920. Eitingon's main interest was psychoanalytical teaching, and his talent for organization made it possible for psychoanalytical training to be internationally regulated and to reach a high level. Eitingon also kept a tireless watch on Freud's welfare, and often stood by him in times of crisis.

In the end the number of Viennese members increased to such an extent that from April 1910 onwards the meetings could no longer be held in Freud's apartment. Certainly this expansion of the Viennese group—regarded absolutely, of course, it still appeared modest—and also the visits from abroad, were important to Freud. But he must have found much more significance in another event which he probably regarded as an unforeseen turning point in the progress of his work, that is, the interest with which psychoanalysis was received in Switzerland. Eugen Bleuler, Professor in Zürich and internationally known as a psychiatrist, and C. G. Jung, university lecturer and Bleuler's first senior resident, showed a favorable attitude towards psychoanalysis. Here, quite unexpectedly, an academic group of high standing had included psychoanalysis among the therapeutic resources of the famous university psychiatric clinic of Burghölzli, and had accepted it as an adequate method for the diagnosis and treatment of serious psychiatric illnesses. On March 3, 1907, Jung visited Freud for the first time. The conversation lasted many hours and was the beginning of a very promising friendship.

In 1910 the International Psycho-Analytical Association was founded in Nuremberg, the local associations having already met together earlier, in 1908 in Salzburg. The year 1908 also saw the founding of the first psychoanalytical periodical, the *Jahrbuch für psychoanalytische und psychopathologische Forschungen*, of which five volumes exist altogether. Publication ended at the outbreak of the First World War.

A second outside event also made a great impression on Freud. In 1909, Granville Stanley Hall, Professor of Psychiatry and President of Clark University in Worcester, Massachusetts, invited him to take part in the celebrations of the twentieth anniversary of the foundation of the university. This invitation was also a complete surprise to Freud. In Worcester he gave five lectures and received an honorary doctorate. The honors and marks of recognition bestowed on him during this visit were to Freud, rejected or ignored almost unanimously by the academic world of Central Europe, "like the realization of some incredible day-dream."[23] Nevertheless, he retained a prejudice against America to the end of his days.

The third event that can be regarded as the outward sign of a favorable change in the fortunes of psychoanalysis was the decision of Lou Andreas-Salomé to become a psychoanalyst. Lou Andreas-Salomé was at that time accounted one of the best-known women writers in the German language. She was the only woman to attract, for a while, the attention of Friedrich Nietzsche. This alone, as Nietzsche became famous, had given her a prominent position, as had also her long association with the Austrian poet Rainer Maria Rilke. In 1911, at the age of fifty, Lou Andreas-Salomé came to Vienna. She became a pupil of Freud's and practiced psychoanalysis until the

nd of her life. Her friendship with Freud lasted unclouded to her death.[24]

We are now in a period in which we meet quite a different Freud from the one we know from his years of storm and stress. The painful emotional crises receded with the end of his self-analysis. The passion and turmoil of those years had yielded to strict discipline, self-control and outward calm. Ferdinand Schmutzer's etching, dating from 1926, shows Freud as he was becoming known to the world in his gradual rise to fame: an inscrutable face, from which the eyes look out keen, wise and understanding; a face which does not flinch from the tragic eventualities of this world; a face which can never again know fear, and which, despite the expression of sadness, is a stranger to despair; a controlled face, with a slight suggestion of those Olympian features that Goethe so loved to show to the world. But that is only *one* aspect of Freud's mature personality. Beneath the self-control, the skeptical detachment of the scholar, strong emotions stirred as they always had.

It became evident, in fact, that the years of "splendid isolation," as Freud once called his period of almost complete solitude,[25] had not been entirely unfavorable. Now that he had become the founder of a school, new problems arose. Some of the scholars whom he had trained for years in psychoanalytical theory and technique began gradually to develop doctrines and hypotheses quite different from those of psychoanalysis, abandoning the basic knowledge that Freud had so laboriously acquired. It finally became clear that a break with these colleagues was inevitable.

The central figure of the first split of this type was Alfred Adler, who later founded what he called "individual psychology." At first Freud thought highly of Adler's new theory, which centers on the inferiority of the organs and their importance to mental life. Freud was even instrumental in Adler's election to the presidency of the Vienna Psycho-Analytical Society and his editorship, with Stekel, of the *Zentralblatt für Psychoanalyse*, founded in 1911. However, the new theories moved further and further away from psychoanalysis, and finally, in 1911, after long and impassioned discussions, Adler left the Society. Later he enjoyed great popularity in Vienna, particularly among intellectuals with socialist leanings. Unlike Freud, he was not particularly concerned with scientific psychology; he was much more interested in the practical understanding of mankind as directly applied to everyday life—that is, to education, hygiene, social work, etc. This explains his considerable success. Psychoanalysis, with its complicated theories and its findings which went counter to common sense and against many traditional ideas, could not expect to be so widely recognized.

The second split was brought about by C. G. Jung, the leading Swiss analyst and at that time President of the International Psycho-Analytical Association. Freud felt this event as a bitter personal affront.[26] He had at first been deeply impressed by Jung's personality and convinced of his outstanding scientific gifts. He determined to make Jung his successor and transfer the leadership of the psychoanalytical movement to him even in his own lifetime. Around 1912, however, Jung began to express opinions with which Freud could not agree. For instance, Jung took the many references to incest which can be found in mythology as symbolic equations of purely mental processes. Jung had not only researched into Western and Eastern mysticism, he was himself a mystic, while Freud subjected himself throughout his life to the discipline of strict scientific empiricism. Freud's method of procedure finally proved incompatible with Jung's intuitive-mystical interpretations.

At the Fourth International Psycho-Analytical Congress in Munich,

1913, it became clear that the chasms could no longer be bridged. Jung too had come around to this view, and in April 1914 he resigned from the presidency of the International Psycho-Analytical Association. Afterwards he founded a school of his own, and finally called his doctrine, which appealed particularly strongly to philosophers and psychologists of religion, "analytical psychology."

In order to relieve Freud of the burdens such controversies inevitably involved, Jones had the idea, when Adler's secession was already complete and Jung was preparing for his, of forming a small group of analysts on whom Freud would be able to rely. The group was not given an official position in the psychoanalytical movement; it was rather intended to work in the background and, whenever differences of opinion arose in the future, to stand by Freud and relieve him of the main burden of argument. Later this group was known as the "Committee."

Freud was captivated by this proposal. Later he wrote in a letter: "The care that weighs me down about the future [. . .] comes from the time when psycho-analysis depended on me alone [. . .]. In 1912 [. . .] the Committee was formed and took on the task of continuation along the right lines. Since then I have felt more light-hearted and carefree about how long my life will last."[27] But this confidence on Freud's part proved not to be justified. The Committee consisted originally of Abraham, Ferenczi, Jones, Rank and Sachs; in 1919 Eitingon was co-opted. The "boyish and perhaps romantic element,"[28] as Freud once called it, which gives rise to such alliances, led him to give the members a Greek gem from his collection, which each of them had set into a gold ring. The Committee began its work in 1913, but was interrupted by the war not long afterwards. In the first ten years after the war, however, it gave sterling service. Later quarrels broke out among the members, and the Committee collapsed, as usually happens with groups of this kind. In later years there were other rifts, though with less serious consequences; one of these was Freud's break with Rank.

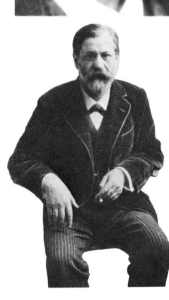

The fact that pupils and collaborators were leaving his circle and founding schools of their own gave Freud the reputation of being an authoritarian, intolerant sort of man. If we read the documents and letters that have come down to us, we get a different impression. Freud tried to minimize as far as possible the differences between his own findings and the results of his collaborators' researches, and to extend as widely as he could the range of activities covered by the name of psychoanalysis. His letters to Rank in particular show his tolerance. When Rank's new theory about the trauma of birth was rejected by most analysts, Freud advised him not to take this rebuff too much to heart, as the future would show whose hypotheses were right. The letters to the Swiss psychiatrist Ludwig Binswanger[29]—Freud was on friendly terms with him to the end of his life, although Binswanger had begun as a strictly orthodox psychoanalyst and gradually moved so far away from psychoanalysis that today he is considered as the founder of existential analysis—show how little Freud allowed his human relationships to be disturbed by differences of scientific opinion, and that basically he was more tolerant than could have been expected. The disagreements with earlier collaborators never misled Freud into wasting his productive energy in polemics, which he abominated. Even his work "On the History of the Psycho-Analytic Movement"[30] was a defense rather than an attack, serving to specify his own point of view and detail the reasons why he could not follow those who had now become his opponents.

We can say, on the contrary, that criticism of psychoanalysis had the effect on Freud of increasing his productivity. It induced him to investigate

ever more thoroughly those areas that were said not to be accessible to his theories. For example, to demonstrate the basic structure of mental illness, he made a psychoanalytical study of the book *Denkwürdigkeiten eines Nervenkranken*[31] in which the President of the Senate of the Dresden Superior Provincial Court, Daniel Paul Schreber, describes the course of his psychosis.[32] Here Freud had the chance to use biographical material available to the public, and was thus not compelled to have recourse exclusively to personal observations made in the seclusion of his consulting room.

Thus everything in Freud's life now seemed to be going well. His doctrines were beginning to gain a foothold and to spread, and his personal relationships were entirely harmonious. His wife had borne him six healthy children. He was tenderly cared for by her and by his sister-in-law Minna Bernays, who had long been a permanent member of Freud's family; after the death of her fiancé Ignaz Schönberg in 1896, she remained unmarried.

Freud's hopes of an untroubled future were soon dashed. The outbreak of the First World War brought far-reaching changes. The group of fellow workers, so important for the further development of psychoanalysis, was torn apart, and contact with psychoanalysts living abroad was abruptly severed. Most of his colleagues in Vienna were conscripted and separated from their psychoanalytical work. It seemed doubtful whether the two leading psychoanalytical journals, *Internationale Zeitschrift für ärztliche Psychoanalyse* and *Imago*, would be able to continue publishing at all. Freud's personal circumstances were also taking a very unfavorable turn. His three sons were called up; two were constantly fighting in the front line, and the eldest was missing for a long time before it was learned that he was a prisoner of the Italians. The number of patients was diminishing, and savings had to be broken into for day-to-day living.

At first wartime conditions did not inhibit Freud's productivity. In 1915 he wrote his fundamental contribution on *Metapsychology*. In the sphere to which Freud gave this name, the results of psychoanalytical research were to be presented in the most abstract form imaginable, at a high intellectual level, an unusually difficult undertaking.

The privations, as they grew more severe, finally began to affect his state of mind. Wrapped in a greatcoat in an unheated room, Freud found writing more and more difficult. In November 1917 he remarked in a letter to Ferenczi: "I have been working very hard, feel worn out and am beginning to find the world repellently loathsome. [. . .] Sometimes I have to fight hard to regain ascendancy over myself."[33] At the end of 1917 we find the following note in a letter to Abraham: "I feel bitterly hostile to the idea of writing, as I feel towards many other things."[34] And Jones, Freud's biographer, writes: "In 1917 Freud had reached the nadir of his expectations about the future of his life's work."[35]

At the end of the war the fortunes of psychoanalysis began to look brighter again. During the war a large number of soldiers suffered from traumatic neuroses (also known as shell shock) and became unfit for service. Official psychiatry fought in vain against this "plague" with electrical therapy. Many analysts, on the other hand, had been able to point to some extraordinary successes in the treatment of such war neuroses, and this had become known. When, at Abraham's instigation, the Fifth International Psycho-Analytical Congress took place in Budapest in the autumn of 1918, that is to say shortly before the collapse of the Central Powers, official representatives of the Central European governments took part. The Congress was a great success, and Freud, under the stimulus of the public interest in psychoanalysis, took courage once more.

Shortly after the end of the war, when the grinding anxiety about his sons' lives had been lifted from him, but Austria was still crushed by poverty and hopelessness, Freud suffered two cruel losses.

Anton von Freund died at the beginning of 1920, at the age of forty. He was a rich brewer in Budapest, and had done many services to psychoanalysis through his generous gifts. His premature death was a bitter blow to Freud, who also had a very close personal relationship with him. Two years earlier, von Freund had had to undergo an operation for the removal of a malignant tumor. The uncertainty of how long he had to live led to the outbreak of severe neurotic symptoms, which Freud treated successfully in 1918–1919. As a recurrence was possible at any moment, von Freund decided to make a will leaving his property for philanthropic purposes. He put a considerable sum at Freud's disposal, which later, despite devaluation, made it possible to found the Internationaler Psychoanalytischer Verlag (publishing house). At first von Freund's condition fluctuated, but from the autumn of 1919 it deteriorated. Freud visited the mortally sick man every day. On January 20, 1920 von Freund died. Four months later Freud wrote to Ferenczi that this loss had gone a long way towards making him feel that he was growing old.[36]

On the day of Anton von Freund's funeral, news reached Freud that his second daughter Sophie, then twenty-seven years old, who had moved to Hamburg when she was married seven years before, and had meanwhile become the mother of two children, was very ill with the dangerous form of influenza then raging. Postwar conditions prevented the parents' travelling at once to Hamburg; on January 25 Sophie died. Freud, who did not hide his feelings from himself any more than from those close to him, noticed that he did not react as he might have been expected to. Despite all the emotional shock, the process of mourning apparently was not able to develop fully. Six years later, when Ludwig Binswanger told him of the death of his eight-year-old son, Freud in his reply spoke once more of the loss of Sophie: "It is true that I lost a beloved daughter at the age of 27, but I bore this remarkably well. It was in 1920, when we were crushed by the misery of war, and prepared for years to hear that we had lost a son or even three sons."[37] His mourning potential was obviously exhausted by the long consuming worry about the life of his sons.

But is this the whole explanation? At this time Freud was already caught up in one of the most productive phases of his life, and it is certainly a peculiarity of genius that energy-consuming creative processes lessen the intensity of personal life. In May 1920 he finished his book *Beyond the Pleasure Principle*[38] in which he laid the biological foundations of psychoanalysis, and built up on them his boldest constructions, the death drive and the repetition compulsion. In December of the same year he finished *Group Psychology and the Analysis of the Ego*.[39] Here Freud laid the foundations for a psychology of social processes by showing how the psychological structure of the individual reacts as soon as he becomes part of a crowd.

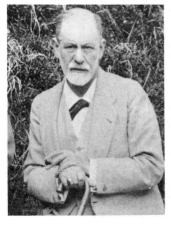

The climax of this creative period, however, was the book *The Ego and the Id*.[40] According to the new theory here developed, we have to imagine the individual's psychological structure to consist of Ego, Superego and Id. The Id means, roughly, the region which in Freud's earlier works is somewhat vaguely referred to as the "unconscious." It includes all instinctual impulses and all repressed material, and is thus the nucleus of what is commonly known in current speech as the irrational, the demonic or even the bestial and evil in man. The Superego, on the other hand, stands for moral

precepts, traditions, and aesthetic and ethical principles. It also fulfills the functions of the conscience and of introspection. It is originally formed from the child's identification with the parents, from whom the child learns what is approved of and what is considered objectionable. The Ego, the third part, is hard-pressed on one side by the instinctual Id impulses and on the other side by the opposing prohibitions of the Superego, and in addition a hard inflexible reality demands that the Ego shall adapt. Equipped with a multiplicity of functions, such as perception, thought and memory, the Ego, in order to prevent the irruption of prohibited wishes, develops an arsenal of defense mechanisms like repression, identification, displacement, isolation, denial and many more. It tries to keep repressed material out of the conscious mind, and lets in only its offshoots in the form of day dreams and fantasies. It has to find compromise solutions. If the Ego succeeds, in one and the same action, in satisfying the Id to some extent, giving the Superego what it needs, and settling the claims of external reality, then it has done the best it can.

Thus, step by step, Freud developed a theoretical system embracing the whole personality, and in which all phenomena of both normal psychology and psychopathology have their place. In this way the field of research of psychoanalysis was extended far beyond its original sphere. A medical doctrine evolved for the cure of neurotic symptoms had, in the space of three decades, become an instrument with which deep insights into the structure of the personality could be gained—a general science of the mental processes.

In the year in which *The Ego and the Id* was written, Freud once more suffered a painful loss. The younger son of his daughter Sophie had been given, after her death, into the care of Freud's eldest daughter, Mathilde Hollitscher. She lived in Vienna, so that Freud got to know his very bright little grandson very well, and became deeply attached to him. The child suddenly fell ill, and it was soon realized that he was dying of an incurable miliary tuberculosis. Freud could never get over this loss, and six years later, on the day when Sophie would have been thirty-six, he spoke once again about this painful event in a letter to Binswanger. He answered Binswanger's letter telling him of the death of his eldest son: "Although we know that after such a loss the acute state of mourning will subside, we also know we shall remain inconsolable, and will never find a substitute. No matter what may fill the gap, even if it be filled completely, it nevertheless remains something else. And actually this is how it should be. It is the only way of perpetuating the love [. . .]."[41] Already during his grandson's mortal illness, Freud had complained that nothing had any meaning left for him.[42] And a month after the death he confessed in a letter to Ferenczi that for the first time in his life he was suffering from a depression.[43]

Freud behaved quite differently when, after the removal of a tumor in his upper jaw, cancer was diagnosed, and the long agonizing period of suffering began which was not to end until sixteen years later. As early as 1917 Freud had suffered for a while from a painful swelling in the palate; he had at that time already considered the possibility of a carcinoma. But as the swelling occurred when he had temporarily given up smoking owing to the lack of cigars, and disappeared as soon as he began smoking again, he decided that the symptom was psychogenic.

In February 1923 Freud discovered, at the right side of his palate, a tumor which had to be removed. This first surgical intervention was followed by thirty-two more operations. Only six months later Professor Hans Pichler, an outstanding Viennese oral surgeon, undertook a radical operation: the

jaw and palate on the affected side were removed. It was a terrible operation which had chronic consequences and affected a vital area. The missing bone necessitated a prosthesis of horrifying size. It was known as "the monster," and the patient had to struggle with it continually; it was painful both to take it out and to put it in. It had to fit tightly in order to shut off the cavity caused by the operation, but because of that it irritated the surrounding tissues, caused sores, and sometimes caused unbearable pain. Many specialists were consulted. Once Freud travelled to Berlin to have a new prosthesis fitted; another time a professor from Harvard who happened to be staying in Europe was induced to take the prosthesis in hand. He worked on it for twenty days, but in vain. Nothing could make life bearable again. Speaking and eating were made much more difficult, and so was the enjoyment of cigars, which had apparently caused the disease. But smoking had long ago become a necessity for Freud and he could give it up only for short periods at a time.

In letters Freud occasionally wrote a few dispassionate words about his illness. He never complained. But it gave him the opportunity to express thoughts about his attitude to life and death. Usually a diagnosis of cancer leaves the patient with the paralyzing feeling that he must expect death at any moment. In Freud's thoughts and emotions, on the contrary, the suffering of the moment seemed insignificant in comparison with far-reaching general questions. He obviously possessed unusual spiritual resistance to physical pain. He took pain-killers only rarely, and then always mild ones. In 1926 he wrote to Eitingon: "I regard it as a triumph to retain a clear judgement in all circumstances [. . .]."[44]

His integrity, guaranteed by the clarity of his consciousness and judgment, seems to have been to Freud the highest of all values, which he would not abandon, in any circumstances, as long as he lived. And his readiness to make sacrifices for it, to bear pain which would have seemed unbearable to others, rather than lose his human dignity or fail to keep his personality intact, is without a doubt an important aspect of his creativity.

His fearless attitude towards death, his rejection, to the very end, of religion, even of the comfort it could give—the strength with which he could accept the process of dying, without seeking refuge in psychological flight, shows that what the ancients saw as the true aim of philosophers had, in Freud, become reality.

Tragic and painful as the years after the loss of his beloved grandchild and the onset of his ravaging disease must have been, they were not without glory. In 1936, Freud was elected to Corresponding Membership of the Royal Society, next to the Nobel Prize the highest honor that can be bestowed on a scientist. He was now witnessing the international rise of psychoanalysis, which was gradually detaching itself from his person and proving itself as an objective cultural phenomenon, a legitimate part of the natural and social sciences.

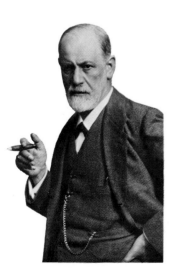

Two of the great figures of the century, Thomas Mann and Albert Einstein, recognized the importance of his achievements. Other writers such as Hermann Hesse, Romain Rolland, Arthur Schnitzler, Arnold Zweig, Stefan Zweig and Franz Werfel became his friends or formed a closer relationship with him. That it was the poets who esteemed him and found in his works the spiritual destinies of the figures they had created, was for Freud an unexpected confirmation that far outweighed his rejection by medical and academic circles.

In 1930 an equally unexpected honor came to Freud. The town of Frankfurt awarded him the Goethe Prize. He could not receive it in person

because of his illness, so his daughter Anna read his speech in the Goethe House. She also represented her father in Freiberg, when in 1931 a commemorative plaque was put up on the house where he was born and a street was named after him.

Freud must have been gratified by all these events, but his spiritual development would not have been essentially different if they had never happened. Even in the early years he had become accustomed to the thought of personal failure. He once said: "[. . .] but science would ignore me entirely during my lifetime. Some decades later, someone else would infallibly come upon the same things—for which the time was not now ripe— would achieve recognition in them and bring me honour as a forerunner whose failure had been inevitable."[45]

The luster that irradiated the last years of his life came in reality from his daughter Anna. And this provides an opportunity to say a word about Freud's relationship with women.

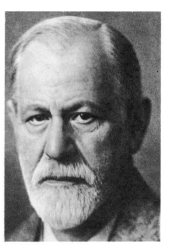

Freud is one of the few great men whose relationships with women were happy. He never entered into dramatic conflicts with them or withdrew into hostility against them—phenomena which are the exception rather than the rule in the lives of geniuses. Without a doubt he had a particularly harmonious relationship with his mother. She was not an extraordinary woman, but she must have had a very deep understanding of the child, because he was able to develop to the full under her care. We must not forget that such a happy course of events is not always due exclusively to the mother, but is often also a consequence of the charm shown by a highly gifted child, which the mother responds to with special affection. If we can go by his early portrait, Freud must have been an enchanting boy. At any rate his strong bond with his mother never slackened throughout his life. When she died, he wrote to Ferenczi: "I was not free to die as long as she was alive, and now I am."[46] Thus his mother was his bridge into life, and only her death could leave the way open for his own.

Martha Bernays seems to have been Freud's ideal fiancée and wife. She bore devotedly the privations of the long engagement, and Freud's then frequent outbreaks of jealousy and pessimism. The young scholar's years of storm and stress cannot have been easy for her to bear. It is also to her credit that throughout the long years of the engagement she could keep Freud's entire interest and undivided attention concentrated upon herself. On his side it says much for his loyalty and capacity for love that despite years of separation and passionate longing he never regretted his choice or gave his fiancée cause for jealousy.

Some of the letters which he wrote her almost every day will find a place in future anthologies of great love letters. When they have been published in their entirety they will also be the most important biographical source for the understanding of Freud's personality and will give us insight into his complicated psychological processes during that serious crisis of his life.[47]

In marriage too Martha Bernays proved her worth; she surrounded Freud with the comfort of a harmonious family life, without ever disturbing his creative processes. She stood clearly by the middle-class ideal of marriage; she devoted herself exclusively to her household and children, and kept apart from her husband's professional life. Her younger sister Minna obviously took a more active part in Freud's intellectual life.

In later life Freud's need for human attachments became more and more concentrated on his daughter Anna. It is doubtful whether he could have borne the exceptional burdens of the last fifteen years in so exemplary a way if she had not been his deputy and his complement. Once more Freud found

the ideal partner. To his astonishment his daughter also proved to be an outstanding collaborator. Without cramping her own originality and individuality, Anna Freud integrated her father's work. Even her earliest publications show her independence. It was her loving care and nursing that enabled Freud to endure the decrepitude of old age, which he had feared so much, without succumbing to internal conflicts. "The source of delight still left to me is called Anna," he wrote to Lou Andreas-Salomé.[48] And to his other favorite pupil, Marie Bonaparte, he confessed six months before his death: "I am growing increasingly incapable of looking after myself and more dependent on her."[49]

On more than one occasion Freud experienced an element of mythology in his relationship with women. At twenty-seven he wrote of Martha as Cordelia,[50] and at seventy-nine he called his daughter "my faithful Anna-Antigone."[51] All that the process of aging was slowly and irrevocably destroying in him was blossoming in her, bright with promise for the future. In this way the idea of approaching death as a final annihilation of his own biological existence could be transformed into the comforting vision of a life continuing in the work of one he loved.

Did illness and age detract from Freud's productivity? He thought so himself. In 1935 he wrote to Arnold Zweig: "Since I can no longer smoke freely, I no longer want to write—or perhaps I am just using this pretext to veil the unproductiveness of old age."[52] This must have been written in a moment of temporary discouragement, for in the next sentence Freud talks about a new work: "Moses [the theme of his book] won't let go of my imagination." Years certainly followed in which he published less, and no more books like *The Interpretation of Dreams* were written. The works of his old age are terse and condensed. But there is no sign of any diminishing of his creative impetus, his acuteness of observation or his range of thought. We might perhaps say: In *The Interpretation of Dreams* Freud put down almost everything about the origin and meaning of the dream, everything, at any rate, that could possibly be said about the psychological aspect of the phenomenon; in the later works, on the other hand, there are many sentences which, if taken separately and developed in all their wealth of meaning, would furnish material for a whole book.

From 1930 onwards Freud saw as his special task to test the productivity of his newly established structural concept, the psychology of the Ego. He had devoted the first half of his life's work to the clinical phenomena which come into evidence more or less against the will of the Ego, particularly in neuroses, which could be described as a capitulation of the conscious intentions of the Ego. To the category of psychic phenomena which are more or less independent of the Ego belong dreams, parapraxes, and instinctual demands in general, which so often prevail against the opposition of the Ego, as well as emotions like anxiety, and expressions of emotion like laughter. Freud had begun the study of laughter for his book on jokes.[53] After 1920 he turned his attention especially to the question of how the Ego could ever succeed in accomplishing the manifold tasks it has to fulfill. The focus of interest was now the problem of defense.

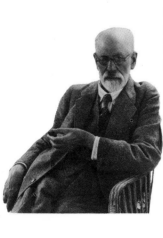

Ego and Id have, of course, an equal part in the origin of all the phenomena mentioned. Freud had shown as early as 1900 that this applies to dreams also. In the writings before 1920, however, the reader learns more about what is foreign to the Ego than about the Ego itself. In the elaboration of Ego-psychology Freud showed yet again all his originality as a psychologist; for he was now concentrating on phenomena which had not been neglected by science at all, and did not lie off the beaten track of research. Many themes, rather, were numbered among the traditional subjects of

onventional philosophy and psychology, but under Freud's observation
.nd analysis they presented entirely new aspects.

Freud also went back in his last years, for instance in his book *Civilization
ind its Discontents,*[54] to a favorite theme of his early period. At the very
beginning of psychoanalysis he had been interested in the relationship of the
ndividual to society. At that time he made reformist proposals for the
mitigation of the sexual deprivation caused by Victorian morality. Now he
urned to the general theoretical problems of civilization and tried to
discover why the demands of civilization obviously bring most human
beings more sorrow than joy.

At the end of his life he finally devoted himself to the bold project of
ipplying psychoanalytical viewpoints to the history of the Jewish people.
He had already concerned himself earlier with historical events and phenom-
ena. In *Totem and Taboo*[55] he made a detailed analysis of early forms of
eligious life as observed in primitive races, and attempted to explain the
origin of the guilt feeling which has had so decisive an influence, for both
good and evil, on the history of human civilization. With the help of his own
observations of obsessional patients, and supported by the theories of
Darwin and others, he reconstructed an historical event from which the
feeling of guilt could have originated: in earlier times, when human society
still existed within the primal horde, the tyrannical and egotistical father
was, he said, murdered by his sons.

In his last book, *Moses and Monotheism,*[56] Freud sought to draw atten-
ion to one of the peculiarities of his people—the fact that it was the first to
sustain a permanently monotheistic religion. The Moses book was rejected
by most experts. Leaving aside the question of historical accuracy, the
extraordinary methodological importance of the magnificent construction
of this late work is undeniable. For it shows us a way in which we can some
day analyze the unconscious forces at work in the history of every nation.
One day, perhaps, we might thus succeed in controlling the irrational
behavior of national groups, destructive of both themselves and others, and
replacing it each time by rational behavior. It may be, then, that Freud in his
ast work has shown us how it might be possible to meet the greatest danger
threatening the peoples of the world today.

Despite worldwide recognition of his achievements, official circles in
Vienna, outside his own groups of pupils, gave little recognition to Freud to
the very end. It was probably due to the temporary loosening of hierarchical
structures after the collapse of the monarchy that in 1919 the University
appointed him titular Professor Ordinarius (full professor). And that was
all. When in 1934 the Republic began again to award the old "Imperial
Austro-Hungarian Medal for Art and Science" introduced by the Emperor
Franz Josef in 1887, it was not given to Freud. He was not even thought
worthy of the Order of Merit given for "work deserving recognition." The
Academy of Sciences took absolutely no notice of him.

Only the Social Democratic city council of Vienna was friendly towards
Freud and psychoanalysis. Perhaps it merely wanted to show appreciation
of the fact that in 1927 Freud had signed a Social Democratic election
manifesto; at any rate it transferred to the Psycho-Analytical Society a plot
of ground not far from Freud's home; a psychoanalytical institute and out-
patient clinic were to be built there. However, the Society would have had to
raise its own funds for building. Freud is supposed to have said, jokingly:
"Now we've got the bare knees for our mountain trip,"[57] probably suspect-
ing that he would never see a psychoanalytical institute built on Viennese
soil with public money. However, the training institute of the Vienna

Psycho-Analytical Society, built on their own initiative, had already existed since 1924.

As we know from a letter, Freud would probably have been pleased to receive the medal, and it would certainly have been a source of satisfaction to him if the Vienna city council had seen to the building of an institute and out-patient clinic. Nevertheless, as long as no serious obstacles were placed in the way of psychoanalytical training and research, it was not so very important to him. For at least the survival of psychoanalysis in Austria seemed for the time being to be fairly secure.

Things were different in Germany after 1933. Because its founder was a Jew and also because of its revolutionary doctrines, psychoanalysis was put on the black list. At the book burnings staged by the Nazis, Freud's works were symbolically "consigned to the flames." In Leipzig in 1936, the book stock of the International Psycho-Analytical Press, which were stored there, were confiscated and destroyed. With the growing Nazi threat to Austria, Freud and his family were soon in actual danger; his friends living abroad urgently advised him to leave Austria. At first Freud firmly refused to do so. The idea of flight and emigration appeared abhorrent to him. But when the situation came to a head and Austria was occupied by German troops in March 1938 and Hitler entered Vienna, Marie Bonaparte and Ernest Jones went to Vienna to expedite Freud's emigration. However, it was probably the intervention of the American ambassador in Paris, William C. Bullitt that saved Freud.

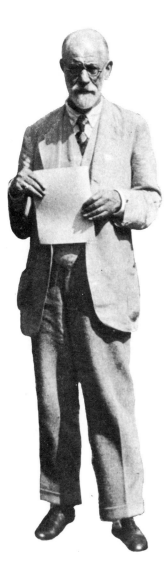

On March 15, 1938, S.A. men forced their way into his home. After they had hunted around in a few of the rooms, Freud came towards them, the light of battle in his eyes. Without uttering a word, he obviously intimidated them so much by his mere presence that they made off only with the 6,000 schillings which they had previously confiscated. There is a delightful story in connection with this. When Anna Freud told him how much money had been taken, he remarked dryly that *he* had never received so much for one single home visit.

On March 22 the Gestapo appeared at Freud's home. After a thorough search of the house, during which, however, they did not enter Freud's study, they left, but took Anna Freud with them. The subsequent wait was agonizing. Something might have happened to her, simply because she was the daughter of a famous father. When Anna came back, on the same day Freud agreed to emigrate.

The greatest difficulty was that of obtaining an exit permit. After three months of anxious waiting he received it. It is still uncertain what would have happened if Dr. Sauerwald, whom the Nazis had made Commissar in charge of the closing of all psychoanalytical establishments, had not, apparently, been impressed by Freud's personality and become in the meantime a protector of the family. An old friendship of Freud's was helpful here Sauerwald had studied under Wilhelm Herzig, the Professor for Pharmacological Chemistry at the University of Vienna, and honored and respected his former teacher. And Herzig had been Freud's lifelong friend.

The fact that Freud remained in Vienna for such a long time saved the lives of many of his Viennese pupils. For reasons of foreign policy it was inadvisable for the German government to persecute Freud, and it was not politic to attack his pupils either; except for Sadger, who chose to remain they all escaped.

On June 4 Freud, accompanied by his wife and Anna, was able to leave Vienna. With them went Doctor Josefine Stross, and Paula Fichtl, their mainstay and help of many years' standing, who would not be parted from

the family. Four old sisters had to remain behind. They were murdered in Auschwitz in 1942.

In Freud's diary, under the date Saturday 3/6 (June 3), is the brief entry: "3 3/4 at the Bridge of Kehl," the border. That was the moment when, after gruelling months, freedom and security at last became once more commonplaces of everyday life. In Paris the travellers were met by Marie Bonaparte and Ambassador Bullitt. They spent a day at the Princess's house.

On June 6 they arrived in London. On the night journey to London Freud dreamed that he was landing at Pevensey. This was the place where, in 1066, William the Conqueror landed in the successful attempt to seize the English throne. In London he had an almost triumphal reception. "[. . .] for the first time and late in life I have experienced what it is to be famous,"[58] he wrote to his brother.

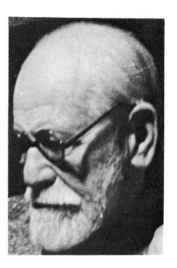

Freud had fifteen months in which to enjoy the freedom and beauty of England, for which he had longed since his first visit in 1875. These months were dignified by many gestures of respect and honor. The most noteworthy of all was the visit of the secretary of the Royal Society, of which, as already mentioned, he was a Corresponding Member. Freud was too frail to appear at the Society's headquarters and there sign his name in the Charter Book, so the book was brought to him, a mark of distinction hitherto accorded only to the King.

Many important people came to visit him. Stefan Zweig brought with him the painter Salvador Dali, who made a sketch of Freud. H. G. Wells, who was friendly with Freud, tried, though unsuccessfully, to obtain British nationality for him immediately. Meanwhile Freud's illness progressed inexorably. On September 8 he was operated on once more by Professor Pichler in London.

Although he never fully recovered from this operation, and radiotherapy, which was used to try to prevent the spread of the disease, increased his physical discomfort, Freud enjoyed his brief time in England. The garden of his house, with a magnificent flowering almond tree, was a source of delight. The fact that his antiques, which he had collected over many years and to which he was very attached, had been successfully brought to England helped him to feel at home quickly. He took up work again with enthusiasm. He devoted half his day to four patients, and for the rest of the time he continued a study he had begun in Vienna.

On September 23, 1939, before midnight, Sigmund Freud died in his house at 20 Maresfield Gardens. On the morning of September 26 he was, at his own wish, cremated at Golders Green Crematorium. His ashes rest there in a Greek vase, a favorite piece from his collection.

Since then psychoanalysis has spread widely throughout the Western world, particularly in the United States, where it has influenced psychiatric thinking more than in any other country. In the process it has undeniably become somewhat watered down. We can make no certain predictions about its future. The rise of chemotherapy brings with it the possibility that one day we shall be able to deal pharmacologically with all symptoms of mental illness. This would not be at all surprising; Freud himself would have envisaged something similar. Nevertheless psychoanalysis will claim its place as a branch of psychology. Modern experimental physiology of the dream has meanwhile confirmed many of the hypotheses of Freudian dream psychology.

Psychoanalysis is still attacked and questioned from many sides. Whatever effective curative methods and new experimental conclusions the future

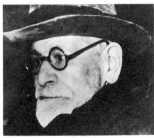

may bring, Freud's work will not be invalidated by them. With its method of free association, it has created an instrument comparable to the microscope. With this method we can observe mental processes which would otherwise remain invisible. Anyone who wants to become aware of what is going on in his unconscious, that is to say anyone who wants to know himself, will always have to use this method. No one who wishes to emancipate himself from the chance events of his childhood and hopes to reach the heights of mental and emotional freedom, can do without psychoanalysis. Freud's work takes in the whole panorama of human existence, and there is hardly a single mental phenomenon that has not come under his observation.

We can learn from textbooks compiled by others about the work of most scientists. Whoever wants to understand Freud's greatness must read his original writings, and these writings, unlike the work of almost any other scholar, have had a general cultural effect.

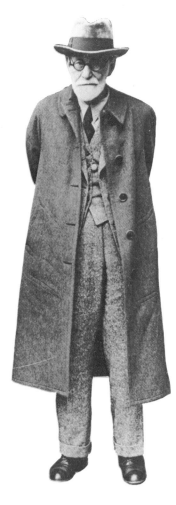

In particular, they have fundamentally changed the attitude to children. It is true that in the Christian era enlightened and humanitarian spirits have constantly called for a more humane approach to children, but such appeals have had only a passing effect, if any. Too little was known about children. Now Freud was neither a pedagogue nor a child psychologist in the present-day sense of the word, but in analyzing his adult patients he succeeded in reconstructing, step by step, the psychological phases of childhood development. This gave him a profound insight into the tribulations every child has to go through before it develops from the primitive, almost animal state of the newborn baby to become an adult member of society. In 1908 the father of a five-year-old boy who was terrified of horses came to Freud. The man himself was not a psychoanalyst, but he had been a member of the circle that had gathered round Freud in the early days, and so was acquainted with the basic tenets of psychoanalysis. This was the beginning of the first child analysis, in the course of which the father, under Freud's guidance, talked with his child and sought out the reasons for this anxiety state. Thus, probably for the first time, a father taught his son gradually to admit his hostile wishes against his father and his covetous longings for his mother.[59] The investigation of infantile wishes and the understanding of the child's helplessness against his own instinctual world, and also against the demands of the adult world—a helplessness that releases terrible anxieties which the adult, because of the amnesia overshadowing his own childhood, cannot spontaneously remember—made possible a hitherto unattainable empathy for the child's mind.

With Freud's psychoanalysis the hypocrisy of our society has also been substantially lessened. Today people can open their hearts to each other with an honesty that our grandparents could scarcely have imagined.

Finally, the recognition of unconscious motives, which in certain circumstances can take complete possession of a human being, has changed our attitude towards mental illness. Because Freud succeeded in deciphering the peculiar "logic" that dominates the unconscious thoughts even of sane people, the absurd and paradoxical speech and behavior of the mentally sick no longer seems uncanny, alien and senseless. Today the psychiatrist can carry on a reasonable conversation with a psychotic patient, for his knowledge of the unconscious has enabled the doctor to understand even the most preposterous utterances of insanity.

Not least, the knowledge of the existence in sane people of primal instinctual urges also promises a more humane approach to criminals.

Here we must also mention psychosomatic medicine, which has developed meanwhile into a branch of research in its own right. While investigating hysteria, which so often shows itself in physical symptoms,

Freud had already asked himself how it was possible for mental disturbance to have such a lasting influence on physical processes. Whether Freud himself shared the view of some modern specialists in psychosomatics that mental conflicts can cause organic diseases is uncertain. But it is historically true that the constant preoccupation with the unconscious, which is the focal point of every psychoanalytical treatment, laid the foundation on which psychosomatic medicine stands.

However great the effect of Freud's work may have been on psychiatry and general medicine, it is surpassed by its influence on the humanities. Psychoanalysis has, in fact, fundamentally altered our views on the origin of art, literature and religion. We can only touch here on the extremely complex problems involved. One aspect is revealed in the first work which Freud devoted to a literary production.[60] He successfully proved in it that the dreams which the writer Wilhelm Jensen, who knew nothing of psychoanalysis, made the hero dream in his short story *Gradiva* correspond exactly with the rules Freud himself had laid down in his *Interpretation of Dreams*.

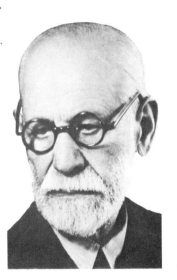

If we want to understand Freud's life and development, we must see it in its historical context. If Freud had been born fifty years earlier, it is certain that he would not have been able to develop into the founder of psychoanalysis. The spirit of the Victorian epoch set the stage for that intense dialogue between therapist and patient on problems closely bound up with the instincts.

More important in this connection, however, is the rise of the natural sciences in the second half of the nineteenth century, though the psychological sphere remained untouched. As a student, Freud learned to apply the scientific method, exact and dependable as it was, and was deeply imbued with the spirit of positivism. Later, faced with the failure of traditional methods in the treatment of neurotic patients, he made it his life's work to chart the no-man's-land which the natural sciences had left on the map of our knowledge of mankind.

We should also mention the emancipation of the Jews in the middle of the nineteenth century. If at that time they had still been refused access to the university and all other educational facilities, Freud's work would obviously never have existed. Freud was certainly not the only one of his race to succeed. It is impressive to note how many of the first generation of emancipated Jews in Vienna achieved great things, especially in the field of medicine.

However, it is not enough to point to the favorable historical factors if we are attempting to explain, or even simply to describe, Freud's genius. The assessment must take into account the quality of the works dating from the preanalytical period. In his early neurological phase he came very near to the discovery of the neuron theory, and he proved himself an outstanding clinician and a pioneer of neuropediatrics.

It is not only Freud's work that is exemplary in its range of subjects, the depth of its perception and the linguistic beauty of its presentation. The same can be said of his life.

Only the cursory reader will find Freud's biography undramatic and worthy of little note. Freud was born in the provinces and grew up at school and university in the capital of the country. As a young man he obtained an academic position; in his practice as a doctor, he became aware of symptoms for the explanation and care of which he created a new theory and method, a new branch of science. He lived a conventionally ordered and meticulous life, ruled by *des Dienstes immer gleichgestellte Uhr* ("the clock

of duty, never fast nor slow"). He maintained his strict daily timetable for decades. During the day he treated patients, and at night he synthesized the scientific results of the practice. Freud shared this life-style with many of his contemporaries. His personal life too was ordered on traditional lines. He married, remained strictly monogamous, fathered children, spent his holidays as people of his social class usually did. Even in what we would call hobbies today—the card game of *tarock*, for which the same circle of friends met every Saturday evening for years; the search for edible fungi, to which Freud passionately devoted himself during the holidays—he confined himself to the customary, one might even say trivial, forms of relaxation.

This is the foreground of Freud's life. But behind it we can detect something of the titanic struggle of a man who, despite his own weaknesses and shortcomings, remained unswerving in his quest for truth, and, in moments of doubt and despair, may have cried out like Jacob: "I will not let thee go except thou bless me."

Notes

1
Cf. Josef Sajner, "Sigmund Freuds Beziehungen zu seinem Geburtsort Freiberg (Příbor) und zu Mähren," in Clio Medica, 3, 1968, pp. 167-180.

2
Letters of Sigmund Freud 1873-1939, edited by Ernst L. Freud, trans. by Tania and James Stern, Hogarth Press, London; Basic Books, New York, 1961, p. 406. For a quotation from this letter, cf. the text accompanying illustration 294.

3
Freud, An Autobiographical Study, 1925, quoted from the Standard Edition of Freud's Psychological Works, 1959, 20, p. 8.

4
Freud, Letters 1873-1939, op. cit., p. 21 ff.

5
Op. cit., p. 22.

6
Freud, The Origins of Psycho-Analysis, Letters to Wilhelm Fliess, Drafts and Notes, 1887-1902, trans. by Eric Mosbacher and James Strachey, Imago Publishing Co., London; Basic Books, New York, 1954, p. 57.

7
Erna Lesky, Die Wiener Medizinische Schule im 19, Jahrhundert, Verlag Böhlau, Graz-Köln, 1965, p. 396.

8
Josef Gicklhorn, "Wissenschaftliche Notizen zu den Studien von S. Syrski (1874) und S. Freud (1877) über männliche Flussaale," in Sitzungsberichte der Österreichischen Akademie der Wissenschaften, Mathematisch-Naturw. Kl., Abt. I, 164, Books 1 und 2.

9
Freud, Postscript to The Question of Lay Analysis, 1927, S. E., 20, p. 253.

10
Freud, "Über Coca," 1884, in Zentralblatt für die gesammte Therapie, 2, p. 289 ff.

11
Freud, The Interpretation of Dreams, 1900, S. E., 4-5, p. 437.

12
Freud, Letters 1873-1939, op. cit., p. 166.

13
Freud, An Autobiographical Study, S. E., 20, p. xxixff.

14
Breuer and Freud, Studies on Hysteria, 1895, S. E., 2, p. 27 ff.

15
The Origins of Psycho-Analysis, op. cit.

16
S. E., 4-5. Actually the work appeared at the end of 1899, although the title page of the first edition, at the request of the publisher, bears the date "1900."

17
The Origins of Psycho-Analysis, op. cit., p. 322.

18
1905, S. E., 7, p. 7.

19
1901, S. E., 6.

20
1905, S. E., 7, p. 123 ff.

21
"On the History of the Psycho-Analytic Movement," 1914, S. E., 14, p. 33.

22
Ernest Jones, Sigmund Freud: Life and Work, 3 vols., Hogarth Press, London; Basic Books, New York, 1953, 1956, 1957.

23
An Autobiographical Study, S. E., 20, p. 52.

24
Sigmund Freud and Lou Andreas-Salomé; Letters, edited by Ernst Pfeiffer, trans. by William and Elaine Robson-Scott, The Hogarth Press, London; Harcourt Brace Jovanovich, New York, 1972.

25
"On the History of the Psycho-Analytic Movement," S. E., 14, p. 22.

26
Details can be found in Sigmund Freud/C. G. Jung, Letters, edited by William McGuire, The Hogarth Press, London; Princeton University Press, Princeton, N.J., 1974.

27
Cf. Jones, op. cit., 2, p. 174.

28
Op. cit., p. 173.

29
Extracts in Ludwig Binswanger, Erinnerungen an Sigmund Freud, Francke Verlag, Bern, 1956.

30
S. E., loc. cit.

31
Daniel Paul Schreber, Memoirs of My Nervous Illness, trans. and edited by Ida Macalpine and Richard A. Hunter, Robert Bentley, Inc., Cambridge, Mass., 1955.

32
"Psycho-Analytic Notes on an Autobiographical Account of a Case of Paranoia (dementia paranoides)," 1911, S. E., 12, p. 9 ff.

33
Cf. Jones, op. cit., 2, p. 218.

34
Op. cit., p. 215.

35
Op. cit., 3, p. 7.

36
Op. cit., p. 20.

37
Binswanger, op. cit., p. 94.

38
S. E., 18, p. 7 ff.

39
S. E., 18, p. 67 ff.

40
1923, S. E., 19.

41
Freud, Letters 1873-1939, p. 386.

42
Op. cit., p. 349.

43
Cf. Jones, 3, p. 97.

44
Quoted in Jones, 3, p. 129.

45
"On the History of the Psycho-Analytic Movement," S. E., 14, p. 22.

46
Letters 1873-1939, op. cit., p. 399.

47
The documents, about fifteen hundred in number, are in the Sigmund Freud Archives of the Library of Congress, Washington, D.C.

48
Freud and Andreas-Salomé; Letters, op. cit., p. 204.

49
Letters 1873-1939, op. cit., p. 455.

50
Op. cit., p. 55.

51
Op. cit., p. 420.

52
Op. cit., p. 421.

53
Jokes and Their Relation to the Unconscious, 1905, S. E., 8.

54
1930, S. E., 12, p. 57 ff.

55
1912/13, S. E., 13.

56
1939, S. E., 23.

57
Personal communication, not yet published.

58
Letters 1873-1939, op. cit., p. 443.

59
Cf. "Analysis of a Phobia in a Five-Year-Old Boy" ("Little Hans"), 1909, S. E., 10, p. 3 ff.

60
Illusions and Dreams in W. Jensen's "Gradiva," S. E., 9, p. 7 ff.

SIGMUND FREUD

His Life in Pictures and Words

1 Map of the Austrian Empire, 1855[1]*

I was born on May 6th, 1856, at Freiberg in Moravia, a small town in what is now Czechoslovakia. My parents were Jews, and I have remained a Jew myself. I have reason to believe that my father's family were settled for a long time on the Rhine (at Cologne), that, as a result of a persecution of the Jews during the fourteenth or fifteenth century, they fled eastwards, and that, in the course of the nineteenth century, they migrated back from Lithuania through Galicia into German Austria.

*An Autobiographical Study.***

** The figures refer to the Notes on the Picture Section in the Appendix.*

*** For exact details of sources see the list of quotations in the Appendix.*

KRONLÄNDER der OESTERREICH. MONARCHIE

I	a	Oesterreich unter der Enns
	b	Oesterreich ob der Enns
	c	Salzburg
II		Tirol
III		Steyermark
IV	A	Triest / Görz, Gradisca u. Istrien — Illyrien
	B	Kärnthen
	C	Krain
V		Dalmatien
VI		Lombard. Venetianisches Königr.
VII		Böhmen
VIII	a	Mähren
	b	Schlesien
IX	a	Galizien und Lodomerien etc. nebst Krakau
	b	Bukowina
X		König. Ungarn
XI		Croatien und Slavonien
XII		Serb. Woiwodschaft und Banat
XIII		Siebenbürgen
1	Croatisch-Slavonische	Militär-Grenze
2	Banatisch-Serbische	

ZEICHEN - ERKLÆRUNG

HAUPT UND RESIDENZ STÆDTE
Hauptstädte
Städte überhaupt
Flecken und Dörfer
Feste Plätze
Eisenbahnen

Maassstäbe
Deutsche Meilen 16 = 1°
Italienische Meilen, 60 = 1°
1:3,444,000

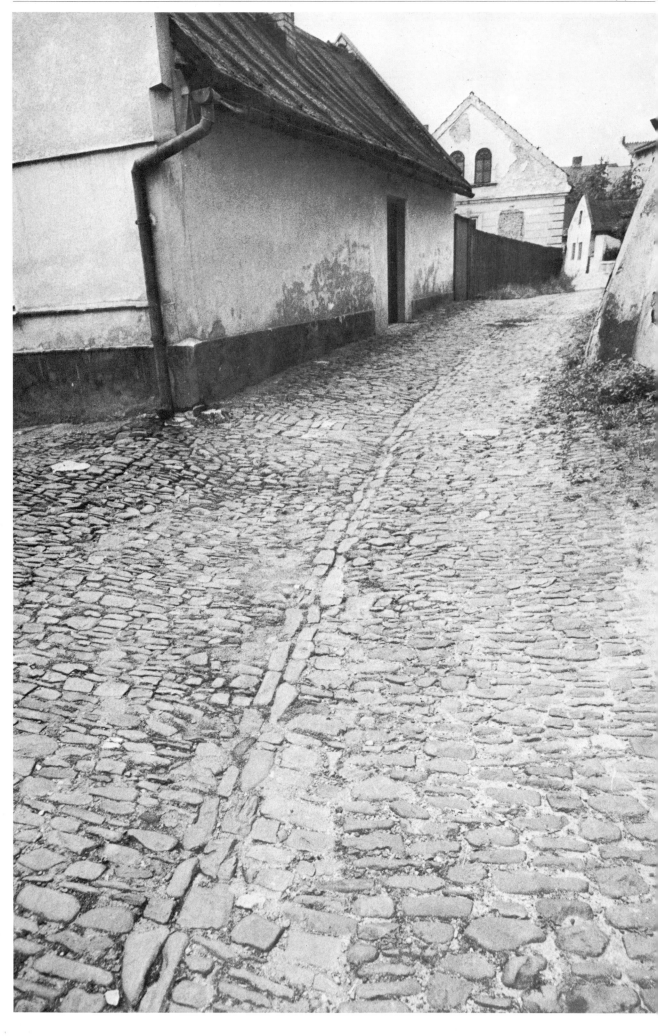

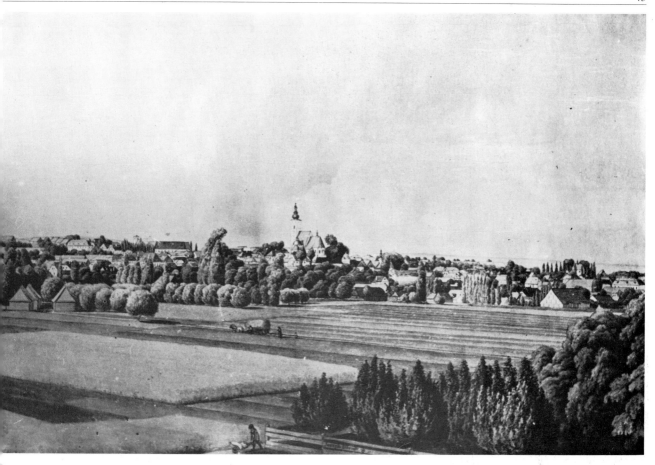

2 Freiberg, Příbor, Freud's native town

[. . .] but of one thing I am certain: deep within me, although overlaid, there continues to live the happy child from Freiberg, the first-born son of a youthful mother, the boy who received from this air, from this soil, the first indelible impressions.

Letter to the Mayor of Příbor-Freiberg, October 25, 1931

When I was seventeen and at my secondary school, I returned for the first time to my birthplace for the holidays [. . .]. I know quite well what a wealth of impressions overwhelmed me at that time. [. . .] I believe now that I was never free from a longing for the beautiful woods near our home, in which [. . .] I used to run off from my father, almost before I had learnt to walk.

Screen Memories

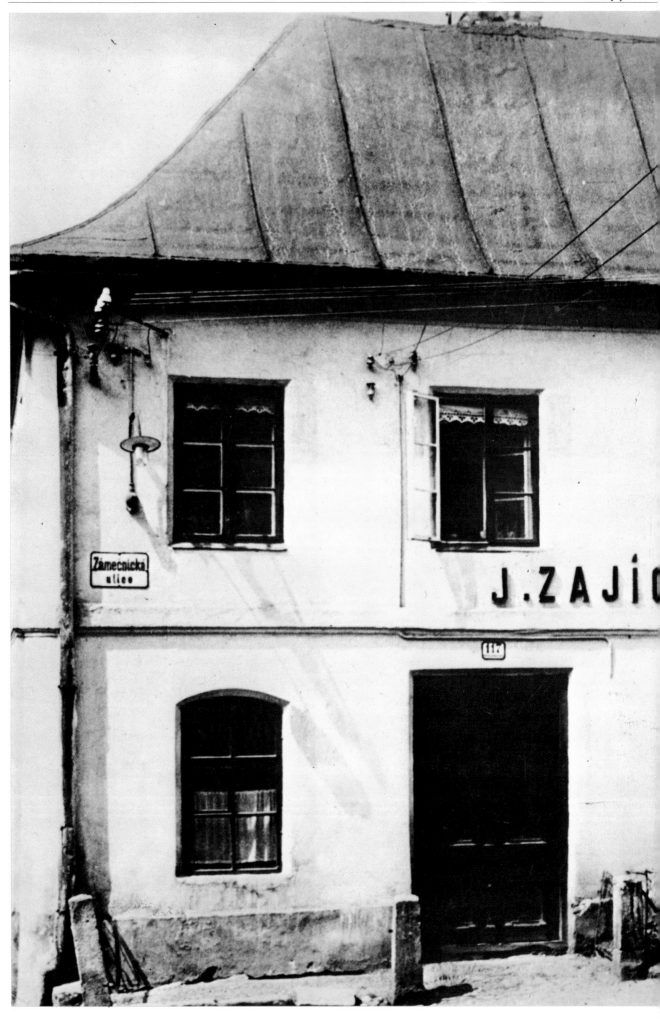

3 The house where Freud was born, Schlossergasse 117[1]

At that point I recalled an anecdote I had often heard repeated in my childhood. At the time of my birth an old peasant-woman had prophesied to my proud mother that with her first-born child she brought a great man into the world. Prophecies of this kind must be very common; there are so many mothers filled with happy expectations and so many old peasant-women and others of the kind who make up for the loss of their power to control things in the present world by concentrating it on the future.
The Interpretation of Dreams

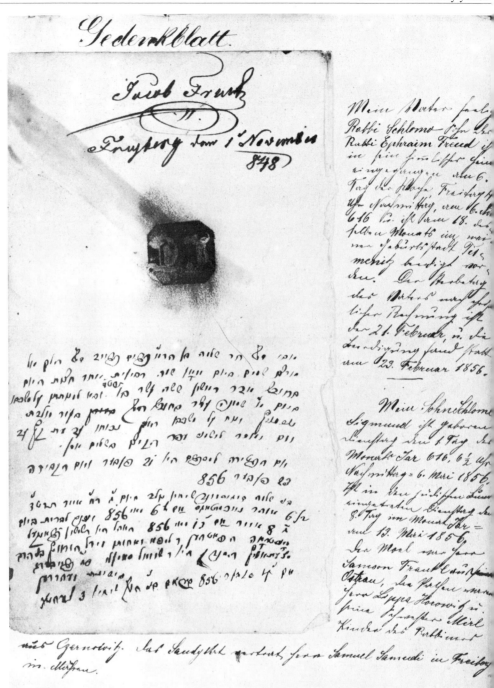

4 Commemorative page in the family Bible[1]

My father Rabbi Schlomo of blessed memory, son of Rabbi Ephraim Freud, entered into his heavenly home on the 6th day of the week, Friday, at 4 o'clock in the afternoon, on the 6th of the month of Adar[2] 616, and on the 18th of the same month was buried[3] in the town of Tismenitz[4] where I was born. According to Christian reckoning he died on February 21 and was buried on February 23, 1856.

My son Schlomo Sigmund was born on Tuesday, the first day of the month of Iar 616 at 6:30 in the afternoon = May 6, 1856. He entered the Jewish community on Tuesday, the 8th day of the month of Iar = May 15, 1856. The Moel[5] was Herr Samson Frankl from Ostrau, the godparents were Herr Lippa Horowitz and his sister Mirl, children of the Rabbi from Czernowitz. The Sandykat was taken by Herr[6] Samuel Samueli in Freiberg in Moravia.
Translation of the German text on the commemorative page

5 Staircase in the house in Freiberg

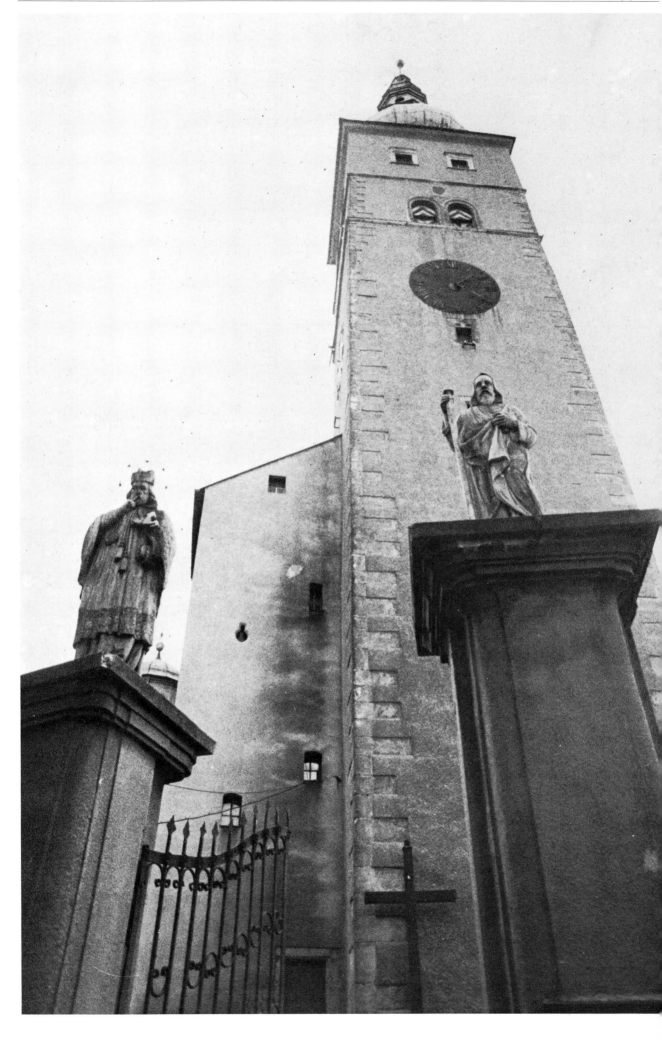

7 Votive pictures in the church of Mariae Geburt[1]

Saint Isidore[2]

6 Parish church of Mariae Geburt (The Nativity of Our Lady) in Freiberg

I asked my mother whether she remembered my nurse.[1] "Of course," she said, "an elderly woman, very shrewd indeed. She was always taking you to church. When you came home you used to preach, and tell us all about how God conducted His affairs."
Letter to Wilhelm Fliess, October 15, 1897

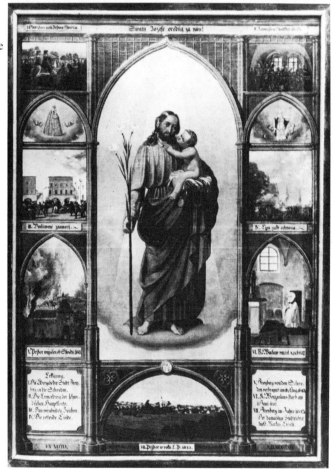

The "Schwedenbild," a commemorative tablet picturing the horrors of the Thirty Years War; Saint Joseph and the Christ Child in the center.[3]

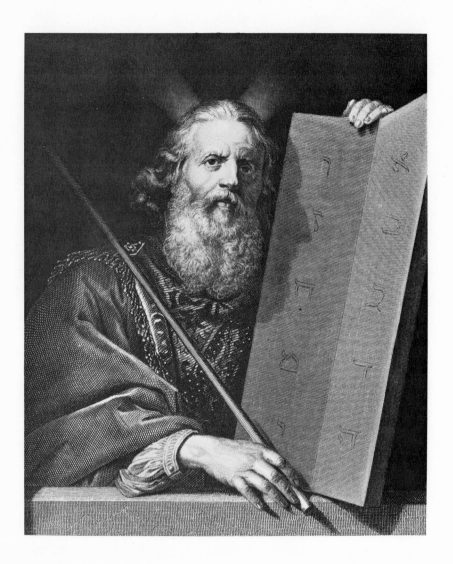

מקרא

תורה נביאים וכתובים.

Die
Israelitische Bibel.

Enthaltend:

Den heiligen Urtext,

die deutsche Uebertragung,

die

allgemeine, ausführliche Erläuterung mit mehr als 500 englischen Holzschnitten.

Herausgegeben von

Dr. Ludwig Philippson.

Erster Theil: Die fünf Bücher Moscheh.

Mit einem Stahlstiche.

Zweite Ausgabe.

Leipzig, 1858.

Baumgärtner's Buchhandlung.

8 Philippson's Bible[1]
My deep engrossment in the Bible story (almost as soon as I had learnt the art of reading) had, as I recognized much later, an enduring effect upon the direction of my interest.
An Autobiographical Study

9 Vienna, about 1860

When I was about three, the branch of industry in which my father was concerned met with a catastrophe. He lost all his means and we were forced to leave the place (Freiberg) and move to a large town (Vienna). Long and difficult years followed, of which, as it seems to me, nothing was worth remembering. I never felt really comfortable in the town.
Screen Memories

A thing I remember from my boyhood is that when wild horses on the pampas have been once lassoed, they retain a certain nervousness for life. In the same way I once knew helpless poverty and have a constant fear of it. You will see that my style will improve and my ideas be better when this town affords me a prosperous livelihood.
Letter to Wilhelm Fliess, September 21, 1899

View from a balloon. Stephansplatz with the cathedral, and, on the right, the Graben leading into it. In the background, left, the Karlskirche.

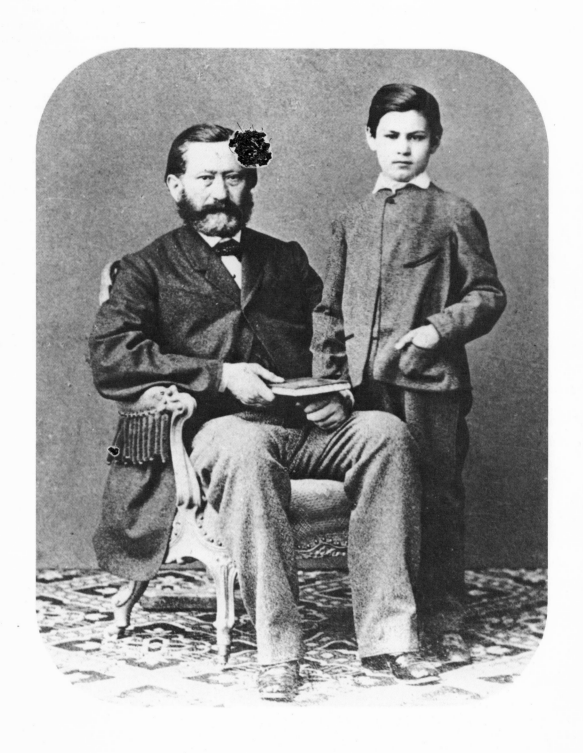

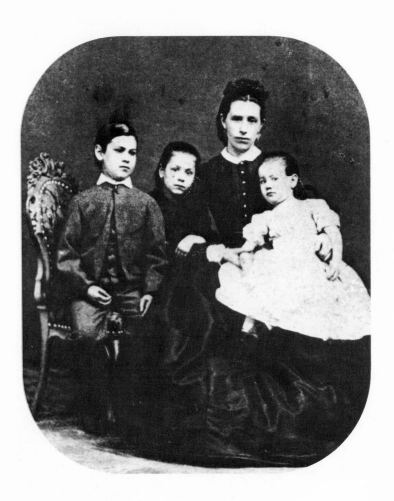

11 With his mother and his sisters Rosa and Adolphine (Dolfi), about 1864

When I was six years old and was given my first lessons by my mother, I was expected to believe that we were all made of earth and must therefore return to earth. This did not suit me and I expressed doubts of the doctrine. My mother thereupon rubbed the palms of her hands together [. . .] and showed me the blackish scales of *epidermis* produced by the friction as a proof that we were made of earth. My astonishment at this ocular demonstration knew no bounds and I acquiesced in the belief which I was later to hear expressed in the words: "*Du bist der Natur einen Tod schuldig.*"[1]
The Interpretation of Dreams

Amalie Freud, née Nathansohn, 1835-1930

10 With his father, about 1864

At that point I was brought up against the event in my youth whose power was still being shown [today] when my father began to take me with him on his walks and reveal to me in his talk his views upon things in the world we live in. Thus it was, on one such occasion, that he told me a story to show me how much better things were now than they had been in his days. "When I was a young man," he said, "I went for a walk one Saturday in the streets of your birthplace; I was well dressed, and had a new fur cap on my head. A Christian came up to me and with a single blow knocked off my cap into the mud and shouted: "Jew! get off the pavement!" "And what did you do," I asked. "I went into the roadway and picked up my cap," was his quiet reply. This struck me as unheroic conduct on the part of the big strong man who was holding the little boy by the hand.[1]
The Interpretation of Dreams

Jacob Freud, 1815-1896, wool merchant

Liaben ...

Ich habe das geschrieben ...

und liebe ...

... erhalten. Ich bedaure

sehr davon nichts verstehen,

der zu ... Neuen ...,

... ich ein ... Gedulten ...

zu richten. Ich die lieben

Eltern und Geschwister ...

finden sich ... Ich ...

... Ich grüße ...

Deine ... Emilia, ...

... Bruder Philipp

**12 Letter written when Freud
was a child, about 1863**[1]
Dear Brother,
I was glad to receive the letter
from your dear son, but I am
very sorry that I did not
understand any of it. Now I
am trying to write a few lines
to you. I and my dear parents
and sisters are thank God well.
Love to you and your family
and also my brother Philipp.
Your loving brother,
Sigismund Freud

Greetings and kisses to my
dear friend Johann, and Pauli.
Translation

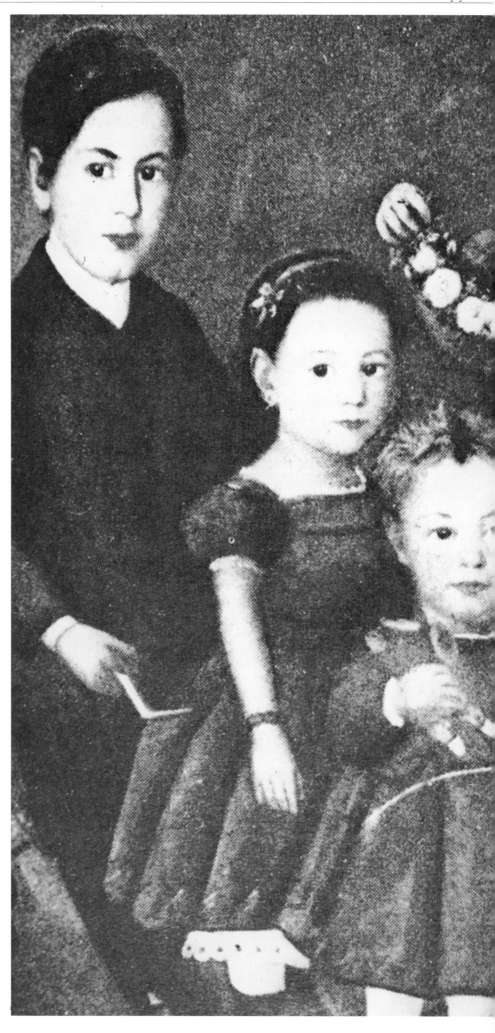

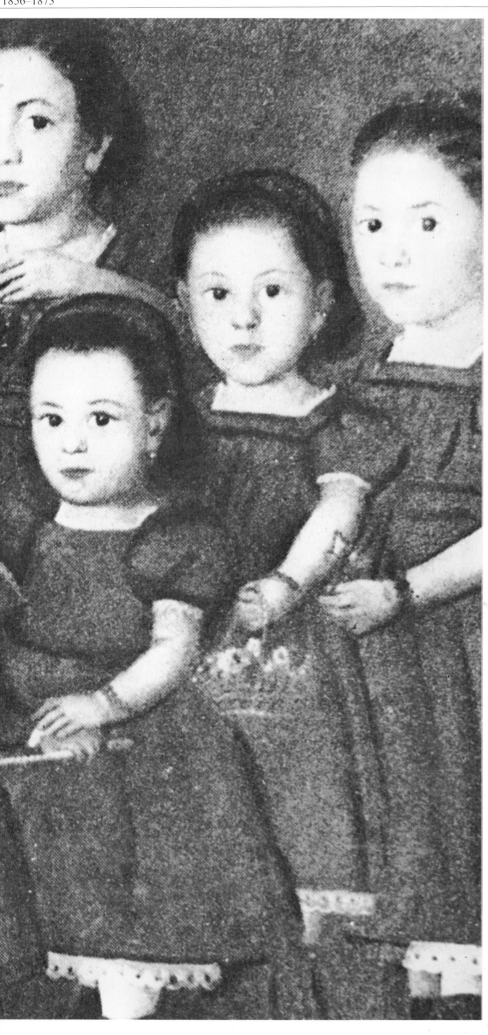

13 Oil painting of the Freud children, about 1868

When I was a boy of six, and my brother Sigmund was sixteen, he said to me: "Look, Alexander, our family is like a book. You and I are the first and the last of the children, so we are like the strong covers that have to support and protect the weak girls who were born after me and before you."
By word of mouth from Alexander Freud

From left to right: Sigmund, Adolphine (Dolfi), Alexander, Anna, Paula, Marie (Mitzi), Rosa

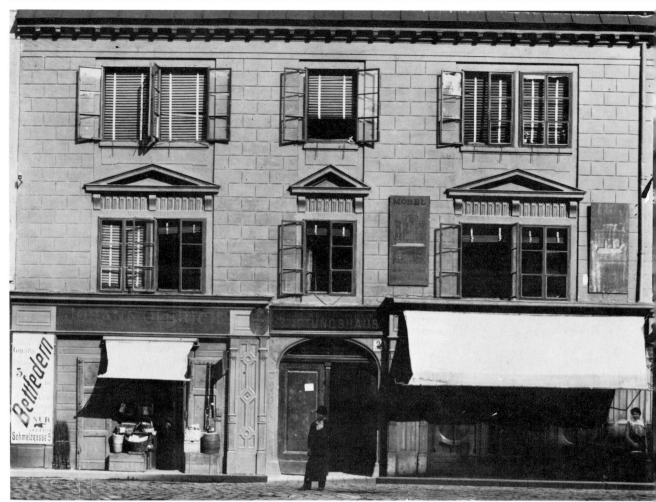

Zu- und Vorname	*Freud Sigismund*	Des Vaters, resp. Vormundes	Name, Stand.	*Jacob F. Wolfschwten*	
Geburts-	Tag und Jahr	*6. Mai 1856*		Wohnort	*II. Pfeffergasse 1.*
	Ort und Vaterland	*Freiberg Mähren*	Religion	*mosaisch.*	
Wohnung	*II. Pfeffergasse 1.*	Muttersprache und Nationalität	*deutsch*		
Stipendist, vom Schulgeld befreit oder zalend	*zal.*	Ob Repetent oder von Aussen neu eingetreten			

I. Semester.	II. Semester.	Anmerkungen:
Sittliches Betragen *musterhaft*	*musterhaft.*	
Aufmerksamkeit —	—	
Fleiss *ausdauernd*	*ausdauernd.*	
Äussere Form der schriftlichen Arbeiten *empfehlend*	*sehr empfehlbar.*	
Zahl der versäumten Lehrstunden *8* entschuldigt: nicht entschuldigt	*32* entschuldigt: —— nicht entschuldigt	
Allgemeine Zeugnissclasse und Platz *erste; 4/60*	*erste mit Vorzug. 3/55.*	

Leistungen in den einzelnen Lehrgegenständen:

	I. Semester		II. Semester	
Religionslehre	*vorzüglich*	*gez. Horneruchlag*	*vorzüglich*	
Deutsche Sprache	*vorzüglich.*		*vorzügl.*	
Lateinische Sprache	*vorzüglich.*		*vorzügl.*	
Geographie:	Geschichte: *lobenswert*	Geogr.:	Gesch.: *lobenswert*	
Mathematik	*lobenswert*		*lobenswert*	
Naturgeschichte	*vorzüglich*		*vorzüglich*	
Freihandzeichnen	*genügend*		*befriedigt*	
Schönschreiben	*befriedigend*		*lobenswert*	
Französische Sprache				

4 Entrance to the school yard, Taborgasse 24

I received my first instruction at home, then attended a private primary school. In the autumn of 1865 I entered the Leopoldstädter Real- und Obergymnasium.
Curriculum vitae

[. . .] the years between ten and eighteen would rise from the corners of my memory, with all their guesses and illusions, their painful distortions and heartening successes—my first glimpses of an extinct civilization (which in my case was to bring me as much consolation as anything else in the struggles of life), my first contacts with the sciences, among which it seemed open to me to choose to which of them I should dedicate what were no doubt my inestimable services. And I seem to remember that through the whole of this time there ran a premonition of a task ahead, till it found open expression in my school-leaving essay as a wish that I might during the course of my life contribute something to our human knowledge.
Some Reflections on Schoolboy Psychology

Until 1877 the "Leopoldstädter Communal-Realgymnasium" (later renamed "Communal-Real- und Obergymnasium"), which Freud attended from 1865 to 1873, was housed on the second and third floors of the Braun-Radislowitz Stiftungshaus, Vienna 2, Taborgasse 24. The building did not face the street, but was reached through a courtyard. There is no contemporary picture; only the plan of the third floor is extant.

15 Report for the first "Gymnasium" year

At the "Gymnasium" (Grammar School) I was at the top of my class for seven years; I enjoyed special privileges there, and had scarcely ever to be examined in class.
An Autobiographical Study

One would hardly guess it from looking at me, and yet even at school I was always the bold oppositionist, always on hand when an extreme had to be defended and usually ready to atone for it.
Letter to Martha Bernays, February 2, 1886

Translation in the Notes

8

[Handwritten text in old German cursive, largely illegible]

S. Fleischer.

Zerstreute Gedanken.

[Handwritten text in old German cursive, largely illegible]

S. Freud.

MUSARION.

Eigentum und Verlag der V. und VI. Classe des Leop. Obergymn.

Inhalt: Schneeglöckchen von S. Fleischer; Georg Gottfried Gervinus von S. Spitz; Erinnerung und Hoffnung von S. Fleischer; Der Sänger von S. Fleischer; Zerstreute Gedanken von S. Freud.

Schneeglöckchen

Wenn im Lenze sanfte Winde
Sich mit warmem Hauche regen
Und des Eises glatte Rinde
Schmelzend von der Erde fegen,
Da erscheint in weißem Kleide
Sanft und zart ein holdes Wesen,
Die Verkünderin der Freude,
Um des Winters Bann zu lösen.

Mit verschämtem Angesichte
Blickt sie ängstlich und mit Zagen,
Ob sie in dem gold'nen Lichte
Frisch zu blühen dürfe wagen,
Und die liebe Frühlingssonne
Heißt sie hoch erfreut willkommen,
Denn die Freude und die Wonne
Sind in neuer Pracht entglommen.

**6 First publication in the
school magazine**

*Only the column of aphorisms
Zerstreute Gedanken (random
thoughts) is by Freud.
Translation in the notes*

b) Zur Physik.

1. Joly'sche Federwage sammt Stange. — 2. Incli-Declinatorium. — 3. Tangentenbussole. — 4. Apparate für Frauenhofer'sche Linien. — 5. Fluoreszenzmappe. — 6. Gekühlte Gläser 5 Stück. — 7. Vergissmeinnicht. — 8. Arrago's Apparat mit Drehvorrichtung. — 9. Kleiner Inductionsapparat. 10. Zum Projections-Apparat: Nikol'sches Prisma, 1 Turmalinplatte, 1 achromatisches Prisma.

c) Zur Chemie.

1. Eine analytische Wage.

d) Zum Zeichnenunterricht.

1. Gérome, cours de dessin. 2 Bl. — 2. Julien, cours de dessin. 10 Bl. — 3. Julien, études d'après l'antique 6 Bl. — 4. Julien cours élémentaire 24 Bl. — 5. Feroggio, Staffagen. 8 Bl. — 6. Taubinger, Figuren. 32 Bl.

e) Zum Gesang.

1. Hoven, 3 Partituren, 2. Mendelssohn Wanderlied. 3. Storch, Sängermarsch. 4. Schubert, Aufenthalt. 5. Potpourri für Streichquartett und Clavier. 6. Prometheus-Ouverture. 8händig.

IV. Schluss des Schuljahres.

Die öffentliche Schlussfeier findet Samstag, den 29. Juli 1871, wie folgt statt.

Heiliges Dankamt in der Kirche der barmherzigen Brüder um 8 Uhr.

Nach Beendigung des heiligen Dankamtes im Turnlocale (Glockengasse Nr. 2, im zweiten Hof,) um 9 Uhr.

I. Gesang. „Waldlust", Volkslied, zweistimmig, gesungen von den Schülern der ersten Abtheilung.

2. Ansprache des Directors.

3. Sprach- und Redeübungen. a) „Aus der Kindheit" von Fr. Hebel, vorgetragen von dem Schüler der 1. Classe Hirschl Isidor. b) „Der Bauer und der Brillenhändler", Gedicht, vorgetragen von dem Schüler der 3. Classe Fleischmann Adolf. c) „La Besace" von Lafontaine, vorgetragen von dem Schüler der 4. Classe Böhm Julius.

4. Gesang. a) „Der Gondelfahrer", von F. Schuberth, dreistimmig arrangirt von L. Fr. Grossbauer, gesungen von den Schülern der zweiten Abtheilung. b) „Jagdlied", von M. L. Storch, dreistimmig mit Waldhörnerbegleitung arrangirt von L. Fr. Grossbauer, gesungen von den Schülern der ersten und zweiten Abtheilung.

5. Sprach- und Redeübungen. a) Julius Cäsar von Shakespeare. Act IV., Scene III., Brutus und Cassius, vorgetragen von dem Schüler der 6. Classe Freud Sigmund und dem Schüler der 7. Classe Löbel Samuel. b) Sophocles Elektra v. 1126 ff. — vorgetragen von dem Schüler der 7. Classe Natterer Robert. c) Vergilii Aeneis II. 195 ff. Laocoon, vorgetragen von dem Schüler der 6. Classe Atzinger Gustav.

6. Gesang. — „Sängermarsch", von Sandtner dreistimmig mit Klavierbegleitung arrangirt von L. Fr. Grossbauer, gesungen von den Schülern der ersten und zweiten Abtheilung.

7. Veröffentlichung der Schülerleistungen.

8. Volkshymne.

Siebenter Jahresbericht

des

Leopoldstädter

Communal-Real- und Obergymnasiums

IN WIEN.

Veröffentlicht

vom Director Dr. ALOIS POKORNY

am Schlusse des

Schuljahres 1871.

Inhalt:

V. v. Kraus. Englische Diplomatie im Jahre 1157. Ein Beitrag zur Geschichte Ferdinand's I. mit einem Anhange bisher noch ungedruckter Briefe aus diesem Jahre.

F. Nahrhaft. Beiträge zur homerischen Syntax.

Schulnachrichten.

WIEN 1871.

Verlag des Leopoldstädter Real- und Obergymnasiums.

Gedruckt bei J. Drückhüber von Hirschfeld.

17 Annual report of the "Gymnasium"[1] for 1871: Speech training

It then struck me as noticeable that in the scene in the dream there was a convergence of a hostile and an affectionate current of feeling [. . .]. Where was an antithesis of this sort to be found, a juxtaposition like this of two opposite reactions towards a single person, both of them claiming to be completely justified and yet not incompatible? Only in one passage in literature—but a passage which makes a profound impression on the reader: in Brutus's speech of self-justification in Shakespeare's *Julius Caesar* (III, 2). "As Caesar loved me, I weep for him; as he was fortunate. I rejoice at it; as he was valiant; I honour him: but as he was ambitious, I slew him." Were not the formal structure of these sentences and their antithetical meaning precisely the same as in the dream-thought I had uncovered? Thus I had been playing the part of Brutus in the dream. [. . .] Strange to say, I really did once play the part of Brutus.

The Interpretation of Dreams

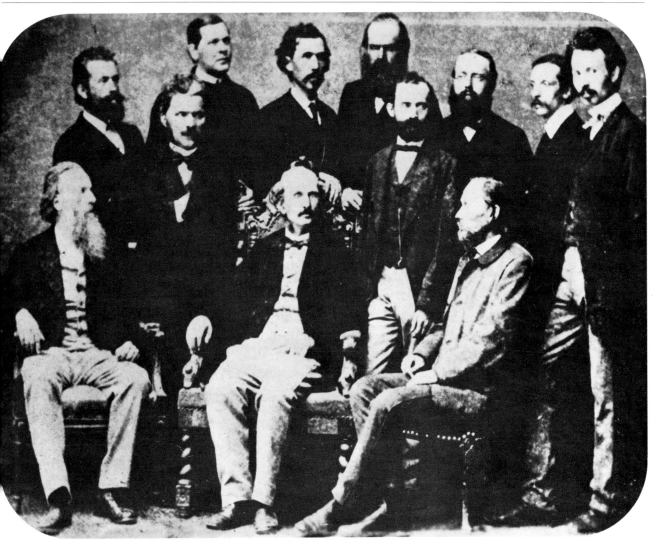

18 The "Gymnasium" staff, about 1870

[. . .] it is hard to decide whether what affected us more and was of greater importance to us was our concern with the sciences that we were taught or with the personalities of our teachers. [. . .] We courted them or turned our backs on them, we imagined sympathies and antipathies in them which probably had no existence, we studied their characters and on theirs we formed or misformed our own. They called up our fiercest opposition and forced us to complete submission; we peered into their little weaknesses, and took pride in their excellences. [. . .] In the second half of childhood a change sets in in the boy's relation to his father—a change whose importance cannot be exaggerated. From his nursery the boy begins to cast his eyes upon the world outside. And he cannot fail now to make discoveries which undermine his original high opinion of his father and which expedite his detachment from his first ideal. He finds that this father is no longer the mightiest, wisest and richest of beings; he grows dissatisfied with him, he learns to criticize him and to estimate his place in society [. . .]. Everything that is hopeful as well as everything that is unwelcome, in the new generation is determined by this detachment from the father. It is in this phase of a youth's development that he comes into contact with his teachers. So that we can now understand our relation to our schoolmasters. These men, not all of whom were in fact fathers themselves, became our substitute fathers.
Some Reflections on Schoolboy Psychology

*Heinrich Braun, 1854-1927,
founded in 1883, together with
Karl Kautsky and Wilhelm
Liebknecht,* Die neue Zeit, *the
central organ of the German
Social Democratic Party. Later
he founded and edited several
important Social Democratic
journals, including the* Annalen
für soziale Politik und
Gesetzgebung *(Annals of
Social Politics and
Jurisdiction). He strove
especially to mediate between
the working-class movement
and intellectuals.*

19 Heinrich Braun, a boyhood friend

I know that I made Heinrich Braun's acquaintance during the first school year on the day of the first annual school report, and that we soon became inseparable friends. [. . .] I think he encouraged me in my aversion to school and what was taught there, aroused a number of revolutionary feelings within me, and we encouraged each other in overestimating our critical powers and superior judgement. [. . .] I admired him, his energetic behavior, his independent judgement, compared him secretly with a young lion and was deeply convinced that one day he would fill a leading position in the world. [. . .] with the vague perception of youth I guessed that he possessed something which was more valuable than any success at school and which I have since learned to call "personality." [. . .] Under his influence I also decided at that time to study law at the university.
Letter to Julie Braun-Vogelstein,[1] *October 30, 1927*

20 Samuel Hammerschlag and his wife Betty

The old professor [. . .] informed me that [. . .] a rich man had given him a sum of money for a worthy person in need, that he had mentioned my name and he was herewith handing it to me. [. . .] It is not the first time the old man has helped me in this way [. . .]. I do not know any people kinder, more humane, further removed from any ignoble motive than they. [. . .] quite apart from the deep-seated sympathy which has existed between myself and the dear old Jewish teacher ever since my school days.
Letter to Martha Bernays, January 10, 1884

21 Seal of the "Academia Castellana"[1]

We[2] became friends at a time when one doesn't look upon friendship as a sport or an asset, but when one needs a friend with whom to share things. We used to be together literally every hour of the day that was not spent on the school bench. We learned Spanish together, had our own mythology and secret names which we took from some dialogue of the great Cervantes. [. . .] Together we founded a strange scholarly society, the *Academia Castellana* (A.C.), compiled a great mass of humorous work which must still exist somewhere among my old papers; we shared our frugal suppers and were never bored in each other's company.
Letter to Martha Bernays, July 2, 1884

22 In the Prater

My parents had been in the habit, when I was a boy of eleven or twelve, of taking me with them to the Prater. One evening, while we were sitting in a restaurant there, our attention had been attracted by a man who was moving from one table to another and, for a small consideration, improvising a verse upon any topic presented to him. I was despatched to bring the poet to our table and he showed his gratitude to the messenger. Before enquiring what the chosen topic was to be, he had dedicated a few lines to myself; and he had been inspired to declare that I should probably grow up to be a Cabinet Minister.
The Interpretation of Dreams

23 The Ministers Eduard Herbst and Karl Giskra

Those were the days of the "*Bürger*" Ministry. Shortly before, my father had brought home portraits of these middle-class professional men—Herbst, Griska, [. . .] and the rest—and we had illuminated the house in their honor. There had even been some Jews among them. So henceforth every industrious Jewish schoolboy carried a Cabinet Minister's portfolio in his satchel. The events of that period no doubt had some bearing on the fact that up to a time shortly before I entered the University it had been my intention to study Law; it was only at the last moment that I changed my mind.
The Interpretation of Dreams

Eduard Herbst, 1820-1892, lawyer; after 1861 in the Bohemian Diet and in the Austrian Parliament; 1868-1870, Minister of Justice.

Karl Giskra, 1820-1879, lawyer; 1848-1849, member of the Frankfurt National Assembly; after 1861 leader of the German liberals in the Austrian Parliament; 1867-1870, Minister of the Interior.

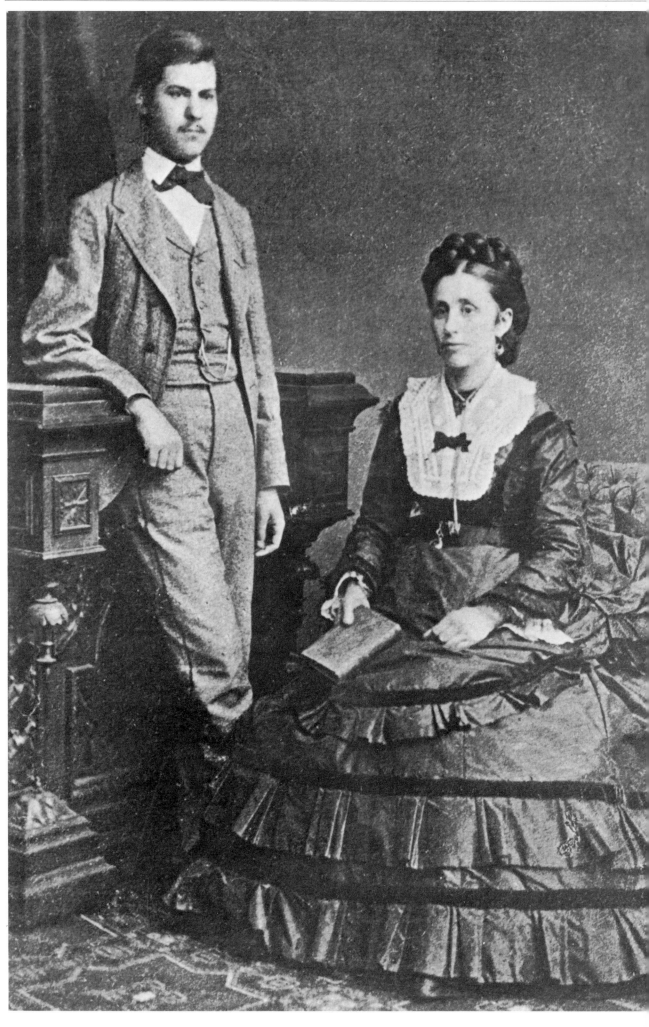

24 Freud at sixteen, with his mother

[. . .] if a man has been his mother's undisputed darling he retains throughout life the triumphant feeling, the confidence in success, which not seldom brings actual success along with it.

A Childhood Recollection from Dichtung und Wahrheit

25 Hannibal and Masséna

Hannibal [. . .] had been the favorite hero of my later school days.[1] Like so many boys of that age, I had sympathized in the Punic Wars not with the Romans but with the Carthaginians. And when in the higher classes I began to understand for the first time what it meant to belong to an alien race, and anti-semitic feelings among the other boys warned me that I must take up a definite position, the figure of the semitic general rose still higher in my esteem. To my youthful mind Hannibal and Rome symbolized the conflict between the tenacity of Jewry and the organization of the Catholic church. [. . .] I believe I can trace my enthusiasm for the Carthaginian general a step further back into my childhood; so that once more it would only have been a question of transference of an already formed emotional relation on to a new object. One of the first books that I got hold of when I had learnt to read was Thiers' history of the Consulate and Empire. I can still remember sticking labels on the flat backs of my wooden soldiers with the names of Napoleon's marshals written on them. And at that time my declared favorite was already Masséna[2] (or to give the name its Jewish form, Manasseh). (No doubt this preference was also partly to be explained by the fact that my birthday fell on the same day as his, exactly a hundred years later.) [. . .] It may even be that the development of this martial ideal is traceable still further back into my childhood; to the times when, at the age of three, I was in a close relation, sometimes friendly, but sometimes warlike, with a boy[3] a year older than myself, and to the wishes which that relation must have stirred up in the weaker of us.

The Interpretation of Dreams

26 Oliver Cromwell

The analysis enabled me to fill in this gap in the dream. It was a mention of my second son,[1] to whom I had given the first name of a great historical figure [Cromwell] who had powerfully attracted me in my boyhood, especially since my visit to England. [. . .] (It is easy to see how the suppressed megalomania of fathers is transferred in their thoughts on to their children, and it seems quite probable that this is one of the ways in which the suppression of that feeling, which becomes necessary in actual life, is carried out.)
The Interpretation of Dreams

28 Sophocles

I have a good deal of reading to do on my own account from the Greek and Latin classics, among them Sophocles's *Oedipus Rex*. You deprive yourself of much that is edifying if you can't read all these, but, on the other hand, you retain that cheerfulness which is so comforting about your letters.
Letter to Emil Fluss, March 17, 1873

His destiny moves us because it might have been ours—because the oracle laid the same curse upon us before our birth as upon him. It is the fate of all of us, perhaps, to direct our first sexual impulse towards our mother and our first hatred and our first murderous wish against our father. Our dreams convince us that that is so. King Oedipus, who slew his father Laïus and married his mother Jocasta, merely shows us the fulfilment of our own childhood wishes.
The Interpretation of Dreams

27 Ludwig Börne

I received Börne as a present when I was very young, perhaps for my thirteenth birthday. I read him avidly, and some of these short essays have always remained very clearly in my memory, not of course the cryptomnesic one.[1] When I read this one again I was amazed to see how much in it agrees practically word for word with things I have always maintained and thought. He could well have been the real source of my originality.
Letter to Sándor Ferenczi, April 9, 1919

29 From the annual report of the "Gymnasium," 1873: Final Examinations

In Latin we were given a passage from Virgil which I had read by chance on my own account some time ago; this induced me to do the paper in half the allotted time and thus to forfeit an *exc.* [. . .] The German-Latin translation seemed very simple; in this simplicity lay the difficulty; we took only a third of the time, so it failed miserably. Result: *fair.* [. . .] The Greek paper, consisting of a 33-verse passage from *Oedipus Rex*, came off better: [I was] the only *good.* This passage I had also read on my own account, and made no secret of it. The maths. paper, which we approached in fear and trembling, turned out to be a great success: I have written *good* because I am not yet positive what I was given. Finally, my German paper was stamped with an *exc.* It was a most ethical subject on "Considerations involved in the Choice of a Profession" [. . .]. Incidentally, my professor told me—and he is the first person who has dared to tell me this—that I possess what Herder so nicely calls an *idiotic* style—i.e. a style at once correct and characteristic.
Letter to Emil Fluss, June 16, 1873
Translation in the Notes

Prot
Leopold. Co: Real...
der am ~~k. k.~~ Ober-Gymnasium zu Wien-
abgehalte

Nro.	Name, Geburtsort und Vaterland. Stand der Eltern, Religion des Examinanden	Sittliches Betragen	Religions- lehre	Lateini... Sprach...
1.	Atzinger Gustav aus Wien Vater Franz A. Director der Waaghallbahn, röm. Katholisch. ... d. 25 Juli 1855 hat die Gymnasialstudien beendigt, und zwar: alle 8 Classen ohne Unterbrechung am Leopoldstädter Co: Real u. Ober-gymnasium vom J. 1865-1873.	..., einfach.	vorzüglich	befriedig...
2.	Franceschini Robert aus Tramin in Tirol. Mutter Magdanna ... in Tramin ... und ... Sigwalt in Haard. röm. Katholisch. ... 1862. hat die Gymnasialstudien beendigt, und zwar: I und II Cl. Privat, III Cl. zu Feldkirch öff., IV Cl. in ... Privat, V und VI Cl. am Gymn. zu Mehrerau, VII und VIII Cl. am Leopoldst. Co: Real-u. Ober-gymn. vom J. 1864-1873.	lobenswert.	befriedigend.	...friedi...
3.	Freud Sigmund aus Freiberg in Mähren. Vater Jacob S: Wollhändler in Wien. mosaisch, ... 6. ... 1856. hat die Gymnasialstudien beendigt, und zwar: alle 8 Classen ohne Unterbrechung am Leopoldstädter Co: Real u. Obergymnasium vom J. 1865-1873.	musterhaft	vorzüglich	vorzüglich

Themata zur schriftlichen Maturitätsprüfung.

1. Aus dem Deutschen: Welche Rücksichten sollen uns bei der Wahl des Berufes leiten? — 2. Aus dem Latein: Vergilius lib. IX. 176—223. — Seyffert für Secunda p. 283 Nr. XIII. bis zu den Worten „zur Befreiung des Vaterlandes aufzufordern." — 3. Aus dem Griechischen: Sophocles Oed. R. v. 14—57. — Aus der Mathematik:

1. Von einem Dreiecke ist der Flächeninhalt ($J = m^2$) und zwei Höhen (h_a und h_b) gegeben, man soll das Dreieck zeichnen. — 2. Wie gross ist eine Seitenfläche einer einem geraden Cylinder eingeschriebenen geraden Pyramide, wenn der Cylinder die Höhe h und die Basis desselben den Radius r besitzt? Man berechne die Seitenfläche für $r = 4$, $h = 8$. — 3. Ein Kaufmann verkauft eine Flüssigkeit in Flaschen zu 5 fl. und 9 fl. Wie viele Flaschen der ersten und wie viele der zweiten Art muss er nehmen, wenn alle zusammen einen Werth von 71 fl. repräsentiren sollen? — 4. Welcher Kettenbruch ist dem gemeinen Bruche $\frac{406}{1109}$ gleich, welches sind seine Näherungswerthe und welches ist die Grenze des Fehlers, den man macht, wenn man den vorletzten Näherungsbruch für den ganzen Bruch setzt?

o l l

Monate *Juli* 18*73*.

aturitäts-Prüfung.

Griechische Sprache	Deutsche Sprache	Geschichte und Geographie	Physik	Mathematik	Propädeutik	Reife zur Universität
genügend	*befriedigend*	*lobenswerth*	*vorzüglich.* / Allg. Nat. K. *vorzüglich.*	*lobenswerth.*	*vorzüglich.*	*mit Auszeichnung*
genügend	*befriedigend*	*genügend.*	*befriedigend* / Allg. Nat. K. *befriedigend*	*genügend.*	*befriedigend.*	*reif.*
vorzüglich.	*ausgezeichnet.*	*vorzüglich.*	*vorzüglich.* / Allg. Nat. K. *lobenswerth.*	*vorzüglich.*	*vorzüglich.*	*mit Auszeichnung*

b) Verzeichniss der Abiturienten des Schuljahres 1873.

Name	Geburtsort	Reifegrad
22. Atzinger Gustav,	Wien	mit Auszeichnung
23. Franceschini Robert,	Tramin, Tirol	reif
24. Freud Sigmund,	Freiberg, Mähren	mit Auszeichnung
25. Knöpfmacher Wolf,	Nicolsburg, Mähren	reif
26. Neuschiller Moriz,	Nicolsburg, Mähren	reif
27. Pettik Leopold,	Budweis, Böhmen	reif
28. Smeschkall Wilhelm,	Mölk, Nieder-Oesterr.	reif
29. Wagner Julius,	Wien	reif

31 Facsimile of two pages of the "Matura-Brief" (Examination letter)[1]

Translation in the Notes

geborgen, trösten Sie mich. Wovor geborgen, muss
ich fragen, doch nicht geborgen u versichert dass
er nicht ist? ~~Rat~~ ~~~~
~~~~
~~~~
~~~~ Was verschlägt, ob Sie etwas
fürchten oder nicht? ist nicht die Hauptsache
ob es so wahr ist, wie wir fürchten.
Nicht wahr, dass auch stärkere Geister vom
Zweifel an sich selbst ergriffen werden, ist
darum jeder der im Verdienst in Zweifel
zieht ein starker Geist? Es kann ein
Schwächling an Geist sein, nur ein schlimmer
Mann dabei, aus Erziehung, Gewohnheit
– oder gar aus Selbstqual. Ich will
Sie nicht auffordern, wenn Sie in irgendwelche
zweifelnde Lage kommen, Ihre Empfindungen
unbarmherzig zu zerstieben, aber wenn die es
thun werden Sie sehen, wie wenig sie
sicher an sich haben. Die Großartigkeit
der Welt beruht ja auf dieser Mannichfaltigkeit
viel der Mühe in Ketten, nur ist's leider
kein fester Grund für unsre
Selbstvertrauen.

## 32  World Exhibition in Vienna, 1873

I have been to the exhibition twice already. Interesting, but it didn't bowl me over. Many things that seemed to please other people didn't appeal to me because I am neither this nor that, not really anything completely. Actually, the only things that fascinated me were the works of art and general effects. A great comprehensive panorama of human activity, as the newspapers profess to see, I don't find in it, any more than I can find the features of a landscape in an herbarium. On the whole it is a display for the aesthetic, precious and superficial world, which also for the most part visits it. When my "martyrdom" (this is what we call the *Matura* among ourselves) is over, I intend to go there every day. It is entertaining and distracting. One can also be gloriously alone there in all that crowd.
*Letter to Emil Fluss, June 16, 1873*

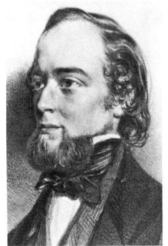

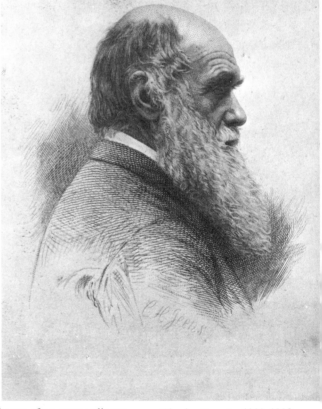

## 33  Carl Brühl; Charles Darwin

Although we lived in very limited circumstances, my father insisted that, in my choice of a profession, I should follow my inclinations alone. Neither at that time, nor indeed in my later life, did I feel any particular predilection for the career of a doctor. I was moved, rather, by a sort of curiosity, which was, however, directed more towards human concerns than towards natural objects; nor had I grasped the importance of observation as one of the best means of gratifying it. [ . . . ] At the same time, the theories of Darwin, which were then of topical interest, strongly attracted me, for they held out hopes of an extraordinary advance in our understanding of the world; and it was hearing Goethe's beautiful essay on Nature read aloud at a popular lecture by Professor Carl Brühl just before I left school that decided me to become a medical student.
*An Autobiographical Study*

*Charles Darwin, 1809-1882, after an engraving found in Freud's desk*

*Carl Brühl, 1820-1899, Professor of zootomy at the University of Vienna. On Sundays he gave lectures for the general public, which Freud attended.*

## 34  The University of Vienna

When, in 1873, I first joined the University, I experienced some appreciable disappointments. Above all, I found that I was expected to feel myself inferior and an alien because I was a Jew. I refused absolutely to do the first of these things. I have never been able to see why I should feel ashamed of my descent or, as people were beginning to say, of my "race." I put up, without much regret, with my non-acceptance into the community; for it seemed to me that in spite of this exclusion an active fellow-worker could not fail to find some nook or cranny in the framework of humanity. These first impressions at the University, however, had one consequence which was afterwards to prove important; for at an early age I was made familiar with the fate of being in the Opposition and of being put under the ban of the "compact majority." The foundations were thus laid for a certain degree of independence of judgement.
*An Autobiographical Study*

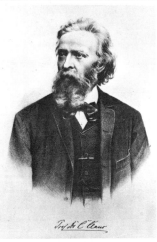

## 35  Carl Claus

*Carl Claus, 1835-1899, professor of zoology and comparative anatomy at the University of Vienna. In his second semester (summer 1874) Freud attended, besides lectures in anatomy, chemistry and physiology, a course given by Claus on Darwinism; in his third semester he attended Claus's zoological lectures for medical students. In his fourth semester Freud concentrated on the regular lectures in the faculty of zoology, and also spent ten hours a week on*

*laboratory work. He continued the laboratory work in zoology during the two following semesters.*

*The former University building, also called the "Üniversitätshaus," now the "Haus der Österreichischen Akademie der Wissenschaften" (House of the Austrian Academy of Sciences).*

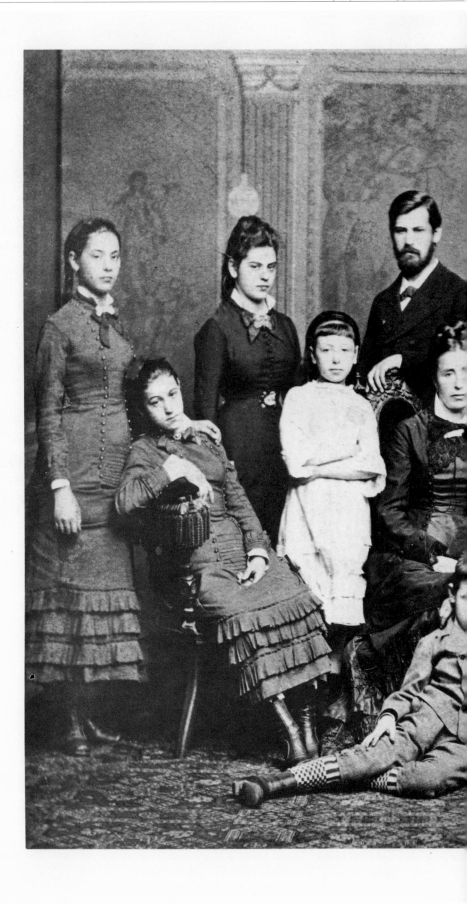

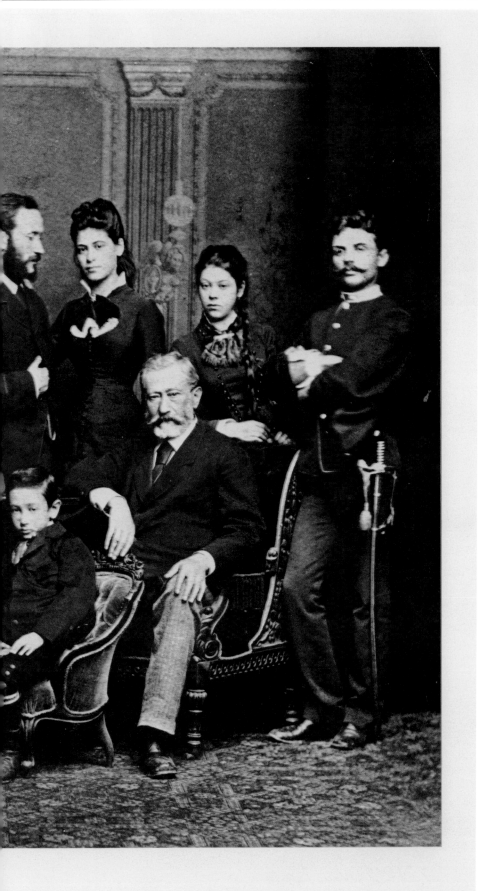

**36   Family photograph, 1876**

*From left to right and from
back to front: Paula, Anna,
Sigmund, Emanuel (Freud's
half brother), Rosa, Mitzi,
Simon Nathansohn (Amalie's
cousin), Dolfi, ?, Amalie, Jacob,
Alexander, ?.*

**37    Laboratory of the Zoological Experimental Station in Trieste**

In the first years of my University life I attended lectures mainly in physics and natural history [ . . . ] and was twice sent on vacation courses to the zoological station at Trieste.
*Curriculum vitae*

*Carl Claus, whose main interest was the zoology of marine animals, had set up a zoological experimental station in Trieste. As a student, in 1875/76, Freud twice received a grant for a period of research at this station.*

**38    Application for the second grant, 1876**

Gentlemen,
The undersigned, after attending lectures in zoology for several semesters, worked during the winter semester 1875/76 at the Zoologic and Zootomic Institute, and would consider it a great opportunity for advancement if he could continue his studies in Trieste during the Easter vacation. As he is unable to raise enough for his expenses out of his own resources, he is applying to the distinguished Ministry for a travel grant. Vienna, 22nd February, 1876.
Sigmund Freud
*Translation*

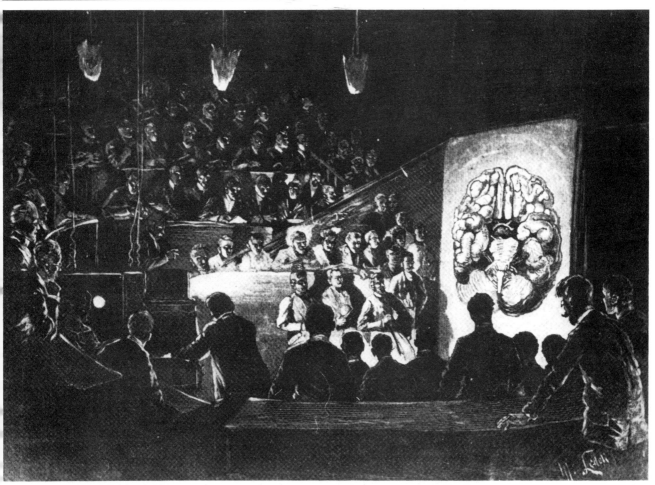

### 39 First scientific publication, 1877

Dr. Syrski had recently recognized a paired, lobulated, grooved organ occurring in the abdominal cavity of the eel as the animal's male sexual organ which had long been looked for. At Professor Claus's suggestion I investigated the occurrence and tissue components of these lobed organs at the zoological station in Trieste.
*Abstracts of the Scientific Writings of Dr. Sigm. Freud, 1877-1897*

### 40 Demonstration of a brain during a lecture at the University of Vienna

*For experimental pathology a lecture room had been set up, with special electrical equipment. With the help of the projection microscope and the epidiascope, Salomon Stricker introduced lecture-demonstrations into the medical curriculum of the University of Vienna.*

---

Arbeiten aus dem zoologisch-vergleichend-anatomischen Institute der Universität Wien.

———

VII. Beobachtungen über Gestaltung und feineren Bau der als Hoden beschriebenen Lappenorgane des Aals.

(Mit 1 Tafel.)

Von **Sigmund Freud,** stud. med.

(Vorgelegt in der Sitzung am 15. März 1877.)

In den Monaten März und September des Jahres 1876 habe ich in der zoologischen Station zu Triest auf Anregung meines Lehrers, des Herrn Professors Claus, die Geschlechts-organe des Aals untersucht, über welche einige Zeit vorher Dr. Syrski eine zu neuen Untersuchungen anregende Mit-theilung gemacht hatte. Diejenige Jahreszeit, welche von den Autoren als die Laichzeit des Aals bezeichnet wird — von October bis Januar — konnte ich nicht in Triest zubringen. Herr Professor Claus hat aber in den letztgenannten Monaten eine grössere Menge von Aalen aus Triest kommen lassen und sie mir zur Untersuchung im zoologisch - vergleichend - anato-mischen Institut übergeben. Dafür, wie für die anderweitige Unterstützung bei der Ausführung dieser Arbeit, sei mir gestattet, Herrn Prof. Claus aufs Wärmste zu danken.

Ich habe im Ganzen etwa 400 Aale untersucht, die zwischen 200ᵐᵐ und 650ᵐᵐ lang waren; doch befanden sich unter dieser Anzahl nur wenige Thiere kleiner als 250ᵐᵐ oder grösser als 480ᵐᵐ, denn ich war nicht im Stande mir hinreichend viele winzige Thierchen zu verschaffen und habe andererseits die Unter-suchung von Aalen, deren Länge einen halben Meter über-schritt, bald aufgegeben, weil ich bei keinem dieser grossen

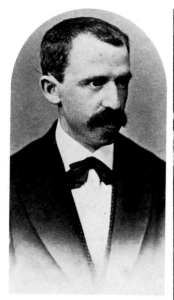

**41   Salomon Stricker**
For one semester I had the
opportunity to practice animal
experiments in Prof. Stricker's
laboratory of experimental
pathology.
*Curriculum vitae*

*Salomon Stricker, 1834-1898,
professor of general and
experimental pathology at the
University of Vienna, and also
a follower of Darwin. His
institute was then developing
into an influential research
center.*[1] *Along with research in
physiology and electrology in
particular, Stricker dealt in
depth with the epistemological
questions of his time.*[2]

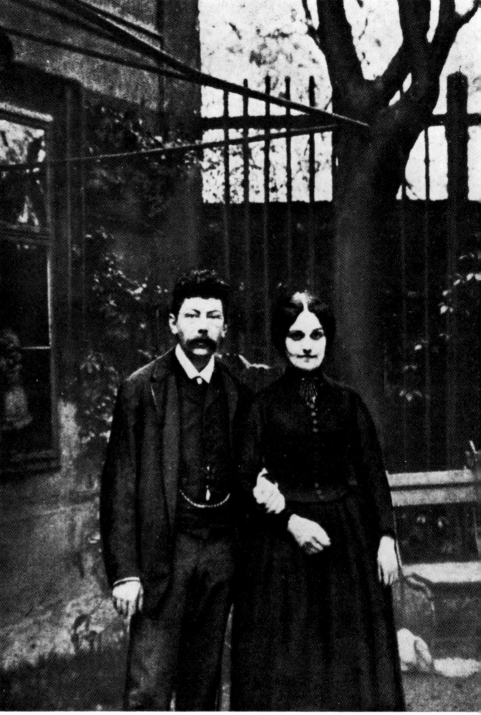

**42   Victor Adler and his wife
in the garden of Berggasse 19**[1]
The [ . . . ] scene [ . . . ] dated
from my early student days.
There was a discussion in a
*German* students' club on the
relation of philosophy to the
natural sciences. I was a green
youngster, full of materialistic
theories, and thrust myself
forward to give expression to
an extremely one-sided point
of view. Thereupon someone
who was my senior and my
superior, someone who has
since then shown his ability
as a leader of men and an
organizer of large groups (and
who also, incidentally, bears a
name derived from the Animal
Kingdom), stood up and gave
us a good talking-to: he too, he
told us, had fed swine in his
youth and returned repentant
to his father's house. *I fired up*
(as I did in the dream) and
replied boorishly [ . . . ] that
since I now knew that he had
fed *swine* in his youth I was no
longer *surprised* at the tone of
his speeches. (In the dream I
was *surprised* at my German-
nationalist attitude). There was
a general uproar and I was
called upon from many sides to
withdraw my remarks, but I
refused to do so. The man I
had insulted was too sensible
to look upon the incident as a
*challenge*, and let the affair
drop.
*The Interpretation of Dreams*

*Victor Adler, 1852-1918, the
Austrian socialist. He founded
the* Arbeiterzeitung *in 1889; in
1888/89 he united the Austrian
Social Democrats, who were
scattered at that time, and from
1905 onwards was their leader
in the "Abgeordnetenhaus"
(House of Deputies).*

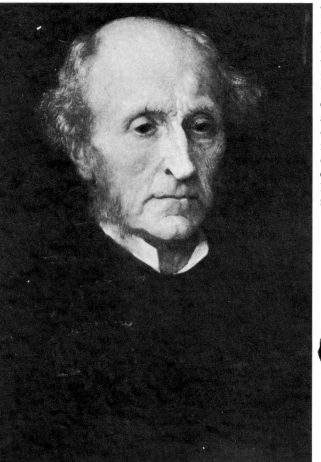

### 45  John Stuart Mill

I got the idea of reading him when Gomperz entrusted to me the translation of his last work.[1] At the time I found fault with his lifeless style and the fact that in his work one could never find a sentence or a phrase that would remain in one's memory. But later on I read a philosophical work of his which was witty, epigrammatically apt and lively. Very possibly he was the man of the century most capable of freeing himself from the domination of the usual prejudices.

*Letter to Martha Bernays, November 15, 1883*

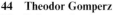

### 43  Franz Brentano

*Franz Brentano, 1838-1917, professor of philosophy at the University of Vienna*[1]

*During his studies, Freud often made excursions into neighboring disciplines. Between 1874 and 1876 he attended Brentano's lectures, including a course on the philosophy of Aristotle. It was Brentano who recommended Freud to Theodor Gomperz as translator for the twelfth volume of the works of John Stuart Mill.*

### 44  Theodor Gomperz

The little notebook containing the handwriting of your unforgotten husband reminded me of that time lying so far behind us, when I, young and timid, was allowed for the first time to exchange a few words with one of the great men in the realm of thought. It was soon after this that I heard from him the first remarks about the role played by dreams in the psychic life of primitive men—something that has preoccupied me so intensively ever since.

*Letter to Elise Gomperz, November 12, 1913*

*Theodor Gomperz, 1832-1912, professor of classical philology at the University of Vienna*

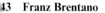

| Albert | | Ludwig | Kundrat | Wedl | | Billroth | Hofmann | G. Braun | Langer | Stricker | Meynert |
| Vogl | | Duchek | Stellwag | | Späth | Bamberger | | Brücke | Arlt | | C. Braun |

### 46  Staff of the Medical Faculty at Vienna, 1882

*Freud attended lectures by Ernst Ludwig on physiological and pathological chemistry, Theodor Billroth on clinical surgery, Eduard von Hofman on special sections of forensic medicine, Carl Langer on anatomy, Salomon Stricker on general pathology, Theodor Meynert on clinical psychiatry, Joseph Späth on clinical obstetrics, Heinrich von Bamberger on internal medicine, Ernst Wilhelm von Brücke on physiology and Ferdinand Arlt on ophthalmology.*[1]

### 47  Hermann von Helmholtz

The great Helmholtz is at present in Vienna to visit the electrical exhibition; the man is one of my idols,[1] but I didn't manage to see him.
*Letter to Martha Bernays, October 18, 1883*

*Hermann von Helmholtz, 1821-1894, the great physicist, and, in the Forties, cofounder of antivitalistic physiology, a doctrine also followed by Freud's teacher Ernst Wilhelm von Brücke (illustration 49). Representatives of Helmholtz's school started rigorously from the principle that no forces other than physical and chemical ones were active in the organism. When Freud was a student, the dominance and crusading spirit of this physical physiology were still unbroken, and he started out as one of its enthusiastic adherents.*[2]

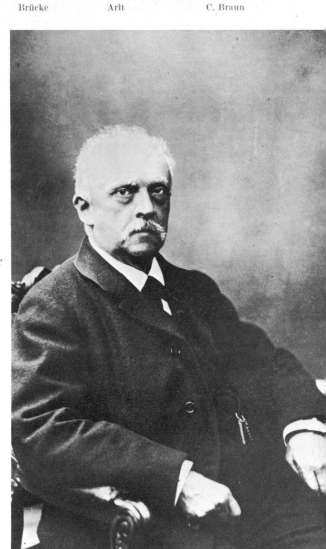

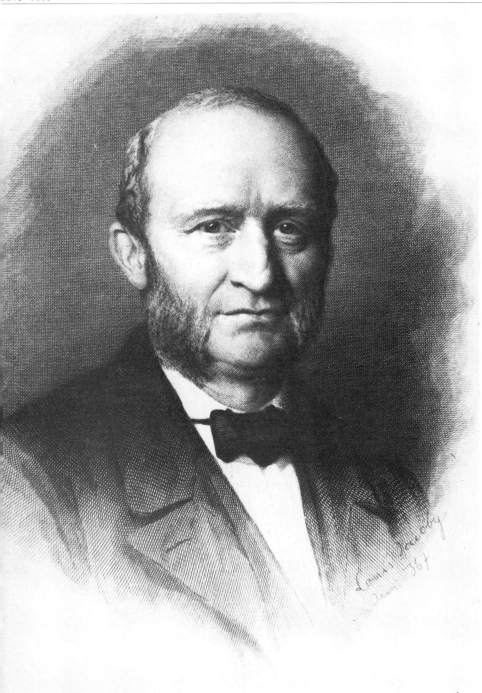

*Ernst Wilhelm von Brücke, 1819-1892, like Rudolf Virchow, Hermann von Helmholtz and Emil Du Bois-Reymond, had studied in Berlin with the physiologist Johannes Müller. In 1849 he became professor at the University of Vienna. As director of the Physiological Institute, he introduced modern laboratory medicine into the predominantly morphologically orientated school of Vienna, and with it the completely new physical form of medical thinking. In addition to his studies in microscopic anatomy, Brücke became famous for research into the physiology of the eye, the digestion and the voice. In addition he is the author of a large number of works on the theory of art. In 1879 he was the first Protestant Rector at the University of Vienna.*

**48   The Physiological Institute in the "Alte Gewehrfabrik" (old weapons factory)**
At length, in Ernst Brücke's physiological laboratory, I found rest and full satisfaction—and men, too, whom I could respect and take as my models, [ . . . ] I worked at this Institute, with short interruptions, from 1876 to 1882 [ . . . ].
*An Autobiographical Study*

**49   Ernst Wilhelm von Brücke**
At the time I have in mind I had been a demonstrator at the Physiological Institute[1] and was due to start work early in the morning. It came to Brücke's ears that I sometimes reached the students' laboratory late. One morning he turned up punctually at the hour of opening and awaited my arrival. His words were brief and to the point. But it was not they that mattered. What overwhelmed me were the terrible blue eyes with which he looked at me and by which I was reduced to nothing [ . . . ]. No one who can remember the great man's eyes, which retained their striking beauty even in his old age, and who has ever seen him in anger, will find it difficult to picture the young sinner's emotions.
*The Interpretation of Dreams*

Freud: Über Spinalganglien

kz

n

Fig. 2.

ang gf
se

**50   Ernst von Fleischl-Marxow**
He is a thoroughly excellent person in whom nature and education have combined to do their best [ . . . ] with the stamp of genius in his manly features, good-looking, refined, endowed with many talents and capable of forming an original judgement about most things, he has always been my ideal [ . . . ].
*Letter to Martha Bernays, June 27, 1882*

[ . . . ] I admire and love him with an intellectual passion, if you will allow such a phrase. His destruction will move me as the destruction of a sacred and famous temple would have affected an ancient Greek.
*Letter to Martha Bernays, October 28, 1883*

*Ernst von Fleischl-Marxow, 1847-1891, physicist and physiologist, Freud's friend and Brücke's assistant at the Physiological Institute. He was especially concerned with physiological optics and with the physiology of nerves and muscles. Fleischl-Marxow's "destruction" refers to his illness, which was considered incurable.*[1]

**51   Freud's own drawings for "On the Spinal Ganglia and Spinal Cord of the Petromyzon," 1878**
The subject which Brücke had proposed for my investigations had been the spinal cord of one of the lowest of the fishes [ . . . ].
*An Autobiographical Study*

When I myself had begun to publish papers, I had been obliged to make my own drawings to illustrate them.
*The Interpretation of Dreams*

Fig. 1

Fig. 4

Fig. 3.

*[Handwritten examination records in old German script, including entries for:]*

*Fischer Rudolf ... geb. am 4. December 1859 ...*

*Fischer Ludwig ... geb. 2. Januar 1853 zu Török Szent Miklos ... Matura*

*Freud Sigmund geb. 6. Mai 1856 zu Freiberg Mähren ... Matur Wien*

*I. Rigorosum abgeschlossen 9. Juni 1880 ... Prom. vun 30. März 1881*

*Frisch ... geb. am 14. December 1858 ...*

*Friedinger Karl aus Wien geb. am 22. Jänner 1850 ... Prom. vun 13. Februar 1884*

**52   Three examinations *(rigorosa)* for the medical degree, 1880/81**
*Translation in Notes*
The *five years* which are prescribed for medical studies were once again too few for me. I quietly went on with my work for several more years; and in my circle of acquaintances I was regarded as an idler and it was doubted whether I should ever get through. Thereupon I *quickly* decided to take my examinations [ . . . ].
*The Interpretation of Dreams*

**53   Aula of the former University building**
*Here Freud's graduation took place on March 30, 1881.*

**54   Graduation record**
The various branches of medicine proper, apart from psychiatry, had no attraction for me. I was decidedly negligent in pursuing my medical studies, and it was not until 1881 that I took my somewhat belated degree as a Doctor of Medicine.
*An Autobiographical Study*

| Post N° | Name Geburtsort et Vaterland | Jahr u. Tag der Promotion | Eigenhändige Unterschrift des neu graduirten Doctors |
|---|---|---|---|
| 1201 | Moriz Riegler aus Grozesti p. Bacau in Rumänien | Am 16. März | Dr. Maurice Riegler |
| 1202 | Josef Sedlak aus Gross-Latein p. Katinitz in Mähren | | Dr. Jos. Sedlak |
| 1203 | Josef Blazsur aus Heiligenkreuz in Ungarn | Am 30. März 1881 | Dr. Josefus Blazsur |
| 1204 | August Fabritius aus Kronstadt in Siebenbürgen | | Dr. August Fabritius |
| 1205 | Karl Flechtenmacher aus Kronstadt in Siebenbürgen | | Dr Carl Flechtenmacher |
| 1206 | Sigmund Freud aus Freiberg in Mähren | | Dr Sigm Freud |
| 1207 | Eduard Fröhlich aus Libitz in Böhmen | | Dr Ed. Fröhlich |
| 1208 | Alexander Greiber aus Temesvar | 30. März 1881 | Alexander Greiber |

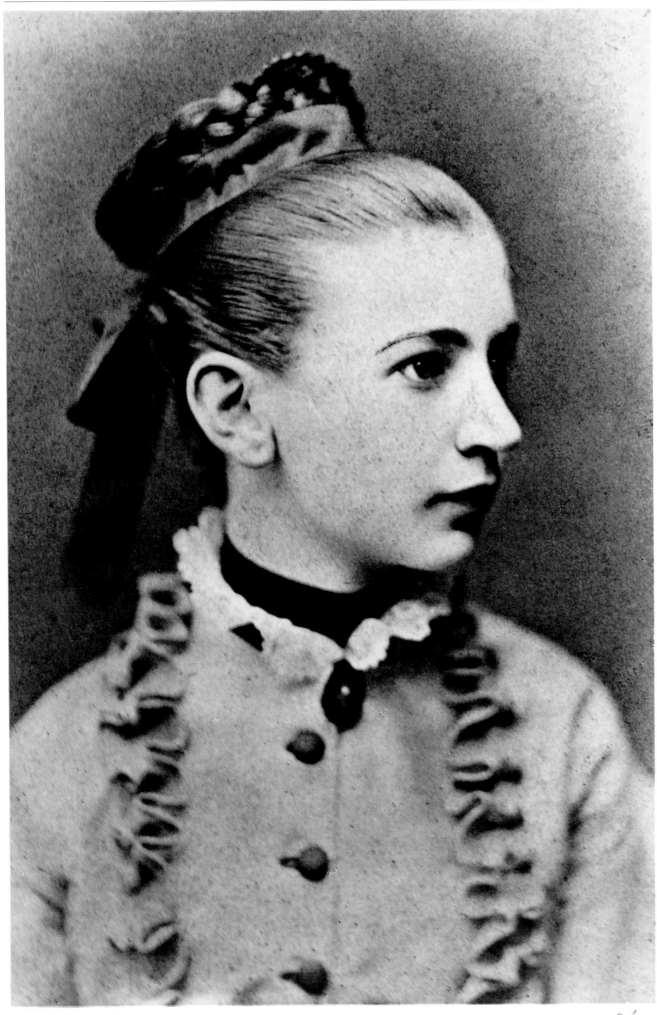

Sch...

**55  Martha Bernays, 1880**

When I look at the photo of you as a young girl, it certainly shows that you were beautiful, very beautiful, and now a spiritual expression lights up the whole of your little face. And yet I shall have to displease you by saying that no photograph will ever do you justice.
*Letter to Martha Bernays, March 15, 1884*

I knew it was only after you had gone[1] that I would realize the full extent of my happiness and, alas! the degree of my loss as well. I still cannot grasp it, and if that elegant little box and that sweet picture were not lying in front of me, I would think it was all a beguiling dream and be afraid to wake up. Yet friends tell me it's true, and I myself can remember details more charming, more mysteriously enchanting than any dream-phantasy could create. It must be true. Martha is mine, the sweet girl of whom everyone speaks with admiration, who despite all my resistance captivated my heart at our first meeting, the girl I feared to court and who came towards me with high-minded confidence, who strengthened the faith in my own value and gave me new hope and energy to work when I needed it most.
*Letter to Martha Bernays, June 19, 1882*

*Martha Bernays, 1861-1951, engaged to Freud in 1882, eventually his wife*

**56  Martha at about two years of age**
Do please try to steal from your fond relations all the photos of you as a child
[ . . . ].
*Letter to Martha Bernays, June 19, 1882*

One has to consider the past, since without understanding it one cannot enjoy the present; nor can one understand the present without knowing the past.
*Letter to Martha Bernays, July 8, 1882*

**57   Martha, 1884**

After all, you know the key to my life, that I can work only when spurred on by great hopes for things uppermost in my mind. Before I met you I didn't know the joy of living, and now that "in principle" you are mine, to have you completely is the one condition I make to life, which I otherwise don't set any great store by. I am very stubborn and very reckless and need great challenges, I have done a number of things which any sensible person would be bound to consider very rash. For example, to take up science as a poverty-stricken man, then as a poverty-stricken man to capture a poor girl—but this must continue to be my way of life: risking a lot, hoping a lot, working a lot. To average bourgeois common sense I have been lost long ago.

*Letter to Martha Bernays, June 19, 1884*

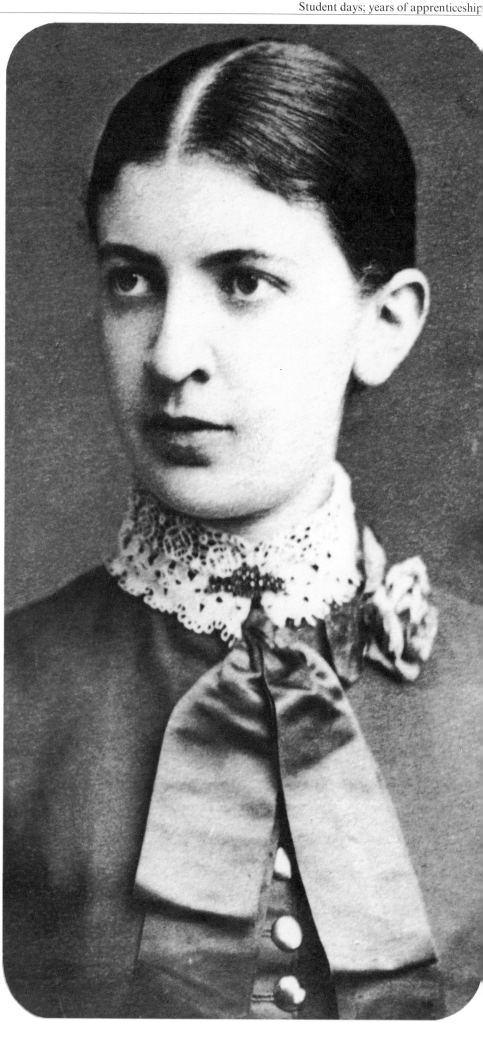

## 58  Ink blots

Here the pen fell out of the writer's hand and wrote this secret sign. Please forgive, and don't ask for an interpretation.

*Translation*

*Freud wrote this letter to Martha Bernays on August 9, 1882, in great agitation due to unfounded jealousy. The request not to ask him for an "interpretation" of the "secret sign" is the first indication of recognition that hidden motivation might lie behind an unconscious lapse, about twenty years before the publication of Freud's book* The Psychopathology of Everyday Life.

## 59  Monograms on Martha's notepaper

In my opinion the B on the notepaper is too ostentatious and the M too modest. As you know, I am interested only in the M.

*Letter to Martha Bernays, January 28, 1884*

*Left, the one criticized by Freud; right, the improved monogram he commissioned*

**60   John Milton**
I don't know how it came
about, but today I was
thinking that everyone ought
to have someone great and
powerful to be his lord and
protector, to whom he could
turn in dark, heavy hours. I
reached out for John Milton,
with his sublime enchantment
that can transport me as
nothing else can from the dull,
unsatisfying world of daily
care, so that the earth becomes
like a little dot in the universe,
and the vast heavens open.
*Letter to Martha Bernays,*
*July 12, 1883*

*John Milton, 1608-1674, whose*
*epic poem on the fall of the*
*human race,* Paradise Lost,
*Freud counted among his*
*favorite books.*[1]

**61   Lessing's monument in the
Gänsemarkt in Hamburg**
Then I thought of one who has
nearer, older rights over me,
and can direct us on this earth
instead of leading us beyond it.
I thought how refreshing it
would be, now, to read a page
of our Lessing, and I am
resolved to set up a statue to
him in our future home,
wherever it may be, and to
keep his works in a prominent
place. I remember that with the
last remains of my religious
faith I put you under his
protection when I came upon
him unexpectedly in Hamburg.
*Letter to Martha Bernays,*
*July 12, 1883*

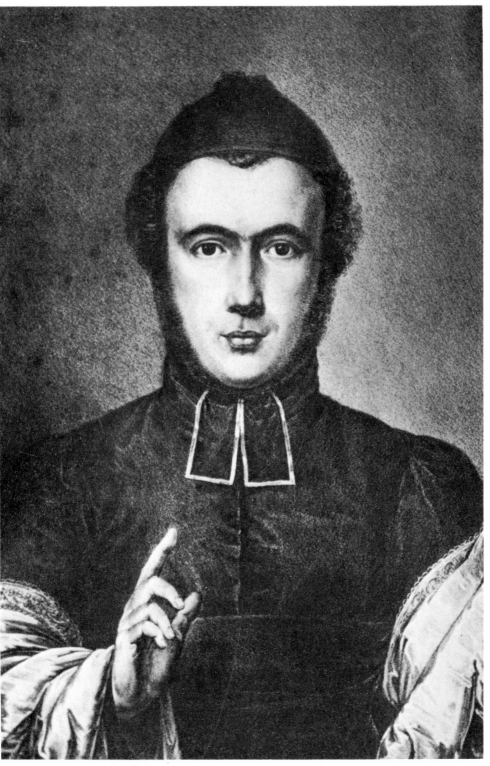

*Isaac Bernays, 1792-1849, chief rabbi in Hamburg, Martha's grandfather*

*Michael Bernays, 1834-1897, eminent scholar and specialist in the works of Goethe and Shakespeare, professor of the history of modern German literature at the University of Munich, and official reader to King Ludwig II of Bavaria; Martha's uncle*

**62    Members of the Bernays family**

Years ago Hamburg and Altona formed one Jewish community, later they separated; until the Reform movement came to Germany, instruction was carried out by inferior teachers. Then it was realized that something had to be done, and a certain Bernays was called and chosen to be "Chacham."[1] This man has educated us all.—The old Jew[2] was about to embark on his achievements, but I was more interested in Bernays the man. Was he from Hamburg? No, he came from Würzburg, where he had studied at Napoleon's expense. [ . . . ] Did you know his family? "Me? I grew up with the sons." I now remembered two names, Michael Bernays in Munich, Jacob Bernays[3] in Bonn. That's they, he confirmed, and there was also a third son,[4] who lived in Vienna [ . . . ]. Glory to the memory of him who presented me with my Marty! [ . . . ] in this method of teaching lay enormous progress, a kind of education of mankind in Lessing's sense. Religion was no longer treated as a rigid dogma, it became an object of reflection for the satisfaction of cultivated artistic taste and of intensified logical efforts, and the teacher of Hamburg recommended it finally not because it happened to exist and had been declared holy, but because he was pleased by the deeper meaning which he found in it or which he projected into it. [ . . . ] And as for us, this is what I believe: even if the form wherein the old Jews were happy no longer offers us any shelter, something of the core, of the essence of this meaningful and life-affirming Judaism will not be absent from our home.
*Letter to Martha Bernays, July 23, 1882*

**63  Emmeline Bernays,
Freud's mother-in-law**

[ . . . ] I see her as a person of
great mental and moral power
standing in our midst, capable
of high accomplishments,
without a trace of the absurd
weaknesses of old women, but
there is no denying that she is
taking a line against us all, like
an old man. Because her charm
and vitality have lasted so
long, she still demands in
return her full share of life—
not the share of old age—and
expects to be the centre, the
ruler, an end in herself. [ . . . ] '
she wants to move to
Hamburg[1] at the behest of
some extraordinary whim,
oblivious of the fact that by so
doing she would be separating
[ . . . ] Martha and myself for
years to come. This certainly
isn't very noble-minded, nor
is it downright wicked; it is
simply the claim of age, the
lack of consideration of
energetic old age, an
expression of the eternal
conflict between age and youth
which exists in every family, in
which no member wants to
make any sacrifice and each
one wants a free rein to go his
own way.
*Letter to Minna Bernays,
February 21, 1883*

*Emmeline Bernays, née Philipp,
1830-1910*

*Minna Bernays, 1865-1941, Martha's sister, who, after her fiancé's death,[1] remained unmarried, lived with Freud's family from 1908 on.*

*Ignaz Schönberg, 1856-1886, Sanskrit scholar, Minna's fiancé*

## 64 Minna Bernays and Ignaz Schönberg

And now that the house is secure[2] we can think about the things that will adorn its rooms; and among them I count a sincere, warm, unequivocal friendship with you. Not only because you are Martha's only sister, whom she loves deeply and whom I could not neglect without harm; I believe that there is in our own natures enough reason to expect joy and profit from faithful companionship.
*Letter to Minna Bernays, January 22, 1883*

I see him [Ignaz Schönberg] now upon a road which I myself have had to abandon;[3] I hope he will not be faced with such a necessity. The first time one penetrates a little more deeply into science, the dawning of the first successes, the transition from the schoolboy to the independent worker and researcher, discovering for the first time his strength and the intellectual road before him; these are experiences which bring lasting enrichment, and in which a friend too may rejoice.
*Letter to Minna Bernays, January 22, 1883*

## 65 Freud's mother

My mother is a fragile woman both physically and spiritually, but I offer her the most sincere apologies in case I have not done justice to her. I do not know one action of hers in which she has followed her own moods or interests against the interests or happiness of one of her children.
*Letter to Martha Bernays, July 23, 1884*

**66   The Zwinger in Dresden**
I believe I acquired there a
lasting benefit, for until now I
have always suspected it to be
a silent understanding among
people who don't have much
to do, to rave about pictures
painted by the famous masters.
Here I rid myself of this
barbaric notion and myself
began to admire.
*Letter to Martha Bernays,*
*December 20, 1883*

*Freud saw the two following*
*pictures in the Zwinger gallery.*

**67   Madonna of Bürgermeister**
**Meyer of Basel, after Hans**
**Holbein**
Do you know this picture?
Kneeling in front of the
Madonna are several ugly
women and an unattractive
little girl, to the left a man with
a monk's face, holding a boy.
The Madonna holds a boy in
her arms and gazes down on
the worshippers with such a
holy expression. I was annoyed
by the ordinary ugly human
faces, but learned later that
they were the family portraits
of the Mayor of X., who had
commissioned the painting.[1]
Even the sick misshapen child
whom the Madonna holds in
her arms is not meant to be
the Christ child, rather the
wretched son of the Mayor,
whom the picture was
supposed to cure. The
Madonna herself is not exactly
beautiful, the eyes protrude,
the nose is long and narrow,
but she is a true queen of
Heaven such as the pious
German mind dreams of.
I began to understand
something about this
Madonna.
*Letter to Martha Bernays,*
*December 20, 1883*

**68   The Tribute Money, by**
**Titian, called by Freud "The**
**Maundy Money"**
But the picture that really
captivated me was the
"Maundy Money," by Titian,
which of course I knew already
but to which I had never paid
any special attention. This
head of Christ [ . . . ] is the
only one that enables even
people like ourselves to
imagine that such a person did
exist. [ . . . ] And nothing
divine about it, just a noble
human countenance, far
from beautiful, yet full of
seriousness, intensity,
profound thought, and deep
inner passion; if these qualities
do not exist in this picture,
then there is no such thing as
physiognomy. I would love to
have gone away with it, but
there were too many people
about. English ladies making
copies, English ladies sitting
about and whispering. English
ladies wandering about and
gazing. So I went away with a
full heart.
*Letter to Martha Bernays,*
*December 20, 1883*

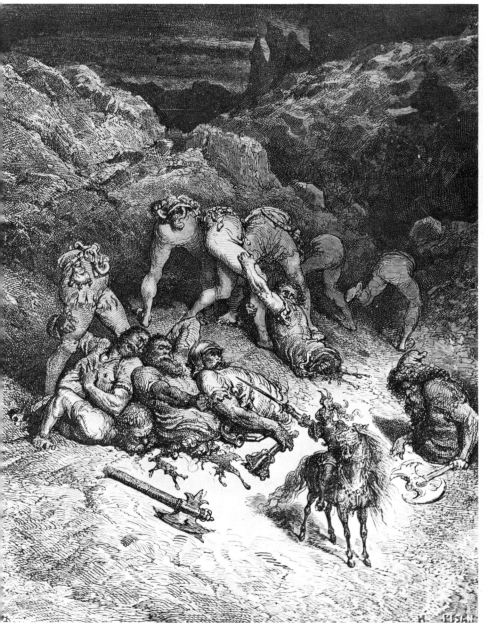

**9   Illustration by Doré to
Cervantes' *Don Quixote***

have just spent two hours—
t's now midnight—reading
*Don Quixote*, and have really
revelled in it. [ . . . ] none of
his is very profound, but it is
pervaded by the most serene
harm imaginable. [ . . . ] And
hen Doré's illustrations; they
re superb only when the artist
pproaches his subject from
he fantastic angle: when for
nstance he picks out a few
vords of the tavern-keeper's
vife to show how a wretched
ttle knight has cut in half six
iants with one blow of his
word, the lower halves of the
odies still standing while the
pper halves roll in the dust.
his picture is really of a
narvellous absurdity and a
plendid contribution towards

dispelling all the romantic
nonsense about chivalry.
*Letter to Martha Bernays,
August 23, 1883*

**70   Gustave Flaubert**
[ . . . ] and now on top of it all
came this book which in the
most condensed fashion and
with unsurpassable vividness
throws at one's head all the
dross of the world: for it calls
up not only the great problems
of knowledge (*Erkenntis*), but
the real riddles of life, all the
conflicts of feelings and
impulses; and it confirms the
awareness of our perplexity in
the mysteriousness that reigns
everywhere. These questions, it
is true, are always there, and
one should always be thinking
of them. What one does,
however is to confine oneself to
a narrow aim every hour and
every day and gets used to the
idea that to concern oneself
with these enigmas is the task
of a special hour, in the belief
that they exist only in those
special hours. Then they
suddenly assail one in the
morning and rob one of one's
composure and one's spirits.
[ . . . ] What impresses one
above everything is the
vividness of the hallucinations,
the way in which the sense
impressions surge up,
transform themselves [ . . . ].
One understands it better when
one knows that Flaubert was
an epileptic and given to
hallucinations himself.
*Letter to Martha Bernays,
July 26, 1883*

*Freud is reporting on his
reading of Flaubert's* La
Tentation de Saint-Antoine
(*1874*).

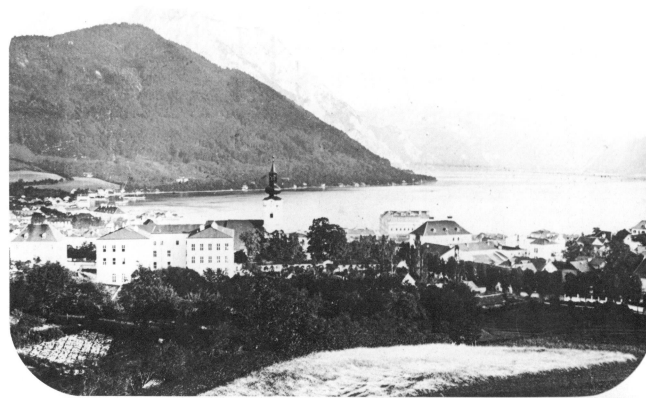

**71   Gmunden in the Salzkammergut**

It was a glorious morning [ . . . ]. It is an immense pleasure to explore new country for the first time. First of all [ . . . ] I looked out of the window and let the beautiful picture sink deep into my mind. The deep dark green lake, stretching far away into the distance, so that if you look at it lengthways you can't see the other end; if you look across it at the narrowest point, you can see two mountains, the first sloping more gently down, so that a few isolated villas can lie at its foot—the Grünberg, so called from the trees that cover it, giving it the same dark green colour as the lake. And next to it, dominating the whole picture, the huge, almost treeless and thus more sharply outlined crags of the Traunstein, which plunges almost vertically into the lake from a height of five thousand feet.
*Letter to Martha Bernays, July 26, 1883*

*Freud bought this picture for his fiancée during his first stay in Gmunden as the guest of Josef and Mathilde Breuer.*

**72   Josef and Mathilde Breuer**

When I think about my relationship with you and your wife I realize that I owe you thanks especially for your good opinion of me, which raises me high above my present situation; in giving it, you will either be moving out ahead of the others, or even remaining a lone voice.
*Letter to Josef Breuer, January 16, 1884*

*Josef Breuer, 1842-1925, a Viennese physiologist and internist, had been, like Freud, a pupil of Ernst Wilhelm von Brücke's. He was not only a highly esteemed general practitioner, but also an outstanding theoretical and experimental physiologist. His discoveries include the autonomic control of respiration and the function of the semicircular canals in the labyrinth of the ear as organ of balance. For many years Breuer was Freud's fatherly friend and mentor. Later he played a decisive part in the origins of psychoanalysis.*[1]

*Mathilde Breuer, 1846-1931*

### 3  The General Hospital, Vienna

The turning point came in 1882, when my teacher,[1] for whom I felt the highest possible esteem, corrected my father's generous improvidence by strongly advising me, in view of my bad financial position, to abandon my theoretical career. I followed his advice, left the physiological laboratory and entered the General Hospital as a *Aspirant* (clinical assistant). [ . . . ] In complete contrast to the diffuse character of my studies during my earlier years at the University, I was now developing an inclination to concentrate my work exclusively upon a single subject or problem.
*An Autobiographical Study*

Now let me tell you some things that we are familiar with in all the wards. Would you believe it, there is no gas installed in any of the—non-clinical—rooms in the hospital, so that in the long winter evenings the patients have to lie in the dark, and the doctor makes his rounds [ . . . ] and even operates in utter darkness, lit by a wax candle. And would you believe, what is more, that there are no polished floors or carpets, and even where ten out of every twenty patients have serious lung diseases, the place is swept out once a day, and the whole room is then enveloped in clouds of dust? That is what the humanity of our time is like. It's true that the poor devils have a bed and more care than they have ever had in their lives, but haven't they, as sick people, a right to more of what society has denied them through no fault of theirs, just because of its own mismanagement? And how much would it cost to buy the equipment we need to let these worn-out, hopeless wretches live like human beings for a little while, in comparison with what we squander on the inanities of our European armies?
*Letter to Martha Bernays, January 2, 1884*

*In his work in the various wards of the General Hospital Freud was especially concerned to acquire the practical medical knowledge he needed to set up his own practice.*

*Courtyard of the General Hospital*

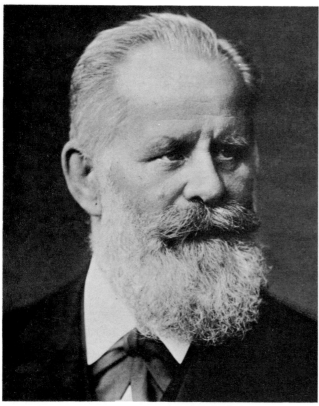
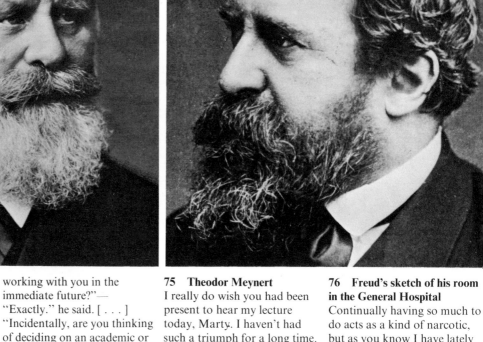

### 74   Hermann Nothnagel

[ . . . ] should I report on the outsome of my visit to Prof. Nothnagel? [ . . . ] It gives one quite a turn to be in the presence of a man who has so much power over us, and over whom we have none. [ . . . ] A germanic cave-man. Completely fair hair, head, cheeks, neck, eyebrows, all covered with hair and hardly any difference in color between skin and hair. Two enormous warts, one on the cheek and one on the bridge of the nose; no great beauty, but certainly unusual. Outside, I had felt a bit shaky, but once inside, as usual in "battle," I felt calm. [ . . . ] "What can I do for you, Herr Doktor?" [ . . . ] "It is known that you're about to engage an assistant, and it is also said that before long you will have a new job to offer. I also understand that you set great store by scientific research. I have done a certain amount of scientific research, but at the moment I have no opportunity to continue, so I thought it advisable to present myself as an applicant." [ . . . ] "I won't conceal from you that several people have applied for this job, and as a result I can't raise any hopes. It wouldn't be fair. [ . . . ]" [ . . . ] "If I understand you correctly then, I am to act as though there won't be any hope of my working with you in the immediate future?"—"Exactly." he said. [ . . . ] "Incidentally, are you thinking of deciding on an academic or a practical career?"—"My inclinations and my past experience point towards the former, but I've got to—"— "Of course, first you've got to live. Well, I'll keep you in mind."[1]

*Letter to Martha Bernays, October 5, 1882*

*Hermann Nothnagel, 1841-1905, professor of internal medicine at the University of Vienna; he concentrated on the physiology and pathology of the nervous system, the action of the heart, and the digestive organs, and edited the* Handbuch der speciellen Pathologie und Therapie.[2] *In 1882/83 Freud worked for a few months as clinical assistant in his clinic.*

### 75   Theodor Meynert

I really do wish you had been present to hear my lecture today, Marty. I haven't had such a triumph for a long time. Just imagine your timid lover, confronted by the severe Meynert and an assembly of psychiatrists and several colleagues [ . . . ]. Imagine him beginning with allusions, unable to control his voice, then drawing on the blackboard, in the middle of it all managing to make a joke at which the audience bursts out laughing! The moments in which he is afraid of getting stuck, each time fortunately concealed, become fewer, he slides into the waters of discussion where he sails about for a full hour [ . . . ].

*Letter to Martha Bernays, February 14, 1884*

*Theodor Meynert, 1833-1892, professor of psychiatry at the University of Vienna. He was the leading representative of the comparative anatomical school of brain research, and founded its biogenetic method as well as the cytoarchitectonics of the cerebral cortex. His aim was to place psychiatry on an anatomical basis. Freud worked at Meynert's psychiatric clinic in 1883 for about five months.[1]*

### 76   Freud's sketch of his room in the General Hospital

Continually having so much to do acts as a kind of narcotic, but as you know I have lately been looking for something to rescue me from my great emotional and excitable state. Now I have it. It seems as though the waves of the great world do not lap against my door, at other times I have to fight against the sensation of being a monk in his cell, as described by Scheffel.[1]

*Letter to Martha Bernays, October 9, 1883*

*From May 1883 Freud lived in Meynert's psychiatric clinic, leaving his parents' home for the first time. On October 1, 1883, he moved to the dermatological department of the General Hospital. In a letter to Martha dated October 5, 1883, he described and sketched his new room and its furniture. Translation in the notes*

Animalische Seite

kleiner Bücherkasten — Schreibtisch darüber die Bilder u. Kaulbach — Grosser Bücherkasten

Bett — unabhängigkeits erklärung

Tisch — Wasch tisch — Matten

Vegetative Seite

*[Handwritten prose follows — largely illegible.]*

**77   Nathan Weiss**

[ . . . ] I have just returned from the funeral of my friend Nathan Weiss. On the 13th, at 2 P.M., he hanged himself in a public bath in the Landstrasse. [ . . . ] his death was by no means an accident, rather it was a logical outcome of his temperament; his good and bad qualities had combined to bring about his downfall; his life was as though composed by a writer of fiction, and this catastrophe the inevitable end.
*Letter to Martha Bernays, September 16, 1883*[1]

*Nathan Weiss, 1851-1883, a colleague of Freud's at the General Hospital. Shortly before his suicide he became head of the department of electrotherapy and neuropathology. In 1881 he had published a study on tetany.*

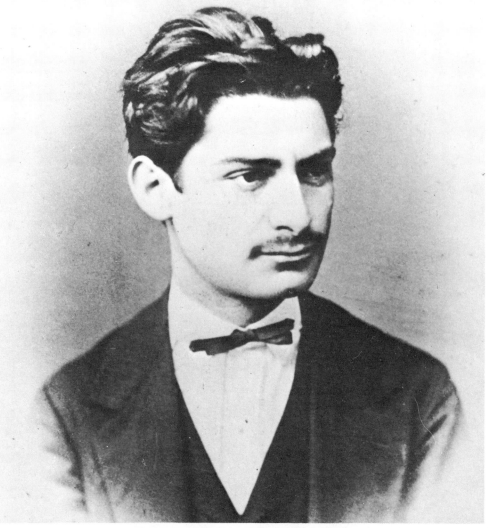

**78   Article on a new method of studying the course of the fibers in the central nervous system, 1884**

If fine sections of the central organ, hardened in chromate, are treated with gold chloride, a strong solution of soda and a 10 = solution of calcium iodide, a red to blue stain is obtained which affects either the medullary sheaths or only the axis cylinders. The method is no more reliable than other methods of gold staining.
*Abstracts of the Scientific Writings of Dr. Sigm. Freud, 1877-1897*

Wöchentlich erscheinen 1—2 Bogen; am Schlusse des Jahrgangs Titel, Namen- und Sachregister.

# Centralblatt

### für die

# medicinischen Wissenschaften.

Redigirt von

**Prof. Dr. H. Kronecker,**
Berlin (NW.), Dorotheenstr. 35.

und

**Prof. Dr. H. Senator,**
Berlin (NW.), Bauhofstr. 7 (am Hegelplatz).

Preis des Jahrganges 20 Mark; zu beziehen durch alle Buchhandlungen und Postanstalten.

**1884.**          **15. März.**          **No. 11.**

## Eine neue Methode zum Studium des Faserverlaufs im Centralnervensystem.

### Von Dr. Sigm. Freud, Secundärarzt im Wiener Allgemeinen Krankenhause.

Anknüpfend an eine Vorschrift FLECHSIG's in dem bekannten Werke: „Die Leitungsbahnen im Gehirn und Rückenmark des Menschen etc." empfehle ich das folgende Verfahren zur Darstellung der Nervenfasern auf Schnitten des nervösen Centralorganes. Feine Schnitte des am besten in ERLICKI'scher Flüssigkeit erhärteten Präparates werden in destillirtem Wasser von dem Alkohol, mit wel-

**79 Facsimile of Freud's curriculum vitae, 1885**
[ . . . ] one more word about the *Dozentur*. There is no salary attached to it, but two kinds of advantages. First the right (actually the only duty) to give lectures on which, if they are well attended [ . . . ], I could manage to live [ . . . ]. Secondly, one rises to a higher social level in the medical world and in the eyes of the public, has more prospects not only of getting the patients but of better paying ones—in short, it helps one to build up a certain reputation. Admittedly, there are also *Dozenten* without patients and in spite of the fair success of my labours our whole future does indeed still look rather dark.
*Letter to Martha Bernays, March 29, 1884*

*Freud wrote this* curriculum vitae *(résumé) when applying for a university lectureship.*

*Translation in the notes*

*[Handwritten testimonial text in German, dated "Wien 28. Februar 1885", with signatures below and a circular university stamp reading "FACULTÄT DER UNIVERSITÄT WIEN"]*

**80   Extract from Ernst Wilhelm von Brücke's[1] testimonial in support of Freud's application for admission as university lecturer**

*Translation in the notes*

**81   Confirmation of lectureship**
In the spring of 1885 I was appointed Lecturer (*Dozent*) in Neuropathology on the ground of my histological and clinical publications.
*An Autobiographical Study*

*Translation in the notes*

**82   Freud, about 1885**
I consider it a great misfortune that Nature has not granted me that indefinite something which attracts people. I believe it is this lack more than any other which has deprived me of a rosy existence. It has taken me so long to win my friends. I have had to struggle so long for my precious girl, and each time I meet someone I realize that an impulse, which defies analysis, leads that person to underestimate me.
*Letter to Martha Bernays, January 27, 1886*

*[Handwritten document fragments with signatures in lower right portion]*

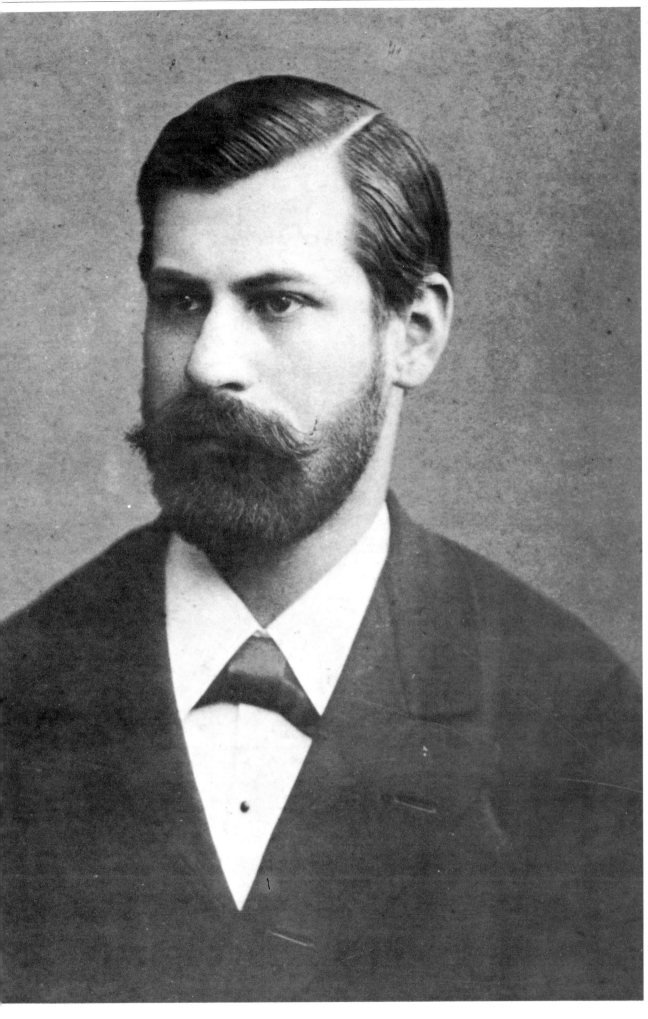

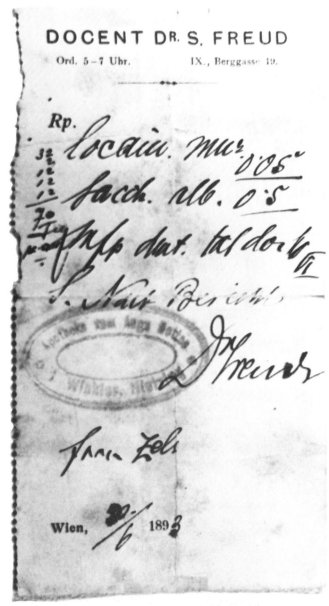

### 84   Cocaine package by Merck, about 1885

A side interest, though it was a deep one, had led me in 1884 to obtain from Merck some of what was then the little-known alkaloid cocaine and to study its physiological action. While I was in the middle of this work, an opportunity arose for making a journey to visit my *fiancée* [ . . . ] I hastily wound up my investigation of cocaine and contented myself in my monograph on the subject with prophesying that further uses for it would soon be found. I suggested, however, to my friend Königstein,[1] the ophthalmologist, that he should investigate the question of how far the anaesthetizing properties of cocaine were applicable in diseases of the eye. When I returned from my holiday I found out that not he, but another of my friends, Carl Koller[2] [ . . . ] whom I had also spoken to about cocaine, had made the decisive experiments upon animals' eyes and had demonstrated them at the Ophthalmological Congress at Heidelberg. Koller is therefore rightly regarded as the discoverer of local anaesthesia by cocaine, which has become so important in minor surgery; but I bore my *fiancée* no grudge for the interruption.
*An Autobiographical Study*

### 85   Carl Koller

*Carl Koller, 1857-1944, a student friend of Freud's and a important ophthalmologist*

### 86   Title page of *On Coca*, 1885

I have carried out experiment and studied, in myself and others, the effect of coca on t healthy human body [ . . . ]. The feeling of excitement which accompanies stimulus by alcohol is completely lacking; the characteristic urg for immediate activity which alcohol produces is also absent. One senses an increas of self-control and feels more vigorous and more capable of work; on the other hand, if on works, one misses that heightening of the mental powers which alcohol, tea, or coffee induce. One is simply normal, and soon finds it difficult to believe that one is under the influence of any dr at all. This gives the impressi that the mood induced by coc in such doses is due not so much to direct stimulation as to the disappearance of elements in one's general stat of well-being which cause depression. One may perhaps assume that the euphoria resulting from good health is also nothing more than the normal condition of a well-nourished cerebral cortex which "is not conscious" of t organs of the body to which i belongs.
*On Coca*[1]

### 83   Prescription for cocaine

I had been the first to recommend the use of cocaine, in 1885, and this recommendation had brought serious reproaches down on me. The misuse of that drug had hastened the death of a dear friend[1] of mine. This had been before 1895.
*The Interpretation of Dreams*

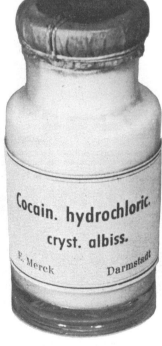

*Heil-Anstalt in Ober-Döbling.*
Hauptgebäude.

# ÜBER COCA.

Von

DR. SIGM. FREUD

Secundararzt im k. k. Allgemeinen Krankenhause
in Wien.

---

*Neu durchgesehener und vermehrter Separat-Abdruck aus dem
„Centralblatt für die gesammte Therapie".*

---

WIEN, 1885.

VERLAG VON MORITZ PERLES

Stadt, Bauernmarkt Nr. 11.

**87   Sanatorium in Oberdöbling**
Have you ever seen this Sanatorium? Do you remember the lovely park at the end of the Hirschen Strasse which continues towards Grinzing where the road curves? On a little hill in this park stands the Sanatorium [ . . . ]. I arrived here yesterday at 8 A.M. with a walking stick for luggage and became a member of this very mixed community. [ . . . ] There are 60 patients in the house, mental cases of every shade from light feeble-mindedness, which the layman wouldn't detect, to the final stages of withdrawal. The medical treatment is of course negligible, confined to their secondary surgical and internal complaints; the rest consists of supervision, nursing, diet, and non-interference. The kitchen of course is in the [big] house. The mildest cases lunch with the director, the doctor and the inspector. Needless to say, they are all rich people; counts, countesses, barons, etc. The *pièces de résistance* are two Highnesses, Prince S. and Prince M. The latter, as you may remember, is a son of Marie Louise, wife of Napoleon, and thus, like our Emperor, a grandson of Emperor Franz. You cannot imagine how dilapidated these princes and counts look, although they are not actually feebleminded, rather a mixture of feebleminded and eccentric.
*Letter to Martha Bernays, June 8, 1885*

*For a few weeks in June 1885 Freud acted as* locum tenens *in this private hospital, near Vienna, for patients with emotional and nervous disorders.*

**88 Facsimile of a letter to Martha when Freud was awarded the travel grant for his visit to Paris and Berlin, 1885**
Saturday, June 20, 1885.
Evening
Princess, my little princess
Oh, how wonderful it will be!
I am coming with money and staying a long time and bringing something beautiful for you and then go on to Paris and become a great scholar and then come back to Vienna with a huge, enormous halo, and then we will soon get married, and I will cure all the incurable nervous cases and through you I shall be healthy and I will go on kissing you till you are strong and gay and happy—and "if they haven't died, they are still alive today."
*Translation*

*This grant, awarded to Freud for Autumn 1885 and Spring 1886, was intended to finance study trips, each of six months' duration; candidates could be proposed to the Academic Senate of the University by the individual Faculties in turn. Freud wanted to continue his researches on the anatomy of*
*the brain, particularly of children's brains, both at the Salpêtrière, Jean-Martin Charcot's Paris clinic, and in Berlin.*

**89 The engaged couple**
If the energy I feel within me remains with me, we may yet leave behind us some traces of our complicated existence.
*Letter to Martha Bernays, June 26, 1885*

*Before going to Paris, Freud spent forty days with his fiancée at Wandsbek. The photograph was taken during this visit.*

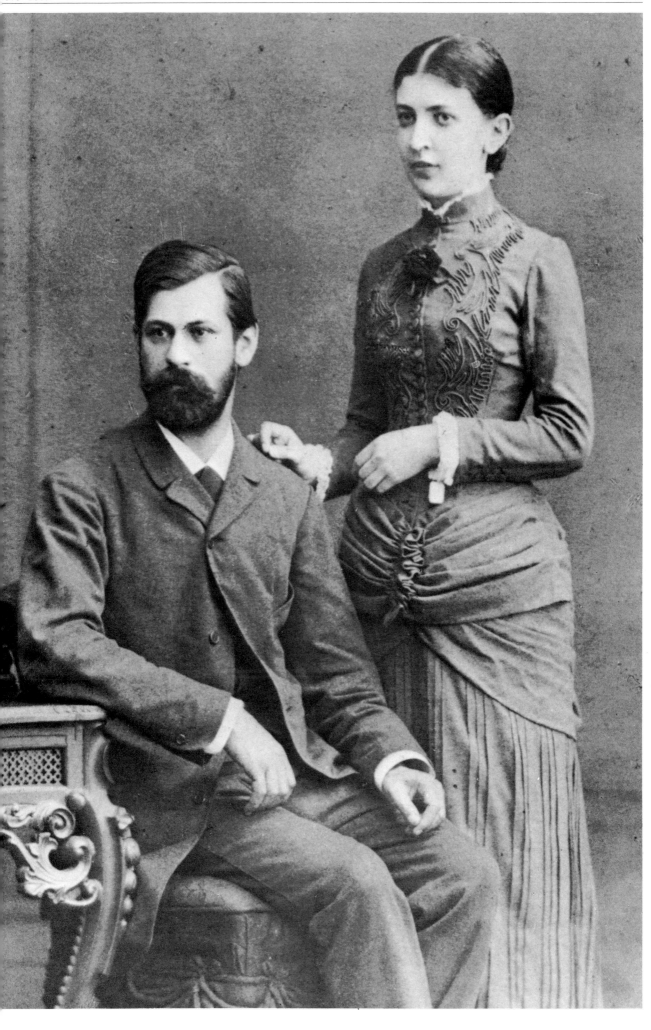

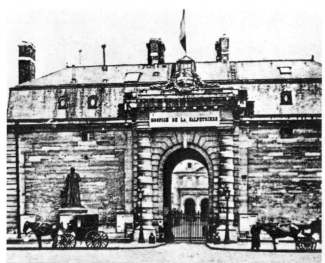

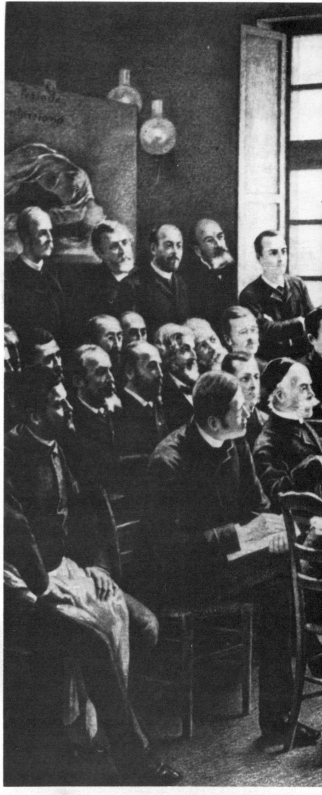

## 90  The Salpêtrière

You are right in thinking that Paris means a new beginning to my life. I have found Charcot there, a teacher as I have always imagined him, I've learnt to observe clinically as far as I am capable of it, and have brought away with me a great deal of positive knowledge.
*Letter to Carl Koller, October 13, 1886*

Charcot, who is one of the greatest of physicians and a man whose common sense borders on genius, is simply wrecking all my aims and opinions. I sometimes come out of his lectures as from out of Notre-Dame, with an entirely new idea about perfection. But he exhausts me; when I come away from him I no longer have any desire to work at my own silly things [ . . . ]. My brain is sated as after an evening in the theater. Whether the seed will ever bear any fruit, I don't know; but what I do know is that no other human being has ever affected me in the same way.
*Letter to Martha Bernays, November 24, 1885*

*The Salpêtrière[1] clinic had won wide renown through the neuroanatomical and, in particular, the psycho-pathological, achievements of its director.*

## 91  Charcot demonstrating a case of hysteria

On Tuesdays Charcot held his *"consultation externe,"* at which his assistants brought before him for examination the typical or puzzling cases among the very large number attending the out-patient department. It was sometimes discouraging when the great man allowed some of these cases, to use his own expression, to sink back "into the chaos of a still unrevealed nosography"; but others gave him the opportunity of using them as a peg for the most instructive remarks on the greatest variety of topics in neuropathology. [ . . . ] He seemed, as it were, to be working with us, to be thinking aloud and to be expecting to have objections raised by his pupils. Anyone who ventured might put in a word in the discussion and no comment was left unnoticed by the great man.
*Report on my Studies in Paris and Berlin*

*This picture, painted by André Brouillet, hung in Freud's consulting room in Vienna, and later in London.*

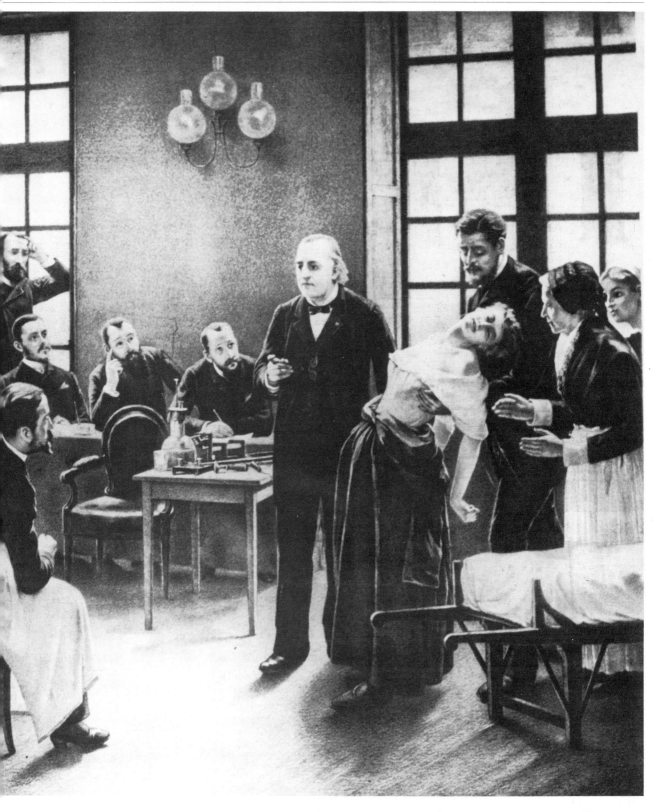

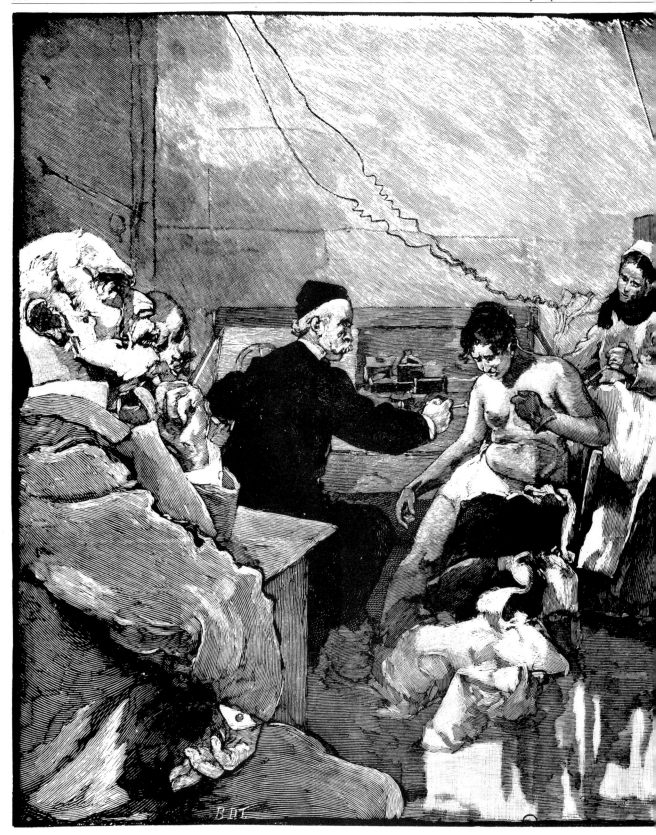

**92    Electro-diagnostic
treatment in the Salpêtrière**

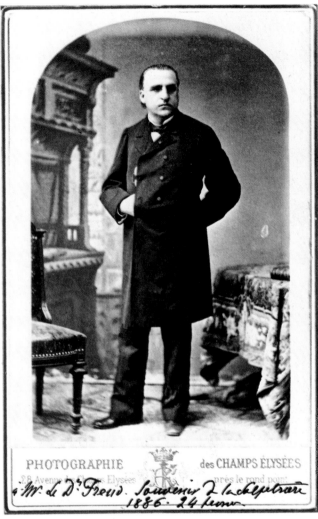

**93 Jean-Martin Charcot**

At 10 o'clock M. Charcot arrived, a tall man of 58 [ . . . ] with dark, strangely soft eyes (or rather one is, the other is expressionless and has an inward cast), long wisps of hair stuck behind his ears, clean shaven, very expressive features with full protruding lips—in short, like a worldly priest from whom one expects a ready wit and an appreciation of good living.
*Letter to Martha Bernays, October 21, 1885*

He was not a reflective man, not a thinker: he had the nature of an artist—he was, as he himself said, a "*visuel*," a man who sees. Here is what he himself told us about his method of working. He used to look again and again at the things he did not understand, to deepen his impression of them day by day, till suddenly an understanding of them dawned on him. [ . . . ] He might be heard to say that the greatest satisfaction a man could have was to see something new—that is, to recognize it as new; and he remarked again and again on the difficulty and value of this kind of "seeing."
*Charcot*

*Jean-Martin Charcot, 1825-1893, professor of pathological anatomy at the Collège de France and director of the Salpêtrière. Through association with Charcot, and through the observation of the phenomena of hysteria and hypnotism which he arranged, Freud's scientific interest gradually detached itself from the anatomy of the nervous system, and, with a fundamental change of direction, became orientated towards questions of psychopathology.*

Neue Vorlesungen

über die

# Krankheiten des Nervensystems

insbesondere über Hysterie.

Von

J. M. CHARCOT.

Autorisirte deutsche Ausgabe

von

D<sup>r</sup>. SIGM. FREUD,
Docent für Nervenkrankheiten an der k. k. Universität in Wien.

Mit 59 Abbildungen.

LEIPZIG UND WIEN.
TOEPLITZ & DEUTICKE.
1886.

**94   Freud's translation of Charcot's lectures, 1886**
When I heard that Charcot was intending to bring out a fresh collection of his lectures, I offered to make a German translation of it; and thanks to this undertaking I came into closer personal contact with Professor Charcot and was also able to prolong my stay in Paris beyond the period covered by my Travelling Bursary.
*Report on my Studies in Paris and Berlin*

**95   Pages from the translation of Charcot's lectures**

*The drawings show positions during an attack of* grande hystérie.

— 222 —

absonderlichsten Lagen und Stellungen ein, welche die von mir für diesen Theil der zweiten Periode vorgeschlagene Bezeichnung „Clownismus" vollauf rechtfertigen. Von Zeit zu Zeit halten die oben beschriebenen Contorsionen einen Moment ein, um der so charakteristischen Bogen- oder Gewölbestellung Platz zu machen. Bald ist es ein wirklicher Opisthotonus, bei dem die Lenden um ungefähr 50 Centimeter über das Bett erhoben sind und der Körper nur einerseits auf dem Scheitel, andererseits auf den Fersen ruht; andere Male ist es ein Bogen mit der Concavität nach oben: die Arme über der Brust gekreuzt, die Beine in der Luft, Haupt und Rumpf erhoben, während nur Lenden und Steiss dem Bette anliegen. Endlich noch andere Male ruht der Kranke, wenn er ein „Gewölbe" macht, dabei auf der rechten oder linken Seite. Dieser ganze

Fig. 28.

Theil des Anfalles ist bei G . . ., wenn ich mich so ausdrücken darf, wunderschön, und jede einzelne Stellung würde verdienen, durch das Verfahren der Instantanphotographie festgehalten zu werden. Ich gebe Ihnen nun die Photographien herum, welche Herr `Londe` auf diese Weise erhalten hat. Wie Sie sehen, lassen dieselben vom künstlerischen Standpunkte nichts zu wünschen übrig, sie sind aber überdies in hohem Grade lehrreich für uns. Sie zeigen uns, dass die Anfälle bei G . . ., was die Regelmässigkeit der einzelnen Perioden und den typischen Charakter der verschiedenen Stellungen anbelangt, nicht im Geringsten hinter jenen zurückstehen, die wir täglich an unseren classischesten Hysteroepileptischen weiblichen Geschlechtes zu beobachten Gelegenheit haben, und diese Aehnlichkeit verdient umsomehr hervorgehoben zu werden, als G . . . niemals in den Krankensaal, wo unsere

— 223 —

„femmes en attaques" untergebracht sind, gedrungen ist, man sich also bei ihm nicht auf den Einfluss der Nachahmung, dieser Art von psychischem Contagium, berufen kann.

Fig. 29.

Nur die Periode der Hallucinationen und leidenschaftlichen Stellungen fällt bei G . . . in der Regel weg. Wir haben blos einige Male beobachten können, dass gegen das Ende

Fig. 30.

des Anfalles hin seine Züge abwechselnd Entsetzen und Freude ausdrücken, während seine Hände, wie um nach einem Wesen seiner Einbildung zu greifen, in die Luft gestreckt sind.

**96   Charcot with his wife**
Madame [ . . . ] is small, rotund, vivacious, hair powdered white, amiable, in appearance not very distinguished. The wealth comes from her; Charcot started out quite poor; her father is rumored to be worth countless millions.
*Letter to Martha Bernays, January 20, 1886*

**97 Freud's lodgings in Paris**
I am staying in the Impasse Royer-Collard near the Pantheon and the Luxembourg, on the ground floor, very nice for 55 fr.
*Letter to Minna Bernays, October 18, 1885*

*The words on the plaque to the left of the entrance are: "Sigmund Freud, Créateur de la Psychanalyse, habita cette maison 1885-1886."*

**98 Notre-Dame**
My first impression on entering was a sensation I have never had before: "this is a church" [ . . . ]. I have never seen anything so movingly serious and sombre, quite unadorned and very narrow, which is no doubt partly responsible for the general impression. I really must read Victor Hugo's novel[1] here, for this is the place properly to understand it.
*Letter to Martha Bernays, November 19, 1885*

**99 The Paris Opera, about 1890**
I am under the full impact of Paris and, waxing very poetical, could compare it to a vast overdressed Sphinx who gobbles up every foreigner unable to solve her riddles. [ . . . ] the city and its inhabitants strike me as uncanny; the people seem to me of a different species from ourselves; I feel they are all possessed of a thousand demons; instead of "Monsieur" and "Voilà l'Écho de Paris" I heard them yelling "À la lanterne" and "À bas" this man and that. [ . . . ] They are people given to psychical epidemics, historical mass convulsions [ . . . ] As you realize, my heart is German provincial and it hasn't accompanied me here [ . . . ].
*Letter to Martha Bernays, December 3, 1885*

**100    The Louvre: Department of Assyrian and Egyptian antiquities**

I just had time for a fleeting glance at the Assyrian and Egyptian rooms, which I must visit again several times. There were Assyrian kings—tall as trees and holding lions for lapdogs in their arms, winged human animals with beautifully dressed hair, cuneiform inscriptions as clear as if they had been done yesterday, and then Egyptian bas-reliefs decorated in fiery colors, veritable colossi of kings, real sphinxes, a dreamlike world.
*Letter to Martha Bernays, October 19, 1885*

**101   Sarah Bernhardt as "Théodora"**

[ . . . ] I had been to the Porte St. Martin theater to see Sarah Bernhardt. I am still rather tired and ravaged by the heat and the blood-&-thunder melodrama which lasted from 8 to 12:30, but it was worth it. [ . . . ] I really cannot praise the play. Victorien Sardou's *Théodora* [ . . . ]. A pompous trifle [ . . . ]. But how this Sarah can act! After the first few words uttered in an intimate, endearing voice, I felt I had known her all my life. I have never seen an actress who surprised me so little; I at once believed everything about her. She was almost never off the stage. In the first scene she is seen giving audience lying on a "throne sofa" with a bored, arrogant expression [ . . . ].
*Letter to Martha Bernays, November 8, 1885*

*Sarah Bernhardt, 1843-1923*

**102   Fritz Kreisler at about ten years of age**

They wrote me from home that the wife of our family physician, Dr. Kreisler, is in Paris [ . . . ]. The unfortunate woman has a 10-year-old son who, after 2 years in the Vienna Conservatorium, won the great prize there and is said to be highly gifted. Now instead of secretly throttling the prodigy the wretched father, who is over-worked and has a house full of children, has sent the boy with his mother to Paris to study at the Conservatoire and try for another prize. Just imagine the expense, the separation, the dispersal of the household! [ . . . ] Little wonder that parents grow vain about their children, and even less that such children grow vain themselves. [ . . . ] The prodigy is pale, plain, but looks pretty intelligent.
*Letter to Martha Bernays, November 26, 1885*

*Fritz Kreisler, 1875-1962, the great violinist*

# Neurologisches Centralblatt.

Uebersicht der Leistungen auf dem Gebiete der Anatomie, Physiologie, Pathologie und Therapie des Nervensystemes einschliesslich der Geisteskrankheiten.

Herausgegeben von

## Professor Dr. E. Mendel
zu Berlin.

Fünfter                  Jahrgang.

Monatlich erscheinen zwei Nummern. Preis des Jahrganges 16 Mark. Zu beziehen durch alle Buchhandlungen des In- und Auslandes, die Postanstalten des Deutschen Reichs, sowie direct von der Verlagsbuchhandlung.

1886.          15. März.          No. 6.

## I. Originalmittheilungen.

## Ueber die Beziehung des Strickkörpers zum Hinterstrang und Hinterstrangskern nebst Bemerkungen über zwei Felder der Oblongata.

Von Dr. L. Darkschewitsch (Moskau) und Dr. Sigm. Freud, Privatdocent (Wien).

Die Ansichten der Hirnanatomen über den Zusammenhang zwischen Strickkörper oder unterem Kleinhirnschenkel und den Hintersträngen des Rückenmarks

**104 Adolf Baginsky**

What appeals to me more than the stones,[1] however, are the children in the clinic [ . . . ]. As long as their brains are free of disease, these little creatures are really charming and so touching when they suffer. I think I would find my way about in a children's practice in no time.
*Letter to Martha Bernays, March 10, 1886*

*Adolf Baginsky, 1843-1922, specialist in pediatrics in Berlin. It was in his clinic in March 1886, on his return journey from Paris, that Freud acquired experience with children suffering from nervous diseases.*

**103 "On the Relation of the Restiform Body to the Posterior Column and the Nucleus of the Posterior Column with Observations on the Two Fields of the Oblongata," 1886**
I am sitting beside my sick Russian friend [L. Darkschewitsch] telling him of a nice discovery which I made in Vienna and which I didn't publish because I was afraid there might be still more behind it. Whereupon he shows me his notes on precisely the same subject and tells me that he has divulged the result to a colleague and rival, who is going to use it in a publication—"No, dear friend," says I, "we will publish that together—and, what's more, at once." [ . . . ] Agreed.—The first day we spent 5½ hours together studying the slides by day- and lamp-light, searching and doubting endlessly till he fell back on the bed and I left with such a buzzing in my head [ . . . ]. The whole problem still seemed rather doubtful to me, but next day in the microscope I glimpsed a few auspicious things, got all excited, everything cleared up, and today we have all we want.
*Letter to Martha Bernays, January 17, 1886*

**105   Hall of the "Gesellschaft der Ärzte" (Medical Society), Vienna**

The duty devolved upon me of giving a report before the "Gesellschaft der Aerzte" (Medical Society) upon what I had seen and learnt with Charcot.[1] But I met with a bad reception. Persons of authority, such as the chairman (Bamberger, the physician), declared that what I said was incredible. Meynert challenged me to find some cases in Vienna similar to those which I had described and to present them before the Society. I tried to do so; but the senior physicians in whose departments I found any such cases refused to allow me to observe them or to work at them. One of them, an old surgeon, actually broke out with the exclamation: "But, my dear sir, how can you talk such

nonsense? *Hysteron* (sic) means the uterus. So how can a man be hysterical?" I objected in vain that what I wanted was not to have my diagnosis approved, but to have the case put at my disposal. At length, outside the hospital, I came upon a case of classical hysterical hemi-anaesthesia in a man, and demonstrated it[2] before the "Gesellschaft der Aerzte." This time I was applauded, but no further interest was taken in me. The impression that the high authorities had rejected my innovations remained unshaken; and, with my hysteria in men and my production of hysterical paralyses by suggestion, I found myself forced into the Opposition. As I was soon afterwards excluded from the laboratory of cerebral anatomy and for terms on end had nowhere to deliver my lectures, I withdrew from academic life and ceased to attend the learned societies.
*An Autobiographical Study*

**106   Reprint of the lecture on an hysterical man, 1886**

Gentlemen—When, on October 15, I had the honor of claiming your attention to a short report on Charcot's recent work in the field of male hysteria, I was challenged by my respected teacher, Hofrat Professor Meynert, to present before the society some cases in which the somatic indications of hysteria—the "hysterical stigmata" by which Charcot characterizes this neurosis—could be observed in a clearly marked form. I am meeting this challenge today— insufficiently, it is true, but so far as the clinical material at my disposal permits—by presenting before you an hysterical man, who exhibits the symptoms of hemi-anaesthesia to what may almost be described as the highest degree. Before beginning my demonstration, I will merely remark that I am far from thinking that what I am showing you is a rare or peculiar case. On the contrary, I regard it as a very ordinary case of frequent occurrence, though one which may often be overlooked.

*Translation of the first paragraph of the lecture*

will, wenn man lauter Rindenzerstörungen gleicher Art, alle eingetreten z. B. 30 Tage vor dem Tode, zur Verfügung hat, dann wird man noch lange nichts von der Gehirnphysiologie des Menschen erfahren. Die Frage ist, was kann man mit den heutigen Mitteln über die Physiologie der Gehirnrinde aussagen und wie gross ist die Wahrscheinlichkeit für die Richtigkeit der ausgesprochenen Thesen? Zur Beantwortung wesentlich auch der letzteren Frage sind meine Methoden ersonnen.

Hingegen haben Luciani und Seppilli ihre Lokalisationsresultate, die sich auf den Menschen beziehen, wieder einzelnen Krankheitsfällen und ihren Sektionen entnommen. Sie führen, wie das schon unzählige Male geschehen ist, eine Anzahl von Fällen an, in welchen ein gewisses Symptom da war, und in welchen sich diese oder jene Stelle der Gehirnrinde verletzt fand, obwohl ich seinerzeit gezeigt habe, dass das eine Methode ist, die zu den unsichersten Resultaten führt. Ich habe mir seinerzeit, um zu zeigen, wie unsicher diese Methode ist, den Scherz erlaubt und habe, obwohl niemals Jemand behauptet hat, dass im Gyrus angularis das motorische Gebiet für die obere Extremität ist, 21 Krankenfälle zusammengestellt, in welchen allen dieser Gyrus angularis verletzt war und Motilitätsstörungen der gegenüberliegenden oberen Extremität vorhanden waren. Man kann, wenn man fleissig ist, auch 20 Krankheitsfälle zusammenstellen, um zu beweisen, dass das motorische Gebiet für die obere Extremität im Stirnlappen liegt u. s. w. Damit kann man Alles beweisen, es handelt sich nur um Fleiss zur Zusammenstellung. Ich glaube, man hat jetzt bessere Methoden, diese Dinge zu erforschen und sollte diese alte Methode, wo eine andere anzuwenden ist, ruhen lassen.

(Fortsetzung folgt.)

## Beiträge zur Kasuistik der Hysterie.

Von Dr. SIGM. FREUD, Dozenten für Nervenkrankheiten in Wien.

### I.

#### Beobachtung einer hochgradigen Hemianästhesie bei einem hysterischen Manne. *)

Meine Herren! Als ich am 15. Oktober d. J. die Ehre hatte, Ihre Aufmerksamkeit für einen kurzen Bericht über Charcot's neuere Arbeiten auf dem Gebiete der männlichen Hysterie in Anspruch zu nehmen, erging an mich von Seiten meines verehrten Lehrers, des Herrn Hofrathes Prof. Meynert, die Aufforderung, ich möge doch solche Fälle der Gesellschaft vorstellen, an denen die somatischen Kennzeichen der Hysterie, die „hysterischen Stigmata", durch welche Charcot diese Neurose charakterisirt, in scharfer Ausprägung zu beobachten sind. Ich komme heute dieser Aufforderung nach — allerdings in ungenügender Weise, so weit eben das mir zufliessende Material an Kranken es gestattet — indem ich Ihnen einen hysterischen Mann zeige, welcher das Symptom der Hemianästhesie in nahezu höchstgradiger Ausbildung darbietet. Ich will nur, ehe ich die Demonstration beginne, bemerken, dass ich keineswegs glaube, Ihnen hiemit einen seltenen und absonderlichen Fall zu zeigen. Ich halte ihn vielmehr für einen sehr gemeinen und häufig vorkommenden, wenn er auch oft genug übersehen werden mag.

Ich verdanke den Kranken der Freundlichkeit des Herrn Kollegen v. Beregszászy, welcher ihn zur Bekräftigung seiner Diagnose in meine Ordination geschickt hat. Es ist der 29jährige Ciseleur August P., den Sie hier sehen; ein intelligenter Mann, der sich in der Hoffnung auf baldige Wiederherstellung bereitwillig meinen Untersuchungen dargeboten hat.

*) Vorgetragen in der k. k. Gesellschaft der Aerzte in Wien am 26. November 1886.

Gestatten Sie mir zunächst, Ihnen seine Familien- und Lebensgeschichte mitzutheilen. Der Vater des Kranken verstarb, 48 Jahre alt, an M. Brightii; er war Kellermeister, schwerer Potator und jähzornigen Charakters. Die Mutter ist im Alter von 46 Jahren an Tuberkulose gestorben, sie soll in früheren Jahren viel an Kopfschmerzen gelitten haben; von Krampfanfällen u. dergl. weiss der Kranke nichts zu berichten. Von diesem Elternpaare stammen sechs Söhne, von denen der erste einen unordentlichen Lebenswandel geführt hat, und an einer luëtischen Gehirnerkrankung zu Grunde gegangen ist. Der zweite Sohn hat für uns ein besonderes Interesse; er spielt eine Rolle in der Aetiologie der Erkrankung bei seinem Bruder und scheint auch selbst ein Hysteriker zu sein. Er hat nämlich unserem Kranken erzählt, dass er an Krampfanfällen gelitten hat; und ein eigenthümlicher Zufall liess mich heute einen Berliner Kollegen begegnen, der diesen Bruder in Berlin während einer Erkrankung behandelt, und die auch im dortigen Spitale bestätigte Diagnose einer Hysterie bei ihm gestellt hatte. Der dritte Sohn ist Militärflüchtling und seither verschollen, der vierte und fünfte sind im zarten Alter gestorben, und der letzte ist unser Kranker selbst.

Unser Kranker hat sich während seiner Kindheit normal entwickelt, niemals an Fraisen gelitten und die gewöhnlichen Kinderkrankheiten überstanden. In seinem 8. Lebensjahre hatte er das Unglück, auf der Strasse überfahren zu werden, erlitt eine Ruptur des rechten Trommelfells mit bleibender Störung des Gehörs am rechten Ohre, und verfiel in eine Krankheit von mehrmonatlicher Dauer, während welcher er häufig an Anfällen litt, deren Natur heute nicht mehr zu eruiren ist. Diese Anfälle hielten etwa zwei Jahre an. Seit diesem Unfalle datirt eine leichte geistige Hemmung, die der Kranke an seinem Fortschritt in der Schule bemerkt haben will, und eine Neigung zu Schwindelgefühlen, so oft er aus irgend einem Grunde unwohl war. Er absolvirte später die Normalschule, trat nach dem Tode seiner Eltern als Lehrling bei einem Ciseleur ein, und es spricht sehr zu Gunsten seines Charakters, dass er als Geselle zehn Jahre lang bei demselben Meister verblieben ist. Er schildert sich selbst als einen Menschen, dessen Gedanken einzig und allein auf Vervollkommnung in seinem Kunsthandwerke gerichtet waren, der zu diesem Zwecke viel las und zeichnete und allem Verkehre wie allen Vergnügungen entsagte. Er musste viel über sich und seinen Ehrgeiz nachdenken, gerieth dabei häufig in einen Zustand von aufgeregter Ideenflucht, bei welchem ihm um seine geistige Gesundheit bange wurde; sein Schlaf war häufig unruhig, seine Verdauung durch seine sitzende Lebensweise verlangsamt. An Herzklopfen leidet er seit neun Jahren, sonst aber war er gesund und in seiner Arbeit niemals gestört.

Seine gegenwärtige Erkrankung datirt seit etwa drei Jahren. Er gerieth damals mit seinem lüderlichen Bruder, welcher ihm die Rückzahlung einer geliehenen Summe verweigerte, in Streit; der Bruder drohte ihn zu erstechen und ging mit dem Messer auf ihn los. Darüber gerieth der Kranke in eine namenlose Angst, er verspürte ein Sausen im Kopfe, als ob ihm dieser zerspringen wolle, eilte nach Hause, ohne sich besinnen zu können, wie er dahin gekommen sei, und fiel vor seiner Thürschwelle bewusstlos zu Boden. Es wurde später berichtet, dass er durch zwei Stunden die heftigsten Zuckungen gehabt und dabei von der Szene mit seinem Bruder gesprochen habe. Als er erwachte, fühlte er sich sehr matt; er litt in den nächsten sechs Wochen an heftigem linksseitigem Kopfschmerze und Kopfdrucke, das Gefühl in seiner linken Körperhälfte kam ihm verändert vor, und seine Augen ermüdeten leicht bei der Arbeit, die er bald wieder aufnahm. So blieb sein Zustand mit einigen Schwankungen durch drei Jahre, bis vor sieben Wochen eine neue Aufregung eine Verschlimmerung herbeiführte. Der Kranke wurde von einer Frauensperson des Diebstahls beschuldigt, bekam heftiges Herzklopfen, war durch etwa 14 Tage so

1*

**107   Max Kassowitz**
Dr. Kassowitz, the head of an out-patient clinic for children's diseases, intends to expand the Institute into a polyclinic, create several departments, and put me in charge of the one for nervous diseases.
*Letter to Martha Bernays, July 11, 1885*

*Max Kassowitz, 1842-1913, professor of pediatrics at the University of Vienna*

**108   The Pediatric Institute**
There is no question of remuneration for a director of the department, which doesn't make the position less valuable. The consultations take place in a special room containing among other things electrical equipment; there will be one or two students to keep the records; the consultations are held 2 or 3 times a week, unpaid, but in return one has material and if one is a *Dozent* one can lecture on this material [ . . . ]. The chief advantages lie in having access to the material and in the reputation one can acquire in this way as a specialist.
*Letter to Martha Bernays, February 10, 1886*

*The building in the Steindlgasse 2 where Kassowitz's first public pediatric institute was housed. From 1886 to 1897 Freud was director of the neurological department. As a result of this work he published a series of important writings on neuropediatrics.[1]*

**109   Vienna I, Rathausstrasse 7**
On returning from Paris [ . . . ] I moved in here, despairing rather than hopeful. A rented room with service and a small, rapidly dwindling supply of cash. But I was luckier than I expected. I will not analyse what Breuer's help, Charcot's name and perhaps the understandable attraction of a novelty had to do with it, but in three and a half months I took 1100 fl. and decided that I could marry if things continued to improve in the same proportion. Then a series of events brought my marriage forward: the fact that the apartment could not be kept for us, my call-up for weapon training in Olmütz from 10th August to 10th September, certain family circumstances and so on [ . . . ].
*Letter to Carl Koller, October 13, 1886*

*In this house Freud opened his practice on April 25, 1886.*

**110   Freud at about thirty**
Do you really find my appearance so attractive? Well, this I very much doubt. I believe people see something alien in me and the reason for this is that in my youth I was never young and now that I am entering the age of maturity I cannot mature properly. There was a time when I was all ambition and eager to learn, when day after day I felt aggrieved that Nature in a benevolent mood hadn't stamped my face with that mark of genius which now and again she bestows on man. Now for a long time I have known that I am not a genius and cannot understand how I ever could have wanted to be one. I am not even very gifted; my whole capacity for work probably springs from my character and from the absence of outstanding intellectual weakness.
*Letter to Martha Bernays, February 2, 1886*

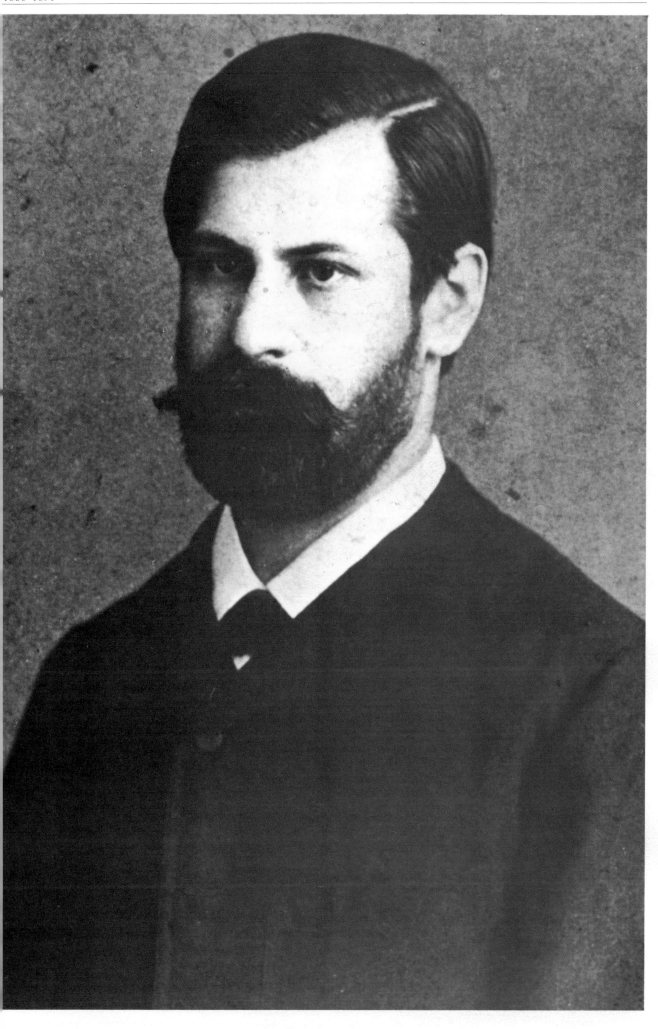

**111　List of qualifications for the medical officer, Reserve Militia, Dr. Sigmund Freud, 1886**

We continually play at war, once we even enacted the siege of a fortress, and I am acting the role of the medical officer doling out handbills showing gruesome injuries. While my battalion makes an assault, and I lie with my medical orderlies on some old stones, and a battle is being fought with blank cartridges, the General rides up as he did yesterday and says: "Men! Men! Where would you be if those things had been loaded? Not one of you would be alive." The only thing that makes Olmütz bearable is a citified café which has ice-creams, newspapers and good pastry. [ . . . ] The service, however, like everything else, suffers from the military atmosphere. When the two or three Generals—who keep reminding me of parrots, I can't help it but mammals just don't dress in such colors, with the exception of the reddish-blue mandrils' posteriors—whenever these Generals sit together any-where, a whole swarm of waiters buzzes around them to the exclusion of everyone else. Once in despair I was forced to indulge in some serious boasting. I seized one of these waiters by the coat-tails and shouted: "Look, I too may be a General one day, go and get me a glass of water."—It worked.

*Letter to Josef Breuer, September 1, 1886*

*Translation in the notes*

| 8 | Sprachkenntnisse | *[handwritten]* deutsch in Wort und Schrift vollkommen; französisch ziemlich gut; italienisch und ... ziemlich gut. |
|---|---|---|
| 9 | Geschicklichkeit in sei-nem Berufe und Kennt-niß des Sanitätsdien-stes, genießt Vertrau-en beim Militär und Civile | *[handwritten]* in seinem Berufe sehr geschickt, kennt die Vor-... und den ... ...; genießt großes Vertrauen beim Militär und im Civile. |
| 10 | Besondere außerberufliche Geschicklichkeiten | *[handwritten]* —/— |
| 11 | Eigenschaften des Gemüthes und Charakters | *[handwritten]* ... festen Charakter, heiter. |
| 12 | Eifer, Ordnung und Verläßlichkeit im Dienste | *[handwritten]* sehr eifrig ... Pflichtgefühl, hält Ordnung und ist im Dienste sehr verläßlich |
| 13 | Ob im Besitze der vorgeschriebenen Uniform und des Verbandzeuges | *[handwritten]* besitzt die vorgeschriebene Uniform und das ... |

| | | vor dem Feinde | *[handwritten]* nicht gedient. |
|---|---|---|---|
| 14 | | | |
| 15 | | gegen Vorgesetzte | *[handwritten]* gehorsam und offen ... bescheiden |
| 16 | Benehmen / dienstliches | gegen Gleichgestellte | *[handwritten]* freundlich |
| 17 | | gegen Untergebene | *[handwritten]* wohlwollend mit guter ... |
| 18 | | gegen Kranke | *[handwritten]* sehr fürsorglich und human |
| 19 | | außerdienstliches | *[handwritten]* sehr anständig und bescheiden mit guten Umgangsformen. |

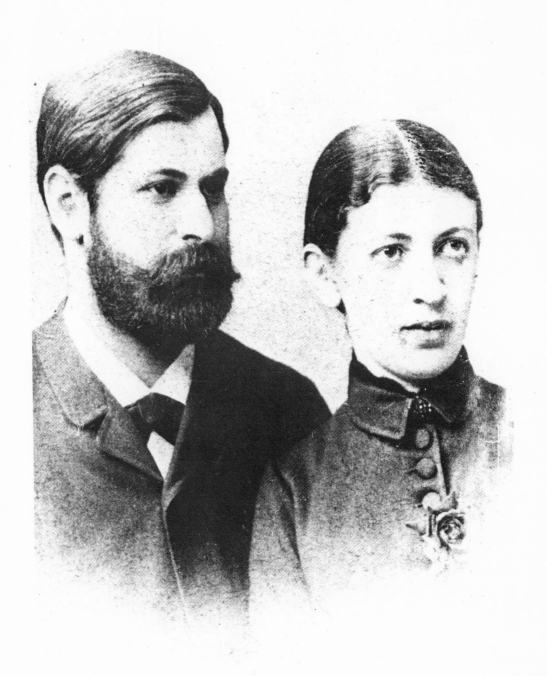

DOZENT D<sup>R.</sup> SIGM. FREUD

beehrt sich anzuzeigen, dass
er seit 1. Okt. d. J.

I., Maria Theresienstrasse 8
(k. Stiftungshaus)

wohnt und von 1 — 3<sup>h.</sup> ordinirt.

**112   Wedding photograph**
But if today were to be my last on earth and someone asked me how I had fared, he would be told by me that in spite of everything—poverty, long struggle for success, little favor amongst men, over-sensitiveness, nervousness and worries—I have nevertheless been happy simply because of the anticipation of one day having you to myself and of the certainty that you love me. [ . . . ] For a long, long time I have criticized you and picked you to pieces, and the result of it all is that I want nothing but to have you and have you just as you are.
*Letter to Martha Bernays, February 2, 1886*

*The wedding took place on September 14, 1886.*

**113   The "Stiftungshaus" ("Sühnhaus")**[1]
Anyway, I'm finding it all most strange: [ . . . ] my large apartment in the most beautiful house in Vienna, and my utter effrontery in getting married and setting myself up as a man who can do anything he likes; but the Bodensee is frozen over, and my happy heart is leaping gaily across it.
*Letter to Minna Bernays, August 25, 1886*

*The picture shows the façade on the Schottenring. Freud's living quarters and consulting rooms were on one floor at the rear of the "Sühnhaus," situated at Maria-Theresienstrasse 8, from July 1886 to August 1891.*

**114   Notice of the opening of the practice**
We arrived here on September 29th, and on October 4th we were already in a position to announce the opening of the practice. My little wife, with the help of her dowry and the wedding presents, has made a charming home. [ . . . ] Only one thing has not up to now gone as I would have wished: the practice. It's a completely new beginning, and a much harder one than the first, however perhaps things will soon begin to look up for us.
*Letter to Carl Koller, October 13, 1886*

**115   The first child**
Life goes on tolerably well
here, and our pretensions are
constantly abating. When our
little Mathilde chuckles we
think it is the most beautiful
thing that could happen to
us [ . . . ].
*Letter to Wilhelm Fliess,*
*May 28, 1888*

*Mathilde Freud, born 1887*

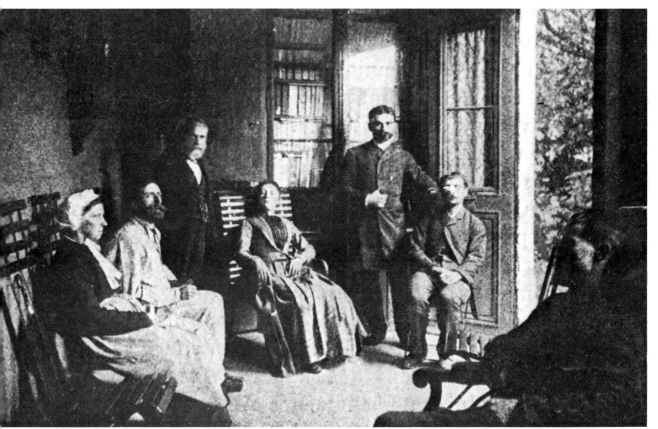

*Hippolyte Bernheim, 1837-1919, professor at the medical faculty in Nancy, whose works,* De la suggestion et de ses applications à la thérapeutique *and* Hypnotisme, suggestion, psychothérapie: études nouvelles, *Freud translated in 1888/89 and in 1892.*

*Auguste Ambroise Liébeault, 1823-1904, doctor in Nancy, was, with Bernheim, the leader of the so-called Nancy School, devoted particularly to the study of hypnosis and suggestion as treatment for hysterical phenomena.*

### 116  Nancy: Bernheim and Liébeault

*In Liébeault's waiting room*

With the idea of perfecting my hypnotic technique, I made a journey to Nancy in the summer of 1889 and spent several weeks there. I witnessed the moving spectacle of old Liébeault working among the poor women and children of the laboring classes. I was a spectator of Bernheim's astonishing experiments upon his hospital patients, and I received the profoundest impression of the possibility that there could be powerful mental processes which nevertheless remained hidden from the consciousness of men.
*An Autobiographical Study*

**117　Inscription to Freud on his birthday, by his father**[1]

My dear son Schlomo (Salomo)
in the seventh . . .[2] of your life the spirit of the Lord began[3] to move you [cf. Judges 13, 25] and said to you: Go, read in my Book that I have written, and there will be opened to you the sources of wisdom, of knowledge and understanding. See, the Book of Books, from which the wise men dug out their wisdom and the lawmakers learned law and justice. [cf. Numbers 21, 18]. You have looked upon the face of the Almighty [cf. Numbers 24, 4, 16] have heard and striven to climb upwards, and you flew upon the wings of the Spirit. [cf. Psalms 18, 10]. For a long time the Book has been hidden (kept safe) like the fragments of the Tables of the Law in the shrine of his

servant,[4] [yet] for the day on which you have completed your 35th year I have had it covered with a new leather binding and given it[5] the name: "Spring up, O well! Sing ye unto it!" [cf. Numbers 21, 17] and offer it to you for a remembrance and a memorial of love.
—From your father, who loves you with unending love—Jacob, son of Rabbi Sch. Freud.

In the capital city of Vienna 29 Nisan 5651, May 6, 1891. *Translation of the Hebrew dedication*

*Freud's father wrote this inscription in the family Bible, when he handed it over to his son on his 35th birthday.*

**118　Freud, 1891**

[ . . . ] a man like me cannot live without a hobby-horse, a consuming passion—in Schiller's words a tyrant. I have found my tyrant, and in his service I know no limits. My tyrant is psychology; it has always been my distant, beckoning goal and now, since I have hit on the neuroses, it has come so much the nearer.
*Letter to Wilhelm Fliess, May 25, 1895*

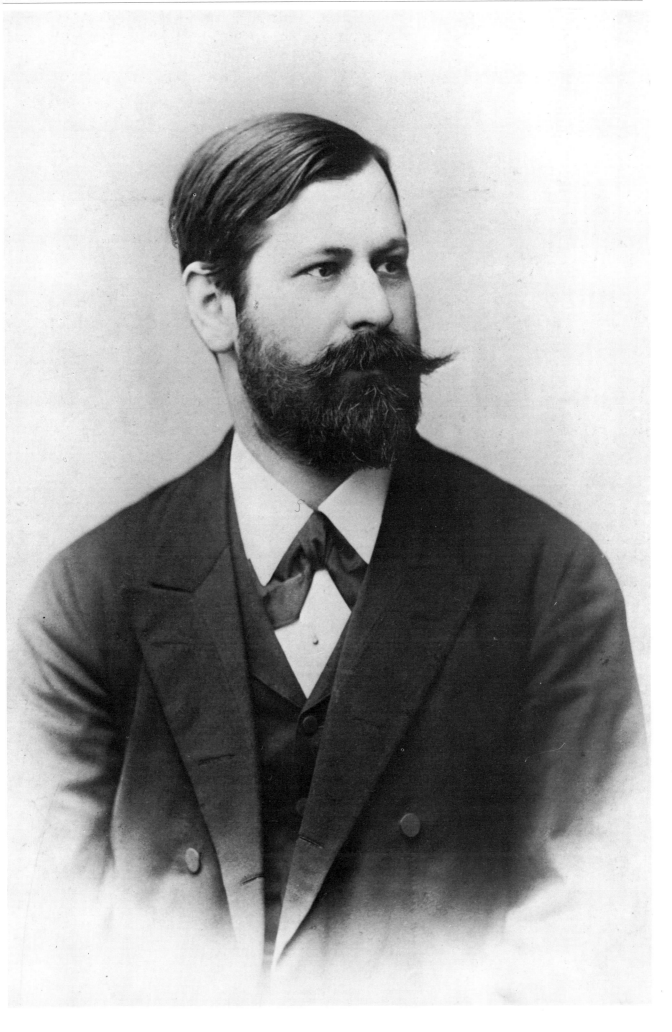

Beiträge zur Kinderheilkunde aus dem I. öffentlichen
Kinderkrankeninstitute in Wien.
Herausgegeben von **Dr. Max Kassowitz.**
III. Heft.

# Klinische Studie

über die

## halbseitige Cerebrallähmung der Kinder

von

**Docent Dr. SIGM. FREUD**

und

**Dr. OSCAR RIE.**

**Wien 1891.**
Verlag von Moritz Perles.
I., Seilergasse 4 (Graben).

---

# ZUR AUFFASSUNG

DER

# APHASIEN.

EINE KRITISCHE STUDIE

VON

## DR. SIGM. FREUD

PRIVATDOCENT FÜR NEUROPATHOLOGIE AN DER UNIVERSITÄT WIEN.

MIT 10 HOLZSCHNITTEN IM TEXTE.

LEIPZIG UND WIEN.
FRANZ DEUTICKE.
1891.

HERRN

## DR. JOSEF BREUER

IN FREUNDSCHAFTLICHER VEREHRUNG

GEWIDMET.

---

**119   Title page of the study on infantile cerebral paralysis, 1891**

During the period from 1886-1891 I did little scientific work, and published scarcely anything. I was occupied with establishing myself in my new profession and with assuring my own material existence as well as that of a rapidly increasing family. In 1891 there appeared the first of my studies[1] on the cerebral palsies of children, which was written in collaboration with my friend and assistant, Dr. Oskar Rie.
*An Autobiographical Study*

**120   Title page of the study on aphasia, 1891**

In a few weeks I look forward to sending you a paper on aphasia,[1] for which I have a good deal of feeling. I have been very cheeky in it, and have crossed swords with your friend Wernicke, as well as with Lichtheim and Grashey, and have even scratched the high and mighty idol Meynert.
*Letter to Wilhelm Fliess, May 2, 1891*

**121   The dedication**

The "Aphasia" [ . . . ] has already caused me deep disappointment. Breuer's reception of it was such a strange one; he hardly thanked me for it, was very embarrassed, made only derogatory comments on it [ . . . ]. The breach between us is widening all the time, and my efforts to patch things up with the dedication have probably had the opposite effect.
*Letter to Minna Bernays, July 13, 1891*

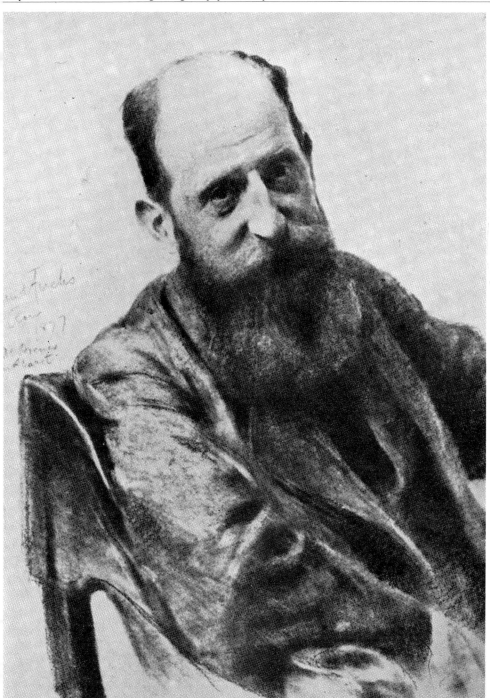

**122   Josef Breuer**

He[1] was a man of striking intelligence and fourteen years older than myself. Our relations soon became more intimate and he became my friend and helper in my difficult circumstances. We grew accustomed to share all our scientific interests with each other. In this relationship the gain was naturally mine. The development of psycho-analysis afterwards cost me his friendship. It was not easy for me to pay such a price, but I could not escape it.

*An Autobiographical Study*

## 123 "Anna O."—Bertha Pappenheim

Even before I went to Paris, Breuer had told me about a case of hysteria which, between 1880 and 1882, he had treated in a peculiar manner which had allowed him to penetrate deeply into the causation and significance of hysterical symptoms. [ . . . ] He repeatedly read me pieces of the case history, and I had an impression that it accomplished more towards an understanding of neuroses than any previous observation. I determined to inform Charcot of these discoveries when I reached Paris, and I actually did so. But the great man showed no interest in my first outline of the subject, so that I never returned to it and allowed it to pass from my mind.

When I was back in Vienna I turned once more to Breuer's observation and made him tell me more about it. The patient had been a young girl of unusual education and gifts, who had fallen ill while she was nursing her father, of whom she was devotedly fond. When Breuer took over her case it presented a variegated picture of paralyses with contractures, inhibitions and states of mental confusion.

*An Autobiographical Study*

I used to visit her in the evening, when I knew I should find her in her hypnosis, and I then relieved her of the whole stock of imaginative products which she had accumulated since my last visit. It was essential that this should be effected completely if good results were to follow. When this was done she became perfectly calm, and next day she would be agreeable, easy to manage, industrious and even cheerful; but on the second day she would be increasingly moody, contrary and unpleasant, and this would become still more marked on the third day. When she was like this it was not always easy to get her to talk, even in her hypnosis. She aptly described this procedure, speaking seriously, as a "talking cure," while she referred to it jokingly as "chimney-sweeping."

*Josef Breuer,* Studies on Hysteria

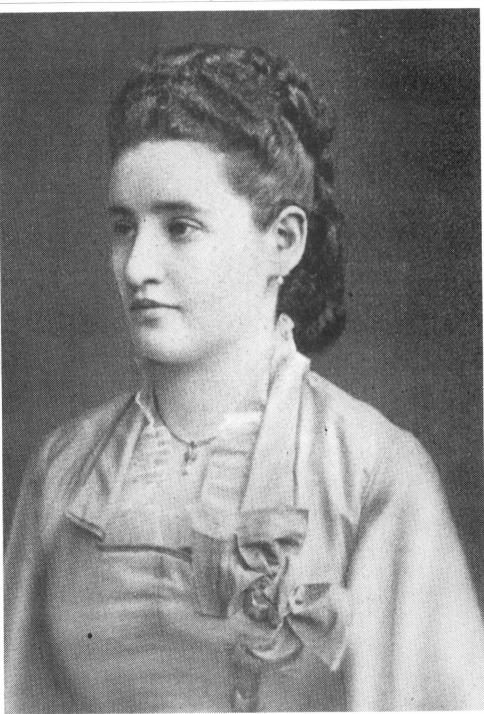

*Bertha Pappenheim, 1859-1936, whose case-history, "Frl. Anna O. . . . ," laid the foundations for the* Studies on Hysteria,[1] *developed, after her treatment, into one of the first fighters for women's rights.*

— 4 —

haut traf; ob die Narcosa in toto oder nur partiell so reizbar ist, weiss ich nicht. Jedenfalls ist die Magenempfindlichkeit immer schwankend, periodisch, parallel der Stärke der neurasthenischen Symptome, sodass ich wohl dazu auch die Rumination zählen darf, um so mehr, als dieselbe — abgesehen von den der Idiosynkrasie für Fett schon in den Knabenjahren — sich voll erst mit dem Eintritt der Nervosität, d. h. seit ca. 10 Jahren einstellte.

Jedenfalls sehen wir, dass bei neurasthenischer Anlage und anscheinend normaler Function und Anatomie des Magens sich Rumination einstellen kann. Beim Auslösen des Actes selbst scheint das mechanische Moment der Nahrung das Wichtigste zu sein; solange wird regurgitirt, bis die Stücken klein genug sind, um nicht mehr zu reizen.[1]

Den echten Merycismus haben wir wohl als motorische Reflexneurose anzusehen, die aber, glaube ich, immer einen disponirten Boden voraussetzt. Dass bei Geisteskranken und Idioten Wiederkauen nicht allzu selten angetroffen wird, ist bekannt und EICHHORST (Handbuch der spec. Pathol. u. Ther., Wien und Leipzig 1890, Bd. II) erwähnt, dass eine Reihe von Neurosen ihm Vorschub leisten, spricht dabei aber nicht speciell von der Neurasthenie, ebensowenig wie bei Schilderung derselben BEARD in seinem bekannten Buche und STRÜMPELL die Rumination berühren.

Ich glaube also, dass es in gewissen Fällen, auch der 1. LEVA'sche Fall gehört hierher — vielleicht sogar in recht vielen — ein echt neurasthenisches Zeichen ist, bei dem eventuell vorhandene Secretionsanomalien im Magen, Paresen der Cardia etc., eben auch nur Ausfluss derselben Ursache sind und wobei mechanische und chemische Reize der Ingesta, die bei anderen Leuten unwirksam sind, die motorische Reflexneurose nicht etwa erzeugen, sondern nur an den Tag bringen und allenfalls unterhalten können. So allein erklärt sich meiner Ansicht nach das Periodische mancher Fälle, bei gleichen Umständen, so der zeitlich verschiedene Beginn und das eventuelle Aufhören der Rumination, entsprechend dem Eintritt, Verschwinden und den Intensitätsschwankungen der Neurasthenie.

---

## 2. Ueber den psychischen Mechanismus hysterischer Phänomene.

### (Vorläufige Mittheilung.)

**Von Dr. Josef Breuer und Dr. Sigm. Freud in Wien.**

#### I.

Angeregt durch eine zufällige Beobachtung forschen wir seit einer Reihe von Jahren bei den verschiedensten Formen und Symptomen der Hysterie nach der Veranlassung, dem Vorgange, welcher das betreffende Phänomen zum ersten

---

[1] ALT giebt in seinem Falle von Hyperacidität eine andere Erklärung dafür.

---

**124 First publication of the "Preliminary Communication," 1893**[1]

If we put the hysteric under hypnosis and lead his thoughts back to the time at which the symptom in question first appeared, a memory of a psychical trauma [ . . . ] belonging to that time awakens in him with a hallucinatory vividness, the symptom having persisted as a mnemic symbol of the trauma. Thus hysterics suffer mainly from reminiscences. If the traumatic scene which has been arrived at in this way is reproduced vividly, accompanied by a generation of affect, the symptom which has hitherto been obstinately maintained disappears. We must therefore suppose that the forgotten memory has been acting like a foreign body in the mind, with the removal of which the irritating phenomena cease. This discovery, first made by Breuer in 1881, can be made the basis of a therapy of hysterical phenomena which deserves to be described as "cathartic."
*Abstracts of the Scientific Writings of Dr. Sigm. Freud 1877-1897*

What really happened with Breuer's patient I was able to guess later on, long after the break in our relations, when I suddenly remembered something Breuer had once told me in another context before we had begun to collaborate and which he never repeated. On the evening of the day when all her symptoms had been disposed of, he was summoned to the patient again, found her confused and writhing in abdominal cramps. Asked what was wrong with her, she replied: "Now Dr. B.'s child is coming!"

At this moment he held in his hand the key that would have opened the "doors to the Mothers,"[2] but he let it drop. With all his great intellectual gifts there was nothing Faustian in his nature. Seized by conventional horror he took flight [ . . . ].
*Letter to Stefan Zweig, June 2, 1932*

$$\mathfrak{Docent\ Dr.\ Sigm.\ Freud}$$

beehrt sich anzuzeigen, dass er von Mitte
September 1891 an

## IX. Berggasse 19,

wohnen und daselbst von 5 – 7 Uhr (auch
8 – 9 Uhr Früh) ordiniren wird.

WIEN, Datum des Poststempels.

**125   Plate with street number**

**126   Notice of change of address**

*Docent Dr. Sigm. Freud
takes pleasure in announcing
that as from mid-September
1891, he has moved to
    IX. Berggasse 19
with office hours
from 5-7 P.M. (also 8-9 A.M.)
    Vienna, date of postmark*

**127   House at Berggasse 19**[1]
*Here Freud lived and practiced
from September 20, 1891, to
June 5, 1938. During the first
years his living quarters and
office were on the second floor.
The windows of Freud's
consulting room are those
marked A and B in the picture.
In 1892 or 1893, however, he
moved his consulting rooms
down to the mezzanine, the
windows of which overlook the
garden, because his family,
which had increased in the
meantime, needed the rooms on
the second floor. Until 1908 his
widowed sister Rosa Graf
shared the second floor with her
brother and his family. Only
after she had moved out did
Freud with his family and
practice use the whole of the
second floor.*

**128  Entrance hall of
Berggasse 19**
I occupy two flats in a house in
Vienna, which are connected
only by the public staircase.
My consulting-room and study
are on the upper ground floor
and my living rooms are one
storey higher. When, late in the
evening, I have finished my
work down below, I go up the
stairs to my bedroom.
*The Interpretation of Dreams*

*The front door, on the right, led
into the upper ground-floor flat,
where Freud had his office from
1892 or 1893 to 1908. The
staircase above it leads to his
private flat.*

### 129 Consulting room

I hold to the plan of getting the patient to lie on a sofa while I sit behind him out of his sight. [ . . . ] What the material is with which one starts the treatment is on the whole a matter of indifference— whether it is the patient's life-history or the history of his illness or his recollections of childhood. But in any case the patient must be left to do the talking and must be free to choose at what point he shall begin. We therefore say to him: "Before I can say anything to you I must know a great deal about you; please tell me what you know about yourself." [ . . . ] "One more thing before you start. What you tell me must differ in one respect from an ordinary conversation. Ordinarily you rightly try to keep a connecting thread running through your remarks and you exclude any intrusive ideas that may occur to you and any side-issues, so as not to wander too far from the point. But in this case you must proceed differently. [ . . . ] So say whatever goes through your mind. Act as though, for instance, you were a traveller sitting next to the window of a railway carriage and describing to someone inside the carriage the changing views which you see outside. Finally, never forget that you have promised to be absolutely honest, and never to leave anything out because, for some reason or other, it is unpleasant to tell it."
*On Beginning the Treatment*

*When Freud first moved into the Berggasse, he was still using mainly the cathartic method. It was not until about 1896 that he gave up hypnosis and developed his revolutionary method of free association, which gave him complete access to the unconscious life of the mind, with its bizarre workings and its key processes such as resistance and transference.*

### 130 First publication of *The Neuro-Psychoses of Defence,* 1894[1]

I am pretty well alone here in tackling the neuroses. They regard me rather as a monomaniac, while I have the distinct feeling that I have touched on one of the great secrets of nature. There is something comic about the incongruity between one's own and other people's estimation of one's work. Look at my book on the diplegias,[2] which I knocked together almost casually, with a minimum of interest and effort. It has been a huge success. [ . . . ] But for the really good things, like the "Aphasia," the "Obsessional Ideas," which threaten to appear shortly, and the coming aetiology and theory of the neuroses, I can expect no more than a respectable flop. This is bewildering and somewhat embittering. There are a hundred gaps, large and small, in my ideas about the neuroses; but I am getting nearer to a comprehensive picture and some general points of view. I know three mechanisms: (1) conversion of affect (conversion hysteria); (2) displacement of affect (obsessions) and (3) transformation of affect (anxiety neurosis and melancholia). In all these cases what seems to undergo the change is sexual excitation [ . . . ].
*Letter to Wilhelm Fliess, May 21, 1894*

---

— 402 —

#### I. Originalmittheilungen.

#### 1. Die Abwehr-Neuro-psychosen.

Versuch einer psychologischen Theorie der acquirirten Hysterie, vieler Phobien und Zwangsvorstellungen und gewisser hallucinatorischer Psychosen.

Von Dr. Sigm. Freud, Privatdocent in Wien.

(Schluss.)

Ich kann nun nicht behaupten, dass die Willensanstrengung, etwas derartiges aus seinen Gedanken zu drängen, ein pathologischer Act ist, auch weiss ich nicht zu sagen, ob und auf welche Weise das beabsichtigte Vergessen jenen Personen gelingt, welche unter denselben psychischen Einwirkungen gesund bleiben. Ich weiss nur, dass ein solches „Vergessen" den von mir analysirten Patienten nicht gelungen ist, sondern zu verschiedenen pathologischen Reactionen geführt hat, die entweder eine Hysterie, oder eine Zwangsvorstellung, oder eine hallucinatorische Psychose erzeugten. In der Fähigkeit, durch jene Willensanstrengung einen dieser Zustände hervorzurufen, die sämmtlich mit Bewusstseinsspaltung verbunden sind, ist der Ausdruck einer pathologischen Disposition zu sehen, die aber nicht nothwendig mit persönlicher oder hereditärer „Degeneration" identisch zu sein braucht.

Ueber den Weg, der von der Willensanstrengung des Patienten bis zur Entstehung des neurotischen Symptoms führt, habe ich mir eine Meinung gebildet, die sich in den gebräuchlichen psychologischen Abstractionen etwa so ausdrücken lässt: Die Aufgabe, welche sich das abwehrende Ich stellt, die unverträgliche Vorstellung als „non arrivée" zu behandeln, ist für dasselbe directe unlösbar; sowohl die Gedächtnissspur als auch der der Vorstellung anhaftende Affect sind einmal da und nicht mehr auszutilgen. Es kommt aber einer ungefähren Lösung dieser Aufgabe gleich, wenn es gelingt, aus dieser starken Vorstellung eine schwache zu machen, ihr den Affect, die Erregungssumme, mit der sie behaftet ist, zu entreissen. Die schwache Vorstellung wird dann so gut wie keine Ansprüche an die Associationsarbeit zu stellen haben; die von ihr abgetrennte Erregungssumme muss aber einer anderen Verwendung zugeführt werden.

Soweit sind die Vorgänge bei der Hysterie und bei den Phobien und Zwangsvorstellungen die gleichen; von nun an scheiden sich die Wege. Bei der Hysterie erfolgt die Unschädlichmachung der unverträglichen Vorstellung dadurch, dass deren Erregungssumme in's Körperliche umgesetzt wird, wofür ich den Namen der Conversion vorschlagen möchte.

Die Conversion kann eine totale oder partielle sein und erfolgt auf jene motorische oder sensorische Innervation hin, die in einem innigen oder mehr lockeren Zusammenhang mit dem traumatischen Erlebniss steht. Das Ich hat

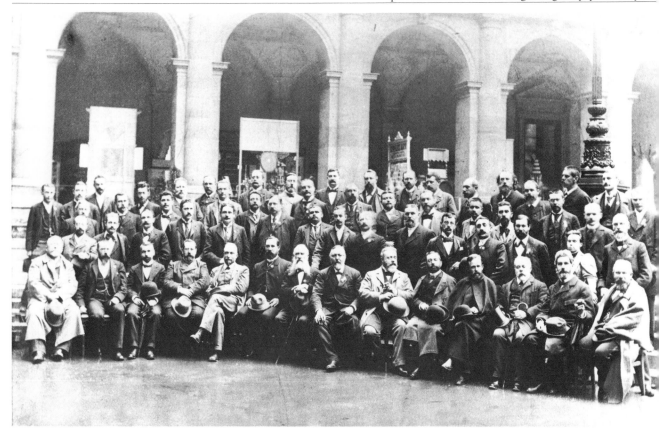

**131   Meeting of German naturalists and physicians in Vienna, 1894**

I forget if I have already told you that I am going to be secretary of the neurological section of the natural sciences congress in September.
*Letter to Wilhelm Fliess, February 7, 1894*

*The Congress of the "Gesellschaft Deutscher Naturforscher und Ärzte" (Society of German Naturalists and Physicians) took place from September 24 to 30, 1894. The photograph was taken in the Arkadenhof of the University of Vienna. Freud is in the second row, third from the right.*

**132   First edition of the *Studies on Hysteria*, 1895**

[ . . . ] in 1895 there followed our book, *Studies on Hysteria*. [ . . . ] As regards the *theory* put forward in the book, I was partly responsible, but to an extent which it is today no longer possible to determine. That theory was in any case unpretentious and hardly went beyond the direct description of the observations. It did not seek to establish the nature of hysteria but merely to throw light upon the origins of its symptoms. Thus it laid stress upon the significance of the life of the emotions and upon the importance of distinguishing between mental acts which are unconscious and those which are conscious (or rather capable of being conscious); it introduces a dynamic factor, by supposing that a symptom arises through the damming-up of an affect, and an economic factor, by regarding that same symptom as the product of the transformation of an amount of energy which would otherwise have been employed in some other way. (This latter process was described as *conversion*.) Breuer spoke of our method as *cathartic*; its therapeutic aim was explained as being to provide that the quota of affect used for maintaining the symptom, which had got on to the wrong lines and had, as it were, become strangulated there, should be directed on to the normal path along which it could obtain discharge (or *abreaction*). [ . . . ] In answering the question of when it is that a mental process becomes pathogenic—that is, when it is that it becomes impossible for it to be dealt with normally—Breuer preferred what might be called a physiological theory [ . . . ]. I, on the other hand, was inclined to suspect the existence of an interplay of forces and the operation of intentions and purposes such as are to be observed in normal life.
*An Autobiographical Study*

STUDIEN

ÜBER

HYSTERIE

VON

Dr. JOS. BREUER und Dr. SIGM. FREUD

IN WIEN.

LEIPZIG UND WIEN.
FRANZ DEUTICKE.
1895.

**133  A page of Freud's account book, 1896**
I hope to be occupied with scientific interests to the end of my life. Apart from them I am scarcely a human being any longer. At 10:30 after my practice I am dead tired.
*Letter to Wilhelm Fliess, February 13, 1896*

**134   Martha Freud with two-year-old Sophie**

She is small, but behaves very intelligently, as though she had already learnt in her mother's womb that she must find some other compensation here for her dowerlessness.
*Letter to Minna Bernays,*
*April 15, 1893*

*Sophie Freud, the fifth of the six children, 1893-1920*

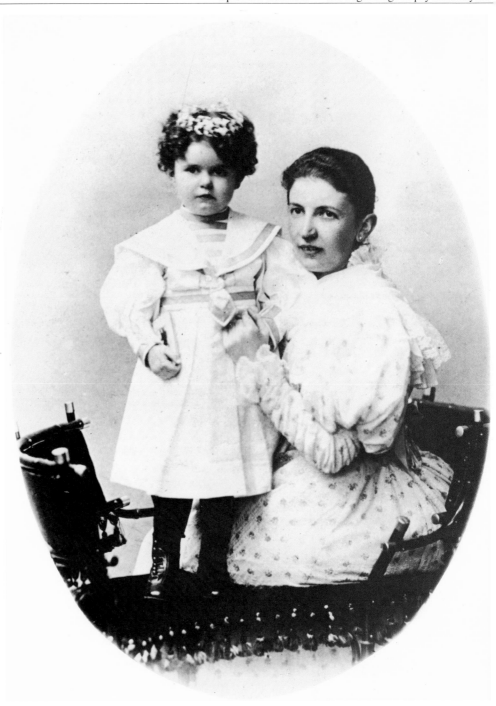

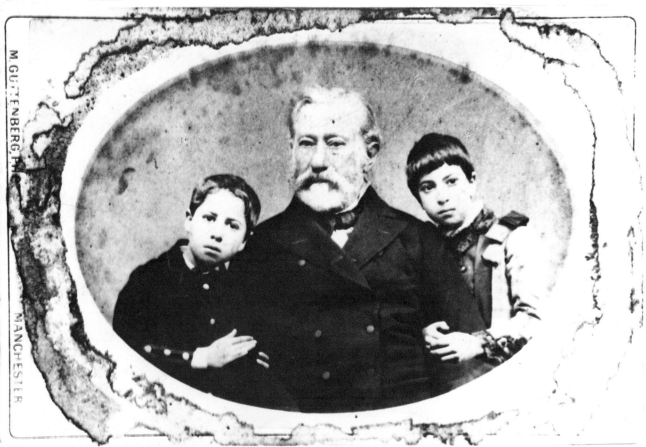

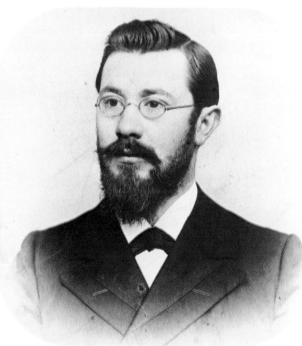

**135   Freud's father with his grandchildren Jean Martin and Oliver,**[1] **about 1895**
My aged father (he is eighty-one) is in Baden in a very shaky condition [ . . . ]. My father is a stalwart fellow [ . . . ].
*Letter to Wilhelm Fliess, June 30, 1896*

**136   Alexander Freud**
Every year, at that time, towards the end of August or the beginning of September, I used to set out with my younger brother on a holiday trip, which would last for some weeks and would take us [ . . . ] to some part of the Mediterranean sea-board.
"A Disturbance of Memory on the Acropolis"

*Freud's brother Alexander, 1866-1943, professor at the Exportakademie in Vienna, editor of the periodical* Tarifanzeiger

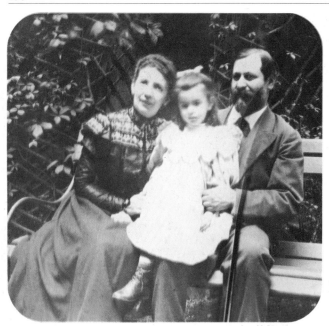

**137   With Martha and Anna, aged about three**
*Anna Freud, the youngest child, born in 1895*

**138   Family photograph, about 1898**
*In the garden of the Berggasse house. From left to right and from front to back: Sophie, Anna and Ernst Freud; Oliver and Martha Freud, Minna Bernays; Martin and Sigmund Freud*

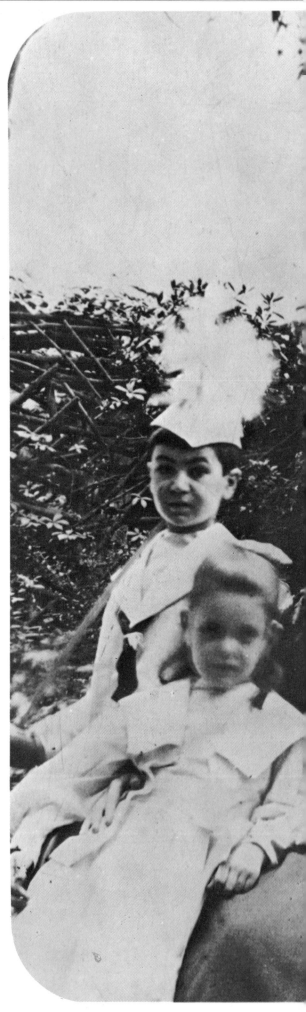

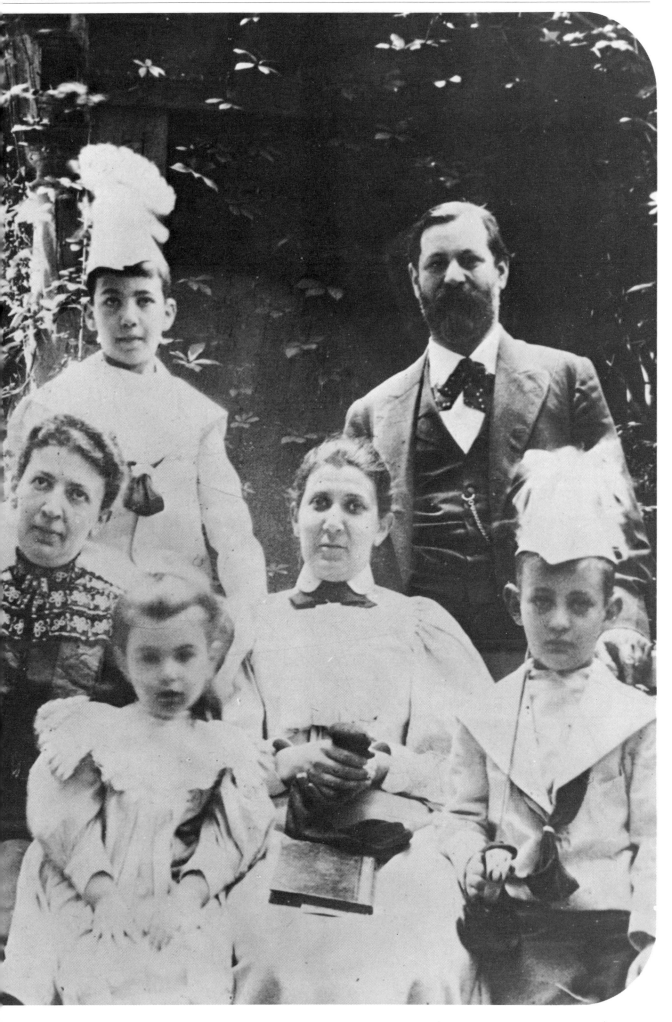

**139    The Vienna Opera at the
turn of the century**
It is a misery to live here, and it
is no atmosphere in which the
hope of completing anything
difficult can survive.
*Letter to Wilhelm Fliess,
September 22, 1898*

I did not give the lecture
announced last Monday in the
*Neue Freie Presse*. [ . . . ] I
reluctantly agreed, and then,
when I came to preparing it, I
found I should have to bring in
all sorts of intimate and sexual
things which would be quite
unsuitable for a mixed
audience of people who were
strangers to me. So I wrote a
letter calling it off. That was
the first week. Thereupon a
delegation of two called on me
and pressed me to deliver it
after all. I warned them very
seriously to do nothing of the
sort, and suggested that they
should come and hear the
lecture themselves one evening
at my house (second week).
During the third week I gave
two of them the lecture. They
said it was wonderful and that
their audience would take no
exception to it, etc. The lecture
was therefore arranged for the
fourth week. A few hours
beforehand, however, I

received an express letter,
saying that some members had
objected after all and asking
me to be kind enough to start
by illustrating my theory with
inoffensive examples and then
announce that I was coming to
objectionable matter and make
a pause, during which the
ladies could leave the hall. Of
course I immediately cried off,
and the letter in which I did so
at any rate did not lack pepper
and salt. Such is scientific life
in Vienna!
*Letter to Wilhelm Fliess,
February 15, 1901*

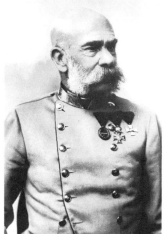

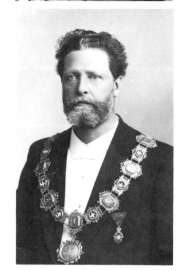

**140    The Emperor Franz
Josef I; Karl Lueger**
[ . . . ] I am keeping to the
prescription (not to smoke),
and only over-indulged one
day for joy at Lueger's non-
confirmation in office.
*Letter to Wilhelm Fliess,
November 8, 1895*

*Karl Lueger, 1844-1910, was at
that time leader of the Christian
Social Party which, from 1889,
had declared war on
"unbridled" liberalism, and
also on the "materialistic
and antireligious" Social
Democratic movement, and had
open anti-Semitic leanings. The
municipal elections of 1895
gave the party a majority, and
Lueger was elected Mayor.
The Emperor Franz Josef I,
however, refused to confirm
him. It was only after the
election had been repeated three
times that he agreed in 1897.
Lueger remained Mayor of
Vienna until his death.*

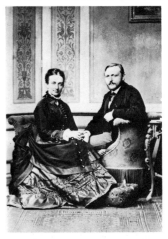

**142   Richard von Krafft-Ebing and his wife**

Freud's stay at the Salpêtrière awakened his interest in the psychic side of the clinical picture of hysteria and in research into hypnotism and the use of suggestion therapy in neuroses. [ . . . ] The novelty of this research, and the difficulty of verifying it, makes it impossible at present to reach a definite judgment as to its importance. It is possible that Freud overestimates it and generalizes too much on the results obtained. At all events his research in this field shows unusual talent and the ability to find new directions for scientific research.
*From the report attached to the Faculty's proposal to appoint Freud as Professor Extra-ordinarius, May 10, 1897*

*Richard Freiherr von Krafft-Ebing, 1840-1902, had succeeded Meynert at the psychiatric clinic in 1892. He pleaded for psychiatry as a descriptive science, and, criticizing the explanatory trend of Meynert's research, saw cerebral anatomy, experimental pathology and physiology simply as auxiliary sciences. He became famous, especially through his* Psychopathia Sexualis *(1886), as the founder of modern sexual pathology.— Krafft-Ebing had proposed Freud's promotion, and was one of the signatories of the report quoted above.*

**141   Official testimonial, 1897**
In the spring of 1897 I learnt that two professors at our university[1] had recommended me for appointment as *professor extraordinarius*. The news surprised and greatly delighted me, since it implied recognition by two eminent men, which could not be put down to any considerations of a personal kind. But I at once warned myself not to attach any expectations to the event.
*The Interpretation of Dreams*

*The official report shows the stage which the proposal of the Faculty to promote Freud to the rank of Professor Extraordinarius had reached within the beaurocracy at that time. Nevertheless, Freud did not receive the title until five years later (cf. illustration 163).*
*Translation in the notes*

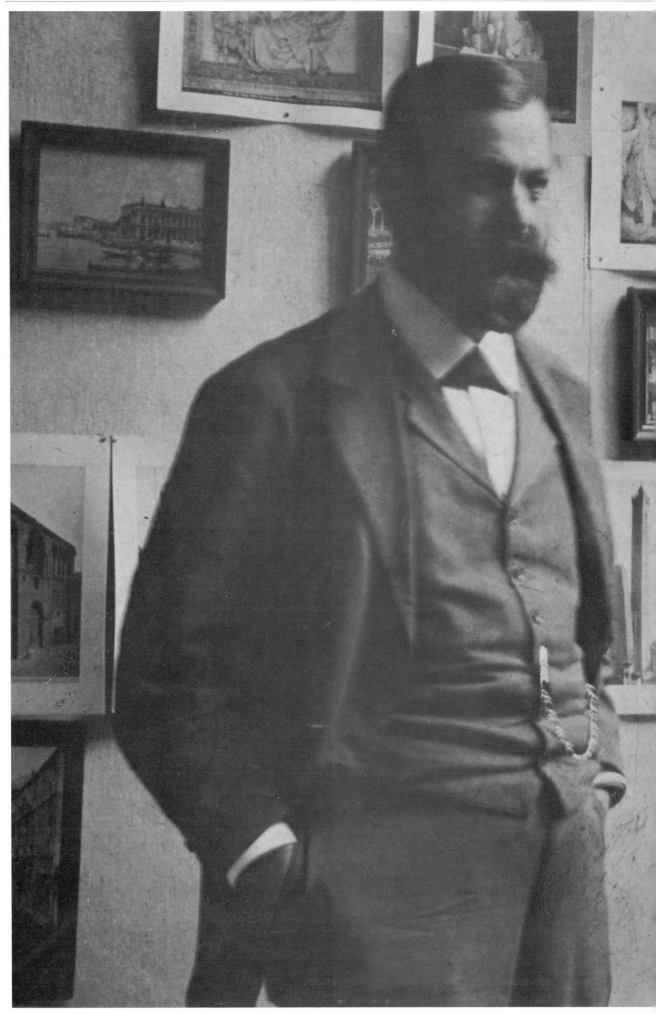

**143   Freud, about 1898**
Before going further into the question of infantile sexuality I must mention an error into which I fell for a while and which might well have had fatal consequences for the whole of my work. Under the influence of the technical procedure which I used at that time, the majority of my patients reproduced from their childhood scenes in which they were sexually seduced by some grown-up person. With female patients the part of the seducer was almost always assigned to their father. I believed these stories, and consequently supposed that I had discovered the roots of the subsequent neurosis in these experiences of sexual seduction in childhood. [ . . . ] When, however, I was at last obliged to recognize that these scenes of seduction had never taken place, and that they were only phantasies which my patients had made up or which I myself had forced on them, I was for some time completely at a loss. [ . . . ] When I had pulled myself together, I was able to draw the right conclusions from my discovery: namely, that the neurotic symptoms were not related directly to actual events but to wishful phantasies, and that as far as the neurosis was concerned psychical reality was of more importance than material reality.
*An Autobiographical Study*

Let me tell you straight away the great secret which has been slowly dawning on me in recent months. I no longer believe in my *neurotica*. [ . . . ] It is curious that I feel not in the least disgraced, though the occasion might seem to require

it. Certainly I shall not tell it in Gath, or publish it in the streets of Askalon, in the land of the Philistines—but between ourselves I have a feeling more of triumph than of defeat (which cannot be right). [ . . . ] In the general collapse only the psychology has retained its value. The dreams still stand secure [ . . . ]. It is a pity one cannot live on dream-interpretation, for instance.
*Letter to Wilhelm Fliess, September 21, 1897*

**144   Havelock Ellis**
A pleasing thing [ . . . ] is something from—Gibraltar, from Mr. Havelock Ellis, an author who concerns himself with the subject of sex and is obviously a highly intelligent man, as his paper[1] [ . . . ] which deals with the connection between hysteria and sexual life, begins with Plato and ends with Freud. He gives a good deal of credit to the latter, and writes a very intelligent appreciation of *Studies on Hysteria* and later publications.
*Letter to Wilhelm Fliess, January 13, 1899*

*Henry Havelock Ellis, 1859-1939, English sexologist; among his principal works:* Studies in the Psychology of Sex *(1897-1928)*

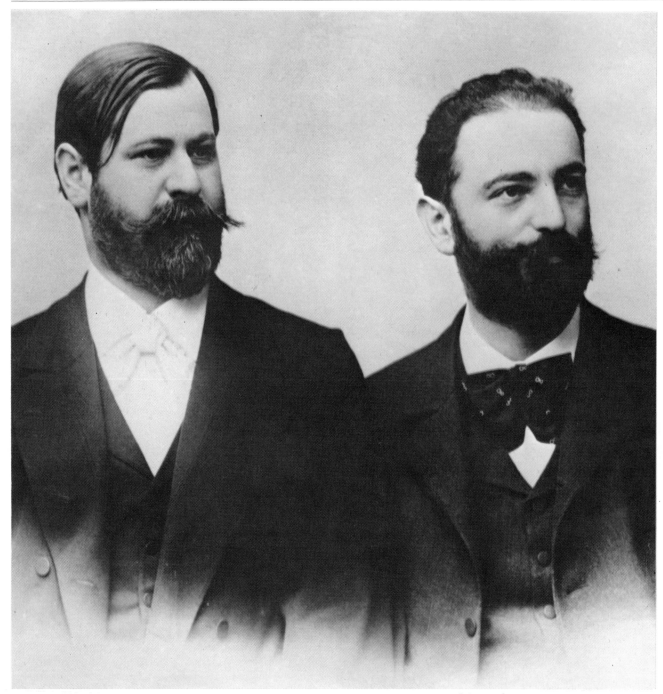

**145   With Wilhelm Fliess in the early Nineties**

If we are both granted a few more years of quiet work, we shall certainly leave behind something which will justify our existence. [ . . . ] When I was young, the only thing I longed for was philosophical knowledge, and now that I am going over from medicine to psychology I am in the process of attaining it. I have become a therapist against my will [ . . . ].
*Letter to Wilhelm Fliess, April 2, 1896*

My self-analysis is the most important thing I have in hand, and promises to be of the greatest value to me, when it is finished. [ . . . ] Being entirely honest with oneself is a good exercise. Only one idea of general value has occurred to me. I have found love of the mother and jealousy of the father in my own case too, and now believe it to be a general phenomenon of early childhood [ . . . ]. If that is the case, the gripping power of *Oedipus Rex*, [ . . . ] becomes intelligible, [ . . . ] the Greek myth seizes on a compulsion which everyone recognizes because he has felt traces of it in himself. Every member of the audience was once a

budding Oedipus in phantasy, and this dream-fulfilment played out in reality causes everyone to recoil in horror with the full measure of repression which separates his infantile from his present state.
*Letter to Wilhelm Fliess, October 15, 1897*

*Wilhelm Fliess, 1858-1928, was a Berlin ear, nose and throat specialist with interests in general biology. From 1887 to 1901 Freud was closely linked with him both as a scholar and as a friend. In an extensive correspondence, in which manuscripts also were included, they shared their discoveries, which they later discussed at occasional meetings jocularly*

*called "Congresses." Fliess thus became the sole witness of the birth of psychoanalysis, which took place in "splendid isolation," and also its "first reader," its "supreme arbiter." Freud called him the "representative of other people";[1] Fliess was indispensable to him during a period which included the most important years of his self-analysis.[2]*

**146   Sexual diagram**
One strenuous night last week
[ . . . ] the barriers suddenly
lifted, the veils dropped, and it
was possible to see from the
details of neurosis all the way
to the very conditioning of
consciousness. Everything
fell into place [ . . . ]. I can
naturally hardly contain myself
with delight.
*Letter to Wilhelm Fliess,*
*October 20, 1895*

*This drawing was appended to*
*one of the manuscripts which*
*Freud sent to Fliess.*[1]

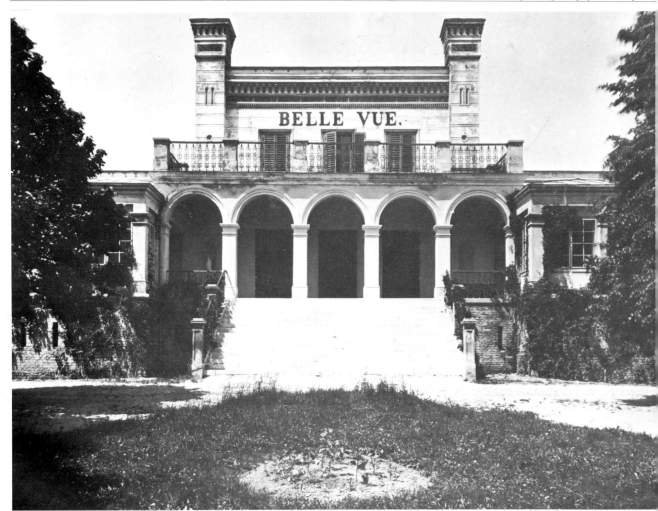

DIE

# TRAUMDEUTUNG

VON

Dᴿ· SIGM. FREUD.

*FLECTERE SI NEQUEO SUPEROS, ACHERONTA MOVEBO.*

LEIPZIG UND WIEN.
**FRANZ DEUTICKE.**
1900.

---

**147  Schloss Bellevue**
Life at Bellevue is turning out
very pleasantly for everyone.
[ . . . ] Do you suppose that
some day a marble tablet will
be placed on the house,
inscribed with these words:

In this house on July 24,
1895,
the Secret of Dreams was
revealed to
Dr. Sigmund Freud.

At this moment I see little
prospect of it. But when I read
the latest psychological books
[ . . . ] and see what they have
to say about dreams, I am as
delighted as the dwarf in the
fairy tale because "the princess
doesn't know."
*Letter to Wilhelm Fliess,
June 12, 1900*

*During a stay at Schloss
Bellevue near Vienna, which
was then rented to summer
vacationers, Freud succeeded,
on July 24, 1895, in interpreting
a dream completely for the first
time.*[1]

**148  "Riemerlehen" in
Berchtesgaden**
I have got on so well with my
work here, in peace and with
nothing to disturb me, and in
almost complete health; and in
between times I have gone for
walks, and enjoyed the
mountains and woods. You
must be lenient with me,
because I am completely
wrapped up in my work and
cannot write about anything
else. I am deep in the chapter
on the "dream-work."
*Letter to Wilhelm Fliess,
August 20, 1899*

*In the summer holidays of 1899
Freud and his family stayed at
a farmstead in Berchtesgaden
called "Riemerlehen." There
he wrote large parts of* The
Interpretation of Dreams.

**149  First edition of *The
Interpretation of Dreams*, 1900**[1]
My patients were pledged to
communicate to me every idea
or thought that occurred to
them in connection with some
particular subject; amongst
other things they told me their
dreams and so taught me that
a dream can be inserted into
the physical chain that has to
be traced backwards in the
memory from a pathological
idea. It was then only a short
step to treating the dream itself
as a symptom and to applying
to dreams the method of
interpretation that had been
worked out for symptoms.
*The Interpretation of Dreams*

Previously psycho-analysis
had only been concerned
with solving pathological
phenomena [ . . . ]. But when
it came to dreams, it was no
longer dealing with a
pathological symptom, but
with a phenomenon of normal
mental life which might occur
in any healthy person. If
dreams turned out to be
constructed like symptoms, if

their explanation required the
same assumptions—[ . . . ]
then psycho-analysis was no
longer an auxiliary science in
the field of psychopathology, it
was rather the starting point of
a new and deeper science of the
mind which would be equally
indispensable for the under-
standing of the normal.
*An Autobiographical Study*

It has been a consolation to me
in many a gloomy hour to
know that I have this book to
leave behind me.
*Letter to Wilhelm Fliess,
March 23, 1900*

*Freud was deeply disappointed
by the reception given to his
book when it appeared. "It has
met with the most meager
understanding; any praise that
has been bestowed has been as
meager as charity [ . . . ]."*[2]

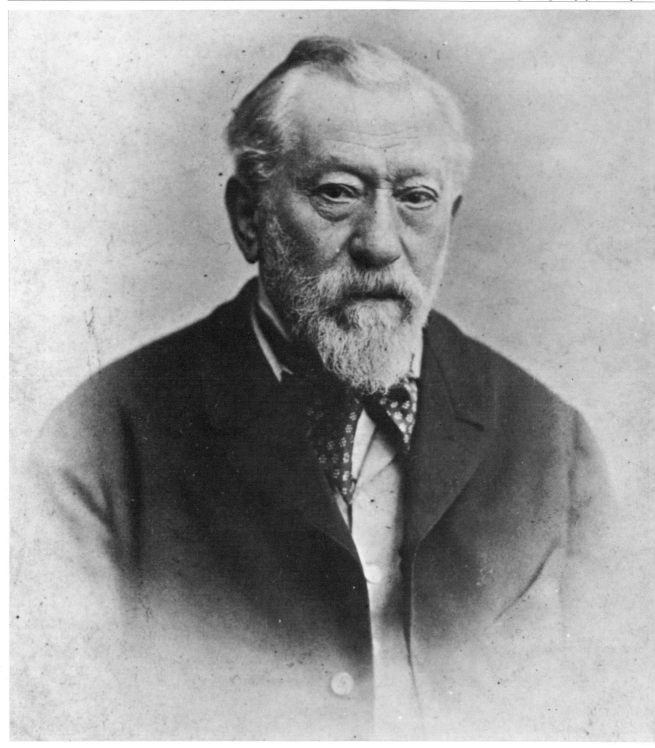

**150   Freud's father in old age**
By one of the obscure routes behind the official consciousness the old man's death affected me deeply. I valued him highly and understood him very well indeed, and with his peculiar mixture of deep wisdom and imaginative light-heartedness he meant a great deal in my life. By the time he died his life had long been over, but at a death the whole past stirs within one.
*Letter to Wilhelm Fliess, November 2, 1896*

For this book has a [ . . . ] subjective significance for me personally—a significance which I only grasped after I had completed it. It was, I found, a portion of my own self-analysis, my reaction to my father's death—that is to say, to the most important event, the most poignant loss, of a man's life. Having discovered that this was so, I felt unable to obliterate the traces of the experience.[1]
*The Interpretation of Dreams*

**151   His parents' grave in the principal cemetery, Vienna**

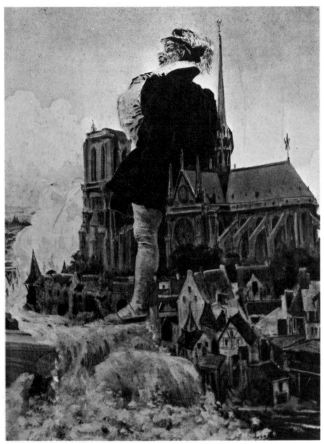

**152   From Freud's own dreams (*The Interpretation of Dreams*): Gargantua illustration by Jules Garnier**

The difficulties of presentation have been further increased by the peculiarities of the material which I have had to use to illustrate the interpreting of dreams. [ . . . ] The only dreams open to my choice were my own and those of my patients undergoing psycho-analytic treatment. [ . . . ] But if I was to report my own dreams, it inevitably followed that I should have to reveal to the public gaze more of the intimacies of my mental life than I liked, or than is normally necessary for any writer who is a man of science and not a poet. Such was the painful but unavoidable necessity; and I have submitted to it rather than totally abandon the possibility of giving the evidence for my psychological findings.
*The Interpretation of Dreams*

The stream of urine which washed everything clean was an unmistakable sign of greatness. It was in that way that Gulliver extinguished the great fire in Lilliput [ . . . ]. But Gargantua, too, Rabelais' superman, revenged himself in the same way on the Parisians by sitting astride on Notre Dame and turning his stream of urine upon the city. It was only on the previous evening before going to sleep that I had been turning over Garnier's illustrations to Rabelais. And, strangely enough, here was another piece of evidence that I was the superman. The platform of Notre Dame was my favorite resort in Paris; every free afternoon I used to clamber about there on the towers of the church between the monsters and the devils.[1]
*The Interpretation of Dreams*

**153   From Freud's own dreams (*The Interpretation of Dreams*): statue of the Emperor Josef II ("Non vixit" dream)**

It was a long time, however, before I succeeded in tracing the origin of the "*Non vixit*" [ . . . ]. But at last it occurred to me that these two words possessed their high degree of clarity in the dream, not as words heard or spoken, but as words *seen*. I then knew at once where they came from. On the pedestal of the Kaiser Josef Memorial in the Hofburg (Imperial Palace) in Vienna the following impressive words are inscribed:

Saluti patriae *vixit*
*non* diu sed totus.[1]
*The Interpretation of Dreams*

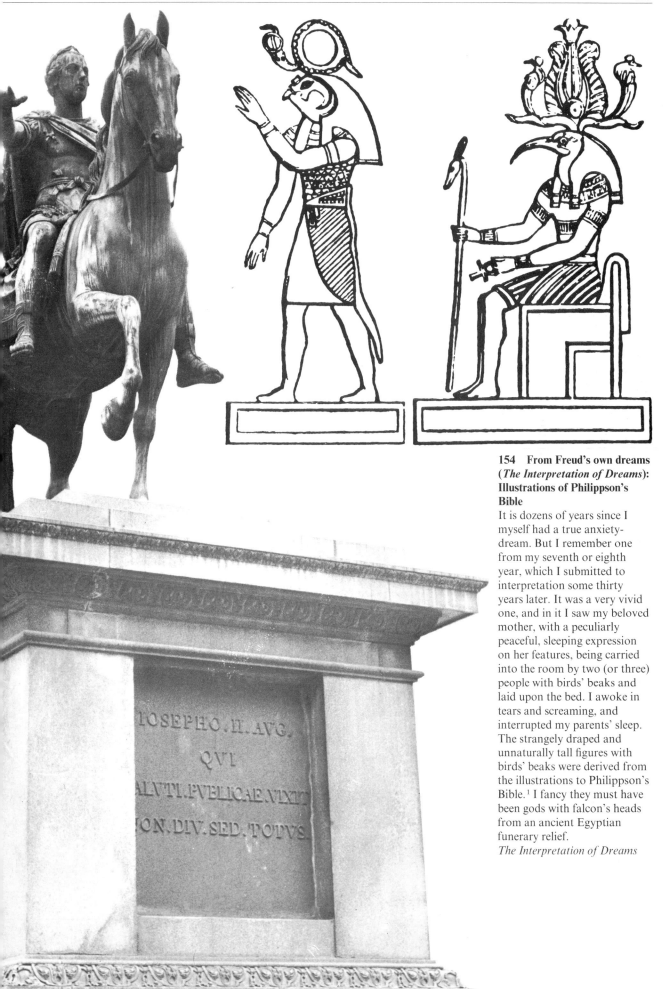

**154  From Freud's own dreams
(*The Interpretation of Dreams*):
Illustrations of Philippson's
Bible**

It is dozens of years since I
myself had a true anxiety-
dream. But I remember one
from my seventh or eighth
year, which I submitted to
interpretation some thirty
years later. It was a very vivid
one, and in it I saw my beloved
mother, with a peculiarly
peaceful, sleeping expression
on her features, being carried
into the room by two (or three)
people with birds' beaks and
laid upon the bed. I awoke in
tears and screaming, and
interrupted my parents' sleep.
The strangely draped and
unnaturally tall figures with
birds' beaks were derived from
the illustrations to Philippson's
Bible.[1] I fancy they must have
been gods with falcon's heads
from an ancient Egyptian
funerary relief.
*The Interpretation of Dreams*

**155   First publication of the case history of "Dora," 1901/1905**[1]

It is a fragment of an analysis of a hysteria, in which the interpretations are grouped round two dreams, so it is really a continuation of the dream book.

*Letter to Wilhelm Fliess, January 25, 1901*

I am aware that—in this city, at least—there are many physicians who (revolting though it may seem) choose to read a case history of this kind not as a contribution to the psycho-pathology of the neuroses, but as a *roman à clef* designed for their private delectation. [ . . . ] Now in this case history—the only one which I have hitherto succeeded in forcing through the limitations imposed by medical discretion and unfavorable circumstances— sexual questions will be discussed with all possible frankness, the organs and functions of sexual life will be called by their proper names, and the pure-minded reader can convince himself from my description that I have not hesitated to converse upon such subjects in such language even with a young woman. Am I, then, to defend myself on this score as well?

"Fragment of an Analysis of a Case of Hysteria"

Sonder-Abdruck aus Monatsschr. f. Psychiatrie u. Neurologie. Bd. XVIII. H. 4.

Herausgegeben von C. Wernicke und Th. Ziehen.

Verlag von S. Karger in Berlin NW. 6.

## Bruchstück einer Hysterie-Analyse.

### Von

### Prof. Dr. SIGM. FREUD

in Wien.

#### Vorwort.

Wenn ich nach längerer Pause daran gehe, meine in den Jahren 1895 und 1896 aufgestellten Behauptungen über die Pathogenese hysterischer Symptome und die psychischen Vorgänge bei der Hysterie durch ausführliche Mitteilung einer Kranken- und Behandlungsgeschichte zu erhärten, so kann ich mir dieses Vorwort nicht ersparen, welches mein Tun einerseits nach verschiedenen Richtungen rechtfertigen, anderseits die Erwartungen, die es empfangen werden, auf ein billiges Maass zurückführen soll.

Es war sicherlich misslich, dass ich Forschungsergebnisse, und zwar solche von überraschender und wenig einschmeichelnder Art, veröffentlichen musste, denen die Nachprüfung von Seiten der Fachgenossen notwendiger Weise versagt blieb. Es ist aber kaum weniger misslich, wenn ich jetzt beginne, etwas von dem Material dem allgemeinen Urteil zugänglich zu machen, aus dem ich jene Ergebnisse gewonnen hatte. Ich werde dem Vorwurfe nicht entgehen. Hatte er damals gelautet, dass ich nichts von meinen Kranken mitgeteilt, so wird er nun lauten, dass ich von meinen Kranken mitgeteilt, was man nicht mitteilen soll. Ich hoffe, es werden die nämlichen Personen sein, welche in solcher Art den Vorwand für ihren Vorwurf wechseln werden, und gebe es von vornherein auf, diesen Kritikern jemals ihren Vorwurf zu entreissen.

Die Veröffentlichung meiner Krankengeschichten bleibt für mich eine schwer zu lösende Aufgabe, auch wenn ich mich um jene einsichtslosen Uebelwollenden weiter nicht bekümmere. Die Schwierigkeiten sind zum Teil technischer Natur, zum anderen Teil gehen sie aus dem Wesen der Verhältnisse selbst hervor. Wenn es richtig ist, dass die Verursachung der hysterischen Erkrankungen in den Intimitäten des psycho-sexuellen Lebens der Kranken gefunden wird, und dass die hysterischen Symptome der Ausdruck ihrer geheimsten verdrängten Wünsche sind, so kann die Klarlegung eines Falles von Hysterie nicht anders, als diese Intimitäten aufdecken und diese Geheimnisse verraten. Es ist gewiss, dass die Kranken nie gesprochen hätten, wenn ihnen die Möglichkeit einer wissenschaftlichen Verwertung ihrer

# Zur Psychopathologie des Alltagslebens (Vergessen, Versprechen, Vergreifen) nebst Bemerkungen über eine Wurzel des Aberglaubens.

### Von

## Dr. SIGM. FREUD
#### in Wien.

> „Nun ist die Luft von solchem Spuk so voll,
> Dass niemand weiss, wie er ihn meiden soll."
> Faust, II T., V. Akt.

## I.

### Vergessen von Eigennamen.

Im Jahrgange 1898 dieser Zeitschrift habe ich unter dem Titel „Zum psychischen Mechanismus der Vergesslichkeit" einen kleinen Aufsatz veröffentlicht, dessen Inhalt ich hier wiederholen und zum Ausgang für weitere Erörterungen nehmen werde. Ich habe dort den häufigen Fall des zeitweiligen Vergessens von Eigennamen an einem praegnanten Beispiel aus meiner Selbstbeobachtung der psychologischen Analyse unterzogen und bin zum Ergebnis gelangt, dass dieser gewöhnliche und praktisch nicht sehr bedeutsame Einzelvorfall von Versagen einer psychischen- Function — des Erinnerns — eine Aufklärung zulässt, welche weit über die gebräuchliche Verwertung des Phänomens hinausführt.

Wenn ich nicht sehr irre, würde ein Psycholog, von dem man die Erklärung forderte, wie es zugehe, dass Einem so oft ein Name nicht einfällt, den man doch zu kennen glaubt, sich begnügen zu antworten, dass Eigennamen dem Vergessen leichter unterliegen als andersartiger Gedächtnisinhalt. Er würde die plausibeln Gründe für solche Bevorzugung der Eigennamen anführen, eine anderweitige Bedingtheit des Vorganges aber nicht vermuten.

Für mich wurde zum Anlass einer eingehenderen Beschäftigung mit dem Phänomen des zeitweiligen Namenvergessens die Beobachtung gewisser Einzelheiten, die sich zwar nicht in allen Fällen, aber in einzelnen deutlich genug erkennen lassen. In solchen Fällen wird nämlich nicht nur vergessen, sondern auch falsch erinnert. Dem sich um den entfallenen Namen Bemühenden kommen andere — Ersatznamen — zum Bewusstsein, die zwar sofort als unrichtig erkannt werden, sich aber doch mit grosser Zähigkeit immer wieder aufdrängen. Der

**156   First publication of *The Psychopathology of Everyday Life*, 1901**[1]

I have at last understood a little thing that I have long suspected. You know how you can forget a name and substitute part of another for it, to which you could swear, though it invariably turns out to be wrong. That happened to me not long ago over the name of the poet who wrote *Andreas Hofer ("Zu Mantua in Banden . . .")*. I felt it must be something ending in *au*— Lindau, Feldau, or the like. Actually of course, the poet's name was Julius Mosen; the "Julius" had not slipped my memory. I was able to prove (i) that I had repressed the name Mosen because of certain associations; (ii) that material from my infancy played a part in the repression; and (iii) that the substitute names that occurred to me arose, just like a symptom, from both groups of material. The analysis resolved the thing completely; unfortunately, I cannot make it public any more than my big dream.

*Letter to Wilhelm Fliess, August 26, 1898*[2]

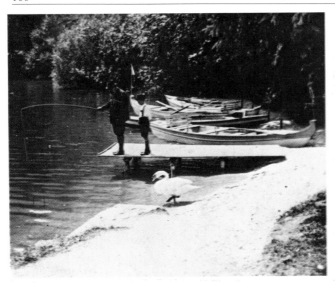

**157    With his son Ernst near Bad Reichenhall, 1901**
Thumsee really is a little paradise, particularly for the children, who are well fed here, fight each other and the visitors for the boats and then vanish on them from their parents' anxious eyes. Living among the fish has made me stupid, but in spite of that I have not yet got the carefree mind that I usually get on holiday [ . . . ].
*Letter to Wilhelm Fliess, August 7, 1901*

**158    The children near Berchtesgaden, 1899**
"How many children have you got now?"—"Six."—He made a gesture of admiration and concern.—"Girls or boys?"— "Three and three: they are my pride and my treasure."
*The Interpretation of Dreams*

**159    Freud's sons: Oliver, Martin and Ernst in Berchtesgaden, 1902**

[ . . . ] the names of my own children. I had insisted on their names being chosen, not according to the fashion of the moment, but in memory of people I have been fond of. Their names made the children into *revenants*. And after all, I reflected, was not having children our only path to immortality?
*The Interpretation of Dreams*

*Jean Martin Freud, 1889-1967, named after Charcot, lawyer. Oliver Freud, 1891-1969, named after Cromwell, civil engineer. Ernst Freud, 1892-1970, named after Brücke, architect.* [1]

### 160   Knossos

Have you read that the English have excavated an old palace in Crete (Knossos) which they declare to be the original labyrinth of Minos? Zeus seems originally to have been a bull. The god of our own fathers, before the sublimation instigated by the Persians took place, was worshipped as a bull. That provides food for all sorts of thoughts which it is not yet time to set down on paper . . .
*Letter to Wilhelm Fliess, July 4, 1901*

*Freud is referring to the first reports on the excavations led by Sir Arthur Evans.*

### 161   Bull's head rhyton from Knossos

It seems that, in those obscure centuries which are scarcely accessible to historical research, the countries round the eastern basin of the Mediterranean were the scenes of frequent and violet volcanic eruptions, which must have made the strongest impression on their inhabitants. Evans assumes that the final destruction of the palace of Minos at Knossos too was the consequence of an earthquake. In Crete at that period (as probably in the Aegean world in general) the great mother-goddess was worshipped. The realization that she was not able to protect her house against the assaults of a stronger power may have contributed to her having to give place to a male deity, and, if so, the volcano god had the first claim to take her place. After all, Zeus (who originally was a bull) always remained the "earth-shaker."
*Moses and Monotheism*

### 162   First visit to Rome, 1901: Temple of Minerva

I ought to write to you about Rome, but it is difficult. It was an overwhelming experience for me, and, as you know, the fulfilment of a long-cherished wish. [ . . . ] a high-spot in my life [ . . . ] (I could have worshipped the humble and mutilated remnant of the Temple of Minerva[1] near the forum of Nerva) [ . . . ].
*Letter to Wilhelm Fliess, September 19, 1901*

Incidentally my longing for Rome is deeply neurotic. It is connected with my schoolboy hero-worship of the Semitic Hannibal[2] [ . . . ].
*Letter to Wilhelm Fliess, December 3, 1897*

**163   Appointment as Professor Extraordinarius, 1902**
When I got back from Rome, my zest for life and work had somewhat diminished. [ . . . ] So I made up my mind to break with my strict scruples and take appropriate steps,[1] as others do after all. One must look somewhere for one's salvation, and the salvation I chose was the title of professor. For four whole years I had not put in a word about it [ . . . ].
*Letter to Wilhelm Fliess, March 11, 1902*

*The appointment, by the Emperor Franz Josef I, took place on March 5, 1902.*

*Translation in the notes*

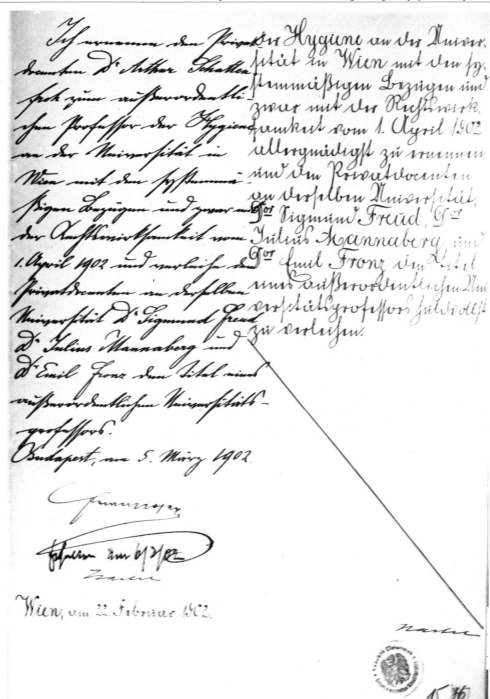

**164   From the Emperor's audience list for October 13, 1902**
It was done. The *Wiener Zeitung* has not yet published it, but the news spread quickly from the Ministry. The public enthusiasm is immense. Congratulations and bouquets keep pouring in, as if the role of sexuality had been suddenly recognized by His Majesty, the interpretation of dreams confirmed by the Council of Ministers [ . . . ].
*Letter to Wilhelm Fliess, March 11, 1902*

**165   The Acropolis, 1904**

When, finally, on the afternoon of our arrival, I stood on the Acropolis and cast my eyes around upon the landscape, a surprising thought suddenly entered my mind: "So all this really *does* exist, just as we learnt at school!" To describe the situation more accurately, the person who gave expression to the remark was divided, far more sharply than was usually noticeable, from another person who took cognizance of the remark; and both were astonished, though not by the same thing. [ . . . ] It must be that a sense of guilt was attached to the satisfaction in having gone such a long way: there was something about it that was wrong, that from earliest times had been forbidden. It was something to do with a child's criticism of his father, with the under-valuation which took the place of the overvaluation of earlier childhood. It seems as though the essence of success was to have got further than one's father, and as though to excel one's father was still something forbidden [ . . . ] Our father had been in business, he had had no secondary education, and Athens could not have meant much to him.[1]

"A Disturbance of Memory on the Acropolis"

DREI ABHANDLUNGEN ZUR

# SEXUALTHEORIE

VON

PROF. DR. SIGM. FREUD

IN WIEN

LEIPZIG UND WIEN
FRANZ DEUTICKE
1905

**166  First edition of *Three Essays on the Theory of Sexuality*, 1905**
If mankind had been able to learn from a direct observation of children, these three essays could have remained unwritten. It must also be remembered, however, that some of what this book contains—its insistence on the importance of sexuality in all human achievements and the attempt that it makes at enlarging the concept of sexuality[1]—has from the first provided the strongest motives for the resistance against psycho-analysis. People have gone so far in their search for high-sounding catch-words as to talk of the "pan-sexualism" of psycho-analysis and to raise the senseless charge against it of explaining "everything" by sex.
*Three Essays on the Theory of Sexuality*

72    III. Die Umgestaltungen der Pubertät.

sog. erogener Zonen, als welche wahrscheinlich jede Hautstelle und jedes Sinnesorgan fungieren könne, während gewisse ausgezeichnete erogene Zonen existieren, deren Erregung durch gewisse organische Vorrichtungen von Anfang an gesichert sei. Ferner entstehe sexuelle Erregung gleichsam als Nebenprodukt bei einer großen Reihe von Vorgängen im Organismus, sobald dieselben nur eine gewisse Intensität erreichen, ganz besonders bei allen stärkeren Gemütsbewegungen, seien sie auch peinlicher Natur. Die Erregungen aus all diesen Quellen setzten sich noch nicht zusammen, sondern verfolgten jede vereinzelt ihr Ziel, welches bloß der Gewinn einer gewissen Lust ist. Der Geschlechtstrieb sei im Kindesalter also objektlos, autoerotisch.

Noch während der Kinderjahre beginne die erogene Zone der Genitalien sich bemerkbar zu machen, entweder in der Art, daß sie wie jede andere erogene Zone auf geeignete sensible Reizung Befriedigung ergebe, oder indem auf nicht ganz verständliche Weise mit der Befriedigung von anderen Quellen her gleichzeitig eine Sexualerregung erzeugt werde, die zu der Genitalzone eine besondere Beziehung erhalte. Wir haben es bedauern müssen, daß eine genügende Aufklärung des Verhältnisses zwischen Sexualbefriedigung und Sexualerregung sowie zwischen der Tätigkeit der Genitalzone und der übrigen Quellen der Sexualität nicht zu erreichen war.

Welches Maß von sexuellen Betätigungen im Kindesalter noch als normal, der weiteren Entwicklung nicht abträglich, bezeichnet werden darf, konnten wir nicht sagen. Der Charakter der Sexualäußerungen erwies sich als vorwiegend masturbatorisch. Wir stellten ferner durch Erfahrungen fest, daß die äußeren Einflüsse der Verführung vorzeitige Durchbrüche der Latenzzeit bis zur Aufhebung derselben hervorrufen können, und daß sich dabei der Geschlechtstrieb des Kindes in der Tat als polymorph pervers bewährt; ferner, daß jede solche frühzeitige Sexualtätigkeit die Erziehbarkeit des Kindes beeinträchtigt.

Trotz der Lückenhaftigkeit unserer Einsichten in das infantile Sexualleben mußten wir dann den Versuch machen, die durch das Auftreten der Pubertät gesetzten Veränderungen

Zusammenfassung.    73

desselben zu studieren. Wir griffen zwei derselben als die maßgebenden heraus, die Unterordnung aller sonstigen Ursprünge der Sexualerregung unter das Primat der Genitalzonen und den Prozeß der Objektfindung. Beide sind im Kinderleben bereits vorgebildet. Die erstere vollzieht sich durch den Mechanismus der Ausnützung der Vorlust, wobei die sonst selbständigen sexuellen Akte, die mit Lust und Erregung verbunden sind, zu vorbereitenden Akten für das neue Sexualziel, die Entleerung der Geschlechtsprodukte werden, dessen Erreichung unter riesiger Lust der Sexualerregung ein Ende macht. Wir hatten dabei die Differenzierung des geschlechtlichen Wesens zu Mann und Weib zu berücksichtigen und fanden, daß zum Weibwerden eine neuerliche Verdrängung erforderlich ist, welche ein Stück infantiler Männlichkeit aufhebt und das Weib für den Wechsel der leitenden Genitalzone vorbereitet. Die Objektwahl endlich fanden wir geleitet durch die infantilen, zur Pubertät aufgefrischten, Andeutungen sexueller Neigung des Kindes zu seinen Eltern und Pflegepersonen, und durch die mittlerweile aufgerichtete Inzestschranke von diesen Personen auf ihnen ähnliche gelenkt. Fügen wir endlich noch hinzu, daß während der Übergangszeit der Pubertät die somatischen und die psychischen Entwicklungsvorgänge eine Weile unverknüpft neben einander hergehen, bis mit dem Durchbruch einer intensiven seelischen Liebesregung zur Innervation der Genitalien die normalerweise erforderte Einheit der Liebesfunktion hergestellt wird.

Jeder Schritt auf diesem langen Entwicklungswege kann zur Fixierungsstelle, jede Fuge dieser verwickelten Zusammensetzung zum Anlaß der Dissoziation des Geschlechtstriebes werden, wie wir bereits an verschiedenen Beispielen erörtert haben. Es erübrigt uns noch eine Übersicht der verschiedenen, die Entwicklung störenden inneren und äußeren Momente zu geben und beizufügen, an welcher Stelle des Mechanismus die von ihnen ausgehende Störung angreift. Was wir da in einer Reihe anführen, kann freilich unter sich nicht gleichwertig sein, und wir müssen auf Schwierigkeiten rechnen, den einzelnen Momenten die ihnen gebührende Abschätzung zuzuteilen.

*Entwicklungsstörende Momente.*

For the most remarkable feature of the sexual life of man is its *diphasic* onset, its onset in two waves, with an interval between them. It reaches a climax in the fourth or fifth year of a child's life. But thereafter this early efflorescence of sexuality passes off [ . . . ]. Of all living creatures man alone seems to show this diphasic onset of sexual growth, and it may perhaps be the biological determinant of his predisposition to neuroses.
*An Autobiographical Study*

  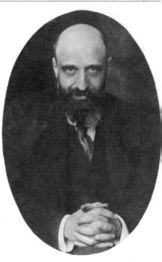

It is difficult to practice
psychoanalysis in isolation;
it is an exquisitely sociable
enterprise.
*Letter to George Groddeck,*
*December 21, 1924*

I am certainly unfit to be a
chief, the *"splendid isolation"*
of my decisive years has set its
stamp on my character.
*Letter to C. G. Jung, April 19,*
*1908*

**167   Wilhelm Stekel**
You are mistaken if you think
that I hate or have hated you.
[ . . . ] I admit that you
have remained loyal to
psychoanalysis and have been
of use to it; you have also done
it great harm.
*Letter to Wilhelm Stekel,*
*January 13, 1924*

You see only the injustice that
has been done to you, and
overlook the mistakes that you
have made. Had you realized
in time the sources of the
rivalry between your pupils,
you could have retained many
valuable supporters. It was not
only a fight between pretenders
to the throne, but a struggle
for your love. It was rather
jealousy over your heart than
claims upon your head.
*Letter from Wilhelm Stekel to*
*Freud, January 22, 1924*

*Wilhelm Stekel, 1868-1940,*
*a member, until he left it in*
*1912, of the "Psychological*
*Wednesday Society," a*
*discussion group of early*
*adherents of psychoanalysis*
*who met to work together every*
*Wednesday in Freud's waiting*
*room in Berggasse.[1] In 1910*
*Stekel was co-founder of the*
Zentralblatt für Psycho-
analyse.[2]

**168   Ludwig Jekels**
Ludwig Jekels, in a recent
Shakespearean study,[1] thinks
he has discovered a particular
technique of the poet's, and
this might apply to *Macbeth.*
He believes that Shakespeare
often splits a character up into
two personages, which, taken
separately, are not completely
understandable and do not
become so until they are
brought together once more
into a unity.
"Some Character-Types met
with in Psycho-Analytic
Work"

It is principally due to L. Jekels
that psycho-analysis has been
introduced to Polish scientific
and literary circles.
"On the History of the Psycho-
Analytic Movement"

*Ludwig Jekels, 1861-1954,*
*member of the "Psychological*
*Wednesday Society"*

**169   Paul Federn**
He is equipped with an
unusually good medical
training as an internist,
considerable specialist
knowledge of psychiatry, and
a comprehensive general
education, as well as a large
number of cultural and social
interests. He has won a
distinguished place among
Viennese analysts, and gained
the right to be considered
a worthy representative of
psychoanalysis in Vienna.
Numerous scientific pub-
lications have brought his
name into prominence in the
literature, and the Analytical
Training Institute in Vienna
has given him the opportunity
to develop a full schedule of
teaching activity for both
native and foreign students.
*From a letter of*
*recommendation by Freud*

*Paul Federn, 1871-1950,*
*member of the "Psychological*
*Wednesday Society"*

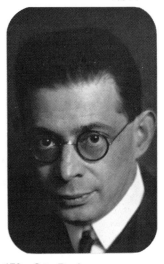

**170   Alfred Adler**

In Vienna there has been a small crisis [ . . . ]. Adler and Stekel have resigned [ . . . ]. Adler's theories were departing too far from the right path, and it was time to make a stand against them. He forgets the saying of the apostle Paul the exact words of which you know better than I: "And I know that ye have not love in you." He has created for himself a world system without love, and I am in the process of carrying out on him the revenge of the offended goddess Libido. I have always made it my principle to be tolerant and not to exercise authority, but in practice it does not always work. It is like cars and pedestrians. When I began going about by car I got just as angry at the carelessness of pedestrians as I used to be at the recklessness of drivers.
*Letter to Oskar Pfister, February 26, 1911*

*Alfred Adler, 1870-1937, member of the "Psychological Wednesday Society" until he broke with Freud in 1911; editor of the* Zentralblatt für Psychoanalyse; *founder of "individual psychology."*

**171   Eduard Hitschmann**

Only a funeral oration at the Central Cemetery is normally as beautiful and affectionate as the speech[1] you did not deliver. I realised that you are able to express things well—you have often proved this in publications—but on this occasion I am downright moved, probably because I myself am the subject. No doubt I have meant to be and to do everything you say about me, but will it be possible in more sober hours to maintain that I succeeded? I don't know, but what I do know is that in order to live one needs a few people who believe it.
*Letter to Eduard Hitschmann, May 7, 1916*

*Eduard Hitschmann, 1871-1958, member of the "Psychological Wednesday Society"*

**172   Hanns Sachs**

In the work of psycho-analysis links are formed with numbers of other mental sciences, the investigation of which promises results of the greatest value: links with mythology and philology, with folklore, with social psychology and the theory of religion. You will not be surprised to hear that a periodical has grown up on psycho-analytic soil whose sole aim is to foster these links. This periodical is known as *Imago*, founded in 1912 and edited by Hanns Sachs and Otto Rank.
*Introductory Lectures on Psycho-Analysis*

In 1913 Otto Rank and Hanns Sachs, in an extremely interesting work (*The Significance of Psychoanalysis for the Mental Sciences*) brought together the results which had been achieved up to that time in the application of psycho-analysis to the mental sciences.
*Preface to Reik's* Ritual: Psycho-Analytic Studies

*Hanns Sachs, 1881-1947, member of the "Psychological Wednesday Society." He worked as an analyst from 1910, and was later a training analyst in Berlin.*

**173   Otto Rank**

One day a young man who had passed through a technical training college introduced himself with a manuscript which showed very unusual comprehension. We persuaded him to go through the *Gymnasium* (Grammar School) and the University and to devote himself to the non-medical side of psycho-analysis. The little society[1] acquired in him a zealous and dependable secretary and I gained in Otto Rank a most loyal helper and co-worker.
"On the History of the Psycho-Analytic Movement"

Otto Rank, in a large volume on the incest complex,[2] has produced evidence of the surprising fact that the choice of subject-matter, especially for dramatic works, is principally determined by the ambit of what psycho-analysis has termed the "Oedipus Complex." By working it over with the greatest variety of modifications, distortions and disguises, the dramatist seeks to deal with his own most personal relations to this emotional theme.
*Preface to Reik's* Ritual: Psycho-Analytic Studies

*Otto Rank, 1884-1939, secretary of the "Psychological Wednesday Society." He broke with Freud in 1924.*

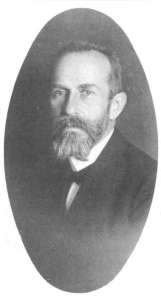

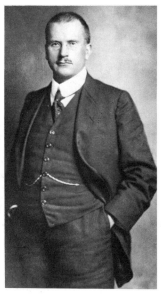

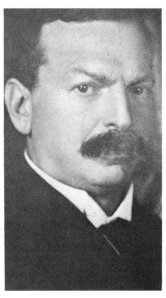

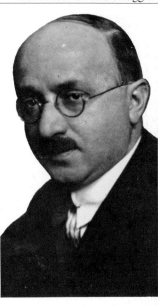

**174   Eugen Bleuler**
In 1907, the situation changed all at once and contrary to all expectations. It appeared that psycho-analysis had unobtrusively awakened interest and gained friends, and that there were even some scientific workers who were ready to acknowledge it. A communication from Bleuler had informed me before this that my works had been studied and made use of in the Burghölzli.
"On the History of the Psycho-Analytic Movement"

*Eugen Bleuler, 1857-1939, professor of psychiatry at the University of Zürich and director of the cantonal sanatorium and University psychiatric clinic "Burghölzli." It was from him and his collaborators, particularly C. G. Jung, that Freud had the first official recognition of his discoveries. Together with Freud, from 1909 to 1913, Bleuler edited the* Jahrbuch für psychoanalytische und psychopathologische Forschungen, *the first psychoanalytic periodical.*[1]

**175   C. G. Jung**
We are certainly getting ahead; if I am Moses, then you are Joshua and will take possession of the promised land of psychiatry, which I shall only be able to glimpse from afar.
*Letter to C. G. Jung, January 17, 1909*

I think I have made clear [ . . . ] that the new teaching which aims at replacing psycho-analysis signifies an abandonment of analysis and a secession from it. Some people may be inclined to fear that this secession is bound to have more momentous consequences for analysis than would another, owing to its having been started by men who have played so great a part in the movement and have done so much to advance it. I do not share this apprehension.
"On the History of the Psycho-Analytic Movement"

*Carl Gustav Jung, 1875-1961, subeditor of the* Jahrbuch für psychoanalytische und psychopathologische Forschungen *and president of the International Psycho-Analytical Association from 1910 until he broke with Freud in 1914.*[1] *Founder of "analytical psychology."*

**176   Oskar Pfister**
In itself psycho-analysis is neither religious nor non-religious, but an impartial tool which both priest and laymen can use in the service of the sufferer. I am very much struck by the fact that it never occurred to me how extraordinarily helpful the psycho-analytic method might be in pastoral work, but that is surely accounted for by the remoteness from me, as a wicked pagan, of the whole system of ideas.
*Letter to Oskar Pfister, February 9, 1909*

*Oskar Pfister, 1873-1956, Protestant minister and pedagogue in Zürich. He came across Freud's writings in 1908 and studied the application of the findings of psychoanalysis to education.*

**177   Max Eitingon**
You were the first emissary[1] to reach the lonely man, and if I should ever be deserted again you will surely be among the last to remain with me.
*Letter to Max Eitingon, January 7, 1913*

Thirty years, dear Friend, is a long time, even for an old man like me. I thank you for drawing my attention to this our anniversary. You will have to be content with the recognition that during this time you have played a most laudable role in our movement and that on the most diverse occasions and in various concerns you have been personally as close to me as few others.
*Letter to Max Eitingon, February 5, 1937*

*Max Eitingon, 1881-1943, founded, in 1920, the first psychoanalytical clinic in Berlin. From 1927 to 1932 he was president of the International Psycho-Analytical Association. In 1933 he founded the Palestinian Psycho-Analytical Association.*

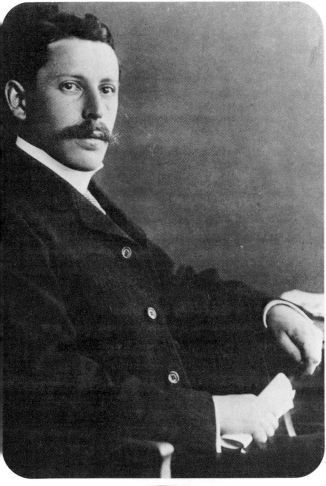

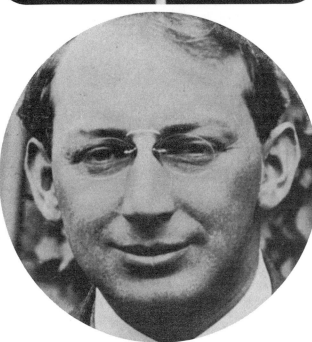

### 178   Karl Abraham

No harm can come to a young man like you from being forced into the open *au grand air*,[1] and the fact that things will be more difficult for you as a Jew will have the effect, as it has with all of us, of bringing out the best of which you are capable. [ . . . ] If my reputation in Germany increases, it will certainly be useful to you, and if I may refer to you as my pupil and follower—you do not seem to me to be a man to be ashamed of that description—I shall be able to back you vigorously.
*Letter to Karl Abraham, October 8, 1907*

[ . . . ] gloomy times lie ahead, and recognition will come only for the next generation. But we have the incomparable satisfaction of having made the first discoveries.
*Letter to Karl Abraham, January 2, 1912*

*Karl Abraham, 1877-1925, psychoanalyst in Germany from 1907 onwards; founded, in 1910, the Berlin Psycho-Analytical Society. From 1924 to 1925 he was president of the International Psycho-Analytical Association.*

### 179   Sándor Ferenczi

Hungary [ . . . ] has produced only one collaborator, S. Ferenczi, but one that indeed outweighs a whole society.
"On the History of the Psycho-Analytic Movement"

I am revelling in satisfaction, my heart is light since I know that my problem child, my life's work, is protected by your interest and that of others, and its future taken care of.
*Letter to Sándor Ferenczi, September 30, 1918*

*Sándor Ferenczi, 1873-1933; founded, in 1913, the Hungarian Psycho-Analytical Association; president, 1918-1920, of the International Psycho-Analytical Association.*

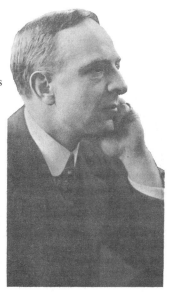

### 180   Ernest Jones

Thus many things that I could have said to you in response to your letter must remain unwritten. Not, however, the assurance that I have always looked upon you as a member of my intimate family circle and will continue to do so, which points (beyond all disagreements that are rarely absent within a family and also have not been lacking between us) towards a fount of affection from which one can always draw again. [ . . . ] It is not in my nature to give expression to my feelings of affection, with the result that I often appear indifferent, but my family knows better.
*Letter to Ernest Jones, January 1, 1929*

*Ernest Jones, 1879-1958, founder of the British Psycho-Analytical Society; from 1932 to 1949 president of the International Psycho-Analytical Association. Freud's biographer.*[1]

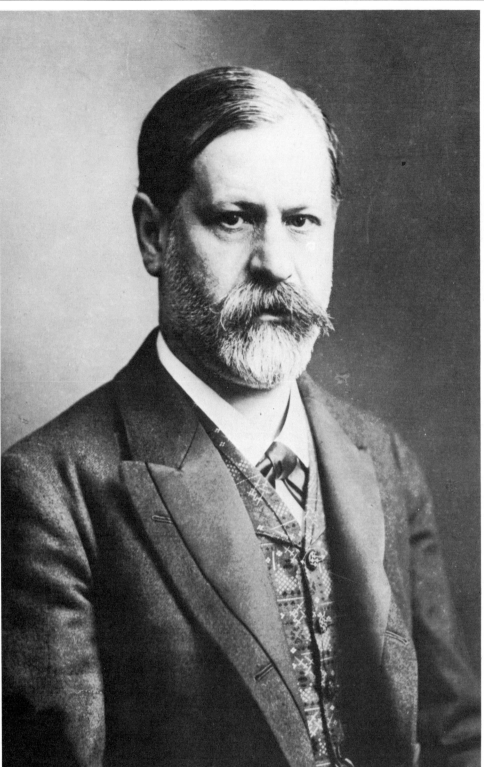

**181   Freud, about 1906**
In the last fifteen years I have
never willingly sat for a
photographer, because I am
too vain to countenance my
physical deterioration. Two
years ago I was obliged (by
the regulations) to have my
picture taken for the Hygiene
Exhibition, but I so detest the
picture that I won't lift a finger
to let you have it. At about the
same time my boys took a
picture of me; it is much better,
not at all artificial.
*Letter to C. G. Jung,
September 19, 1907*

*Left, the photograph for the
Hygiene Exhibition; right, the
photograph taken by his sons*

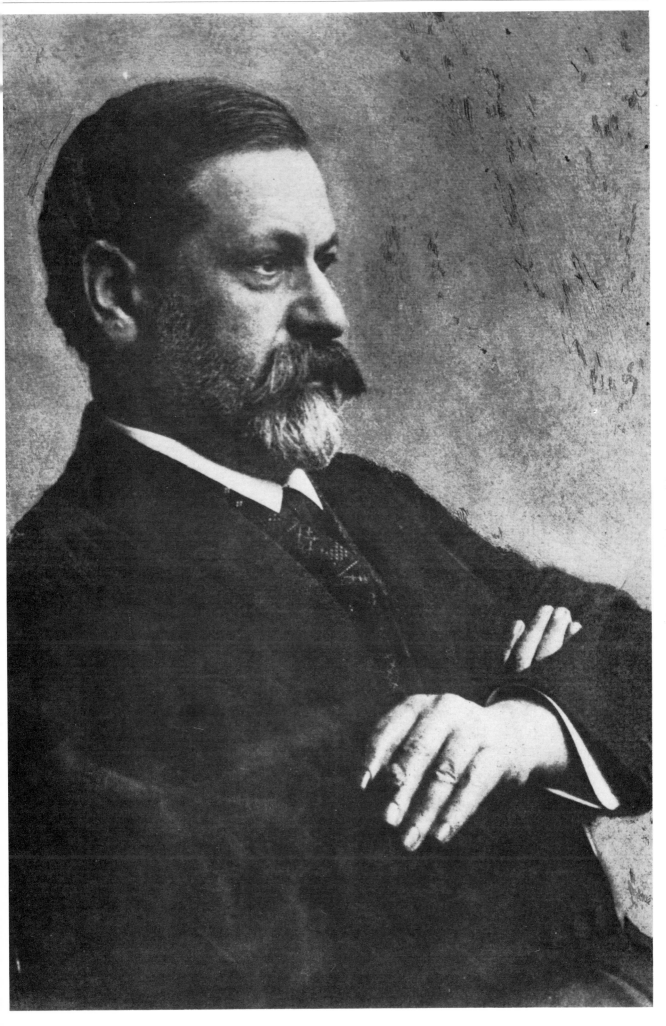

*(Preis: 4 h)*                                                                     **II.**

# Legitimation.

(Zugleich Bestätigung.)

Herr Dr. med. *Eduard Hitschmann*

aus *Wien*

wurde heute als Frequentant der k. k. medizinischen

Fakultät in Wien inskribiert

für { die Vorlesung / den Kurs . . } über *Einführung in d. Psychotherapie*

und hat an Kollegiengeld K *10* „ erlegt.

Von dem Herrn Frequentanten auszufüllen!

Unterschrift des Dozenten.        Unterschrift des k. k. Quästors.

*1905*

---

# DER WITZ

### UND SEINE BEZIEHUNG

## ZUM UNBEWUSSTEN

VON

PROF. DR. SIGM. FREUD

IN WIEN.

LEIPZIG UND WIEN
FRANZ DEUTICKE
1905.

---

**182   Authorization[1] to attend a lecture by Freud, 1905**

Psycho-analysis is not to be blamed for a [ . . . ] difficulty in your relation to it; I must make you yourselves responsible for it, Ladies and Gentlemen, or at least in so far as you have been students of medicine. Your earlier education has given a particular direction to your thinking, which leads far away from psycho-analysis. You have been trained to find an anatomical basis for the functions of the organism and their disorders, to explain them chemically and physically and to view them biologically. But no portion of your interest had been directed to psychical life, in which, after all, the achievement of this marvellously complex organism reaches its peak. For that reason psychological modes of thought have remained foreign to you. You have grown accustomed to regarding them with suspicion, to denying them the attribute of being scientific, and to handing them over to laymen, poets, natural philosophers and mystics. This limitation is without doubt detrimental to your mental activity [ . . . ]. This is the gap which psycho-analysis seeks to fill. It tries to give psychiatry its missing psychological foundation. It hopes to discover the common ground on the basis of which the convergence of physical and mental disorder will become intelligible. With this aim in view, psycho-analysis must keep itself free from any hypothesis that is alien to it, whether of an anatomical, chemical or physiological kind, and must operate entirely with purely psychological auxiliary ideas; and for that very reason, I fear, it will seem strange to you to begin with.
*Introductory Lectures on Psycho-Analysis*

**183   First edition of the book on jokes, 1905**

Let me confess that I have recently made a collection of deeply significant Jewish stories.
*Letter to Wilhelm Fliess, June 12, 1897*

My book on *Jokes and their Relation to the Unconscious* was a side-issue directly derived from *The Interpretation of Dreams*. The only friend[1] of mine who was at that time interested in my work remarked to me that my interpretations of dreams often impressed him as being like jokes. In order to throw some light on this impression, I began to investigate jokes and found that their essence lay in the technical methods employed in them, and that these were the same as the means used in the "dream-work"—that is to say, condensation, displacement, the representation of a thing by its opposite or by something very small, and so on. This led to an economic enquiry into the origin of the high degree of pleasure obtained from hearing a joke. And to this the answer was that it was due to the momentary suspension of the expenditure of energy upon maintaining repression [ . . . ].
*An Autobiographical Study*

**184   Freud's doodles**
*Drawn during a meeting of the Vienna "Psychological Wednesday Society"[1]*

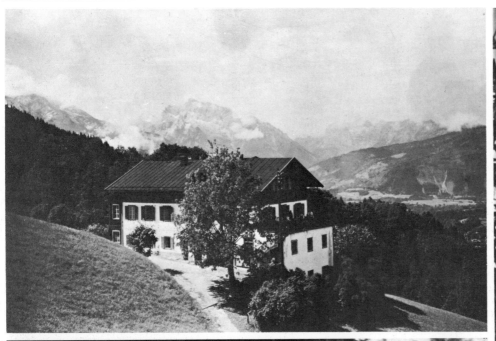

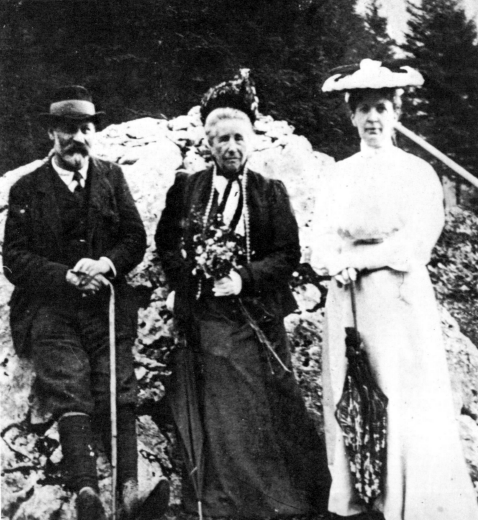

**186    With his mother and wife in Altaussee, 1905**

**185    Summer holidays: Dietfeldhof in Berchtesgaden**
Indeed if I weren't already very impatient to get to the Dietfeldhof, your letter would make me so. I also liked it very much when I was there for the first time in April,[1] when white snow still lay between the clumps of yellow primroses. Strawberries and mushrooms are a very welcome prospect; we are bound to discover some lovely walks in no time. Perhaps we can rent the Aschauer pond for ourselves alone, so that there will be room for us all to bathe. [ . . . ] As for us, we will read and write and wander about in the woods; if only the Almighty doesn't spoil the summer for us by making it rain all the time, it can be very beautiful.
*Letter to Anna Freud, July 7, 1908*

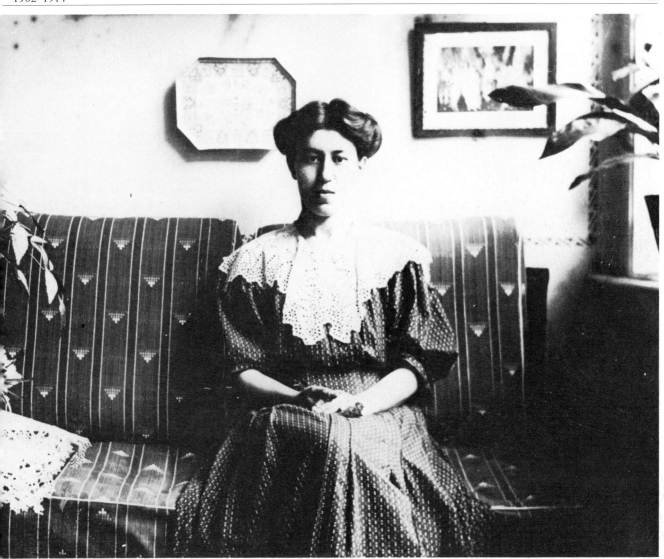

**187  Daughter Mathilde**

I have guessed for a long time that in spite of all your common sense you fret because you think you are not good-looking enough and therefore might not attract a man.[1] I have watched this with a smile, first of all because you seem quite attractive enough to me, and secondly because I know that in reality it is no longer physical beauty which decides the fate of a girl, but the impression of her whole personality. Your mirror will inform you that there is nothing common or repellent in your features, and your memory will confirm the fact that you have managed to inspire respect and sympathy in any circle of human beings.
*Letter to Mathilde Freud, March 26, 1908*

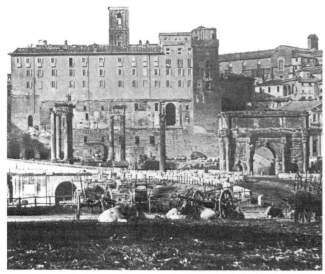

**188   Rome: the Forum**
What a pity one can't live here
always! These brief visits leave
one with an unappeased
longing and a feeling of
insufficiency all the way round.
*Letter to the Family,*
*September 24, 1907*

**189    Rome: Hotel brochure**[1]
[ . . . ] before the war and once
after its end I felt compelled
to spend every year at least
several days or weeks in
Rome [ . . . ].
*Letter to Stefan Zweig,*
*February 7, 1931*

### 190    Pompeian relief, Vatican Museums

Just imagine my joy when, after being alone so long, I saw today in the Vatican a dear familiar face! The recognition was one-sided however, for it was the Gradiva [ . . . ].
*Letter to Martha Freud, September 24, 1907*

A young archaeologist [ . . . ] had discovered in a museum of antiquities in Rome a relief which had so immensely attracted him that he was greatly pleased at obtaining an excellent plaster cast of it which he could hang in his study in a German university town [ . . . ]. The sculpture represented a fully-grown girl stepping along with her flowing dress a little pulled up so as to reveal her sandalled feet. One foot rested squarely on the ground; the other, lifted from the ground in the act of following after, touched it only with the tip of the toes, while the sole and heel rose almost perpendicularly. It was probably the unusual and peculiarly charming gait thus presented that attracted the sculptor's notice.
*Delusions and Dreams in Jensen's "Gradiva"*

*Freud's work on the short story* Gradiva; Ein pompejanisches Phantasiestück *by Wilhelm Jensen, 1837-1911, was the first considerable piece of research on a literary work which he published (1907): "But creative writers are valuable allies, and their evidence is to be prized highly, for they are apt to know a whole host of things between heaven and earth of which our philosophy has not yet let us dream."* [1] *The relief plays a central part in Jensen's story. There was also a plaster cast of it hanging in Freud's study.*

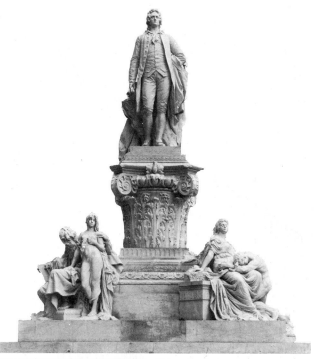

### 191    Goethe's monument in Rome

[ . . . ] a statue of Victor Hugo [ . . . ] so annoyed Kaiser Wilhelm that out of envy he had Eberlein make the statue of Goethe which he had set up in the same garden. It is quite clever but nothing wonderful. Goethe looks too youthful; after all he was over 40 when he first came to Rome; he stands on a shaft of a column, or rather on a chapiter, and the pedestal is surrounded by three groups: Mignon with the harpist (who is perhaps the best); Mignon herself has an empty face; Faust reading from a book while Mephisto looks over his shoulder; Faust himself quite good, the devil rather grotesque, a Jewish face with a cock's comb and horns, and a third group which I cannot interpret, perhaps Iphigenia and Orestes, but if so, it's hard to recognize.
*Letter to the Family, September 21, 1907*

**192 Medallion by Schwerdtner**
The best and most flattering of all is probably the medallion[1] that K. M. Schwerdtner made for my fiftieth birthday.
*Letter to C. G. Jung, September 19, 1907*

**193 Freud, about 1906**
[ . . . ] but now [ . . . ] I wish I were with you [ . . . ] telling you about my long years of honorable but painful solitude, which began after I cast my first glance into the new world, about the indifference and incomprehension of my closest friends, about the terrifying moments when I myself thought I had gone astray and was wondering how I might still make my misled life useful to my family, about my slowly growing conviction, which fastened itself to the interpretation of dreams as to a rock in a stormy sea, and about the serene certainty which finally took possession of me [ . . . ].
*Letter to C. G. Jung, September 2, 1907*

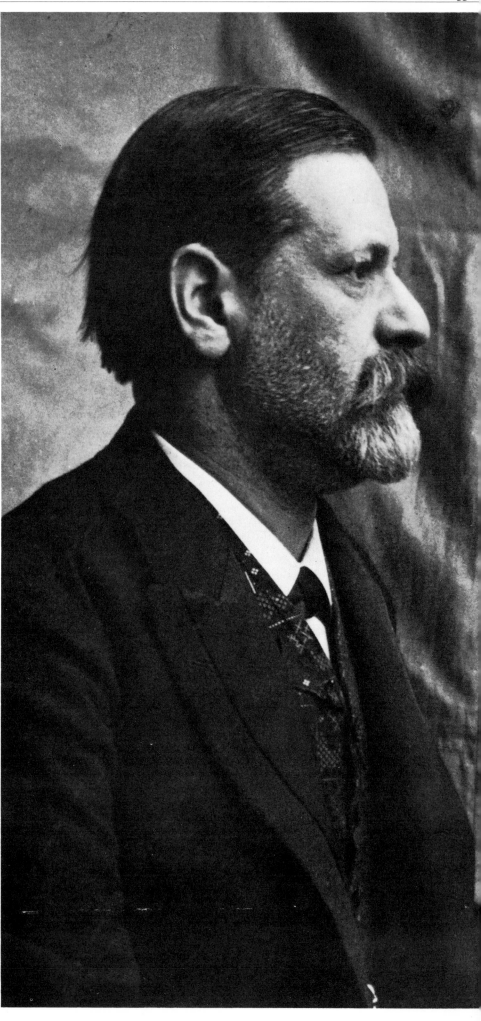

1. Congress für Freud'sche Psychologie.

Sehr geehrter Herr!

Es ist von Seiten verschiedener Anhänger der Freud'schen Lehre der Wunsch nach einer jährlichen Zusammenkunft ausgesprochen worden, um Gelegenheit zur Diskussion und zum Austausch von Erfahrungen zu bekommen. Da die bis jetzt spärlichen Anhänger der Freud'schen Ideen über ganz Europa zerstreut sind, so wurde allgemein als Zeitpunkt unserer ersten Zusammenkunft die Zeit unmittelbar nach dem diesjährigen III. Congress für experimentelle Psychologie in Frankfurt (22.—25. April) vorgeschlagen, um namentlich den Herren Kollegen aus dem Westen Europa's die Teilnahme zu erleichtern. Als Zusammenkunftsort ist **Salzburg** in Aussicht genommen.

Als vorläufiges Programm wird vorgeschlagen:

26. April Abends : Ankunft und Vereinigung in Salzburg.
27.    „    Sitzung. Vorsitzender : Hr. Prof. Dr. S. Freud.
28.    „    Abreise.

Vorträge, casuistische Mitteilungen und formulierte Fragestellungen sind **sehr willkommen**. Anmeldungen dieser Art wollen Sie gefl. **vor dem 15. Februar** an Unterzeichneten senden.

Sollten Sie gesonnen sein, an der Zusammenkunft teilzunehmen, so sind Sie höfl. gebeten, Ihren Entschluss bis zum 5. Februar dem Unterzeichneten mitzuteilen. — Das definitive Programm wird Ihnen später zugehen.

Mit vorzüglicher Hochachtung:

Burghölzli - Zürich
Januar 1908.

Dr. C. G. Jung
Privatdozent der Psychiatrie.

---

## Programm
### für die
### Zusammenkunft in Salzburg.
#### 26. — 27. April 1908.

26. April : Abends Ankunft in Salzburg.
Zwanglose Vereinigung im „Hôtel Bristol."
Für die Herren, die ihre Beteiligung angemeldet haben, ist Logis bestellt im „Hôtel Bristol."
27. April : **Morgens 8 Uhr : Sitzung.** (Das Lokal wird am 26. Abends bekannt gegeben).

### Vorträge.

1. Herr Prof. Dr. S. Freud — Wien :   Casuistisches.
2.   „   „   E. Jones — London :   Rationalisation in every day life.
3.   „   „   Sadger — Wien :   Zur Aetiologie der Psychopathia sexualis.
4.   „   „   Morton Prince — Boston :   Experiments showing psychogalvanic reactions from the subconsciousness in a case of multiple personality.
5.   „   „   Abraham — Berlin :   Psychosexuelle Differenzen zwischen Dementia praecox und Hysterie.
6.   „   „   Stekel — Wien :   Ueber Angsthysterie.
7.   „   „   Adler — Wien :   Sadismus in Leben und Neurose.
8.   „   „   Jung — Zürich :   Ueber Dementia praecox.

Den Herren Vortragenden steht ½ Stunde **Redezeit** zur Verfügung. **Diskussion** findet Abends statt.

**Mittags 1 Uhr :** Gemeinschaftliches Mittagessen im „Hôtel Bristol."
**Nachmittags :** bei gutem Wetter gemeinsamer Spaziergang.
**Abends :** Vereinigung im „Hôtel Bristol."
  1. Diskussion der Vorträge.
  2. Herr Dr. Stein — Budapest : Wie ist die durch die Analyse freigewordene Libido in therapeutisch günstige Bahnen zu lenken ?
  3. Herr Dr. Ferenczi — Budapest : Welche praktischen Winke ergeben sich aus den Freud'schen Erfahrungen für die Kindererziehung ?
  4. Administrative Fragen.

---

**194 Announcement of the First International Psycho-Analytical Congress, 1908**
[ . . . ] at Easter 1908 the friends of the young science met at Salzburg, agreed upon the regular repetition of similar informal congresses and arranged for the publication of a journal[1] [ . . . ].
*An Autobiographical Study*

**196 Picture postcard from Salzburg**
I am very glad that you regard Salzburg as a gratifying event. I am in no position to judge, as I am in the thick of it, but I too am inclined to regard this first gathering as a promising experiment.
*Letter to Karl Abraham, May 3, 1908*

*On the left is the hotel in which the Congress took place. Freud sent this card to his family from Salzburg.*

**195 Program of the Congress**
I believe there is still another matter of importance for our program. You have not yet told me whether you wish to allow *discussion*, and how it is to be controlled. If the latter precaution is not taken, it is perfectly possible that we shall not get beyond the second lecture in one morning. [ . . . ] Perhaps we could dispense with discussion altogether in the morning session and make up for it by allotting more time to each lecture.
*Letter to C. G. Jung, March 5, 1908*

American Journal of Psychology

VOL. XXI                                                   No. 2

TABLE OF CONTENTS

Communications may be sent to any one of the three editors.

All books, pamphlets, off-printed articles, etc., intended for notice in the
JOURNAL should be addressed to the AMERICAN JOURNAL OF PSYCHOLOGY, in
care of Professor E. C. Sanford, Clark College, Worcester, Mass.

Contributors, especially those sending reviews, are requested to follow the
method of citation employed by this JOURNAL, in every case the year, volume and
pages should be given

THE AMERICAN JOURNAL OF PSYCHOLOGY is published quarterly. The sub-
scription price is $5.00 a year   Single numbers $1.50.  Remittances and business
communications should be addressed to FLORENCE CHANDLER, Clark University,
Worcester, Mass.

THE AMERICAN

JOURNAL OF PSYCHOLOGY

Founded by G. STANLEY HALL in 1887

VOL. XXI            APRIL, 1910            No. 2

## THE ORIGIN AND DEVELOPMENT OF PSYCHOANALYSIS[1]

By PROF. SIGMUND FREUD (Vienna)

### FIRST LECTURE

Ladies and Gentlemen: It is a new and somewhat embar-
rassing experience for me to appear as lecturer before students
of the New World. I assume that I owe this honor to the
association of my name with the theme of psychoanalysis, and
consequently it is of psychoanalysis that I shall aim to speak.
I shall attempt to give you in very brief form an historical
survey of the origin and further development of this new
method of research and cure.

Granted that it is a merit to have created psychoanalysis,
it is not my merit. I was a student, busy with the passing of
my last examinations, when another physician of Vienna, Dr.
Joseph Breuer,[2] made the first application of this method to
the case of an hysterical girl (1880-82). We must now ex-
amine the history of this case and its treatment, which can be
found in detail in "Studien über Hysterie," later published
by Dr. Breuer and myself.[3]

But first one word. I have noticed, with considerable satis-

[1] Lectures delivered at the Celebration of the Twentieth Anniversary
of the opening of Clark University, Sept., 1909; translated from the
German by Harry W. Chase, Fellow in Psychology, Clark University,
and revised by Prof. Freud.
[2] Dr. Joseph Breuer, born 1842, corresponding member of the
"Kaiserliche Akademie der Wissenschaften," is known by works on
respiration and the physiology of the sense of equilibrium.
[3] "Studien über Hysterie," 1895, Deuticke, Vienna. Second edi-
tion, 1909. Parts of my contributions to this book have been trans-
lated into English by Dr. A. A. Brill, of New York. ("Selected
Papers on Hysteria and other Psychoneuroses, by S. Freud.")

**197   First publication of the American lectures, 1910**

The introduction of psycho-
analysis into North America
was accompanied by very
special marks of honor. In the
autumn of 1909, Stanley Hall,
the President of Clark
University, Worcester,
Massachusetts, invited Jung
and myself to take part in the
celebration of the twentieth
anniversary of the foundation
of the University by giving a
number of lectures in German.
To our great surprise, we
found the members of that
small but highly esteemed
University for the study of
education and philosophy so
unprejudiced that they were
acquainted with all the
literature of psycho-analysis
and had given it a place in their
lectures to students. In prudish
America it was possible, in
academic circles at least, to
discuss freely and scientifically
everything that in ordinary life
is regarded as objectionable.
The five lectures which I
improvised in Worcester
appeared in an English
translation in the *American
Journal of Psychology* and were
shortly afterwards published in
German under the title *Über
Psychoanalyse.*[1]
*"On the History of the Psycho-
Analytic Movement"*

**198   Certificate of Freud's
honorary doctorate,[1] 1909**

We were rewarded with the
honorary degree of Doctor of
Laws.
"On the History of the Psycho-
Analytic Movement"

At that time I was only fifty-
three. I felt young and healthy,
and my short visit to the new
world encouraged my self-
respect in every way. In
Europe I felt as though I were
despised; but over there I
found myself received by the
foremost men as an equal. As I
stepped on to the platform at
Worcester to deliver my *Five
Lectures on Psycho-Analysis* it
seemed like the realization of
some incredible day-dream:
psycho-analysis was no longer
a product of delusion, it had
been a valuable part of reality.
*An Autobiographical Study*

**199  Granville Stanley Hall**
Who would have imagined
that over in America, an hour's
train journey from Boston, a
worthy old gentleman was
sitting and waiting impatiently
for the Year Book,[1] reading
and understanding everything,
and then, as he himself put it,
ringing the bell for us?
*Letter to Oskar Pfister,
October 4, 1909*

*Granville Stanley Hall, 1846-
1924, professor of psychology
and President of Clark
University, Worcester,
Massachusetts*

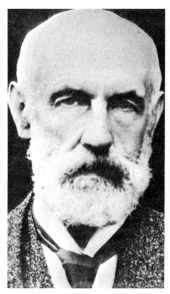

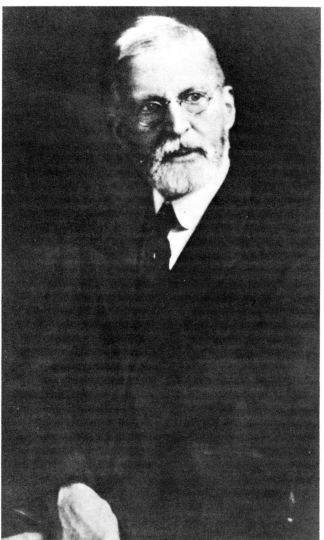

**200  James J. Putnam**
The most important personal
relationship which arose from
the meeting at Worcester was
that with James J. Putnam
[ . . . ]. The esteem he enjoyed
throughout America on
account of his high moral
character and unflinching love
of truth was of great service to
psycho-analysis and protected
it against the denunciations
which in all probability would
have otherwise quickly have
overwhelmed it. Later on,
yielding too much to the strong
ethical and philosophical bent
of his nature, Putnam made
what seems to me an
impossible demand—he
expected psycho-analysis to
place itself at the service of a
particular moral-philosophical
conception of the Universe—
but he remains the chief pillar
of the psycho-analytic
movement in his native land.
"On the History of the Psycho-
Analytic Movement"

James J. Putnam, 1846-1918,
professor of neuropathology at
Harvard University[1]

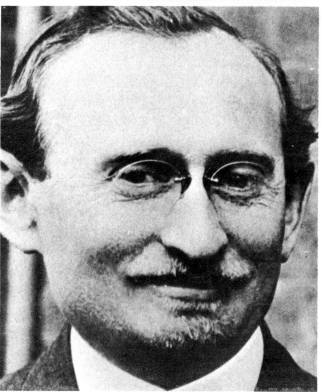

**201  Abraham A. Brill**
For the further spread of this
movement Brill and Jones
deserve the greatest credit: in
their writings they drew their
countrymen's attention with
unremitting assiduity to the
easily observable fundamental
facts of everyday life, of
dreams and neurosis. Brill has
contributed still further to this
effect by his medical practice
and by his translations of my
works [ . . . ].
"On the History of the Psycho-
Analytic Movement"

Abraham A. Brill, 1874-1948.
Brill was the first and only
American doctor to take part
as early as 1908 in the
International Psycho-
Analytical Congress in
Salzburg. In 1921 he founded
the American Psychoanalytic
Association in New York.

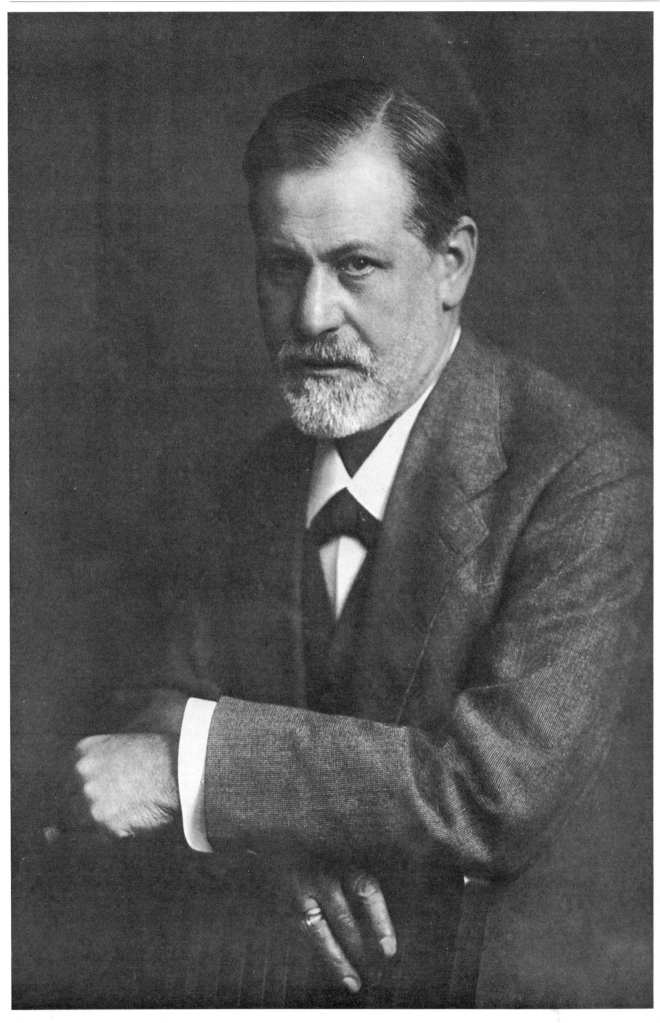

## II. Psychoanalytische Vereinigung in Nürnberg
∴ am 30. und 31. März 1910 ∴

### Abgeändertes Programm.

**30. März,**

**Vormittags 8¹/₂ Uhr:** Vorträge von

1. Prof. FREUD: Die zukünftigen Chancen der Psychotherapie.
2. Dr. ABRAHAM: Psychoanalyse des Fetischismus.
3. Dr. MARCINOWSKY: Sejunktive Prozesse als Grundlage der Psychoneurosen.
4. Dr. STEGMANN: Psychoanalyse und andere Behandlungsarten in der nerven-ärztlichen Praxis.
5. Dr. HONEGGER: Über paranoide Wahnbildung.

**Nachmittags 5 Uhr:**

1. Vortrag von Dr. LÖWENFELD: Über Hypnotherapie.
2. Referat von Dr. FERENCZI: Über die Notwendigkeit eines engeren Zusammen-schliessens der Anhänger der Freud'schen Lehre und Vorschläge zu einer ständigen internationalen Organisation.

**31. März,**

**Vormittags 8¹/₂ Uhr:** Vorträge von

1. Dr. JUNG: Bericht über Amerika.
2. Dr. ADLER: Über psychischen Hermaphroditismus.
3. Dr. MÄDER: Zur Psychologie der Paranoiden.
4. Referat von Dr. STEKEL: Vorschläge zur Sammelforschung im Gebiete der Symbolik und der typischen Träume.

**Nachmittags:** Zwanglose Zusammenkunft.

Alles nähere wird in den Sitzungen bekannt gegeben.
Die Verhandlungen finden im Grand-Hôtel statt.

Juli 1910 No. 1

# CORRESPONDENZBLATT
### der internationalen psychoanalytischen Vereinigung

REDAKTION: DR. C. G. JUNG, KÜSNACHT b ZÜRICH, ZENTRALPRÄSIDENT UND
DR. F. RIKLIN, NEUMÜNSTERSTRASSE 34, ZÜRICH V, ZENTRALSEKRETÄR

### I. Gründung der Ortsgruppe Wien.

In Wien hat sich im April die Ortsgruppe der internationalen psycho-analytischen Vereinigung gegründet. Der Obmann ist Herr Dr. Adler, Czerningasse 7, Wien II.

#### Mitgliederliste.

1. Dr. Adler, Czerningasse 7, Wien II, Obmann.
2. Prof. Dr. Freud, Berggasse 19, Wien IX.
3. Dr. Guido Brecher, Villa Erlenau, Meran.
4. Dr. P. Federn, Riemergasse, Wien I.
5. Dr. Josef R. Friedjung, Ebendorferstraße 6, Wien I.
6. Dr. phil. Karl Furtmüller, Zeltenergasse 6, Wien V.
7. Dr. jur. Max Graf, Untere Viaduktgasse 35, Wien III.
8. Hugo Heller, Bauernmarkt 3, Wien I.
9. Dr. Edward Hitschmann, Gonzagagasse 16, Wien I.
10. Dr. Edwin Hollerung, Schillergasse 24, Graz.
11. Dr. Ludw. Jekels, Sanatorium Bistrai b. Bielitz in Schlesien.
12. Dr. Alb. Joachim, Sanatorium Rekawinkel, Österreich.
13. Dr. phil. D. E. Oppenheim, Zwerggasse 4, Wien II.
14. O. Rank, Simondenkgasse, Wien II.
15. Dr. Rud. Reitler, Dorotheengasse 6, Wien I.
16. Dr. Oscar Rie, Stubenring 22, Wien I.
17. Dr. J. Sadger, Lichtensteinstraße 15, Wien IX ¹/₂.
18. Dr. Maxim. Steiner, Rotenturmstraße 19, Wien I.
19. Dr. Wilh. Stekel, Gonzagagasse 21, Wien I.
20. Dr. jur. Victor Tausk, Ungargasse 56, Wien III.
21. Dr. med. Rud. Urbantschitsch, Sternwartestraße 74, Wien XVIII.
22. Dr. Fritz Wittels, Sternwartestraße 74, Wien XVIII.

## 202 Freud, 1909[1]

I think I ought to tell you that I have always been dissatisfied with my intellectual endowment and that I know precisely in what respects, but that I consider myself a very moral human being who can subscribe to Th. Vischer's excellent maxim: "What is moral is self-evident." I believe that when it comes to a sense of justice and consideration for others, to the dislike of making others suffer or taking advantage of them, I can measure myself with the best people I have known. I have never done anything mean or malicious, nor have I felt any temptation to do so, with the result that I am not in the least proud of it.
*Letter to James J. Putnam, July 8, 1915*

## 203 Program of the Second International Psycho-Analytical Congress, 1910

Two years after the first private Congress of psycho-analysts the second took place, this time at Nuremberg, in March 1910. In the interval between them, influenced partly by the favorable reception in America, by the increasing hostility in German-speaking countries, and by the unforeseen acquisition of support from Zurich, I had conceived a project which with the help of my friend Ferenczi I carried out at this second Congress. What I had in mind was to organize the psycho-analytic movement, to transfer its center to Zurich and to give it a chief who would look after its future career. [ . . . ] I judged that the new movement's association with Vienna was no recommendation but rather a handicap to it. A place in the heart of Europe like Zurich,[1] where an academic teacher had opened the doors of his institution to psycho-analysis, seemed to me much more promising, I also took it that a second handicap lay in my own person, opinion about which was too much confused by the liking or hatred of the different sides: I was either compared to Columbus, Darwin and Kepler, or abused as a general paralytic. I wished, therefore, to withdraw into the background both myself and the city where psycho-analysis first saw the light. [ . . . ] This and nothing else was what I hoped to achieve by founding the "International Psycho-Analytical Association."
"On the History of the Psycho-Analytic Movement"

## 204 First number of the *Correspondenzblatt*

[ . . . ] the publication of a bulletin which should link the Central Executive with the local groups was resolved upon.
"On the History of the Psycho-Analytic Movement"

## ZENTRALBLATT FÜR PSYCHOANALYSE
(Medizinische Monatsschrift für Seelenkunde).

HERAUSGEBER: PROFESSOR Dr. SIGM. FREUD.

Redakteure

Dr. Alfred Adler, Wien, II. Praterstrasse 42  ::  Dr. Wilhelm Stekel, Wien, I. Gonzagagasse 21.

WIEN. Datum des Poststempels.

Sehr geehrter Herr Kollege!

Der reiche Ausbau, den die psychoanalytische Methode und Wissenschaft erfahren haben, die stete anwachsende Bedeutung dieses Verfahrens, haben die Schaffung eines Zentralblattes neben dem Bleuler-Freud'schen, von C. G. Jung redigierten „Jahrbuch für psychoanalytische und psychopathologische Forschungen" zur dringenden Nothwendigkeit gemacht. Im Herbst dieses Jahres wird die erste Nummer eines

### Zentralblattes für Psychoanalyse
einer medizinischen Monatsschrift für Seelenkunde

bei J. F. Bergmann in Wiesbaden erscheinen, deren Herausgeber der Begründer der psychoanalytischen Wissenschaft, Professor Dr. SIGMUND FREUD ist. Die Redaktion liegt in den Händen der Unterzeichneten.

Wir stellen nun an Sie das Ersuchen, sich als ständiger Mitarbeiter an diesem Unternehmen zu beteiligen. — Erwünscht sind uns kleinere Originalartikel im Umfange (höchstens!) eines Druckbogens. Ebenso verschiedene Mitteilungen aus der Praxis, einzelne interessante Beobachtungen, Dichterstellen, Erfahrungen aus der Psychopathologie des Alltaglebens, Beiträge zur Sexualpathologie, Hinweise auf Folklor, Märchen, Sagen, Mythen, u. dgl. Ferner Referate über alle einschlägigen uns interessierenden Arbeiten und Buchkritiken des gesamten in Betracht kommende Gebietes.

Nur durch rationale Arbeitsteilung lässt sich der Zweck erreichen, das Zentralblatt zu einem rasch orientierenden, lückenlosen und verlässlichen Organ der neuen Wissenschaft zu machen. Wir rechnen dabei auf Ihre fleissige Mithilfe und bitten uns bekannt zu geben, welche Originalartikel Sie uns für die nächste Zeit in Aussicht stellen können.

Zugleich fordern wir Sie auf, einige Ihrem engeren Arbeitsgebiete entsprechende periodische Zeitschriften fortlaufend und ständig zu referieren und uns deren Titel baldigst mitzuteilen. Das Mitarbeiterhonorar beträgt sowohl für Originalarbeiten als für Referate und Kritiken 60 Mark per Druckbogen. Selbstständige Werke werden Ihnen von der Redaktion zugesendet werden. Im Gegensatz zu den meisten der landläufigen Kritiken sollen unsere Besprechungen einen wesentlich orientierenden Ueberblick über den Inhalt des Werkes und sein Verhältnis zur Psychoanalyse ermöglichen.

Mit vorzüglicher Hochachtung:

Dr. ALFRED ADLER.                                  Dr. WILHELM STEKEL.

---

Löbliches  Wahl- und  Sitzanzeige!

## k. k. Polizei-Kommissariat

Name des Vereines

Sitz des Vereines

Bei der am 12. Oktober 1910 im I. Bez. Rotenturmstraße 19 abgehaltenen Journal-Versammlung wurden folgende Vorstands-Mitglieder gewählt.

| Funktion: | Name: | Charakter: | Wohnort: |
|---|---|---|---|
| Obmann | D. Alfr. Adler | Arzt | II. Czerningasse 7 |
| I. Obm.-Stellv. | D. Wilh. Stekel | " | I. Gonzagag. 21 |
| II. " | | | |
| I. Schriftführer | Otto Rank | Schriftsteller | IX. Simondenkg 8 |
| II. " | | | |
| I. Kassier | D. Hann. Steiner | Arzt | I. Rotenturmstraße 19 |
| II. " | | | |
| Schriftleiter | | | |
| Ausschuß | | | |
| Revisor | D. Paul Federn | Arzt | I. Riemergasse 1 |

---

### 205  Request for contributions to the *Zentralblatt*

One outcome of the Nuremberg Congress was the founding of the *Zentralblatt für Psychoanalyse* (Central Journal for Psycho-Analysis), for which purpose Adler and Stekel joined forces. It was obviously intended originally to represent the Opposition: It was meant to win back for Vienna the hegemony threatened by the election of Jung.[1] But when the two founders of the journal, laboring under the difficulties of finding a publisher, assured me of their peaceful intentions and as a guarantee of their sincerity gave me a right of veto, I accepted the direction of it and worked energetically for the new organ: its first number appeared in September, 1910.

"On the History of the Psycho-Analytic Movement"

*Translation in the notes*

### 206  Police notice: Formation of the Vienna Psycho-Analytical Society, 1910

The aim of the Society is the practice and promotion of the science of psychoanalysis founded in Vienna by Prof. Sigmund Freud, both in the field of pure psychology and in its application to medicine and other humane sciences. The Society is a scientific one and its further aim is the mutual support of its members in all their endeavors to acquire and disseminate psychoanalytical knowledge. The Society has in addition the task of maintaining intellectual contact and the exchange of scientific ideas with the "International Psycho-Analytical Association" and its affiliated societies.

*From the Constitution of the Vienna Psycho-Analytical Society*

*The Vienna Psycho-Analytical Society arose from the Psychological Wednesday Society, which took the name of Vienna Psycho-Analytical Society as early as 1908. The new creation on October 12, 1910, was a consequence of the foundation, decided upon at the Nuremberg Congress, of the International Psycho-Analytical Association.*

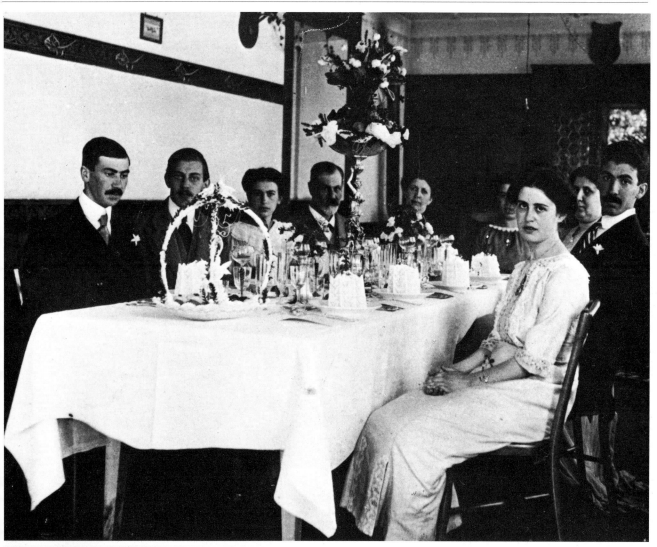

**207   Silver wedding, 1911**
For private family reasons
September 16th is a very
inconvenient, practically
impossible, date, though I am
loth to arrange the date of the
congress[1] according to my
personal requirements.
*Letter to Karl Abraham,*
*May 18, 1911*

*The date of the silver wedding*
*was September 14, 1911. The*
*family gathering took place in*
*Klobenstein near Bozen. From*
*left to right in the order in*
*which they sit at table: Oliver,*
*Ernst, Anna, Sigmund and*
*Martha Freud, Mathilde,*
*Minna Bernays, Martin,*
*Sophie.*

**208   Sanatorium at Karlsbad,**
**1911**
At the moment I am
dissatisfied with everything—
for no obvious reason. I seize
avidly on every trace of my
other life in letters and parcels.
Nothing is enjoyable; it's all a
matter of duty.

*Postcard to Martha Freud,*
*July 12, 1911*

*The picture shows the postcard*
*which Freud sent to his wife*
*with the words quoted.*[1]

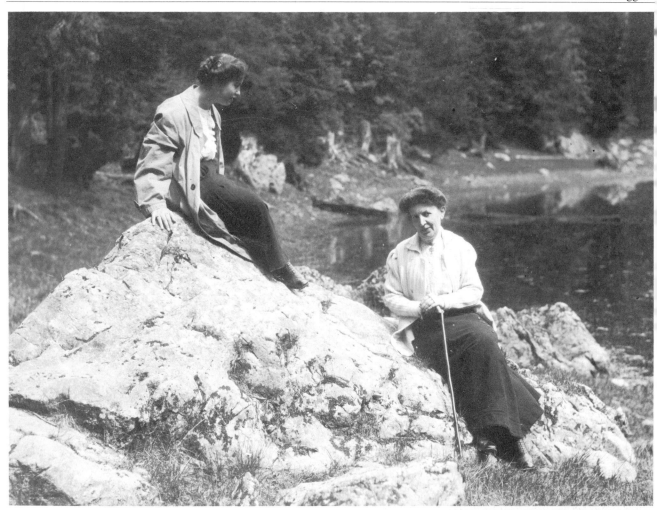

**209   Martha Freud with daughter Sophie, about 1912**

I also always admired Frau Freud's ability to fulfill her part unerringly in things that concerned her. She was always devoted and always ready to make decisions, but she did not take it upon herself to interfere in tasks which she considered her husband's; she was always sure of herself and never a mere spectator. It was doubtless through her that the upbringing of their six children remained remote from psycho-analysis, yet this was certainly not due to any indifference on Freud's part. But he did derive a certain satisfaction, I now see, in knowing that his domestic circle was far removed from any public conflict and his wife's part in this was a source of pleasure to him.
*Lou Andreas-Salomé on her visit to the Freuds*

**210   Max Halberstadt**

My little Sophie[1] whom we had sent on a few weeks' holiday to Hamburg returned two days ago, gay, radiant, determined, and broke the surprising news that she is engaged to you. We realize that this fact makes us so to speak superfluous and that there is nothing left for us to do but go through the formality of bestowing our blessing. Since our wishes have always been for our daughters to feel free to follow their hearts in the choice of a husband, as our eldest daughter has actually done, we have every reason to be satisfied with this event.
*Letter to Max Halberstadt, July 7, 1912*

*Max Halberstadt, 1882-1940, photographer, first in Hamburg, then, following the German emigration after Hitler, in Johannesburg, South Africa*

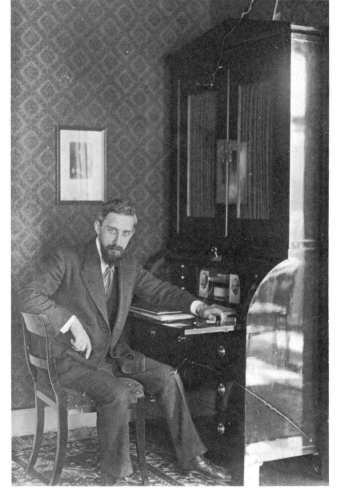

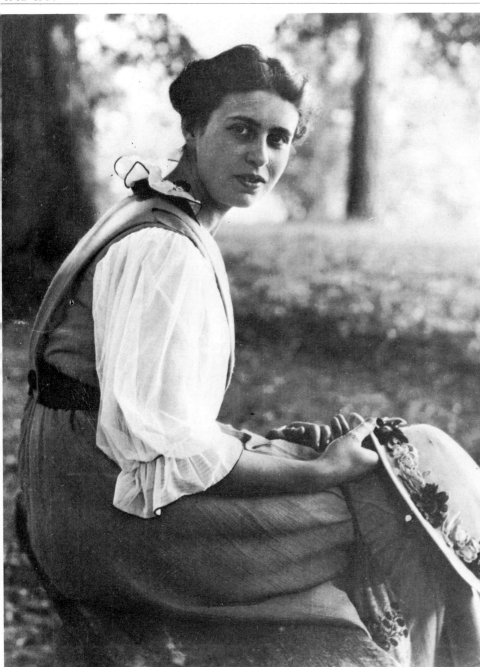

**211 Sophie**
*Sophie Freud-Halberstadt,*
*1893–1920*

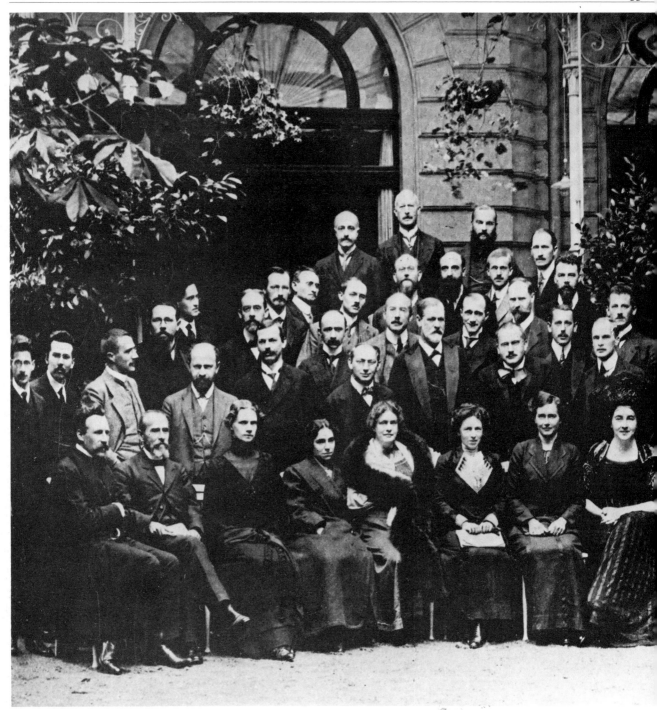

1 Sigmund Feud; 2 Otto
Rank; 3 Ludwig Binswanger;
4 Ludwig Jekels; 5 Abraham
A. Brill; 6 Eduard Hitschmann;
7 Paul Federn; 8 Oskar Pfister;
9 Max Eitingon; 10 Karl
Abraham; 11 James J. Putnam;
12 Ernest Jones; 13 Wilhelm
Stekel; 14 Eugen Bleuler;
15 Lou Andreas-Salomé; 16
Emma Jung (C. G. Jung's
wife); 17 Sándor Ferenczi;
18 C. G. Jung

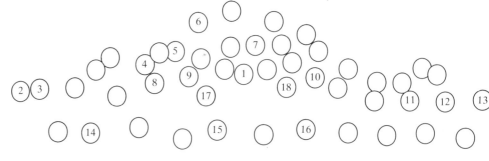

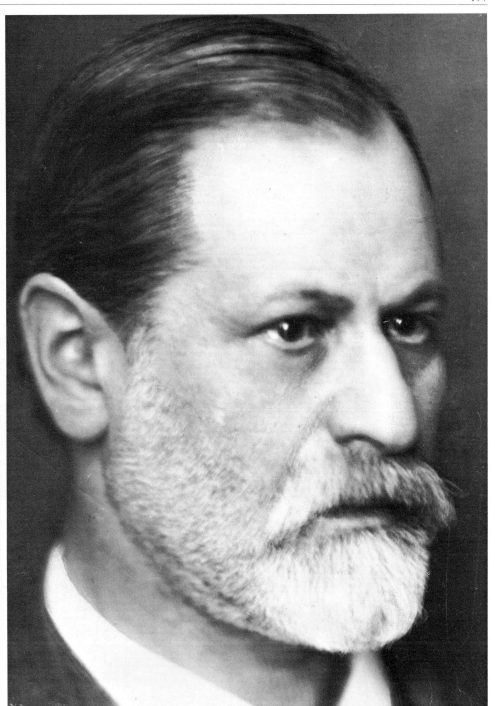

**212    Third International Psycho-Analytical Congress, 1911**

I too think back with pleasure to the days at Weimar [ . . . ]. What gave me most pleasure in your letter was the number of projects you have in mind the source of which you trace back directly to Weimar.
*Letter to Karl Abraham, November 11, 1911*

*The Weimar Congress, attended by very many European and American participants, met on September 21 and 22, 1911.*

**213    Freud, about 1912**

As you know, I suffer all the torments that can afflict an "innovator"; not the least of these is the unavoidable necessity of passing, among my own supporters, as the incorrigibly self-righteous crank or fanatic that in reality I am not.
*Letter to C. G. Jung, December 6, 1906*

**214    Declaration of Alfred Adler and his followers, 1912**

When, after irreconcilable scientific disagreements had come to light, I was obliged to bring about Adler's resignation from the editorship of the *Zentralblatt*, he left the Vienna society as well, and founded a new one[1] [ . . . ]. There is room enough on God's earth, and anyone who can has a perfect right to potter about on it without being prevented; but it is not a desirable thing for people who have ceased to understand one another and have grown incompatible with one another to remain under the same roof.

"On the History of the Psycho-Analytic Movement"
*Translation of the Declaration in the Notes*

## Verlag von Ernst Reinhardt in München.

## SCHRIFTEN DES VEREINS FÜR FREIE PSYCHOANALYTISCHE FORSCHUNG /
### HERAUSGEGEBEN VON DR. ALFRED ADLER • HEFT 1

# Psychoanalyse und Ethik
### Eine vorläufige Untersuchung
### Von Dr. Karl Furtmüller.
#### 48 Seiten.    Preis Mk. 1.—.

## An die Leser.

Die Anregung zur Gründung des „Vereins für freie psychoanalytische Forschung" ging im Juni 1911 von einigen Mitgliedern der unter der Leitung Professor Siegmund Freuds stehenden „Wiener psychoanalytischen Vereinigung" aus, die zu bemerken glaubten, daß man die Mitglieder des alten Vereins auf den ganzen Umfang der Lehrsätze und Theorien Freuds wissenschaftlich festlegen wolle. Ein solcher Vorgang schien ihnen nicht nur mit den allgemeinen Grundbedingungen wissenschaftlichen Forschens schwer vereinbar, sondern bei einer so jungen Wissenschaft, wie es die Psychoanalyse ist, von besonderer Gefahr zu sein. Es hieß nach ihrer Meinung auch den Wert des bisher Erreichten in Frage stellen, wenn man sich voreilig auf gewisse Formeln verpflichten und die Möglichkeit aufgeben wollte, neue Lösungsversuche zu unternehmen. So ließ ihre Überzeugung von der entscheidenden Bedeutung psychoanalytischer Arbeitsweise und Problemstellung es ihnen als eine wissenschaftliche Pflicht erscheinen, einer nach allen Seiten hin unabhängigen psychoanalytischen Forschung eine Stätte zu sichern.

Im Oktober 1911 hat dann die „Wiener psychoanalytische Vereinigung" die gleichzeitige Zugehörigkeit zu beiden Vereinen

**215    C. G. Jung's notice of resignation, 1914[1]**
*Translation in the Notes*

Der Zentralpräsident der „Internationalen psychoanalytischen Vereinigung", Herr Doz. C. G. Jung in Zürich, hat an die Präsidenten der Ortsgruppen folgendes vom 20. April 1914 datierte Schreiben gerichtet, das wir hiemit den Vereinsmitgliedern zur Kenntnis bringen:

„Sehr geehrter Herr Präsident!

Ich habe mich durch die neuesten Ereignisse überzeugen lassen, daß meine Anschauungen in einem so schroffen Kontrast zu den Auffassungen der Mehrzahl der Mitglieder unseres Vereins stehen, daß ich mich nicht mehr als die zum Vorsitz geeignete Persönlichkeit betrachten kann. Ich reiche daher der Obmännerkonferenz meine Demission ein mit bestem Dank für das bisher genossene Zutrauen.

Mit vorzüglicher Hochachtung
ergebenst
Dr. C. G. Jung."

Die „Obmännerkonferenz" hat sich auf schriftlichem Wege dahin geeinigt, den Vorstand der Ortsgruppe Berlin, Dr. Karl Abraham (Berlin W. Rankestraße 24), bis zum nächsten Kongreß mit der provisorischen Leitung der Vereinsgeschäfte zu betrauen.

für unzulässig erklärt und es haben daraufhin eine Anzahl von Mitgliedern den alten Verein verlassen. Es besteht also jetzt zwischen dem „Verein für freie psychoanalytische Forschung" und den in der „Internationalen psychoanalytischen Vereinigung" zusammengeschlossenen Organisationen keinerlei Beziehung. Wir glauben verpflichtet zu sein, das hier ausdrücklich festzustellen, weil wir es für ein Unrecht halten würden, wenn die wissenschaftliche Kritik Männern, von denen wir in unserer Auffassung über die grundlegenden Voraussetzungen freier wissenschaftlicher Arbeit abweichen, die Verantwortung für unsere Arbeiten aufbürden wollte. Ebenso möchten wir unsrerseits beanspruchen, nur auf Grund unserer eigenen Arbeiten beurteilt zu werden.

**Der Vorstand des „Vereins für freie psychoanalytische Forschung".**

————

# Vorwort des Herausgebers.

Die „Schriften des Vereins für freie psychoanalytische Forschung" verfolgen den Zweck, empirisch gewonnene Resultate der Neurosenpsychologie, soweit sie ihre Eignung erwiesen haben, zur weitern Behandlung philosophischer, psychologischer und pädagogischer Fragen in Anwendung zu bringen. Uns leitet dabei der Gedanke, bei der Frage nach dem „Sinn" eines psychischen Geschehens sowohl Ursachen als Richtung und Zweck desselben, Elemente und Zusammenhänge wie im Fluß sehen zu können.

Damit sagen wir, daß wir bei unseren psychologischen Analysen einer Zielvorstellung Raum geben, die uns bei der Untersuchung eines Problems oder einer Persönlichkeit leitet. Individuum aber und Phänomen sind für unsere Betrachtung, wo immer wir diese anstellen, ein Bild einer Entwicklungsreihe, ein Mikrokosmus, ein Symbol der Totalität. Insoferne wir in der Genese einer Erscheinung nach Vergleichspunkten suchen, ist unsere Forschungsrichtung eine vergleichende, die sich auf das Individuum

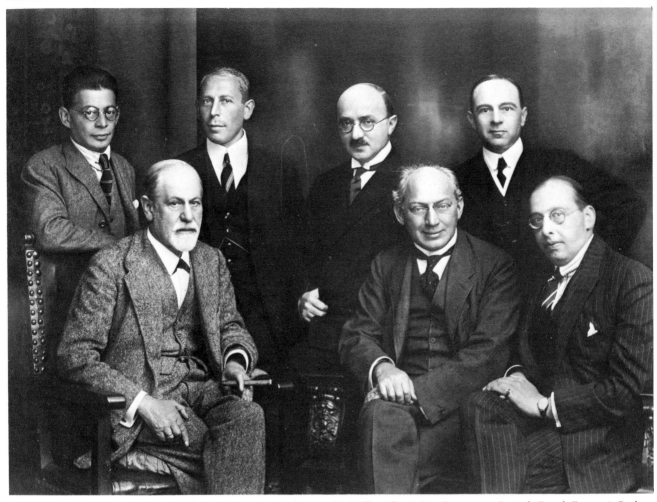

### 216  The "Committee"
I was very happy to know
[ . . . ] that you now belong to
this small but select company
in whose hands the future of
psychoanalysis lies, and which
has up to now pursued its
aims in untroubled friendly
harmony. [ . . . ] The secret of
this Committee is that it has
taken from me my most
burdensome care for the
future, so that I can calmly
follow my path to the end.
*Letter to Max Eitingon,*
*October 22, 1919*

[ . . . ] these rings[1] were
a privilege and a mark
distinguishing a group of men
who were united in their
devotion to psycho-analysis,
who had promised to watch
its development as a "secret
committee," and to practice
among themselves a kind of
analytical brotherhood. Rank
then broke the magic spell; his
secession and Abraham's death
dissolved the Committee.
*Letter to Ernst Simmel,*
*November 11, 1928*

*Seated: Freud, Ferenczi, Sachs;*
*standing: Rank, Abraham,*
*Eitingon, Jones. The Committee*
*(photo taken in 1922) was*
*founded in 1912, on the sug-*
*gestion of Ernest Jones, as a*
*reaction against the crises and*
*quarrels attending the various*
*secessions.*

### 217  Freud, about 1912
I cannot be an optimist, and
I believe I differ from the
pessimists only in that wicked,
stupid, senseless things don't
upset me, because I have
accepted them from the
beginning as part of what the
world is made of.
*Letter to Lou Andreas-Salomé,*
*July 30, 1915*

*On the verandah of his home in*
*the Berggasse, taken by one of*
*his sons*

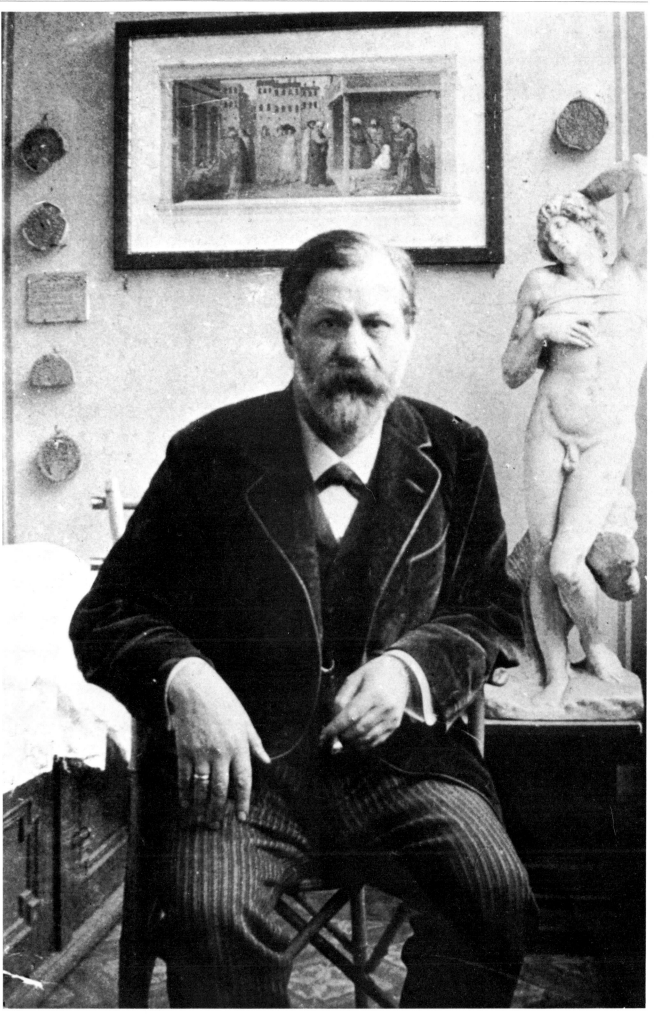

**218   Etching by Max Pollack**
Pollack's etching arrived a few days ago, I like the pose very much. It takes some time to get used to the facial expression, but one comes to like it in the end.
*Letter from Karl Abraham to Freud, April 2, 1914*

**219   First edition in book form[1] of *Totem and Taboo*, 1913**
It will be found that the two principal themes from which the title of this little book is derived—totems and taboos—have not received the same treatment. [ . . . ] The difference is related to the fact that taboos still exist among us. Though expressed in a negative form and directed towards another subject-matter, they do not differ in their psychological nature from Kant's "categorical imperative," which operates in a compulsive fashion and rejects any conscious motives. Totemism, on the contrary, is something alien to our contemporary feelings—a religio-social institution which has been long abandoned as an actuality and replaced by newer forms. It has left only the slightest traces behind it in the religions, manners and customs of the civilized peoples of today [ . . . ]. The social and technical advances in human history have affected taboos far less than the totem. An attempt is made in this volume to deduce the original meaning of totemism from the vestiges remaining of it in childhood—from the hints of it which emerge in the course of the growth of our own children.
*Totem and Taboo*

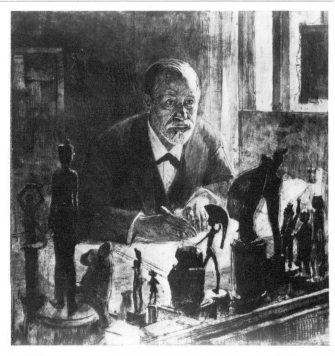

# TOTEM UND TABU

Einige Übereinstimmungen im Seelenleben der Wilden und der Neurotiker.

Von

**Prof. Dr. Sigm. Freud**

1913
HUGO HELLER & CIE.
LEIPZIG UND WIEN, I. BAUERNMARKT 3

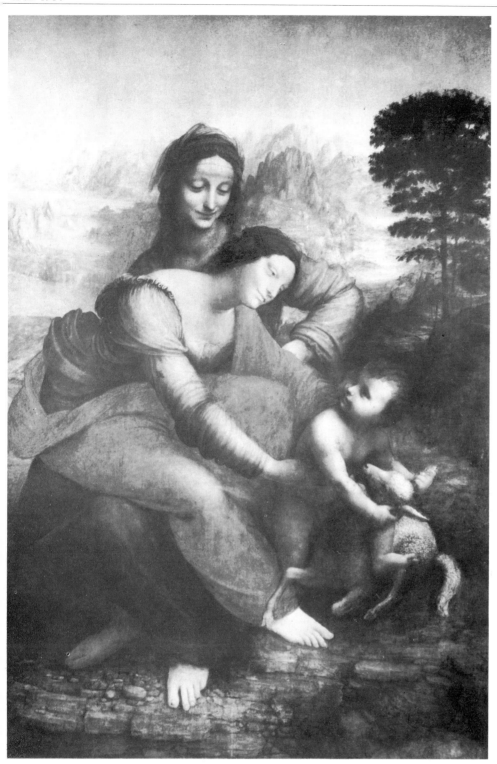

**220   The Virgin and Child with
Saint Anne, by Leonardo**
Leonardo's childhood was
remarkable in precisely the
same way as this picture.[1] He
had had two mothers: First, his
true mother Caterina, from
whom he was torn away when
he was between three and five,
and then a young and tender
stepmother, his father's wife,
Donna Albiera. By his
combining this fact about his
childhood [ . . . ] the design of
"St. Anne with Two Others"
took shape for him.
*Leonardo da Vinci and a
Memory of his Childhood*

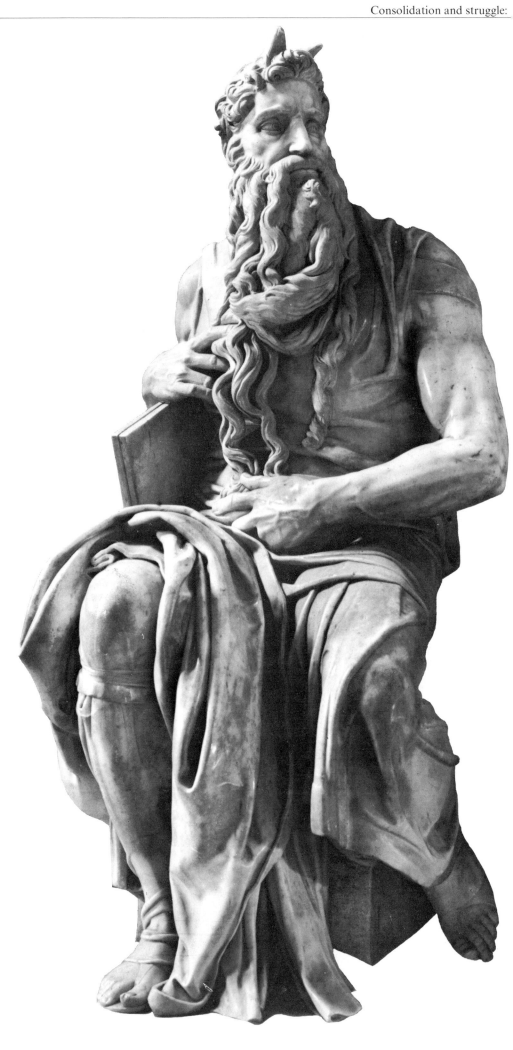

### 221   The Moses of Michelangelo

My relationship to this work is something like that to a love-child. Every day for three lonely weeks in September of 1913[1] I stood in the church[2] in front of the statue, studying it, measuring and drawing it until there dawned on me that understanding which in the essay I only dared to express anonymously.[3] Not until much later did I legitimize this nonanalytical child.
*Letter to Edoardo Weiss,
April 12, 1933*

[ . . . ] for the Moses we have reconstructed will neither leap up nor cast the Tables from him. What we see before us is not the inception of a violent action but the remains of a movement that has already taken place. In his first transport of fury, Moses desired to act, to spring up and take vengeance and forget the Tables; but he has overcome the temptation, and he will now remain seated and still, in his frozen wrath and in his pain mingled with contempt. Nor will he throw away the Tables so that they will break on the stones, for it is on their especial account that he has controlled his anger [ . . . ]. In this way he (Michelangelo) has added something new and more than human to the figure of Moses; so that the giant frame with its tremendous physical power becomes only a concrete expression of the highest mental achievement that is possible in a man, that of struggling successfully against an inward passion for the sake of a cause to which he has devoted himself.
"The Moses of Michelangelo"

I have procured from the hand of an artist three drawings to illustrate my meaning. Fig. 3 reproduces the statue as it actually is; Figs. 1 and 2 represent the preceding stages according to my hypothesis—the first that of calm, the second that of the highest tension, in which the figure is preparing to spring up and has abandoned its hold on the Tables, so that these are beginning to slip down.
"The Moses of Michelangelo"

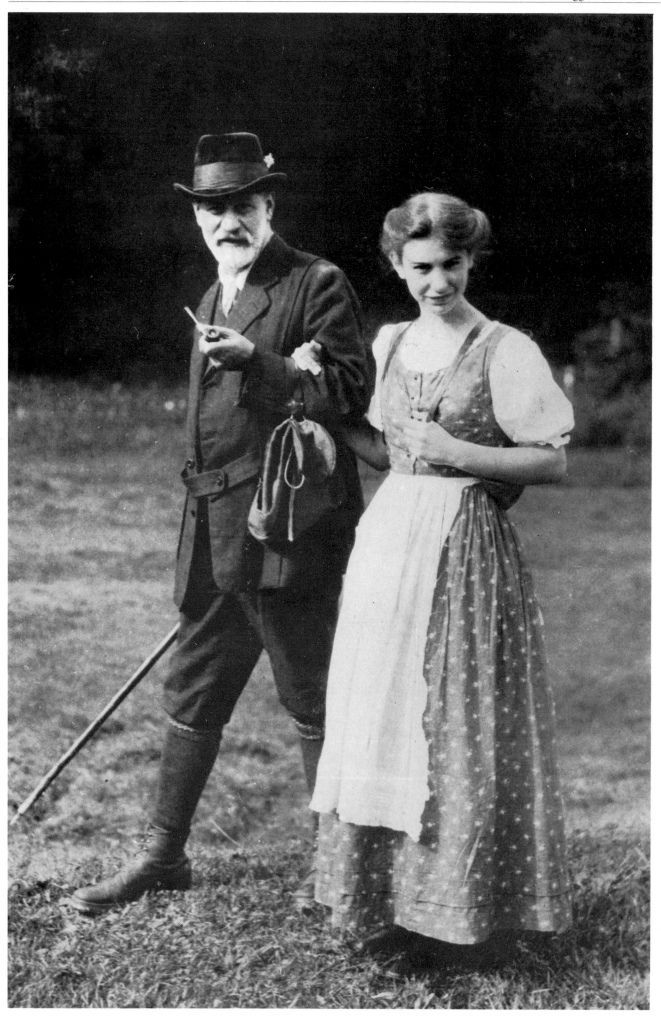

**222   With daughter Anna in the Dolomites, 1913**

My closest companion will be my little daughter, who is developing very well at the moment (you will long ago have guessed the subjective condition for the "Theme of the Three Caskets"[1]).
*Letter to Sándor Ferenczi, July 9, 1913*

**223   Gerbrand Jelgersma**

I am suddenly sent a piece of work by Jelgersma, the Rector's address for the 339th "Verjaardag" of the ancient and famous University of Leyden [ . . . ]. I try to understand it and see that it is about the interpretation of dreams and—it is friendly [ . . . ], then a letter from Abraham[1] confirming that Jelgersma has spoken out quite unreservedly in favour of us and psychoanalysis and is weaving phantasies about translation. Finally a letter from the author himself [ . . . ] actually confirming the miracle. Just think. An official psychiatrist, Rector of a University, swallows PsA. [psychoanalysis], skin and hair. What more surprises are we to expect!
*Letter to Sándor Ferenczi, February 15, 1914*

*Gerbrand Jelgersma, 1859-1942, Professor of Psychiatry and Rector of the University of Leyden, Holland*

**Mitteilung.**

Mit Allerhöchstem Befehl ist die Allgemeine Mobilisierung sowie die Aufbietung und Einberufung des Landsturmes angeordnet worden.

Das Nähere ist aus den Mobilisierungskundmachungen zu entnehmen.

Amtsstempel:                                        Unterschrift:

**224   Mobilization order, 1914**

I do not doubt that mankind will survive even this war, but I know for certain that for me and my contemporaries the world will never again be a happy place. It is too hideous. And the saddest thing about it is that it is exactly the way we should have expected people to behave from our knowledge of psycho-analysis. Because of this attitude to mankind I have never been able to agree with your blithe optimism. My secret conclusion has always been: since we can only regard the highest present civilization as burdened with an enormous hypocrisy, it follows that we are organically unfitted for it. We have to abdicate, and the Great Unknown, He or It, lurking behind Fate will someday repeat this experiment with another race. I know that science is only apparently dead, but humanity seems to be really dead.
*Letter to Lou Andreas-Salomé, November 25, 1914*
*Translation of the order in the Notes*

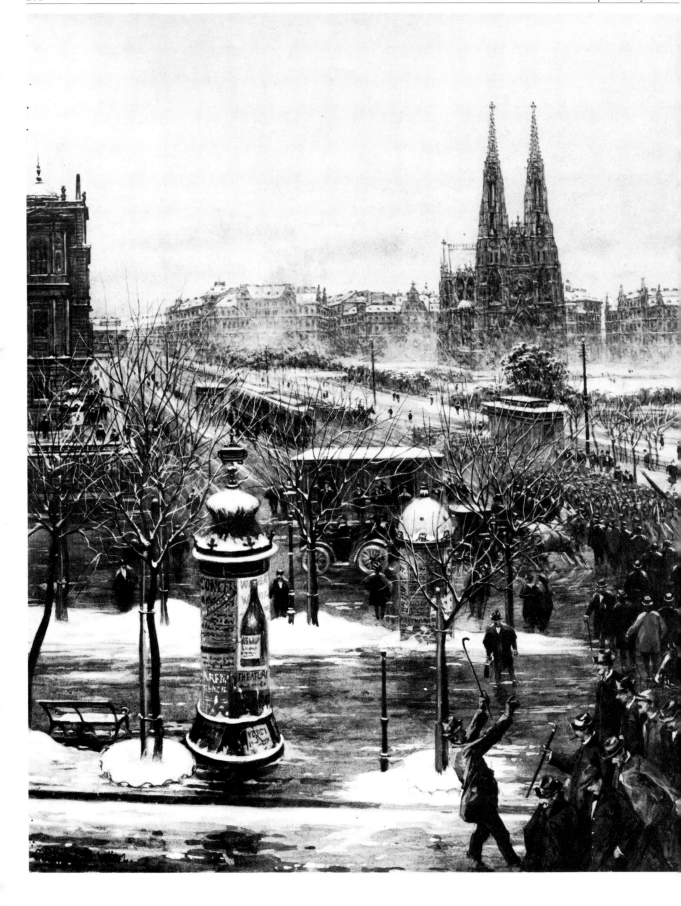

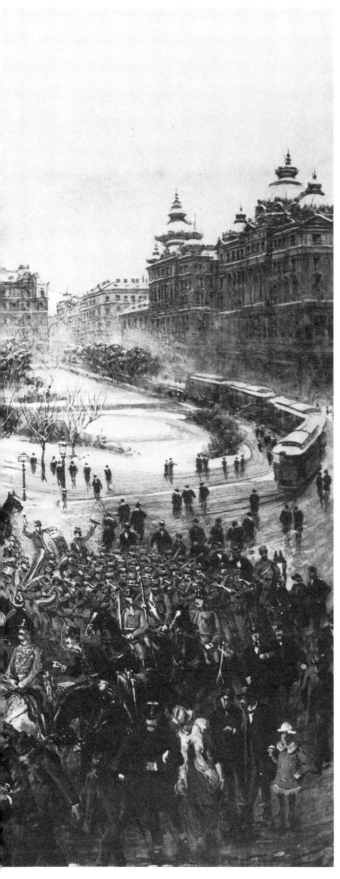

# IMAGO

ZEITSCHRIFT FÜR ANWENDUNG DER PSYCHO-
ANALYSE AUF DIE GEISTESWISSENSCHAFTEN

HERAUSGEGEBEN VON PROF. DR. SIGM. FREUD

SCHRIFTLEITUNG:
IV. 1.    DR. OTTO RANK / DR. HANNS SACHS    1915

### Zeitgemäßes über Krieg und Tod.

Von SIGM. FREUD.

#### I. Die Enttäuschung des Krieges.

Von dem Wirbel dieser Kriegszeit gepackt, einseitig unterrichtet, ohne Distanz von den großen Veränderungen, die sich bereits vollzogen haben oder zu vollziehen beginnen, und ohne Witterung der sich gestaltenden Zukunft, werden wir selbst irre an der Bedeutung der Eindrücke, die sich uns aufdrängen, und an dem Wert der Urteile, die wir bilden. Es will uns scheinen, als hätte noch niemals ein Ereignis soviel kostbares Gemeingut der Menschheit zerstört, soviele der klarsten Intelligenzen verwirrt, so gründlich das Hohe erniedrigt. Selbst die Wissenschaft hat ihre leidenschaftslose Unparteilichkeit verloren; ihre aufs tiefste erbitterten Diener suchen ihr Waffen zu entnehmen, um einen Beitrag zur Bekämpfung des Feindes zu leisten. Der Anthropologe muß den Gegner für minderwertig und degeneriert erklären, der Psychiater die Diagnose seiner Geistes- oder Seelenstörung verkünden. Aber wahrscheinlich empfinden wir das Böse dieser Zeit unmäßig stark und haben kein Recht, es mit dem Bösen anderer Zeiten zu vergleichen, die wir nicht erlebt haben.

Der Einzelne, der nicht selbst ein Kämpfer und somit ein Partikelchen der riesigen Kriegsmaschinerie geworden ist, fühlt sich in seiner Orientierung verwirrt und in seiner Leistungsfähigkeit gehemmt. Ich meine, ihm wird jeder kleine Wink willkommen sein, der es ihm erleichtert, sich wenigstens in seinem eigenen Innern zurechtzufinden. Unter den Momenten, welche das seelische Elend der Daheimgebliebenen verschuldet haben, und deren Bewältigung ihnen so schwierige Aufgaben stellt, möchte ich zwei hervorheben und an dieser Stelle behandeln: Die Enttäuschung, die dieser Krieg hervorgerufen hat, und die veränderte Einstellung zum Tode, zu der er uns — wie alle anderen Kriege — nötigt.

Wenn ich von Enttäuschung rede, weiß jedermann sofort, was

Imago IV/1                                                                        1

**225   The Regiment leaving for the front**

However, for the first time for thirty years I feel myself to be an Austrian and feel like giving this not very hopeful Empire another chance. Morale everywhere is excellent.[1]
*Letter to Karl Abraham, July 26, 1914*

[ . . . ] the abundance of uncorroborated news, the ebb and flow of hope and fear is bound to have an unsettling effect on us all.
*Letter to Karl Abraham, July 29, 1914*

*Square in front of the Votive Church; in the background, right, Währingerstrasse with Berggasse opening into it*

**226   First publication of "Thoughts for the Time on War and Death," 1915**

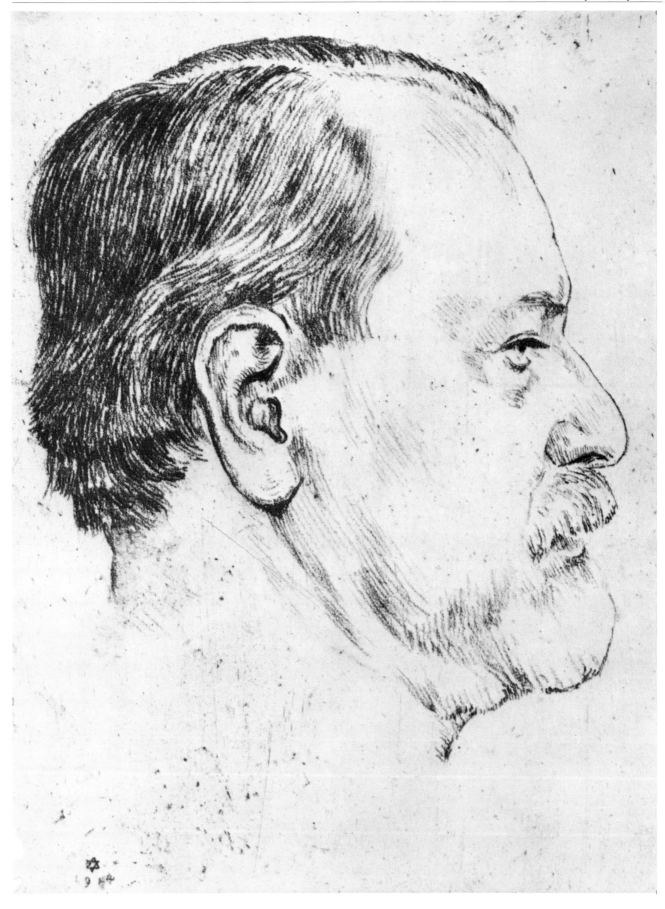

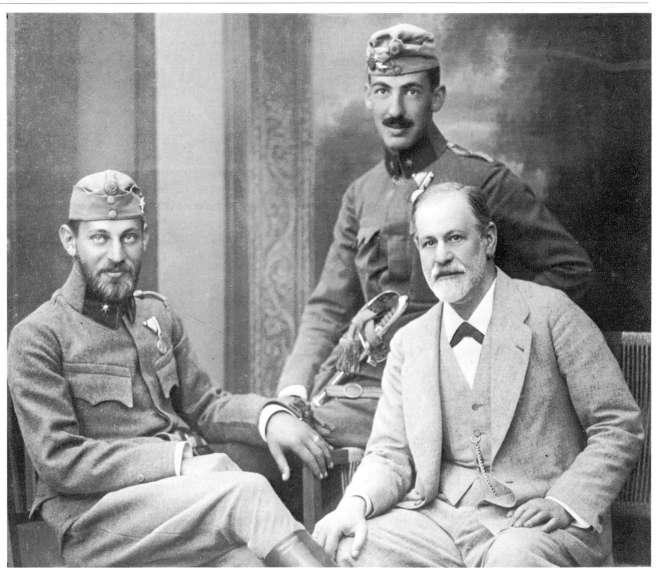

**227  Etching by Hermann Struck**

The etching strikes me as a charming idealization. This is how I should like to look, and I may even be on the way there, but it seems to me I have got stuck half way. Everything that is shaggy and angular about me you have made smooth and rounded. In my opinion an element of unlikeness has been introduced by something unimportant, by your treatment of my hair. You have put my parting on one side, whereas [ . . . ] I wear it on the other. Furthermore, my hairline runs across the temple in a rather concave curve. By rounding it off you have greatly improved on it.
*Letter to Hermann Struck,*
*November 7, 1914*

**228  With sons Ernst and Martin, 1916**

I am glad to tell you that we had both our sons at once on leave with us in Salzburg, both in good health. Now they are off again, one north, the other south, and we haven't had any news from them yet.
*Letter to Max Eitingon,*
*August 26, 1916*

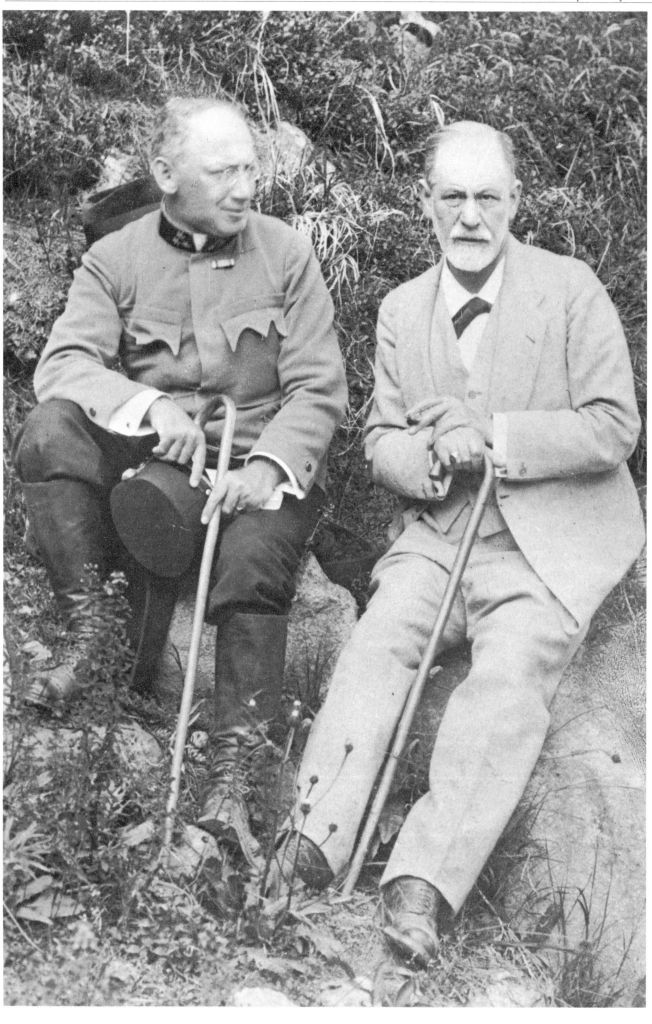

37

## ÖFFENTLICHE VORLESUNGEN

AN DER

# K. K. UNIVERSITÄT ZU WIEN

IM

### WINTER-SEMESTER 1915/16.

Die Frist zur Immatrikulation und Inskription beginnt am 23. September 1915 und danert bis einschließlich 9. Oktober 1915.

Außerdem kann die Einzahlung des Kollegiengeldes auch in der Zeit vom 1. bis 31. Juli und vom 1. bis 21. September 1915 erfolgen. Die näheren Bestimmungen über die Art dieser Einzahlung sind in der Kundmachung vom 25. Juni 1914, Z. 665 ex 1913/14 enthalten.

Nachträgliche Inskriptionen werden nur ganz ausnahmsweise bewilligt, wenn dafür die im § 32 der Studienordnung angeführten Gründe in unzweifelhafter Art nachgewiesen werden und die Vorlesungen nicht schon zu weit vorgerückt sind, um mit gehörigem Erfolge gehört zu werden. Als Endtermin für die Einbringung der Gesuche um nachträgliche Inskription gilt im Wintersemester der 10. Dezember.

(Bei dem Portier der k. k. Universität.)

Preis 20 Heller.

### WIEN.

DRUCK VON ADOLF HOLZHAUSEN,
K. UND K. HOF- UND UNIVERSITÄTSBUCHDRUCKER.

1915.

---

**Pick** Walther, Privatdoz. Dr.: *Die moderne Syphilistherapie*, 1 stünd., Mi. 6—7; Hörsaal der Klinik Riehl. \*K 2.10

**Kren** Otto, Privatdoz. Dr.: *Einführung in die Dermatologie*, 1 stünd., Sa. 12—1; Hörsaal der Klinik Riehl. \*K 2.10

„ °*Diagnostik u. Therapie d. Hautkrankheiten*, 4 woch. Kurs 11—12; Kais.-Jub.-Spital, Wien XIII. †\*\*\*Ärzte K 60.—, Stud. K 30.—

**Scherber** Gustav, Privatdoz. Primararzt Dr.: *Klinik und Therapie der Haut- und Geschlechtskrankheiten*, 3 stünd.; Abteilung für Haut- u. Geschl.-Krankh., k. k. Rudolfspit., III., Boerhavegasse. \*K 6.30

„ °*Kurs über Hautkrankheiten u. Syphilis*, 24 stünd. K 60.—

„ °*Kurs über Klinik u. Therapie der Gonorrhoe*, 12 stünd. K 30.—

**Mucha** Viktor, Privatdoz. Dr.: *Frühdiagnose u. Frühbehandlung der Syphilis*, 1 stünd., Fr. 5—6 (verlgb.); Klinik f. Syph. u. Derm. K 2.10

**Kyrle** Josef, Privatdoz. Dr.: *Klinik u. Therapie der Gonorrhoe*, 1 stünd., n. Übereink.; allg. Krankenhaus, Klinik f. Syph. u. Derm. \*K 2.10

**Müller** Rudolf, Privatdoz. Assistent Dr.: *Neuere Methoden zur Unterstützung der klinischen Diagnosen früh- und spätsyphilitischer Erkrankungen (mit praktischen Übungen)*. 1 mal wöchentl., 2 Stunden. Zeit nach Übereinkunft. K 4.20

„ °*Serodiagnose der Lues (nur für Studenten)*, 2 wochig, 5 stünd. (Teilnehmerzahl 8); Laborator. d. Klinik. \*K 5.25

**Sachs** Otto, Privatdoz. Dr.: *Einführung in die Dermatologie und die Lehre von den Geschlechtskrankheiten*, 1 stünd., Tag und Stunde werden später bekanntgeg.; Hörsaal d. Klinik Finger. \*K 2.10

„ *Gewerbekrankheiten der Haut, mit Krankendemonstrationen*, 1 stünd., Tag u. Stunde werden später bekanntgeg.; ebendort. \*\*\*K 2.10

„ °*Diagnostik u. Therapie d. Haut- u. Geschlechtskrankheiten*, 4 woch. prakt. Kurse, n. Übereink.; ebend. \*Ärzte K 50.—, Stud. K 30.—

### XVI. Psychiatrie.

**Wagner v. Jauregg** Julius, o. ö. Prof. Hofrat Dr.: *Psychiatrische Klinik*, 5 stünd., Di., Do. 5—6½, Sa. 10—12; Hörsaal d. psychiatr. Klinik. IX., Lazarettgasse 14. \*K 10.50

**Obersteiner** Heinrich, o. ö. Prof. Dr.: °*Arbeiten über normale und pathologische Histologie des Nervensystems*, täglich während des Tageslichtes; neurolog. Inst. †\*\*\*Ärzte K 40.—, Stud. K 12.—

**Redlich** Emil, a. o. Prof. Dr.: *Nervenkrankheiten*, 3 stünd., Mo., Fr. 5—6½; Psychiatr. Klinik, IX., Lazarettgasse 14. \*K 6.30

**Raimann** Emil, a. ö. Prof. Dr.: *Forensische Psychiatrie*, 4 stünd., Mi.. Sa. 5—7; gr. Hörsaal d. Klin. v. Wagner. \*K 8.40

**Freud** Sigmund, a. o. Prof. Dr.: *Einführung in die Psychoanalyse*, Sa. 7—9 abends; Hörsaal d. psychiatr. Klinik. †\*\*\*K 10.—

---

**229   With Sándor Ferenczi, 1917**

I think I regard the situation as a repetition of the original one, when I was productive and—isolated. All my friends and helpers are now in the army, and have, so to speak, been taken away from me.
*Letter to Karl Abraham, July 3, 1915*

**230   Announcement of the lecture series *Einführung in die Psychoanalyse (Introductory Lectures on Psycho-Analysis)*, Winter Semester 1915/16**[1]

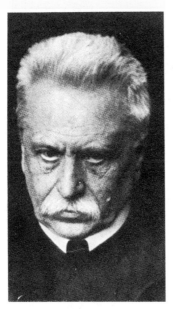

**231   Josef Popper-Lynkeus**
I remember my surprise years ago when I discovered that you (as the only one) recognized that the distortion of dreams is the result of censorship [ . . . ].
*Letter to Josef Popper-Lynkeus, August 4, 1916*

Overwhelmed by meeting with such wisdom, I began to read all his works—his books on Voltaire, on Religion, on War, on the Universal Provision of Subsistence, etc.—till there

was built up clearly before my eyes a picture of this simple-minded, great man, who was a thinker and a critic and at the same time a kindly humanitarian and reformer. I reflected much over the rights of the individual which he advocated [ . . . ]. A special feeling of sympathy drew me to him, since he too had clearly had painful experience of the bitterness of the life of a Jew and of the hollowness of the ideals of present-day civilization. Yet I never saw him in the flesh.
"My Contact with Josef Popper-Lynkeus"

*Josef Popper-Lynkeus, 1838-1921, Austrian engineer, writer and social reformer. In 1899, that is before the appearance of Freud's Interpretation of Dreams, he had published the book Phantasien eines Realisten. Freud, who read the book years later, found in the story "Träumen wie Wachen" an anticipation of his explanation of distortions in dreams, an important part of his theory of dreams.*

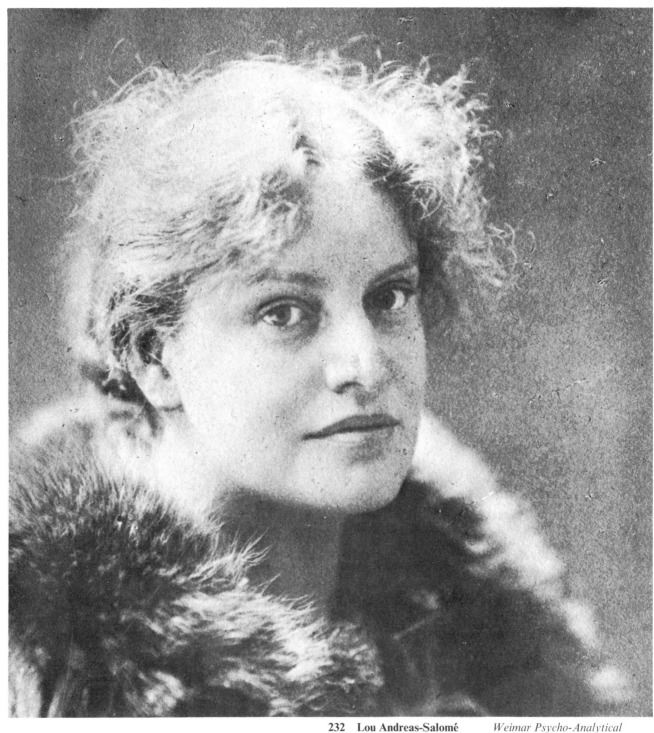

**232   Lou Andreas-Salomé**
I cannot believe that there is
any danger of your mis-
understanding any of our
arguments; if so it must be our
[ . . . ] fault. After all, you
are an "understander" *par
excellence*; and in addition
your commentary is an
amplification and improve-
ment on the original.
*Letter to Lou Andreas-Salomé,
May 25, 1916*

*Lou Andreas-Salomé, 1861-
1937. Her attention was
probably drawn to
psychoanalysis by Arthur
Schnitzler, and in September
1911 she took part in the*

*Weimar Psycho-Analytical
Congress. In 1912-1913 she
studied with Freud in Vienna,
and worked thereafter as a
practicing analyst. She
published a large number of
psychoanalytical writings; her
lifelong friendly relationship
with Freud is documented in her
correspondence with him.*[1]

**233  Rainer Maria Rilke**

I was often on the point of helping myself up out of the depths by having a talk with you. But finally the decision prevailed to struggle through alone, as far as one still has a miserable shred of solitude left. If I can gradually get some measure of control, then I shall certainly invite myself and come to see you; I know that will be good for me.

*Letter from Rainer Maria Rilke to Freud, February 17, 1916*

Rilke [ . . . ] made it quite clear to us in Vienna that "no lasting alliance can be forged with him." Cordial as he was on his first visit, we have not been able to persuade him to pay us a second.

*Letter to Lou Andreas-Salomé, July 27, 1916*

*Rilke, the eminent Austrian poet, served in the Austrian Army from January to June 1916. He had visited Freud in December 1915.*

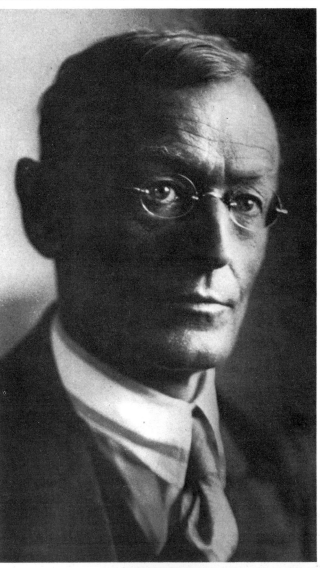

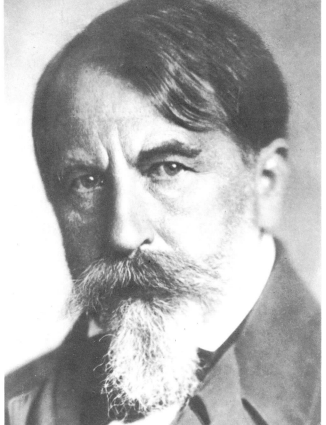

**234  Hermann Hesse**

I feel a kind of shame that you should say a word of thanks to me, for it is I, on the contrary, who owe you deep gratitude. To utter it today for the first time gives me great joy. Poets were always your allies without knowing it, and they will become more and more conscious of it.

*Letter from Hermann Hesse to Freud, September 9, 1918*

**235  Arthur Schnitzler**

I think I have avoided you from a kind of reluctance to meet my double. Not that I am easily inclined to identify myself with another, or that I mean to overlook the difference in talent that separates me from you, but whenever I get deeply absorbed in your beautiful creations I invariably seem to find beneath their poetic surface the very pre-suppositions, interests, and conclusions which I know to be my own. [ . . . ] So I have formed the impression that you know through intuition—or rather from detailed self-observation—everything that I have discovered by laborious work on other people. Indeed, I believe that fundamentally your nature is that of an explorer of psychological depths, as honestly impartial and undaunted as anyone has ever been [. . .].

*Letter to Arthur Schnitzler, May 14, 1922*[1]

**236   Lucie Freud**
My Lux is an enchanting
creature.
*Letter to Max Eitingon,
June 15, 1920*

*Lucie Freud, née Brasch, born
1896, who married Freud's
youngest son Ernst in 1920. She
formed a particularly cordial
relationship with her mother-in-
law.*

**237   Martha Freud, 1919**

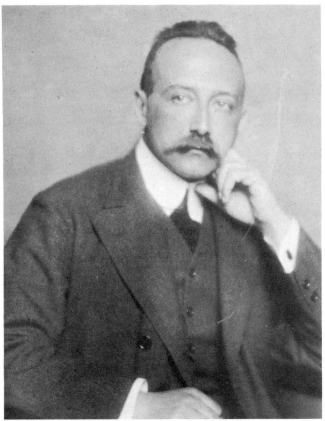

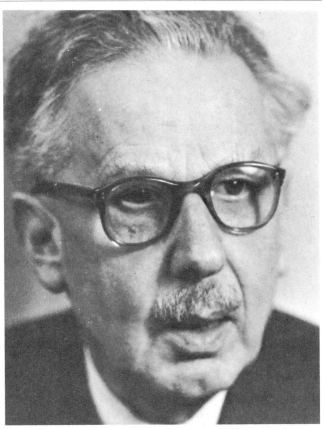

**238    Anton von Freund**

I ascribe a good share of my better spirits to the prospects that have opened up in Budapest for the development of our cause. Materially we shall be strong, we shall be able to maintain and expand our journals and exert an influence, and there will be an end to our hitherto prevailing penuriousness. The individual whom we shall thank for this is not merely a wealthy man, but a man of sterling worth and highly intellectual gifts who is greatly interested in analysis; he is in fact the sort of person whom one would have to invent if he did not already exist. Bad faith on his part is out of the question.
*Letter to Karl Abraham, August 27, 1918*

*Anton von Freund, 1880-1920, brewer in Budapest. He donated a great deal of money which, after the First World War, made possible the establishment of the* Internationaler Psychoanalytischer Verlag *(1919) which allowed the psychoanalysts to publish their works independently. It was only with extreme difficulty that Freud had succeeded in inducing his former publishers to continue with the psychoanalytical periodicals*

*during the war. These journals, together with the most important psychoanalytical monographs, were published from now on by the new Press.*[1]

> **Imago**
> Zeitschrift für Anwendung der Psychoanalyse
> auf die Natur- und Geisteswissenschaften
>
> Herausgegeben von
> **Sigm. Freud**
> Redigiert von Sándor Radó, Hanns Sachs, A. J. Storfer
>
> Jährlich 4 Hefte Großquart im Gesamtumfang von
> etwa 560 Seiten. Abonnement jährlich M. 22.—
>
> Im Januar 1932 beginnt der XVIII. Jahrgang

> **Internationale Zeitschrift**
> **für Psychoanalyse**
> Offizielles Organ der
> Internationalen Psychoanalytischen Vereinigung
>
> Herausgegeben von
> **Sigm. Freud**
> Redigiert von M. Eitingon, S. Ferenczi, S. Radó
>
> Jährlich 4 Hefte Lexikonoktav im Gesamtumfang
> von etwa 600 Seiten. Abonnement jährlich M. 28.—
>
> Im Januar 1932 beginnt der XVIII. Jahrgang

**239    Advertisements of the *Internationaler Psycho-analytischer Verlag***

**240    Ludwig Binswanger**

Quite unlike so many others, you have not let your intellectual development, which carried you further and further from my sphere of influence, ruin our personal relationship as well, and you do not know what a comfort such delicacy can be to a man.
*Letter to Ludwig Binswanger, January 11, 1929*

I have always lived on the groundfloor and in the basement of the building—you maintain that on changing one's viewpoint one can also see an upper floor housing such distinguished guests as religion, art, and others. You are not the only one; most cultivated specimens of *homo natura* think likewise. In this respect you are the conservative, I the revolutionary. If I had another life of work ahead of me, I would dare to offer even those high-born people a home in my lowly hut.
*Letter to Ludwig Binswanger, October 8, 1936*

*Freud was a friend of the Swiss psychiatrist Ludwig Binswanger (1881-1966), a mediator between psychiatry and psychoanalysis, for more than a quarter of a century, although Binswanger never played an active part in the psycho-analytical movement, and followed his own scientific paths in his studies in phenomenology and existential analysis.*

**241   Part of Julius Wagner-Jauregg's testimonial on Freud, 1919**

*This testimonial was enclosed with a letter sent by the Medical Faculty of the University of Vienna to the Ministry of Education on July 23, 1919, recommending that Freud be given the title of Professor Ordinarius.[1]*
*Translation in the Notes*

Staatsamt.
für Inneres und Unterricht.

Unterrichtsamt.                                                Wien, am 7. Jänner 1920.

ad Z.27712/19-Abt. 2

Universität Wien, mediz. Fakultät,
a.o. Professoren Dr. Adolf Lorenz,
Dr. Hubert Peters und Dr. Gustav
Alexander, Titel und Charakter eines
ord. Uni. Professors, tit. a.o. Univ.
Professoren, Privatdozenten Dr. Sieg-
mund Freud und Dr. Leopold Réthi,
Titel eines ord. Univ. Professors.
ad Z. 1957 vom 22. Juli 1919,
ad Z. 1463 vom 17. Mai 1919,
ad Z. 2005 und Z. 1959 vom 23. Juli 1919 und
ad Z. 1958 vom 24. Juli 1919.

                              An

          das D e k a n a t  der medizinischen Fakultät

                    der Universität

                                  in

                                      W i e n .

          Der Präsident der Nationalversammlung hat am 23. De-
     zember 1919 den ausserordentlichen Professoren an der Uni-
     versität in Wien, Regierungsrat Dr. Adolf L o r e n z, Dr.
     Hubert P e t e r s und Dr. Gustav A l e x a n d e r  den
     Titel und Charakter eines ordentlichen Universitätspro-
     fessors, ferner an der genannten Universität den mit dem
     Titel eines ausserordentlichen Universitätsprofessors be-
     kleideten Privatdozenten Dr. Siegmund F r e u d  und Dr.
     Leopold R é t h i den Titel eines ordentlichen Universi-
     tätsprofessors verliehen.

**242  Document conferring titular professorship on Freud, 1920**

Actually I was never a full professor of neurology and was never anything but a lecturer. I became a titular[1] professor in 1902 and a titular full professor in 1920, have never given up my academic post, but have continued with it for thirty-two years, and finally gave up my voluntary lectures in 1918.

*Letter to Oskar Pfister, June 9, 1924*

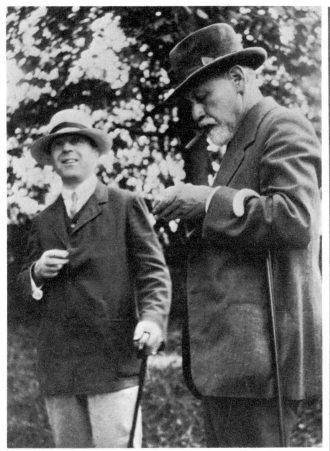

**243   After the war: with Ernest Jones, 1919**

The dreadful conditions in this city, the impossibility of feeding and keeping oneself, the presence of Jones, Ferenczi and Freund, the necessary conferences and decision-making, and the hesitant beginnings of analytic work (five sessions = 500 crowns) result in a vivid present [ . . . ].
*Letter to Karl Abraham, October 3, 1919*

**244   With daughter Sophie**

You know how great our sorrow is; we know what grief you must be suffering; I make no attempt to console you, and you can do nothing for us. [ . . . ] Why am I writing to you, then? I think it is because we are not together, and in this wretched time of captivity[1] we cannot come to each other, so that I cannot say to you the things I am constantly repeating to her mother, brothers and sisters—that it was a senseless, brutal stroke of fate that took our Sophie from us, in the face of which it is useless to recriminate or brood; we can only bow our heads under the blow like the poor helpless creatures we are, mere playthings for the higher powers.
*Letter to Max Halberstadt, January 25, 1920*

*Sophie Freud-Halberstadt, whom Freud used to call his "Sunday child," died suddenly on January 25, 1920, of a severe form of influenza, aged only 27. She left one son six years old and another thirteen months old.[2]*

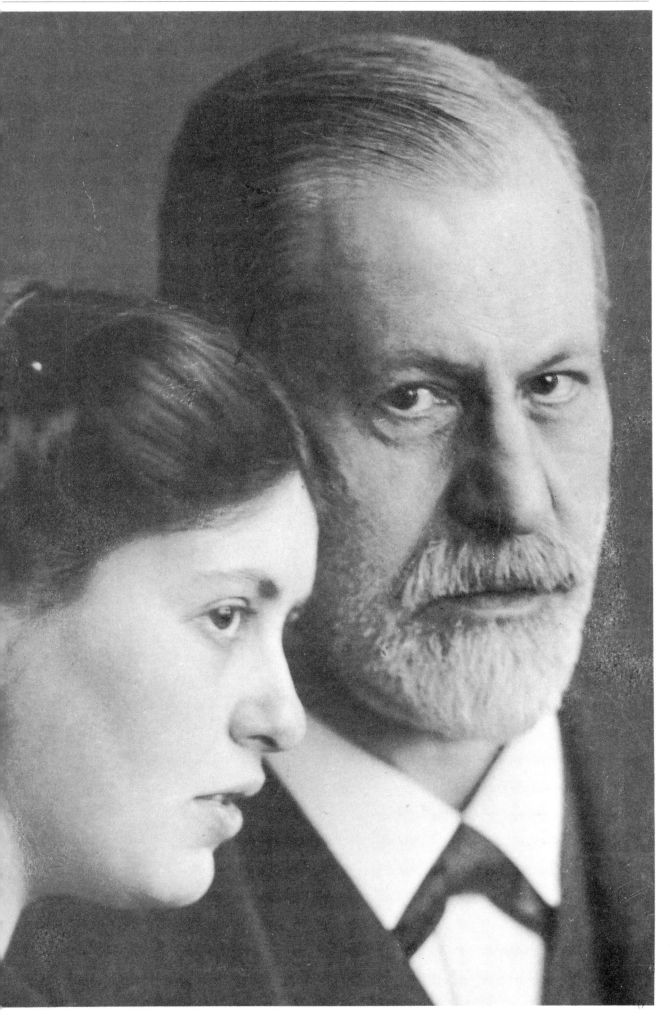

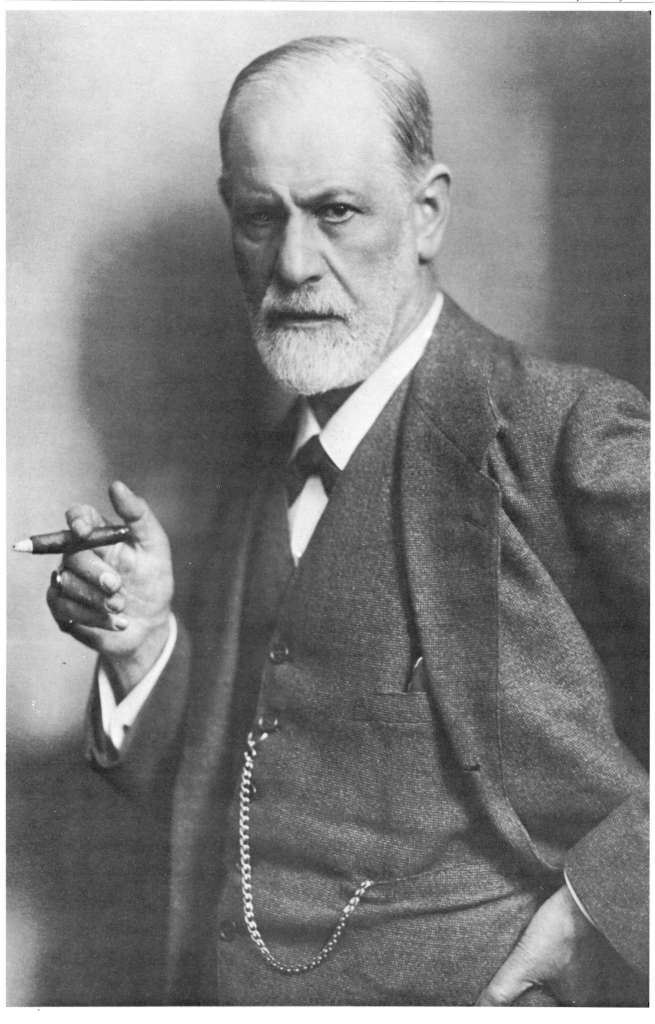

**245  Freud, about 1921**
My capacity for interest is so
soon exhausted: that is to say,
it turns away so willingly from
the present in other directions.
Something in me rebels against
the compulsion to go on
earning money [ . . . ]. Strange
secret yearnings rise in me—
perhaps from my ancestral
heritage—for the East and the
Mediterranean and for a life of
quite another kind: wishes
from late childhood never to
be fulfilled, which do not
conform to reality as if to hint
at a loosening of one's
relationship to it.
*Letter to Sándor Ferenczi,*
*March 30, 1922*

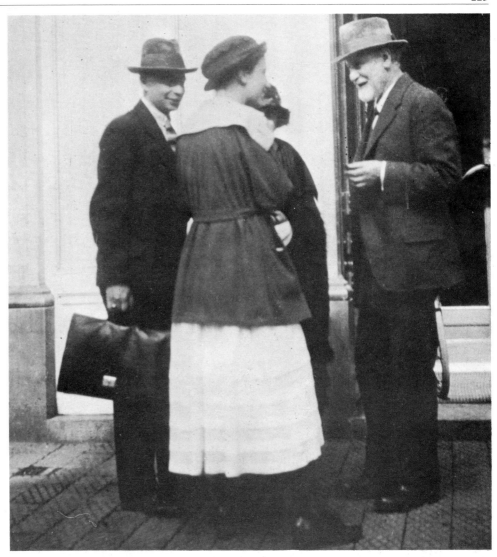

**246  First edition of *Beyond***
***the Pleasure Principle*, 1920**
For my old age I have chosen
the theme of death [ . . . ].
*Letter to Lou Andreas-Salomé,*
*August 1, 1919*

We may pause for a moment
over this pre-eminently
dualistic view of instinctual
life. According to E. Hering's
theory, two kinds of processes
are constantly at work in living
substance, operating in
contrary directions, one
constructive or assimilatory
and the other destructive or
dissimilatory. May we venture
to recognize in these two
directions taken by the vital
processes the activity of our
two instinctual impulses, the
life instincts and the death
instincts?
*Beyond the Pleasure Principle*

**247  At the Sixth International**
**Psycho-Analytical Congress,**
**1920**
The World War, which
broke up so many other
organizations, could do
nothing against our
"International." The first
meeting after the war took
place in 1920, at The Hague,
on neutral ground. It was
moving to see how hospitably
the Dutch welcomed the
starving and impoverished
subjects of the Central
European states; and I believe
this was the first occasion in
a ruined world on which
Englishmen and Germans sat
at the same table for the
friendly discussion of scientific
interests.
*An Autobiographical Study*

*Freud with Anna and Rank.*
*The Congress lasted from*
*September 8 to 11.*

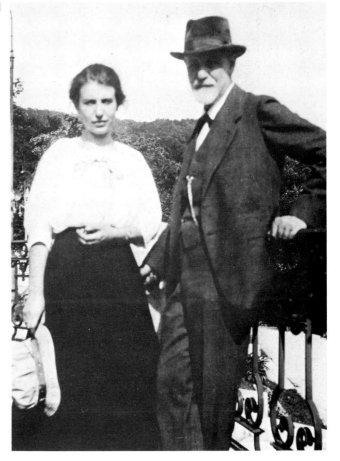

**248  With Anna at the Hague**
**Congress**

# MASSENPSYCHOLOGIE
## UND
# ICH-ANALYSE

### VON

### PROF. SIGM. FREUD

INTERNATIONALER
PSYCHOANALYTISCHER VERLAG G. M. B. H.
LEIPZIG   WIEN   ZÜRICH
1921

# Das Ich und das Es

### von

# Sigm. Freud

1.—8.  Tausend

1923
Internationaler Psychoanalytischer Verlag
Leipzig          Wien          Zürich

---

**249   First edition of *Group Psychology and the Analysis of the Ego*, 1921**
Group psychology is therefore concerned with the individual man as a member of a race, of a nation, of a caste, of a profession, of an institution or as a component part of a crowd of people who have been organized into a group at some particular time for some definite purpose. When once natural continuity has been severed in this way, if a breach is thus made between things which are by nature interconnected, it is easy to regard the phenomena that appear under these special conditions as being expressions of a special instinct that is not further reducible—the social instinct ("herd instinct," "group mind"), which does not come to light in any other situations. But we may perhaps venture to object that it seems difficult to attribute to the factor of number a significance so great as to make it capable by itself of arousing in our mental life a new instinct that is otherwise not brought into play. Our expectation is

therefore directed towards two other possibilities: that the social instinct may not be a primitive one and insusceptible of dissection, and that it may be possible to discover the beginnings of its development in a narrower circle, such as that of the family.
*Group Psychology and the Analysis of the Ego*

**250   First edition of *The Ego and the Id*, 1923**
There are two paths by which the contents of the id can penetrate into the ego. The one is direct, the other leads by way of the ego ideal; which of these two paths they take may, for some mental activities, be of decisive importance. The ego develops from perceiving instincts to controlling them, from obeying instincts to inhibiting them. In this achievement a large share is taken by the ego ideal, which indeed is partly a reaction-formation against the instinctual processes of the id. Psycho-analysis is an instrument to enable the ego to achieve a progressive conquest of the id.

From the other point of view, however, we see this same ego as a poor creature owing service to three masters and consequently menaced by three dangers: from the external world, from the libido of the id, and from the severity of the super-ego.
*The Ego and the Id*

**251   Poster for the film *Psychoanalyse***
The film will be as unpreventable, it seems, as bobbed hair, but I'm not having mine cut, and neither will I have any personal connection with any film.
*Letter to Sándor Ferenczi, August 14, 1925*

*Sachs and Abraham had advocated making a film on psychoanalysis. Freud, however, disagreed: "My chief objection is still that I do not believe that satisfactory plastic representation of our abstractions is at all possible."*[1]

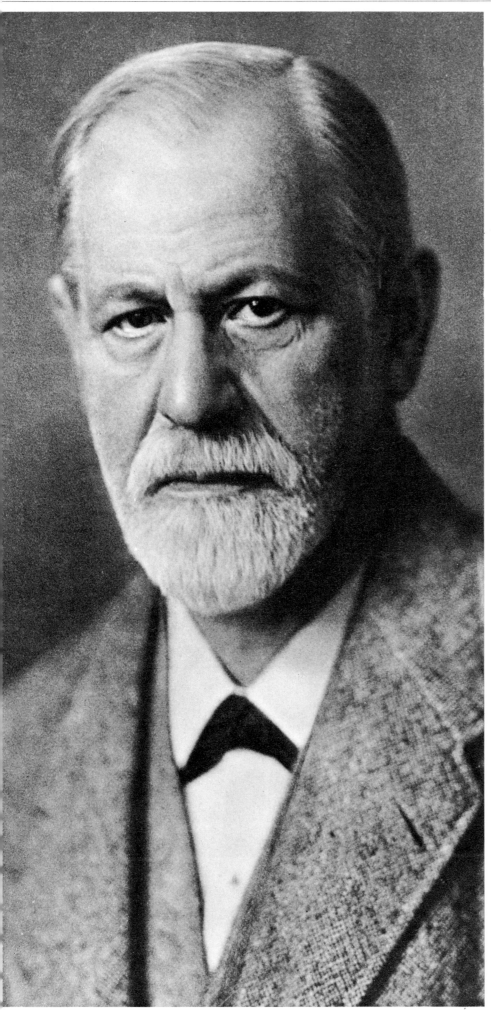

**252   Freud, 1922**
About my operation and
affliction there is nothing to
say [ . . . ]. The uncertainty
that hovers over a man of 67
has now found its material
expression. I don't take it very
hard; one will defend oneself
for a while with help of
modern medicine and then
remember Bernard Shaw's
warning: "Don't try to live for
ever, you will not succeed."
*Letter to Katá and Lajos Levy,
June 11, 1923*

*From April 1923, after the
removal of a tumor of the
palate, it was known that Freud
was suffering from cancer, the
disease[1] from which, after many
more operations, he died in
1939.*

**253  With granddaughter Eva**
The rest of the time I devoted
to my children, large and
small.
*Letter to Sándor Ferenczi,
January 2, 1927*

*His son Oliver's daughter*

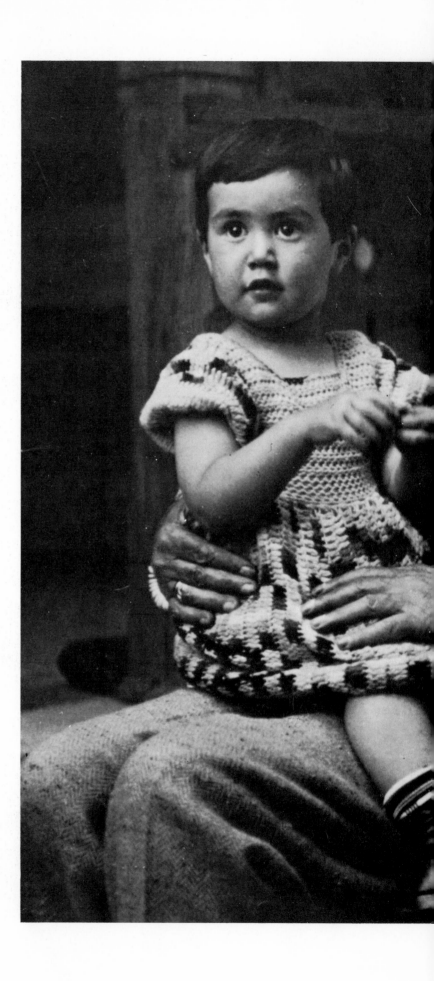

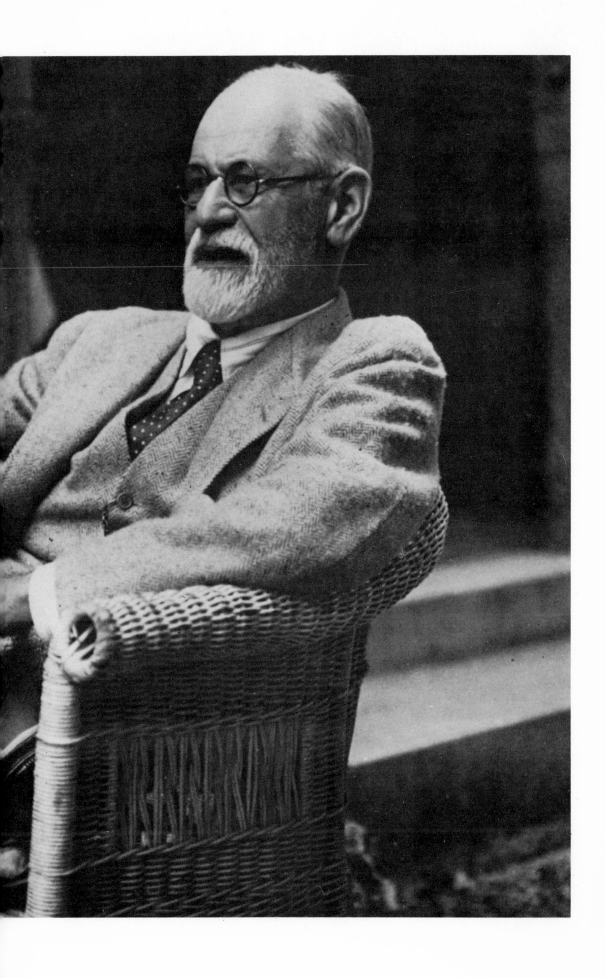

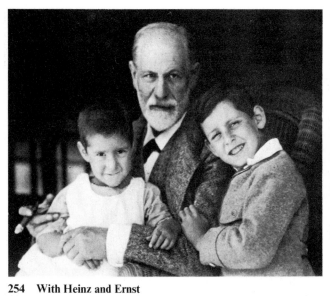

**254   With Heinz and Ernst**

*Sons of his dead daughter
Sophie*

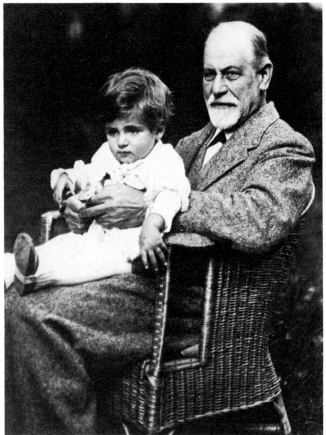

**255   With Stephan Gabriel**

*His son Ernst's firstborn son*

**256   Stephan Gabriel, Lucian
Michael and Clemens Raphael**

*His son Ernst's children*

**257   Anton Walter and Sophie**

*His son Martin's children*

**258   Heinerle**

We brought[1] here from Hamburg Sophie's younger son, Heinerle, [ . . . ] an enchanting little fellow, and I myself was aware of never having loved a human being, certainly never a child, so much. Unfortunately he was very weak, never entirely free of a temperature, one of those children whose mental development grows at the expense of its physical strength. [ . . . ] This child fell ill again a fortnight ago, [ . . . ] for a long time no diagnosis, and finally the slow but sure realization that he has a miliary tuberculosis, in fact that the child is lost. [ . . . ] I find this loss very hard to bear. I don't think I have ever experienced such grief; perhaps my own sickness contributes to the shock. I work out of sheer necessity; fundamentally everything has lost its meaning for me.

*Letter to Katá and Lajos Levy, June 11, 1923*

*Heinz Rudolf Halberstadt, 1919-1923*

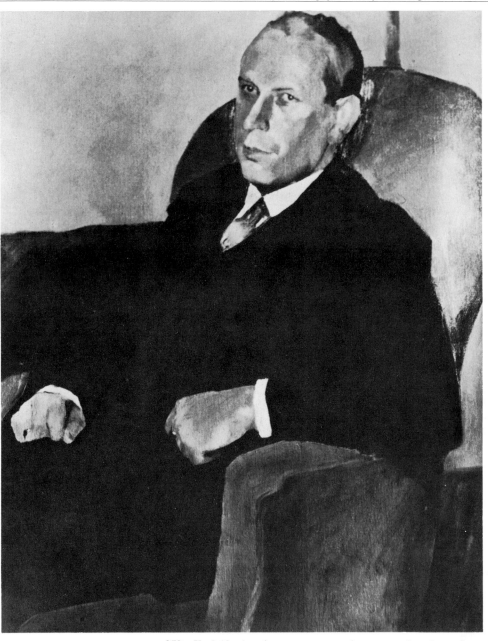

**259   Karl Abraham**[1]

I can only repeat what you have said, that Abraham's death is perhaps the greatest loss that could have struck us, and it has struck us. In my letters I used to call him jestingly my "rocher de bronze"; I felt safe in the absolute confidence he inspired in me, as in everyone else. In the brief obituary which I wrote for the *Zeitschrift*[2] [ . . . ] I applied to him Horace's line:
*Integer vitae scelerisque purus.*
I have always found exaggerations on the occasion of death particularly distasteful and I have been careful to avoid them, but in citing this quotation I feel I have been sincere. Who would have thought [ . . . ] that he would be the first to leave this unreasonable life!—We must continue to work and stand together. As a human being no one can replace this loss, but for psycho-analysis no one is allowed to be irreplacable. I shall soon pass on, the others I hope not till much later, but our work, compared to whose importance we are all insignificant, must continue.
*Letter to Ernest Jones, December 30, 1925*

*Abraham died on December 25, 1925, at only 48 years of age.*[3]

**260   Hans Pichler**
I can now inform you that I
can again speak, chew and
work, indeed even smoking
is permitted—to a certain
moderate, cautious, so to
speak *petit bourgeois* degree.
*Letter to Lou Andreas-Salomé,*
*May 10, 1923*

*Hans Pichler, 1877-1949, oral*
*surgeon and professor at the*
*University of Vienna. He*
*treated Freud from 1923 to*
*1938, and operated on him for*
*the last time in London in 1938.*

**261   Max Schur**
I only want to say that I will
not forget how often your
diagnoses have turned out to
be correct in my case, and that
for this reason I am a docile
patient even when it is not easy
for me.
*Letter to Max Schur, June 28,*
*1930*

*Max Schur, 1897-1969,*
*specialist in internal medicine in*
*Vienna, later psychoanalyst in*
*New York. He looked after*
*Freud from 1928 until the end.*[1]

**262  Freud's mother and sisters, 1925**

The loss of a mother must be something very strange, unlike anything else, and must arouse emotions that are hard to grasp. I myself still have a mother, and she bars my way to the longed-for rest, to eternal nothingness; I somehow could not forgive myself if I were to die before her.
*Letter to Max Eitingon, December 1, 1929*

*At Amalie Freud's 90th birthday party, August 18, 1925. In the front row, from left to right: Rosa Graf, Amalie Freud, Anna Bernays; back row: Paula Winternitz, Dolfi Freud, Marie Freud—Four of Freud's five sisters, who remained in Vienna when he left the country in 1938, were taken by the Nazis to Theresienstadt and murdered in Auschwitz in 1942.*

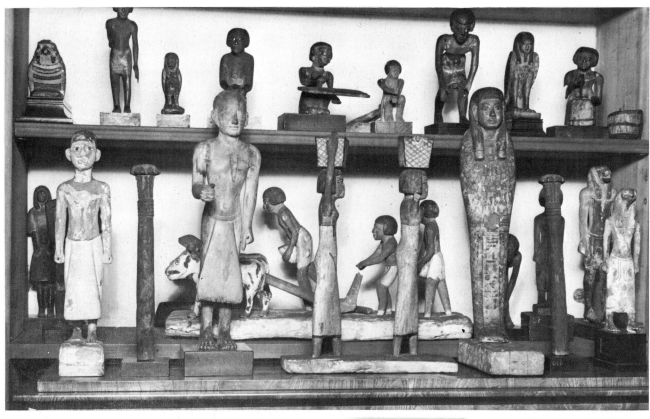

### 263   Part of Freud's collection of antiques

There is one misreading which I find irritating and laughable and to which I am prone whenever I walk through the streets of a strange town on my holidays. On these occasions I read every shop sign that resembles the word in any way as "Antiquities." This betrays the questing spirit of the collector.
*The Psychopathology of Everyday Life*

[ . . . ] despite my much vaunted frugality I have sacrificed a great deal for my collection of Greek, Roman and Egyptian antiquities, have actually read more archaeology than psychology [ . . . ].
*Letter to Stefan Zweig, February 7, 1931*

### 264   Tarock card

[ . . . ] but on Saturday evenings after eleven hours of analytical work, at the end of a Sundayless week, I am no good for anything, and a game of cards is the best thing for me.
*Letter to Sándor Ferenczi, May 24, 1913*

*A card game especially popular in Austria, which Freud played from his student days into old age*

### 265   Part of Freud's library

It had once amused my father to hand over a book with *colored plates* [ . . .] for me and my elder sister to destroy. [ . . . ] I had been five years old at the time and my sister not yet three; and the picture of the two of us blissfully pulling the book to pieces [ . . . ] was almost the only plastic memory that I retained from that period of my life. Then, when I became a student, I had developed a passion for collecting and owning books [ . . . ] I had become a *book-worm*. I had always, from the time I first began to think about myself, referred this first passion of mine back to the childhood memory I have mentioned. Or rather, I had recognized that the childhood scene was a "screen memory" for my later bibliophile propensities. [ . . . ] When I was seventeen I had run up a largish account at the booksellers and had nothing to meet it with; and my father had scarcely taken it as an excuse that my inclinations might have chosen a worse outlet.
*The Interpretation of Dreams*

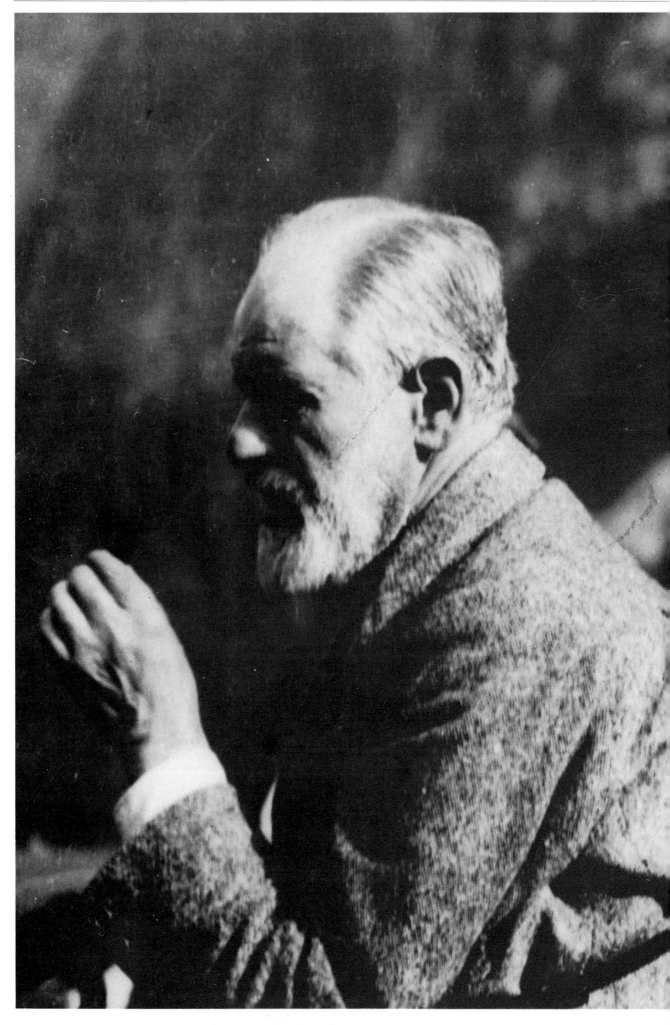

**266 In the mountains, 1925**
As for me, I no longer want to ardently enough. A crust of indifference is slowly creeping up around me; a fact I state without complaining. It is a natural development, a way of beginning to grow inorganic. The "detachment of old age," I think it is called. It must be connected with a decisive turn in the relationship of the two instincts postulated by me. The change taking place is perhaps not very noticeable; everything is as interesting as it was before, neither are the ingredients very different; but some kind of resonance is lacking; unmusical as I am, I imagine the difference to be something like using the pedal or not.
*Letter to Lou Andreas-Salomé, May 10, 1925*

**267 At the Semmering**
I have too clearly recognized my dependence on my doctor's consulting room[1] to put such a distance between him and me, and have taken the Villa Schüler, next to the Süd-bahnhotel at Semmering, from where I can comfortably get to Vienna and back in a day.
*Letter to Karl Abraham, July 4, 1924*

*Places in Bavaria or Austria were mainly chosen for the family holidays, until Freud's serious illness made it impossible to go very far from Vienna. From 1924 onwards the family spent five summers at the Semmering.*

**Hemmung, Symptom
und Angst**

von

**Sigm. Freud**

1926
Internationaler   Psychoanalytischer   Verlag
Leipzig                Wien                    Zürich

**268   Advertisement of the
*Gesammelte Schriften*
(Collected Works), 1925**
*In 1924 the* Internationale
Psychoanalytischer Verlag
*published the first volume of the*
Gesammelte Schriften, *12
volumes in all. This is the first
major German edition of
Freud's works. Most copies held
in stock were later pulped by the
Nazis.*

**269   First edition of
*Inhibitions, Symptoms and
Anxiety*, 1926**
A new pamphlet of mine,
*Inhibitions, Symptoms and
Anxiety*, is now being
published. It shakes up so
much that was established and
puts things which seemed fixed
into a state of flux again.
[ . . . ] But it would be rash to
believe that I have now
succeeded in finally solving the
problem with which the
association of anxiety with
neurosis confronts us.
*Letter to Oskar Pfister,
January 3, 1926*

**270   Announcement of the
B'nai B'rith Lodge on the
occasion of Freud's 70th
birthday, 1926**
I thank you for the honors
you have paid me today.
[ . . . ]
I should like to tell you shortly
how I became a B.B. and what
I have looked for from you.[1]
It happened that in the years
from 1895 onwards I was
subjected to two powerful
impressions which combined
to produce the same effect on
me. On the one hand I had
gained my first insight into the
depths of the life of the human
instincts; I had seen some
things that were sobering and
even, at first, frightening.
On the other hand, the
announcement of my
unpleasing discoveries had as
its result the severance of the
greater part of my human
contacts; I felt as though I
were despised and universally
shunned. In my loneliness I was
seized with a longing to find a
circle of picked men of high
character who would receive
me in a friendly spirit in spite
of my temerity. Your society
was pointed out to me as the
place where such men were to
be found. [ . . . ] There was no
question whatever of my
convincing you of my new
theories; but at a time when no
one in Europe listened to me
and I still had no disciples even
in Vienna, you gave me your
kindly attention. You were my
first audience.
*Address to the Society of B'nai
B'rith, May 6, 1926*

**B'NAI B'RITH MITTEILUNGEN FÜR ÖSTERREICH**
REDIGIERT VON DR. ARNOLD ASCHER, WIEN, II., LAUFBERGERGASSE 8

Eigentum und Verlag des Verbandes der israelitischen Humanitätsvereine „B'nai B'rith" für
Österreich in Wien, IX., Universitätsstraße 4

Heft 5                         Mai 1926                  Jahrgang XXVI

INHALTSVERZEICHNIS

**Festsitzung der »Wien« anläßlich des
70. Geburtstages Br. Univ. Prof. Doktor
Sigmund Freud**

Die überaus große Verehrung und Liebe, deren sich
Br. Sigmund Freud seitens der Wiener B'nai B'rith erfreut, fand
auch in der Beteiligung an der Feier Ausdruck, welche die
„Wien", der er seit 29. September 1897 angehört, am 8. Mai
1926 im großen Saale des Industriehauses, III., Schwarzenberg-
platz, zu seinen Ehren veranstaltete. Die zur Festsitzung geladenen
Brüder und Schwestern waren in solch stattlicher Zahl erschienen,
daß noch vor Beginn der Festsaal und die Galerie voll gefüllt
waren und zahlreiche Gäste schwer Einlaß fanden.

Mit großem Bedauern erfuhren die Anwesenden, daß der
Jubilar selbst sich außerstande erklärt hatte, an der Veranstaltung
teilzunehmen. Nachdem die Mitglieder des Generalkomitees, die
Expräsidenten und Beamten der „Wien" am Präsidialtische, vor
dem eine ausgezeichnete, treffend ähnliche Bronzebüste des Bild-
hauers Paul Königsberger aufgestellt war, Platz genommen,
leitete Prof. Herz den Abend mit einem stimmungsvollen
Präludium ein.

Der Präsident der Loge „Wien" Br. Dr. Felix Kohn eröffnete
die Sitzung mit folgenden Worten:

„Von unserem Bruder Sigmund Freud, dessen siebzigster
Geburtstag uns heute hier vereint, ist eine Bewegung des Geistes
ausgegangen, die mächtig an die Pforten der Zukunft pocht.
Wohin diese Bewegung führen wird, wie weit ihre letzten Wir-
kungen reichen werden, das sind Fragen, deren Beantwortung
die Geschichte der Menschheit übernimmt. Wir aber, die
Generation, die mit Sigmund Freud lebt, und vor allem die

**271   Etching by Ferdinand
Schmutzer**
What bound me to Jewry was
(I am ashamed to admit)
neither faith nor national
pride, for I have always been
an unbeliever and was brought
up without any religion though
not without a respect for what
are called the "ethical"
standards of human
civilization. Whenever I felt
an inclination to national
enthusiasm I strove to suppress
it as being harmful and wrong,
alarmed by the warning
examples of the peoples among
whom we Jews live. But plenty
of other things remained over
to make the attraction of Jewry
and Jews irresistible—many
obscure emotional forces,
which were the more powerful
the less they could be expressed
in words, as well as a clear
consciousness of inner identity,
the safe privacy of a common
mental construction. And
beyond this there was a
perception that it was to my
Jewish nature alone that I
owed two characteristics that
had become indispensable to
me in the difficult course of my

life. Because I was a Jew I
found myself free from many
prejudices which restricted
others in the use of their
intellect; and as a Jew I was
prepared to join the
Opposition and to do without
agreement with the "compact
majority."
*Address to the Society of B'nai
B'rith, May 6, 1926*

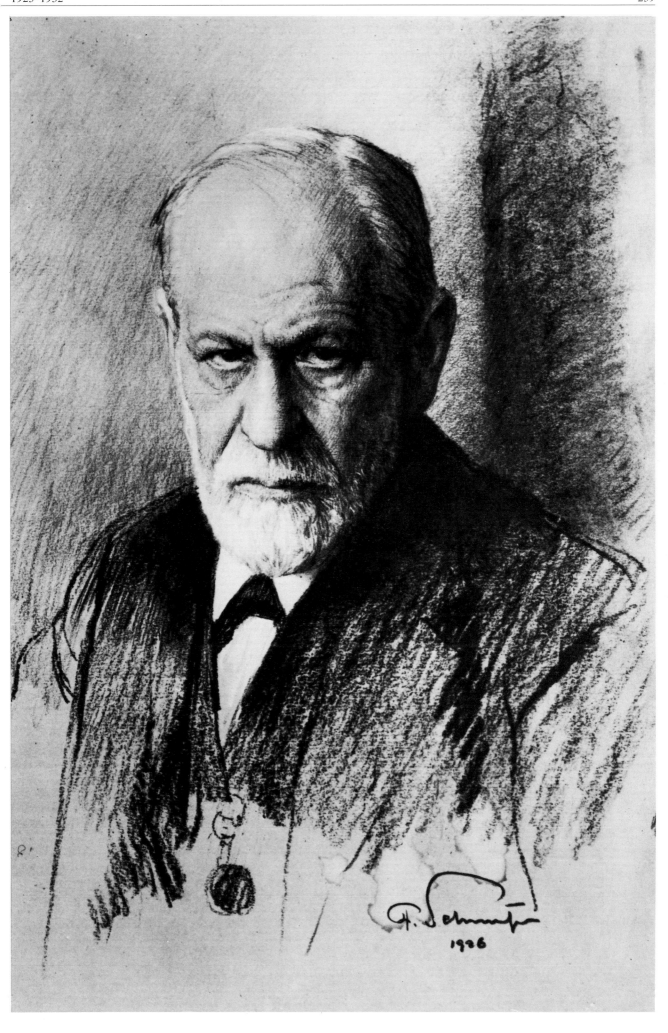

**272  Freud, 1927**

If—which may sound fantastic today—one had to found a college of psycho-analysis, much would have to be taught in it which is also taught by the medical faculty: alongside of depth-psychology, which would always remain the principal subject, there would be an introduction to biology, as much as possible of the science of sexual life, and familiarity with the symptomatology of psychiatry. On the other hand, analytic instruction would include branches of knowledge which are remote from medicine and which the doctor does not come across in his practice: the history of civilization, mythology, the psychology of religion and the science of literature. Unless he is well at home in these subjects, an analyst can make nothing of a large amount of his material. By way of compensation, the great mass of what is taught in medical schools is of no use to him for his purposes.
*The Question of Lay Analysis*

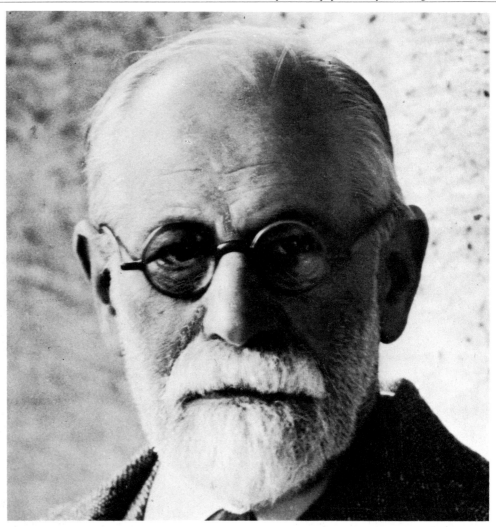

**273  List of courses of the Vienna Psycho-Analytical Training Institute**

There are at the moment two Institutes at which instruction in psycho-analysis is given. The first has been founded in Berlin by Dr. Max Eitingon, who is a member of the Society there. The second[1] is maintained by the Vienna Psycho-Analytical Society at its own expense and at considerable sacrifice. The part played by the authorities is at present limited to the many difficulties which they put in the way of the young undertaking.
*The Question of Lay Analysis*

[ . . . ] there are voluntary institutions which make psycho-analytic treatment accessible to the wage-earning classes.
"Psycho-Analysis"

**274  Galley proof of the work on "Fetishism", 1927**

### LEHRINSTITUT DER WIENER PSYCHOANALYTISCHEN VEREINIGUNG

Das LEHRINSTITUT DER WIENER PSYCHOANALYTISCHEN VEREINIGUNG veranstaltet im Wintersemester 1926/27 folgende Kurse:

I) Fach- und Ausbildungskurse:

1. *Dr. E. Hitschmann:* Einführung in die Psychoanalyse. 10 Stunden. Beginn Samstag, den 30. Oktober, 7 Uhr abends.
2. *Dr. Paul Federn:* Seminar zur gemeinsamen Lektüre der metapsychologischen Schriften Freuds. Beginn Montag, den 18. Oktober, 8 Uhr abends.
3. *Prof. Dr. Paul Schilder:* Psychoanalytische Vorweisungen. Großer Hörsaal der Klinik Wagner-Jauregg, Samstag 7—9. Beginn Oktober.
4. *Anna Freud:* Zur Technik der Kinderanalyse und ihrer Abgrenzung gegen die Analyse der Erwachsenen. Beginn Montag, den 8. November, 8 Uhr abends.
5. *Dr. H. Nunberg:* Allgemeine Neurosenlehre. 25 Stunden. Beginn im November.
6. *Dr. Wilhelm Hoffer:* Was bietet die Psychoanalyse dem Erzieher? (Einführungskurs.) 10 Stunden. Beginn Mitte November.
7. *Dr. W. Reich:* Spezielle Neurosenlehre. 12 Stunden. Beginn Donnerstag, den 13. Januar, 7 Uhr abends.
8. *Dr. Helene Deutsch:* Schwierigkeiten des weiblichen Seelenlebens (typische Neurosen mit besonderer Berücksichtigung der Fortpflanzungsfunktionen). 8 Stunden. Beginn Dienstag, den 11. Januar, 7 Uhr abends.
9. *Dr. Theodor Reik:* Psychoanalyse der Religion. I. Das Dogma. 12 Stunden. Beginn Dienstag, den 8. Februar, 8 Uhr abends.

II) Praktische Übungen für Ausbildungskandidaten.

Am Ambulatorium der Wiener Psychoanalytischen Vereinigung: *Dr. E. Hitschmann* und *Dr. W. Reich:* Seminar für psychoanalytische Therapie.

Bei genügender Beteiligung werden im Herbst 1926 folgende englische Kurse abgehalten:
   a) *Dr. Paul Federn:* Introduction into Psycho-Analysis for Physicians.
   b) *Dr. Paul Federn:* Principles of Psycho-Analytic Therapy.
   c) *Dozent Dr. Felix Deutsch:* What ought the Practitioner to know about Psycho-Analysis?

Ort: Vortragssaal des Lehrinstituts, Wien, IX., Pelikangasse 18.
Honorar: öst. Schilling 1·50 pro Stunde. Ermäßigungen werden fallweise gewährt.
Auskunft: Auskunft über Fragen des theoretischen Unterrichts und der praktischen Ausbildung in der Psychoanalyse bei der Vorsitzenden des Lehrinstituts, Frau Dr. Helene Deutsch, Wien, I., Wollzeile 33. jeden Mittwoch von 2—5 Uhr nachmittags.

63

# Fetischismus

Von

Sigm. Freud

In den letzten Jahren hatte ich Gelegenheit, eine Anzahl von Männern, deren Objektwahl von einem Fetisch beherrscht war, analytisch zu studieren. Man braucht nicht zu erwarten, daß diese Personen des Fetisch wegen die Analyse aufgesucht hatten, denn der Fetisch wird wohl von seinen Anhängern als eine Abnormität erkannt, aber nur selten als ein Leidenssymptom empfunden, meist sind sie mit ihm recht zufrieden oder loben sogar die Erleichterungen, die er ihrem Liebesleben bietet. Der Fetisch spielte also in der Regel die Rolle eines Nebenbefundes.

Die Einzelheiten dieser Fälle entziehen sich aus naheliegenden Gründen der Veröffentlichung. Ich kann darum auch nicht zeigen, in welcher Weise zufällige Umstände zur Auswahl des Fetisch beigetragen haben. Am merkwürdigsten erschien ein Fall, in dem ein junger Mann einen gewissen „Glanz auf der Nase" zur fetischistischen Bedingung erhoben hatte. Das fand seine überraschende Aufklärung durch die Tatsache, daß der Patient eine englische Kinderstube gehabt hatte, dann aber nach Deutschland gekommen war, wo er seine Muttersprache fast vollkommen vergaß. Der aus den ersten Kinderzeiten stammende Fetisch war nicht deutsch, sondern englisch zu lesen, der „Glanz auf der Nase" war eigentlich ein „Blick auf die Nase" (*glance* = Blick), die Nase war also der Fetisch, dem er übrigens nach seinem Belieben jenes besondere Glanzlicht verlieh, das andere nicht wahrnehmen konnten.

Die Auskunft, welche die Analyse über Sinn und Absicht des Fetisch gab, war in allen Fällen die nämliche. Sie ergab sich so ungezwungen und erschien mir so zwingend, daß ich bereit bin, dieselbe Lösung allgemein für alle Fälle von Fetischismus zu erwarten. Wenn ich nun mitteile, der Fetisch ist ein Penisersatz, so werde ich gewiß Enttäuschung hervorrufen. Ich beeile mich darum hinzuzufügen, nicht der Ersatz eines beliebigen, sondern eines bestimmten, ganz besonderen Penis, der in frühen Kinderjahren eine große Bedeutung hat, aber später verloren geht. Das heißt: er sollte normalerweise aufgegeben werden, aber gerade der Fetisch ist dazu bestimmt, ihn vor dem Untergang zu behüten. Um es klarer zu sagen, der Fetisch ist der Ersatz für den Phallus des Weibes (der Mutter) an den das Knäblein geglaubt hat und auf den es — wir wissen warum — nicht verzichten will.

Der Hergang war also der, daß der Knabe sich geweigert hat, die Tatsache seiner Wahrnehmung, daß das Weib keinen Penis besitzt, zur Kenntnis zu nehmen. Nein, das kann nicht wahr sein, denn wenn das Weib kastriert ist, ist sein eigener Penisbesitz bedroht, und dagegen sträubt sich ein Stück Narzißmus, mit dem die Natur vorsorglich gerade dieses Organ ausgestattet hat. Eine ähnliche Panik wird vielleicht der Erwachsene später erleben, wenn der Schrei ausgegeben wird, Thron und Altar sind in Gefahr, und sie wird zu ähnlich unlogischen Konsequenzen führen. Wenn ich nicht irre, würde Laforgue in diesem Falle sagen, der Knabe skotomisiert die Wahrnehmung des Penismangels beim Weibe. Ein neuer Terminus ist dann berechtigt, wenn er einen neuen Tatbestand beschreibt oder heraushebt. Das liegt hier nicht vor; das älteste Stück unserer psychoanalytischen Terminologie, das Wort „Verdrängung" bezieht

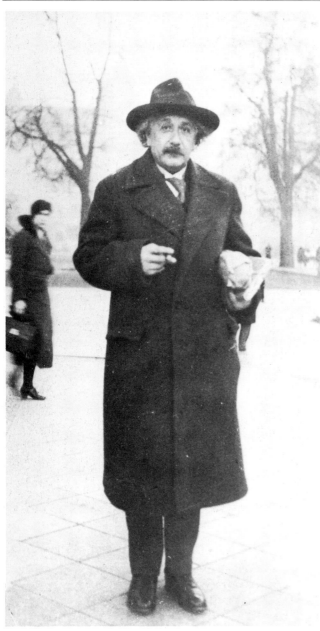

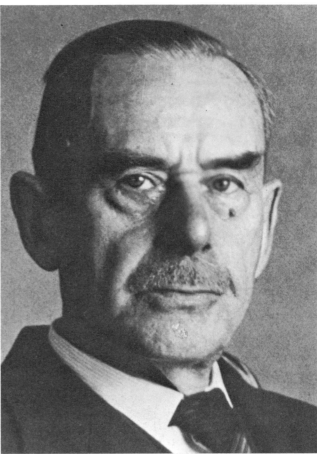

**276   Thomas Mann**
I am one of your "oldest"
readers and admirers: [ . . ] in
the name of countless numbers
of your contemporaries I wish
to express the confidence that
you will never do or say
anything—an author's words,
after all, are deeds—that is
cowardly or base, and that
even at a time which blurs
judgement you will choose the
right way and show it to
others.
*Letter to Thomas Mann,*
*June 6, 1935*

The beneficent personal
impressions of your last visit to
Vienna[1] keep coming back to
my mind. Not long ago I laid
aside your new volume of the
Joseph legend[2] with the
melancholy thought that this
beautiful experience is now
over and that I shall probably
not be able to read the sequel.
*Letter to Thomas Mann,*
*November 29, 1936*

**275   Albert Einstein**
Yes, I spent [ . . . ] two hours
chatting with Einstein [ . . . ].
He is cheerful, assured and
likeable, and understands as
much about psychology as I do
about physics, so we got on
together very well.
*Letter to Sándor Ferenczi,*
*January 2, 1927*

You have delighted the League
of Nations and me with a truly
classical reply![1] When I wrote
to you I was utterly convinced
of the insignificance of my
letter, which was only meant as
an expression of good will,
with myself as the worm on the
hook to tempt the wonderful
fish to bite.
*Letter from Albert Einstein to*
*Freud, December 3, 1932*

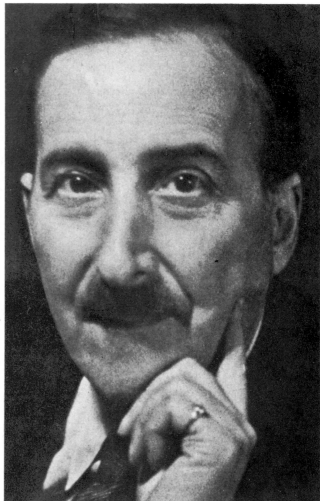

**277   Franz Werfel**
The half hour I was privileged
to spend in your company
recently was a powerful
experience for me, and its
echoes lingered for a long time
in my mind. To experience
the physical proximity of a
historical personality is a
shattering sensation which left
me overwhelmed and helpless.
For in you we honor the man
who has not only learned the
secrets of the mind and given
them a form that will stand for
centuries, but, like Copernicus,
Kepler or Newton, has
revolutionized to its very
foundations our attitude to
and knowledge of the world. It
would be presumptuous on my
part to speak of my personal
respect and gratitude, or the
dazzling revelation that your
works meant and still mean to
me.
*Letter from Franz Werfel to
Freud, September 13, 1926*

**278   Stefan Zweig**
That one doesn't like one's
own portrait[1] [ . . . ] is a
general and well-known fact. I
therefore hasten to express my
satisfaction at your having
recognized correctly the most
important feature in my case.
Namely, that in so far as
achievement is concerned it
was less the result of intellect
than of character. [ . . . ] On
the other hand I feel inclined
to object to the emphasis you
put on the element of *petit-
bourgeois* correctness in my
person. The fellow is actually
somewhat more complicated;
your description doesn't tally
with the fact that I, too, have
had my splitting headaches
and attacks of fatigue like
anyone else, that I was a
passionate smoker (I wish I
still were), that I ascribe to the
cigar the greatest share of my
self-control and tenacity in
work, [ . . . ] and so on.
*Letter to Stefan Zweig,
February 7, 1931*

**280   Lytton Strachey**
You recognize what historians are otherwise very apt to ignore, that it is impossible to understand the past with any certainty, because we cannot guess at men's motives and their mental processes, and so cannot interpret their actions [ . . . ]. So the people of times past are to us like dreams for which we are given no associations, and only laymen can expect us to interpret dreams like that. Thus you show yourself to be a historian imbued with the spirit of psychoanalysis.
*Letter to Lytton Strachey, December 25, 1928*

*Lytton Strachey, 1880-1932, English historian and biographer of historical figures including Queen Elizabeth I and Queen Victoria.*

**279   Romain Rolland**
I revered you as an artist and apostle of love for mankind many years before I saw you. I myself have always advocated the love for mankind not out of sentimentality or idealism but for sober, economic reasons: because in the face of our instinctual drives and the world as it is I was compelled to consider this love as indispensable for the preservation of the human species as, say, technology.
*Letter to Romain Rolland, January 29, 1926*

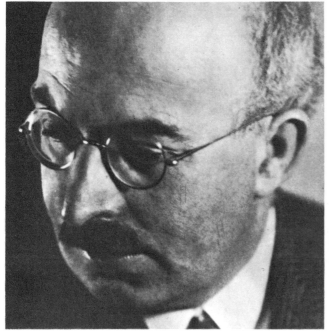

**281   Arnold Zweig**
[ . . . ] only today [ . . . ] can I settle down and write you a letter,[1] alarmed by the threat that you want to become my biographer—you, who have so much better and more important things to do, you who can establish monarchs and who can survey the brutal folly of mankind from a lofty vantage point; no, I am far too fond of you to permit such a thing. Anyone who writes a biography is committed to lies, concealments, hypocrisy, flattery and even to hiding his own lack of understanding, for biographical truth does not exist [ . . . ].
*Letter to Arnold Zweig, May 31, 1936*

**282   Marie Bonaparte**
To the writer immortality evidently means being loved by any number of anonymous people. Well, I know I won't mourn your death, for you will survive me by years, and over mine I hope you will quickly console yourself and let me live on in your friendly memory— the only form of limited immortality I recognize.
*Letter to Marie Bonaparte, August 13, 1937*

*Marie Bonaparte, Princess George of Greece and Denmark, 1882-1962, Freud's pupil and friend. She published a large number of psycho-analytical works, including a comprehensive study of Edgar Allan Poe.*

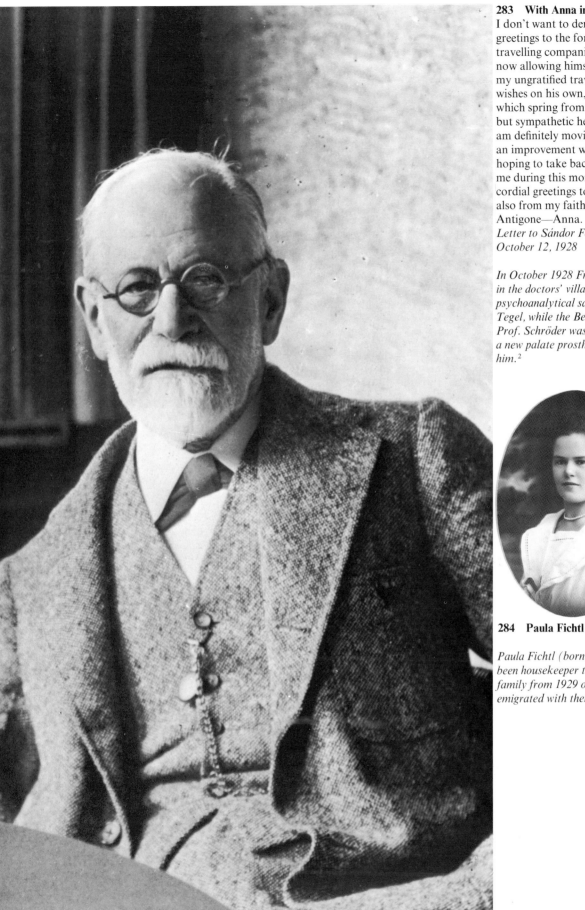

**283 With Anna in Tegel, 1928**
I don't want to deny cordial greetings to the former travelling companion[1] who is now allowing himself to fulfil my ungratified travelling wishes on his own, greetings which spring from an envious but sympathetic heart. I myself am definitely moving towards an improvement which I am hoping to take back home with me during this month. Many cordial greetings to you [ . . . ] also from my faithful Antigone—Anna.
*Letter to Sándor Ferenczi, October 12, 1928*

*In October 1928 Freud stayed in the doctors' villa of the psychoanalytical sanatorium at Tegel, while the Berlin dentist Prof. Schröder was working on a new palate prosthesis for him.[2]*

**284 Paula Fichtl**

*Paula Fichtl (born 1902) has been housekeeper to the Freud family from 1929 on. She emigrated with them.[1]*

**285  Dostoevsky**
Nearly all the peculiarities of
his production [ . . . ] can be
traced back to his—for us
abnormal, for the Russian
fairly common—psychic con-
stitution, or more correctly,
sexual constitution which
could be illustrated very well in
detail. Above all, everything
that is alien and tormenting.
He cannot be understood
without psychoanalysis—i.e.,
he isn't in need of it because he
illustrates it himself in every
character and every sentence.
The fact that *The Brothers
Karamazov* deals with D.'s
most personal problem, that of
parricide, and bases it on the
analytical theory of the
equivalence of the actual deed
and the evil intention would
be but one example. The
strangeness of his sexual love,
which is either blind lust or
sublimated compassion, the
doubts of his heroes as to
whether they love or hate,
whom they love, when they
love, etc., also shows clearly
from what soil his psychology
has sprung. With you I
do not have to fear the
misunderstanding that this
emphasis on the so-called
pathological is intended to
belittle or explain away the
splendour of D.'s creative
power.
*Letter to Stefan Zweig,
October 19, 1920*

It can scarcely be owing to
chance that three of the
masterpieces of the literature
of all time—the *Oedipus Rex*
of Sophocles, Shakespeare's
*Hamlet* and Dostoevsky's *The
Brothers Karamazov*—should
all deal with the same subject,
parricide.
"Dostoevsky and Parricide"

**286  Napoleon I, by Jacques
Louis David**
I keep wondering if there isn't
a figure in history for whom
the life of Joseph was a
mythical prototype, allowing
us to detect the phantasy of
Joseph as the secret daemonic
motor behind the scenes of his
complex life? I am thinking of
Napoleon I. [ . . . ] His eldest
brother was called Joseph, and
this fact [ . . . ] was fateful for
him. In a Corsican family the
privilege of the eldest is
guarded with a particularly
sacred awe. [ . . . ] By this
Corsican tradition a normal
human relationship becomes
exaggerated. The elder brother
is the natural rival; the younger
one feels for him an elemental,
unfathomably deep hostility
for which in later life the
expressions death-wish and
murderous intent may be
found appropriate. To
eliminate Joseph, to take his
place, to become Joseph
himself, must have been
Napoleon's strongest emotion
as a small child. [ . . . ] just
these very excessive, infantile
impulses tend to turn into their
opposite. The hated rival
becomes the loved one. This
was the case with Napoleon.
We assume that he started out
with an ardent hatred of
Joseph, but we learn that later
on he loved him more than any
other human being and could
hardly find a fault with this
worthless, unreliable man.
Thus the original hatred had
been overcompensated, but the
early aggression released was
only waiting to be transferred
to other objects. Hundreds of
thousands of unknown
individuals had to atone for
the fact that this little tyrant
had spared his first enemy.[1]
*Letter to Thomas Mann,
November 29, 1936*

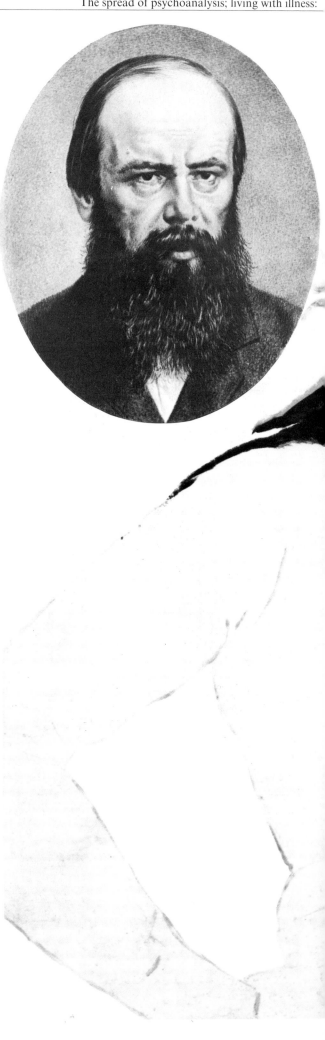

**287 Sarcophagus of Queen Elizabeth I**

When, many years ago, I stood before the tomb of this queen in Westminster,[1] a few ideas took shape in my mind [ . . ]. I believed it was Elizabeth—the childless queen—who inspired the character of Shakespeare's Lady Macbeth, about whom he found so little in historical sources. When in Act V, Scene 5, the cry rings out: "The Queen is dead," the Londoner of that time may have been reminded of how recently he had heard the same news, so that the identification of the two queens was suggested to him. Reports of Elizabeth's depression and remorse after Essex's execution may have given the poet the material for his picture of the torments of Lady Macbeth's conscience. Elizabeth too had actually been responsible for the killing of a guest (Mary Stuart) who had entrusted herself to her, and this murder could have reinforced that of Essex. As far as possible, I thought, the history of the period appears indeed to be compelled by Shakespeare's treatment of the legendary material to divide Elizabeth's character between two people, Macbeth and Lady Macbeth, who, however, complement each other and thus show that they are actually only one person. In the Macbeth couple Elizabeth's irresolution, her hardness and her remorse are all given expression. If she really was an hysteric, as L. Str. [Lytton Strachey] diagnoses her, the great psychologist[2] was perhaps not unjustified in splitting her personality into two.
*Letter to Lytton Strachey, December 25, 1928*

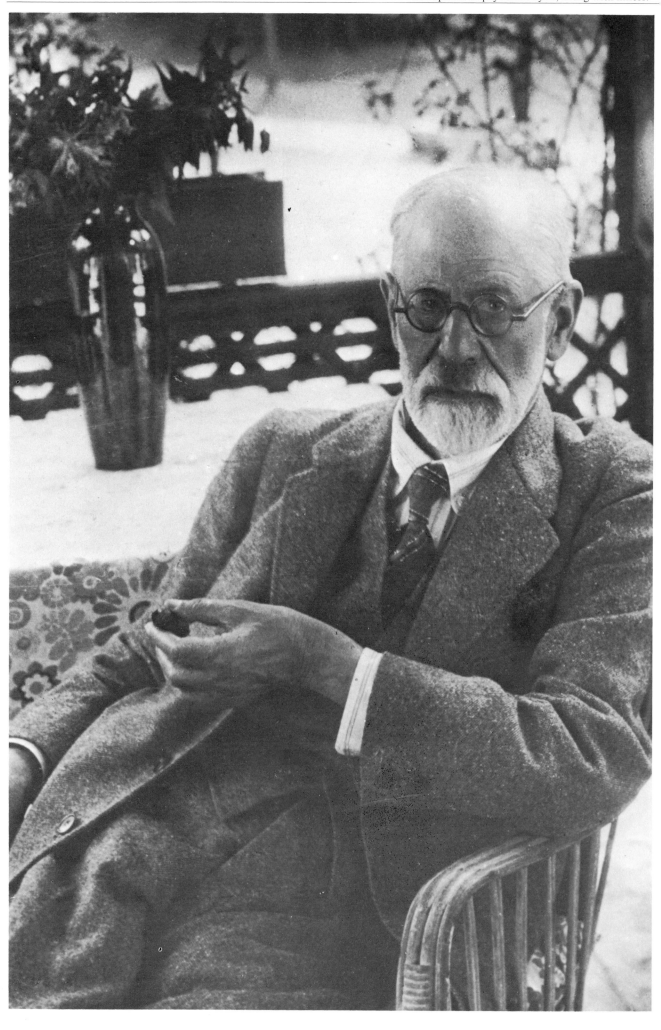

Den von ihr gestifteten

# GOETHEPREIS

verleiht in diesem Jahre die

## STADT FRANKFURT

dem als Schöpfer grundlegend neuer Betrachtungsformen anerkannten Forscher

## SIGMUND FREUD
aus WIEN

In streng naturwissenschaftlicher Methode, zugleich in kühner Deutung der von den Dichtern geprägten Gleichnisse hat Sigmund Freud einen Zugang zu den Triebkräften der Seele gebahnt und dadurch die Möglichkeit geschaffen, Entstehen und Aufbau der Kulturformen zu erkennen und manche ihrer Krankheiten zu heilen. Die Psychoanalyse hat nicht nur die ärztliche Wissenschaft, sondern auch die Vorstellungswelt der Künstler und Seelsorger, der Geschichtsschreiber und Erzieher aufgewühlt und bereichert. Über die Gefahren der Selbstzergliederung und über alle Unterschiede geistiger Richtungen hinweg lieferte Sigmund Freud die Grundlage einer erneuerten Zusammenarbeit der Wissenschaften und eines besseren gegenseitigen Verständnisses der Völker. Wie die frühesten Anfänge der Freudschen Seelenforschung auf einen Vortrag von Goethes Aufsatz „Die Natur" zurückgehen, so erscheint im letzten auch der durch die Freudsche Forschungsweise geförderte mephistophelische Zug zum schonungslosen Zerreissen aller Schleier als ein unzertrennlicher Begleiter der

**288    Freud, 1929**

**289    Goethe Prize, 1930**
This was the climax of my life as a citizen.
Postscript to *An Autobiographical Study*

I have not been spoiled by public honors, and have therefore accustomed myself to getting along without them. I cannot deny, however, that the Award of the Goethe Prize by the City of Frankfurt has given me great pleasure. There is something about it that particularly warms the imagination [ . . . ]. Unfortunately I cannot come to the celebration in Frankfurt; my health is not reliable enough for such an undertaking. The audience will lose nothing by my absence; my daughter is certainly more pleasant to the eye and ear than I am. She is going to read a few lines[1] dealing with Goethe in relation to psychoanalysis and defending the analysts against the reproach of having impugned the veneration due to the great man by their analytical investigations.
*Letter to Alfons Paquet,[2] July 26, 1930*
*Translation of the award in the Notes*

faustischen Unersättlichkeit und Ehrfurcht vor den im Unbewussten schlummernden bildnerisch - schöpferischen Gewalten. Dem grossen Gelehrten, dem Schriftsteller und Kämpfer Sigmund Freud ist bisher jede äussere Ehrung versagt geblieben, obgleich die umwälzende Wirkung seines Werkes wie die kaum eines anderen Lebenden den Zeitgeist mitbestimmte. Das Kuratorium wünscht nach sorgfältiger Erwägung aller Für und Wider mit dieser Ehrung auf die Auswertung der Freudschen Vorstellungswelt hinzuweisen als auf einen Durchgang zu einer von überlebten Vorstellungen gereinigten und neu gefestigten Welt der Werte.

**DER OBERBÜRGERMEISTER**

Frankfurt am Main, an Goethes Geburtstag, den 28. August 1930

**290   First edition of**
***Civilization and its Discontents,***
**1930**
The fateful question for the
human species seems to me to
be whether and to what extent
their cultural development
will succeed in mastering the
disturbance of their communal
life by the human instinct
of aggression and self-
destruction. It may be that
in this respect precisely the
present time deserves a special
interest. Men have gained
control over the forces of
nature to such an extent that
with their help they would
have no difficulty in exter-
minating one another to
the last man. They know this,
and hence comes a large part
of their current unrest, their
unhappiness and their mood of
anxiety.
*Civilization and its Discontents*

**291   Boarding an aeroplane,**
**Berlin 1930**
In the Sanatorium[1] I learnt
that health was to be had at a
certain cost, and since it is the
same with health as with the
Sibylline Books I paid the
price. That is to say. I have
given up smoking completely,
after it has served me for
exactly fifty years as sword and
buckler in the battle of life.
Thus I am now better than I
was, but not happier. Here
Schröder is measuring me for a
new prosthesis. So I shall not
see Vienna again for some
time.
*Letter to Lou Andreas-Salomé,*
*May 8, 1930*

*While being treated by Prof.*
*Schröder in Berlin, Freud seized*
*the opportunity to fly for the*
*first and only time in his life.*

DAS UNBEHAGEN
IN DER
KULTUR

VON

SIGM. FREUD

1.—12. Tausend

1930
INTERNATIONALER
PSYCHOANALYTISCHER VERLAG
WIEN

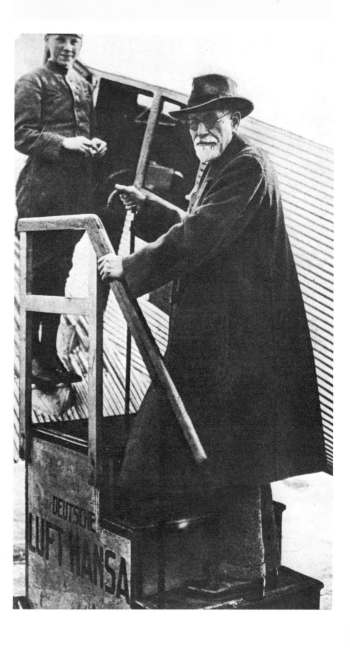

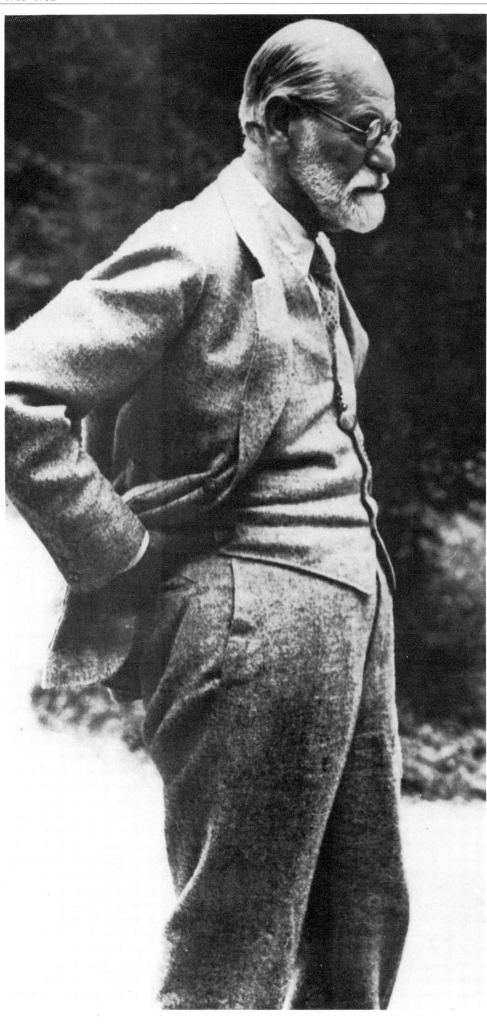

**292   Freud, 1931**

Formerly, I was not one of those who are unable to hold back what seems to be a new discovery until it has been either confirmed or corrected. My *Interpretation of Dreams* and my "Fragment of an Analysis of a Case of Hysteria" (the case of Dora) were suppressed by me—if not for the nine years enjoined by Horace—at all events for four or five years before I allowed them to be published. But in those days I had unlimited time before me—"oceans of time" as an amiable author[1] puts it—and material poured in upon me in such quantities that fresh experiences were hardly to be escaped. Moreover, I was the only worker in a new field, so that my reticence involved no danger to myself and no loss to others.

But now everything has changed. The time before me is limited. The whole of it is no longer spent in working, so that my opportunities for making fresh observations are not so numerous. If I think I see something new, I am uncertain whether I can wait for it to be confirmed. And further, everything that is to be seen up on the surface has already been exhausted; what remains has to be slowly and laboriously dragged up from the depths.
"Some Psychical Consequences of the Anatomical Distinction Between the Sexes"

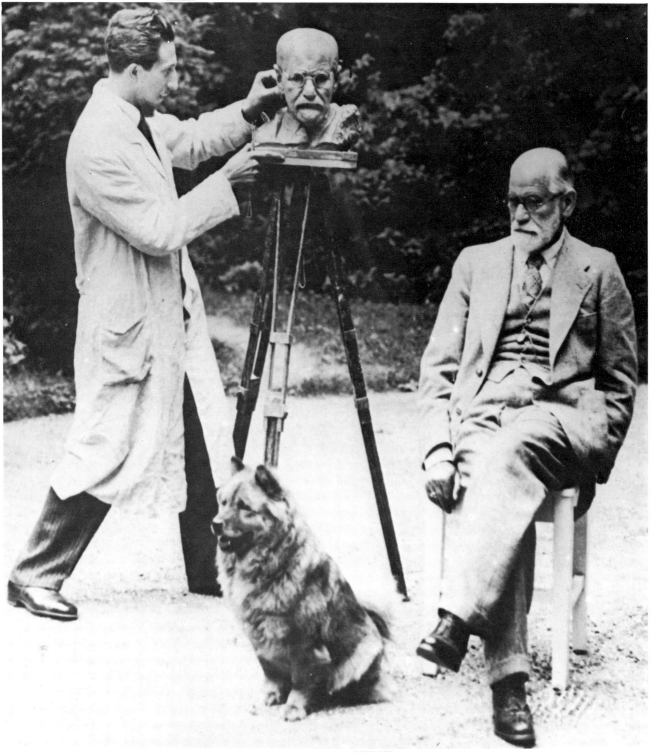

**293   With Oscar Némon, 1931**[1]
[ . . . ] on April 24th I had to undergo a further operation [ . . . ] and this has robbed me of a good deal of my energy [ . . . ]. Tomorrow I shall make my first attempt to creep back to work. An hour in the morning and another in the afternoon. Living one's life for one's health and guarded like an historical monument is otherwise hard to bear.
*Letter to Arnold Zweig, May 10, 1931*

**294   Freud honored in Freiberg (Příbor); address by Paul Federn, 1931**
I wish to thank the Mayor of Příbor-Freiberg, the organizers of the celebration and all those taking part in it, for the honor they are doing me by distinguishing the house of my birth with this memorial plaque created by the hand of an artist.[1] And this, moreover, during my lifetime and while the contemporary world is not yet agreed on the value of my achievement.

*Letter to the Mayor of Příbor-Freiberg, October 25, 1931*

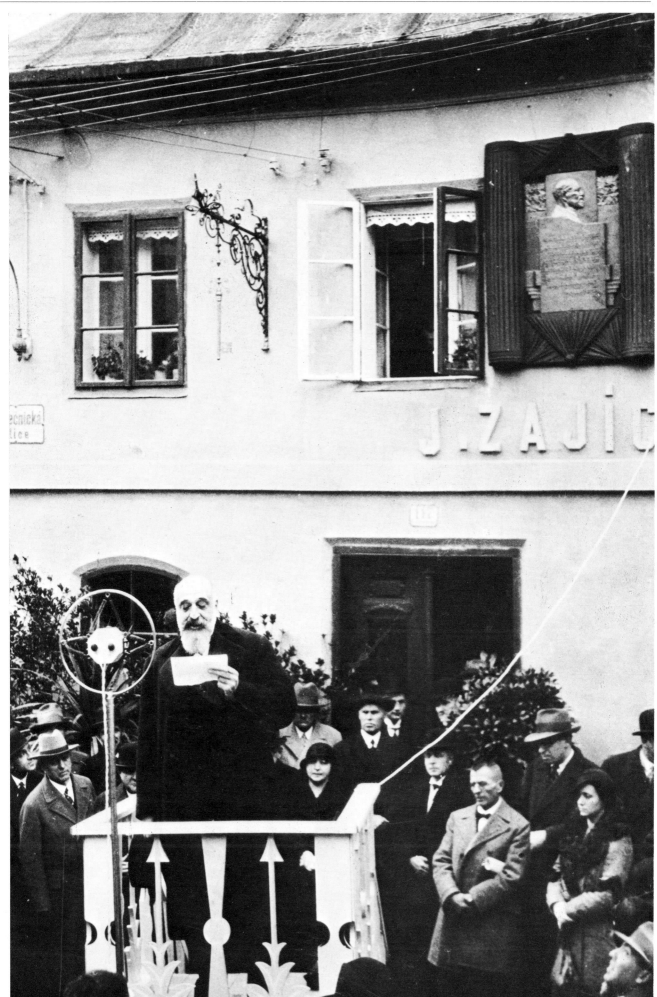

**295  Freudova**

*The street, seen from the front of Freud's birthplace, runs along the lefthand wall of the house. It was renamed "Freudova," also to mark the occasion of Freud's 75th birthday.*

**Süddeutsche Monatshefte**
Heft 11      28. Jahrgang      August 1931

# Gegen Psycho- Analyse

Alfred E. Hoche, Die psychoanalytische Bewegung im Rahmen der Geistesgeschichte / Rudolf Allers, Die weltanschaulichen Voraussetzungen / Charles E. Maylan, Die Psychoanalyse am Scheidewege / Adolf Albrecht Friedländer, Die psychoanalyt. Therapie Siegfried Placzek, Gefahren psychoanalyt. Behandlung / Helene Klepetar, Erinnerungen einer Patientin Gustav Aschaffenburg, Psychoanalyse und Strafrecht

**Süddeutsche Monatshefte G.m.b.H. München**
Vierteljährlich RM. 4.50      Einzelheft RM. 1.75

---

*EINSTEIN, FREUD, STEINACH*

*Drei Männer bilden das Staunen der Welt:*
*Der erste stürmte das Himmelszelt,*
*Der zweite der Seele Tiefen durchforscht,*
*Der dritte den alternden Leib entmorscht.*

*Und alle sind schon bei Lebenszeit*
*Totsicher ihrer Unsterblichkeit.*
*Was aber brüllt der alte Chor?*
*Die Juden drängen sich überall vor!*

---

**296    Example of an anti-psychoanalytical publication, 1931**[1]

Even today it is of course impossible for me to foresee the final judgement of posterity upon the value of psychoanalysis for psychiatry, psychology, and the mental sciences in general. But I fancy that, when the history of the phase we have lived through comes to be written, German science will not have cause to be proud of those who represented it. I am not thinking of the fact that they rejected psycho-analysis or of the decisive way in which they did so; both of these things were easily intelligible, they were only to be expected and at any rate they threw no discredit on the character of the opponents of analysis. But for the degree of arrogance which they displayed, for their conscienceless contempt of logic, and for the coarseness and bad taste of their attacks there could be no excuse.
*An Autobiographical Study*

**297    Caricature, 1931**

*At the ball given by "Concordia," the union of journalists and authors, in Vienna on February 2, 1931, a little book of caricatures of prominent politicians, scholars and artists was distributed as* Damenspende—*a gift of the organizers to the ladies, customary at balls in Vienna.*

EINSTEIN, FREUD, STEINACH

Three men, three wonders of the world,
The first 'gainst Heaven his bolts has hurled.
The second probes mind's hidden truth,
The third gives aging bodies youth.

Dead sure of their immortal state
While yet on earth, all three—
but wait!
What ancient chorus cleaves the air?
"Those Jews will push in anywhere!"

*Translation*

EINSTEIN          FREUD          STEINACH          Nº 6

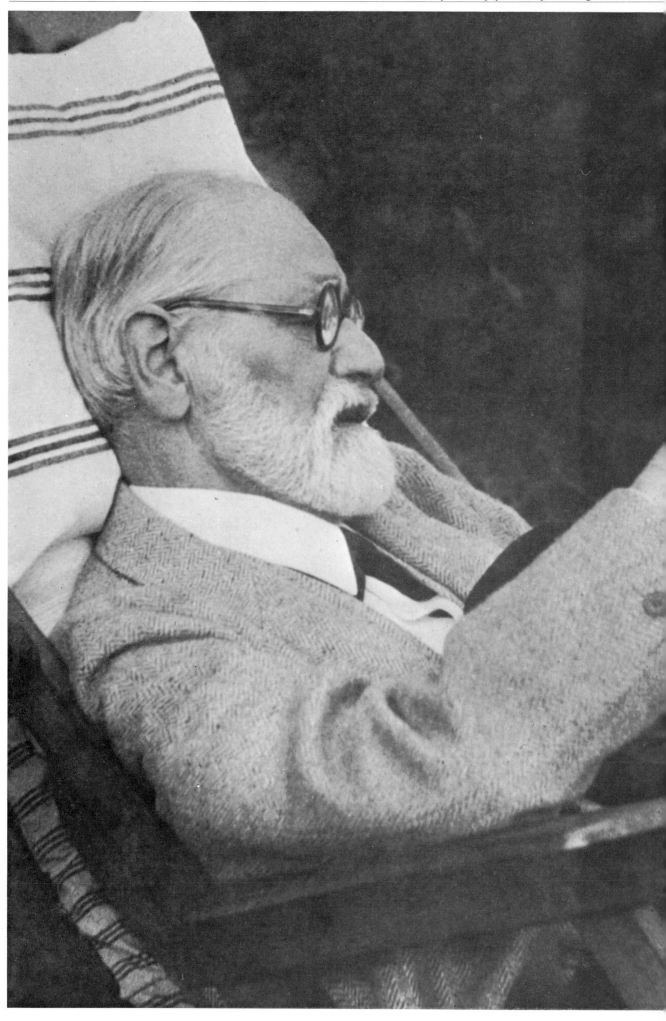

**298   Hochroterd, 1932**
Where am I writing from?
From a small farmhouse on a
hillside, forty-five minutes by
car from the Berggasse, which
my daughter and her American
friend [Dorothy Burlingham]
(who owns the car) have
bought and furnished as a
weekend cottage.
*Letter to Arnold Zweig, May 8,
1932*

**299   Dorothy Burlingham**
The years that I knew him
were the most important ones
of my life. During this time I
had the opportunity of being
in contact with an unusual
personality. I felt the greatness
of his spirit and the warmth of
his feelings, and above all, how
he met life. Another quality
which I learned to value was
his ability to enjoy, whenever
there was something to enjoy.
*Dorothy Burlingham on the
occasion of Freud's death*

*Dorothy Burlingham, born
1891, psychoanalyst and
colleague of Anna Freud's at
her clinic in Hampstead,
London*[1]

## Aufruf an die Ärzte aller Länder

Wir unterzeichneten deutschen Ärzte begrüssen den Aufruf von Henri
Barbusse zum Kampf gegen einen neuen Krieg. Wir Ärzte kennen die
Schrecken des Krieges am besten, weil wir noch heute die irreparablen
Gesundheitsschäden des letzten Krieges täglich sehen.

Der nächste Krieg kennt keinen Unterschied zwischen Front und Hin-
terland. Giftgase, Brandbomben und Bakterien werden alles Lebendige
vernichten. Im Weltkriege wurden fast 10 Millionen Menschen auf den
Schlachtfeldern getötet, 17 Millionen verwundet und verstümmelt. Der
Lebensstandart der werktätigen Bevölkerung ist durch den Krieg und die
danach folgende Wirtschaftskrise in ungeheurem Masse heruntergedrückt
worden. Die Massenarbeitslosigkeit hat zur Massenverelendung geführt.
Der Abbau der Leistungen der sozialen Versicherungen, der Mittel zur
Bekämpfung der Krankheiten führt zu immer neuen und schwereren Schädi-
gungen der Gesundheit des Einzelnen. Chronische Unterernährung und Woh-
nungselend lassen Volksseuchen wie die Tuberkulose wieder ansteigen.
Die Zahl der Nervenerkrankungen nimmt ständig zu und mit ihnen die Zahl
der Selbstmorde.

Trotz dieser fortdauernden Vernichtung von Kulturwerten durch Krieg
und Nachfolgen, trotzdem die Schreckensbilder des Weltkrieges nicht
unvergessen blieben, sind schon wieder Kräfte am Werke, die den Aus-
weg aus der Wirtschaftskrise in einen neuen Krieg sehen wollen. Der
Krieg, der jetzt im Osten tobt, kann nicht lange lokalisiert bleiben.
Bedroht ist in erster Linie Sowjetrussland. Ein Angriff auf dieses
Land, das den friedlichen Aufbau will, bedeutet einen neuen Weltkrieg.

Deshalb rufen wir Unterzeichneten die Ärzte aller Länder auf, ge-
gen den Krieg zu kämpfen und den Genfer Antikriegskongress am 28.Juli
1932 zu beschicken.

Als Hüter der Volksgesundheit erheben wir unsere warnende Stimme
gegen ein neues internationales Blutbad, in das die Völker planmäs-
sig hineingetrieben und dessen Folgen unabsehbar sein werden!

*Sigm. Freud
Wien*

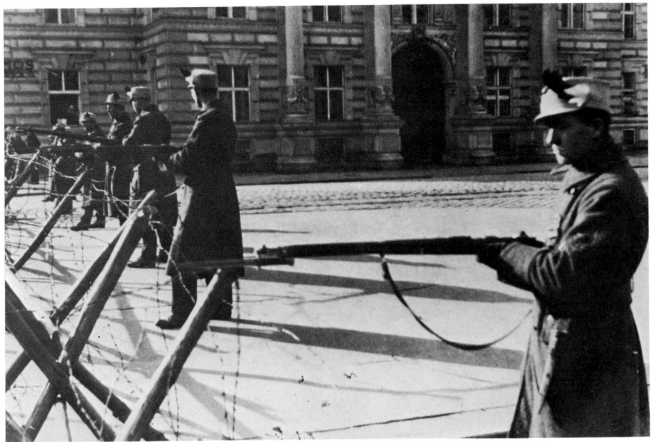

**300    Appeal for the Geneva Anti-War Congress, 1932**

*The writer Henri Barbusse called upon the physicians of all countries to take part in the Geneva Anti-War Congress on July 28, 1932. Freud signed this appeal.*
*Translation in the Notes*

**301    Freud, 1933**
I think this time I have established my right to a sudden fatal heart attack, not a bad prospect. It was a coronary thrombosis; however, I am still alive and as I do not smoke any more I am hardly likely to write anything again—except letters. It reminds me of that Chasen[1] of whom it was said: he'll live, but he won't sing.
*Letter to Arnold Zweig, October 25, 1933*

**302    The February risings in Vienna, 1934**
Our little bit of civil war was not at all nice. You could not go out without your passport, electricity was cut off for a day, and the thought that the water supply might run out was very unpleasant. Now everything is calm, the calm of tension, you might say; just like waiting in a hotel room for the second shoe to be flung against the wall. It cannot go on like this; something is bound to happen. Whether the Nazis will come, or whether our own home-made Fascism will be ready in time, or whether Otto von Habsburg will step in, as people now think. [ . . . ]
You are quite right in your expectation that we intend to stick it out here resignedly. For where should I go in my state of dependence and physical helplessness? And everywhere abroad is so inhospitable. Only if there really were a satrap of Hitler's ruling in Vienna I would no doubt have to go, no matter where.
*Letter to Arnold Zweig, February 25, 1934*

**303  Marie Bonaparte**
Again warm thanks for repeating your invitation. It is naturally invaluable to know that a beautiful spot exists where one would be welcome until a new home could be found. But it is assuredly understandable that I am in no hurry to leave the old home, especially since I have four bodily troubles that would make so much harder any change of domicile. So everything turns on whether we feel compelled to flee from Vienna. It is hard to judge that; no one can be sure about it, for the future is unpredictable.
*Letter to Marie Bonaparte, February 19, 1934*

**304  Prince George of Greece**

*The efforts of Marie Bonaparte and her husband, the Prince of Greece (1869-1957), were later decisive in making it possible for the Freud family to leave Austria.*

**305  Lou Andreas-Salomé, about 1935**

If one lives long enough [ . . . ] one may live to get a letter and even a photo from you [ . . . ].
*Letter to Lou Andreas-Salomé, May 16, 1935*

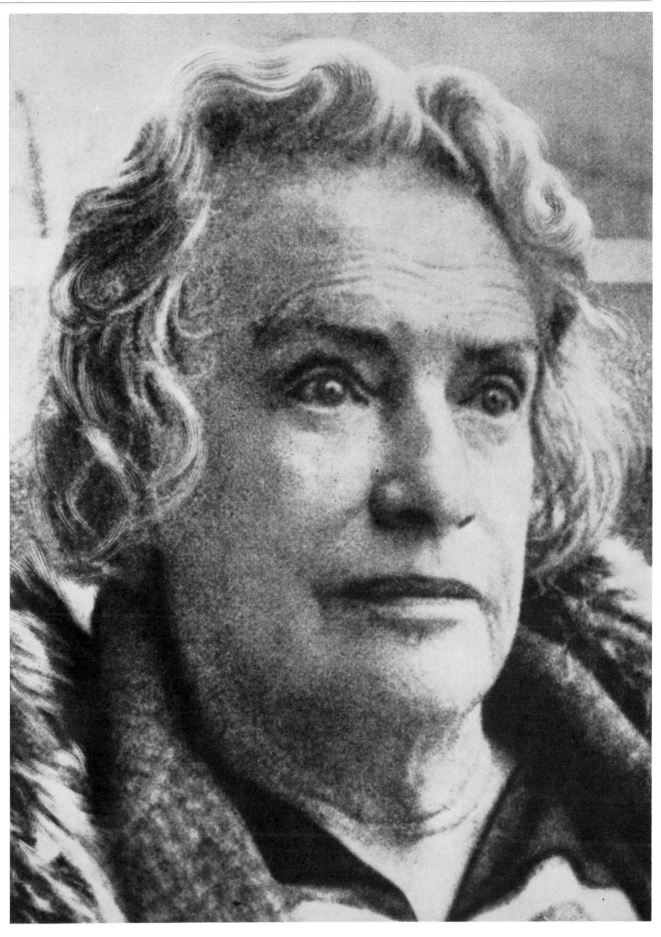

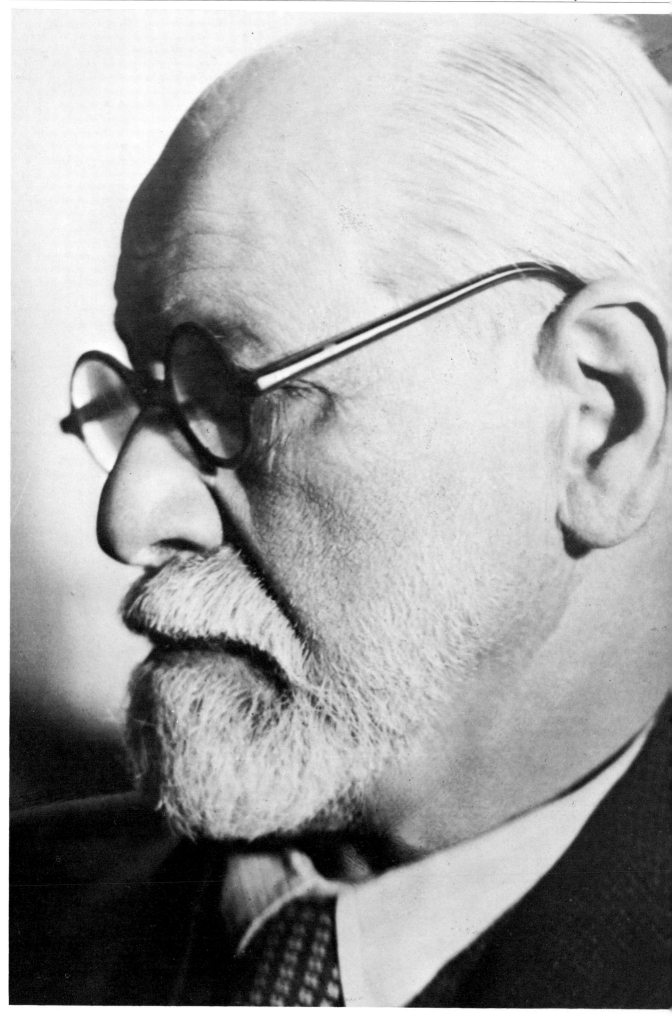

**306    Freud, about 1935**

What an amount of good nature and humor it takes to endure the gruesome business of growing old. [ . . . ] I am, of course, more and more dependent on Anna's care, just as Mephistopheles once remarked:

> In the end we all depend
> On creatures we ourselves
>      have made.

In any case it was very wise to have made her.

*Letter to Lou Andreas-Salomé, May 16, 1935*

**The Royal Society of Medicine**

**Empowered** *by the Charter granted by*
*His Majesty King William IV*
*confirmed by a Supplementary Charter granted by*
*His Majesty King Edward VII*
*to admit as Honorary Fellows such persons as in*
*the opinion of the Society are entitled to the honour*

**THE ROYAL SOCIETY OF MEDICINE**

*has in General Meeting assembled elected*

*Professor Sigmund Freud, M.D. LL.D.*

*in recognition of his distinguished*
*services to Science*
*and he is hereby declared to be an*

**HONORARY FELLOW OF THE ROYAL SOCIETY OF MEDICINE**

*and entitled to all the privileges*
*of such Fellowship.*

*London, May 21ˢᵗ, 1935.*

**307    Document of the Royal Society of Medicine, 1935**

An unexpected honor [1] came my way recently. I was unanimously elected an honorary member of the Royal Society of Medicine. This will make a good impression on the world at large. In Vienna dark goings-on are afoot, directed in the first place against the practice of child-analysis.

*Letter to Arnold Zweig, June 13, 1935*

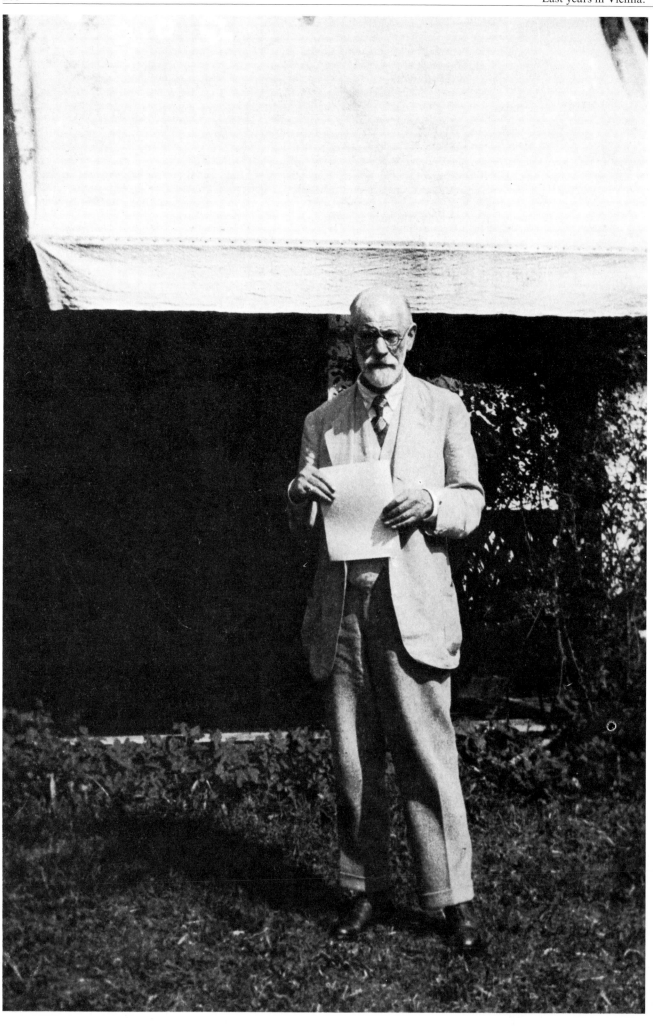

**309 Congratulatory address for Freud's 80th birthday, 1936**
*The congratulatory address, signed by 191 writers and artists altogether, was handed to Freud by Thomas Mann in the Berggasse. The signatories included Hermann Broch, Fritz Busch, Salvador Dali, Alfred Döblin, André Gide, Knut Hamsun, Hermann Hesse, Aldous Huxley, James Joyce, Paul Klee, Else Lasker-Schüler, André Maurois, Robert Musil, Gunnar Myrdal, Pablo Picasso, Bruno Walter, Franz Werfel, Thornton Wilder.*
*Translation in the Notes*

Der 80. Geburtstag Sigmund Freud's sei uns willkommener Anlaß, um dem Initiator eines neuen und tieferen Wissens vom Menschen unseren Glückwunsch und unsere Ehrfurcht auszusprechen. In jeder Sphäre seines Wirkens bedeutend, als Arzt und Psychologe, als Philosoph und Künstler, ist dieser mutige Erkenner und Heiler ein Wegweiser für zwei Generationen gewesen in bisher ungeahnte Welten der menschlichen Seele. Ein ganz auf sich selbst gestellter Geist, ein „Mann und Ritter mit erzenem Blick", wie Nietzsche von Schopenhauer sagt, ein Denker und Forscher, der allein zu stehen wusste und dann freilich viele an sich und mit sich zog, ist er seinen Weg gegangen und zu Wahrheiten vorgestoßen, die deshalb gefährlich erschienen, weil sie ängstlich Verdecktes enthüllten und Dunkelheiten erleuchteten. Allerorts legte er neue Probleme frei und änderte die alten Maße; er hat im Suchen und Finden den Raum der geistigen Forschung vervielfacht und auch seine Gegner sich verpflichtet durch den schöpferischen Denkantrieb, den sie von ihm erfuhren. Mögen künftige Zeiten dies oder jenes Ergebnis seiner Forschung modeln und einschränken, nie mehr sind die Fragen, die Sigmund Freud der Menschheit gestellt hat, zum Schweigen zu bringen, seine Erkenntnisse können nicht dauernd verneint oder getrübt werden. Die Begriffe, die er gestaltet, die Worte, die er für sie wählt, sind schon als selbstverständlich eingegangen in die lebendige Sprache; auf allen Gebieten der Geisteswissenschaft, in Literatur- und Kunstforschung, Religionsgeschichte und Prähistorie, Mythologie, Volkskunde und Pädagogik, nicht zuletzt in der Dichtung selbst, ist die tiefe Spur seines Wirkens zu sehen, und wenn eine Tat unseres Geschlechtes, so wird, wir sind dessen gewiß, seine Erkenntnistat der Seelenkunde unvergeßlich bleiben.

Wir, die wir Freud's kühnes Lebenswerk aus unserer geistigen Welt nicht wegzudenken vermögen, sind glücklich, diesen großen Unermüdlichen unter uns zu wissen und mit ungebrochener Kraft am Werke zu sehen. Möge unser dankbares Empfinden den verehrten Mann noch lange begleiten dürfen.

| | |
|---|---|
| Thomas Mann | H. G. Wells |
| Romain Rolland | Virginia Woolf |
| Jules Romains | Stefan Zweig |

**308 Freud, about 1936**
The beautiful address which you and Thomas Mann composed together and Mann's speech[1] in Vienna were the two events which almost reconcile me to having grown so old. For although I have been exceptionally happy in my home, with my wife and children and in particular with one daughter who to a rare extent satisfies all the expectations of a father, I nevertheless cannot reconcile myself to the wretchedness and helplessness of an old age, and look forward with a kind of longing to the transition into non-existence.
*Letter to Stefan Zweig, May 18, 1936*

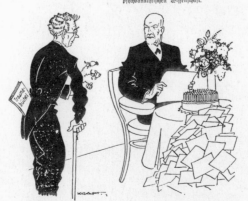

Karikatur der Woche
Prof. Sigmund Freud
Zum 80. Geburtstag des Bahnbrechers der psychoanalytischen Wissenschaft.

Sigmund Freud, du Götterfunken,
Sohn aus Analysium,
Statt mit Würden kannst du prunken
Um so mehr mit deinem Ruhm.

Unter den bewußt Beschränkten
Schränkt man dein Genie zwar ein,
Aber daß sie dich verdrängten,
Wird doch nur ein Wunschtraum sein.

Libidinerei beiseite,
Anerkannt wird weit und breit:
Ungezählte schon befreite
Seelen-Freud von Seelenleid.

Jeder Gutgesinnte wird dir
Heute huldigen wie wir,
Und vor allem gratuliert dir
Der Neurosenkavalier.

**310 Caricature in *Der Morgen***

Son of Analysium,
Freud, divine flame!
You may go unhonored,
Be proud of your fame.

To our inhibitions
Your genius is ill-meant;
If we seek to repress you
There's no wish fulfillment.

Leave out the libido!
Great hosts overjoyed
Are those you have rescued
from being a-Freud.

All men of goodwill
For you raise a cheer
And above all salute you
The Neurosencavalier.

*Translation*

## 1936

### Juni

| Fr 5/6 | Besuch im neuen Lokal Berggasse 7 |
| So 14/6 | Vorlesung von Thomas Mann bei uns |
| Do 18/6 | Minna 71 Jahre |
| Mo 29/6 | Maler Krausz, Ella Braun |
| Di 30/6 | foreign member Royal Society |

### Juli

| Sa 11/7 | Verständigung mit Deutschland |
| Di 14/7 | Operation bei Pichler — |
| Mi/Sa 15/7 | Sanatorium Operation |
| So 19/7 | Zurück mit verbundenem Auge |
| Do 23/7 | aus schwerem Kranksein |
| Fr 31/7 | Anna Marienbad Congress |

### August

| Do 6/8 | Anna zurück von Congress |
| Fr 14/8 | Arn. Zweig und H. Struck |
| Di 18/8 | Moses mit Arn. Zweig |
| Do 20/8 | Anna auf Rax — Plakette von Willy Levy |
| Di 25/8 | wandert — Bullitt nach Paris |
| Fr 28/8 | Jones mit familie — reist nach Russland |

### Sept.

| Do 6/9 | Kadimah — |
| Sa 12/9 | Gruss u. Lex — doch noch einmal — |
| Mo 14/9 | 50 jährige - Ehe - |

### Okt.

| | Berggasse Hofmann |
| Sa 17/10 | Beer — Hofmann |
| So 18/10 | Arnold Zweig griess Feuchtwanger |
| Do 21/10 | Einladen u. Sanatorium u. Pichler Feuchtwanger |
| Sa 24/10 | Nasenblutung |
| Di 27/10 | Neues Pferd |
| Fr 30/10 | Wien mit Boehm |

### Nov.

| So 1/11 | Versammlung mit |
| | Direktor v. Demel |
| So 8/11 | Fieber Herzig |
| Sa 21/11 | + Ella Herzig |
| So 22/11 | Eli abgereist |
| Do 26/11 | |

### Dezember

| | Anna 41 Jahre |
| | Martin 47 Jahre |
| Do 3/12 | Eduard VIII abgedankt |
| Mo 7/12 | Operation bei Pichler |
| So 10/12 | Prof. Otto Loewi Schwanen |
| Sa 12/12 | Weihnacht im Schwesser |
| So 20/12 | Stefan Zweig |
| Do 24/12 | |
| So 27/12 | |

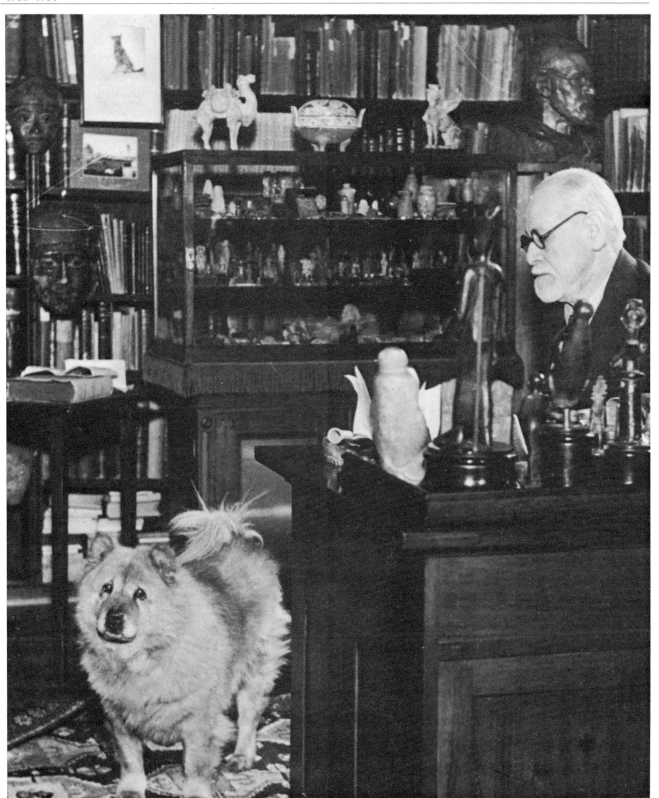

**311    Extract from Freud's diary, 1936**

*Freud kept a sort of abbreviated diary, the* Kürzeste Chronik. *The page reproduced here records the events of the second half of 1936.*
*Translation in the Notes*

**312    With the chow Jofi, 1937**
It really explains why one can love an animal like Topsy[1] (or Jo-fi) with such an extraordinary intensity: affection without ambivalence, the simplicity of a life free from the almost unbearable conflicts of civilization, the beauty of an existence complete in itself. And yet, despite all divergence in the organic development, that feeling of an intimate affinity, of an undisputed solidarity. Often when stroking Jo-fi, I have caught myself humming a melody which, unmusical as I am I can't help recognizing as the aria from *Don Giovanni:*

"A bond of friendship
Unites us both . . ."

*Letter to Marie Bonaparte, December 6, 1936*

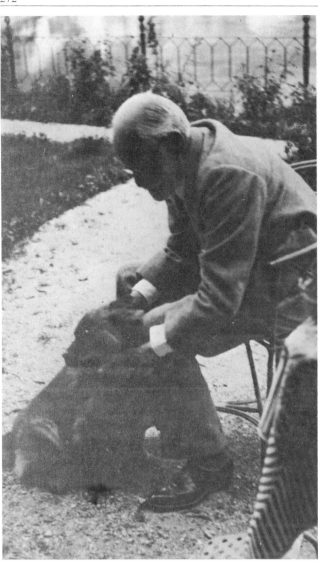
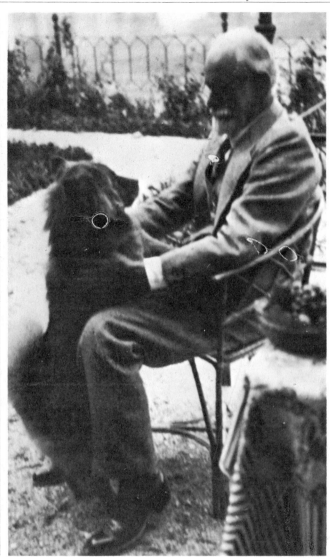

**313   With the chow Lün in Grinzing, 1937**

The moment a man questions the meaning and value of life, he is sick, since objectively neither has any existence; by asking this question one is merely admitting to a store of unsatisfied libido to which something else must have happened, a kind of fermentation leading to sadness and depression. I am afraid these explanations of mine are not very wonderful. Perhaps because I am too pessimistic. I have an advertisement floating about in my head which I consider the boldest and most successful piece of American publicity:

> "Why live, if you can be buried for ten dollars?"

Lün has taken refuge with me after having been given a bath. If I understand her right, she wants me to thank you warmly for the greeting.
*Letter to Marie Bonaparte, August 13, 1937*

**314   Old friends: Emanuel Löwy**

[ . . . ] my friend Emanuel Löwy, who is professor of archaeology in Rome. He has a fine and penetrating mind and is an excellent fellow. He pays me a visit every year and keeps me up till three o'clock in the morning.
*Letter to Wilhem Fliess, November 5, 1897*

*Emanuel Löwy, 1857-1938, professor of archaeology in Rome and later in Vienna*

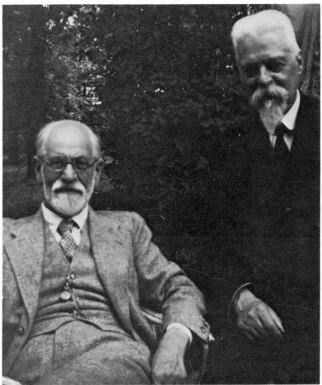

**315   Old friends: with Oscar Rie**

Your friendly words about me have done me good although they didn't tell me anything new, because I have been looking upon your friendship for more than a lifetime as an assured possession. I have been able to give something to many people in my life, from you fate has allowed me only to receive.
*Letter to Oscar Rie, August 4, 1921*

*Oscar Rie, 1863-1931, pediatrician in Vienna, who looked after the Freud children from the beginning; he formerly worked with Freud at Kassowitz's Pediatric Institute.*[1]

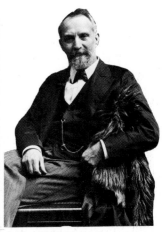

**316   Old friends: Leopold Königstein**

[ . . . ] I had had a good hour's lively conversation with my friend the eye-surgeon [ . . . ] and I had had memories stirred up in me which had drawn my attention to a great variety of internal stresses in my own mind.
*The Interpretation of Dreams*

*Leopold Königstein, 1850-1924, professor of ophthalmology at the University of Vienna. His friendship with Freud dates from their student days.*[1] *Königstein was Freud's partner in the regular games of tarock on Saturday evenings.*

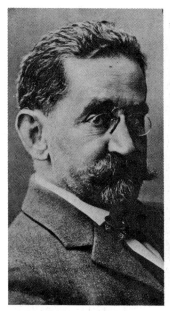

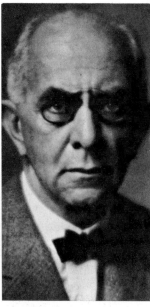

**317   Old friends: Wilhelm Herzig**

But the only person one can be with and talk to intimately is Herzig, whose value you know or at least can guess.
*Letter to Martha Bernays, August 22, 1883*

*Wilhelm Herzig, 1853-1924, professor of pharmacological chemistry at the University of Vienna. Freud knew him from their schooldays; he had given Freud the copy of* Don Quixote *with the Doré illustrations.* [1]

**318   Old friends: Ludwig Braun**

[ . . . ] this high-minded man, outstanding in more ways than one, was one of my nearest and warmest friends. There was something predestined about our friendship. An older cousin of his, Heinrich Braun, [1] had been my most intimate companion in our schooldays, until events obliged us to go our separate ways. Then in the last few decades Ludwig Braun became my intimate friend, and, temporarily, my doctor, without my knowing of this relationship. Our intimacy was surely based on the consciousness of having so many things in common.
*From Sigmund Freud's obituary on Ludwig Braun*

*Ludwig Braun, 1861-1936, professor of internal medicine at the University of Vienna* [2]

**319   Anna Freud**

But it cannot have remained concealed from you that fate has granted me as compensation for much that has been denied me the possession of a daughter who, in tragic circumstances, would not have fallen short of Antigone.
*Letter to Arnold Zweig, February 25, 1934*

*Anna Freud received her psychoanalytical training in Vienna. She was one of the pioneers of child analysis, lectured at the Training Institute in Vienna, and from 1937 onwards directed an experimental kindergarten for small children from poor districts of Vienna. In 1940, after her emigration, she founded a children's community in London, the "Hampstead Nurseries," for orphans and children separated from their parents. Since 1952 she has been director of the "Hampstead Child Therapy Clinic," a leading center for research and training in child psychoanalysis. She has published a wide range of scientific work.*

**320   With his brother
Alexander in the garden, 1937**
The advantage the emigration
promises Anna justifies all our
little sacrifices. For us old
people [ . . . ] emigrating
wouldn't have been
worthwhile.
*Letter to Ernest Jones, May 13,
1938*

*The garden of the house at
Strassergasse 47 in Grinzing,
which was the Freuds' summer
residence in the years 1934 to
1937*

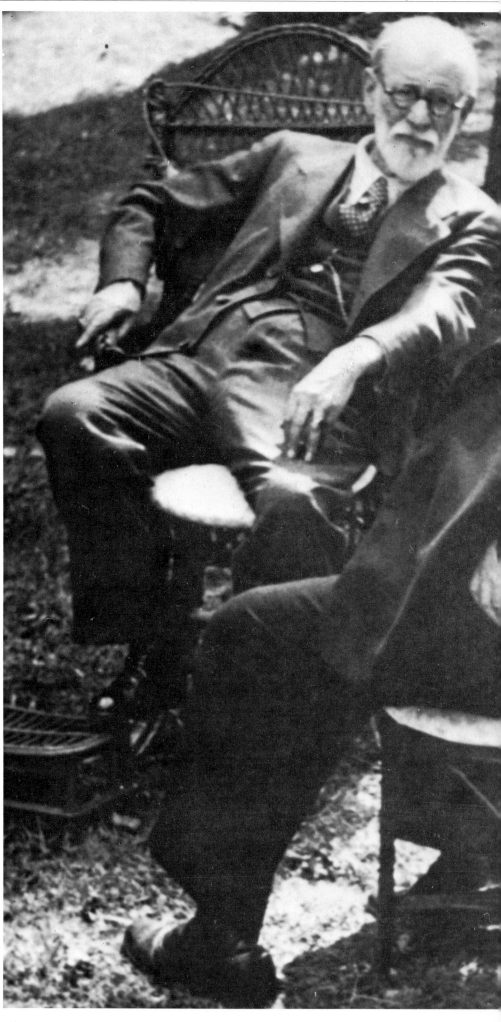

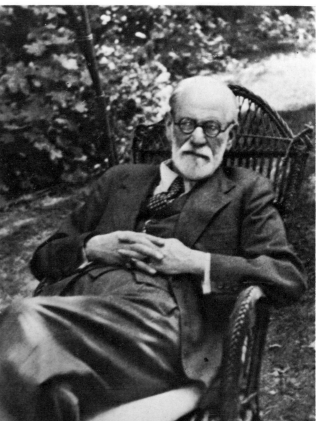

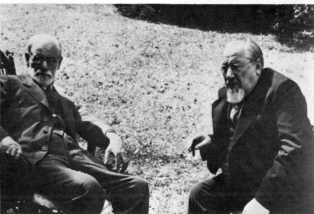

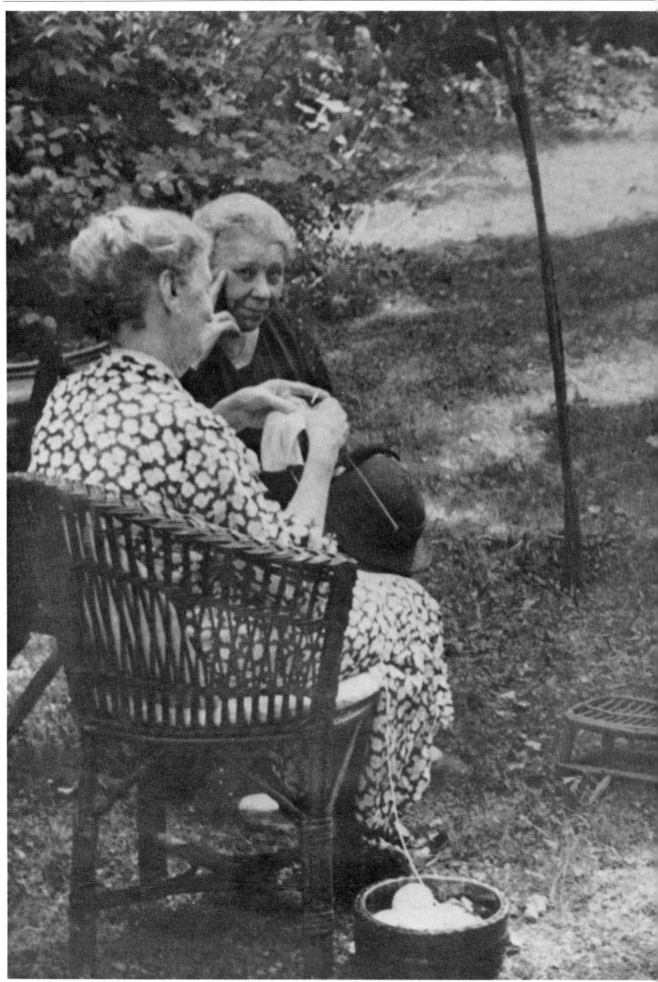

**321 Conversation in the
garden**

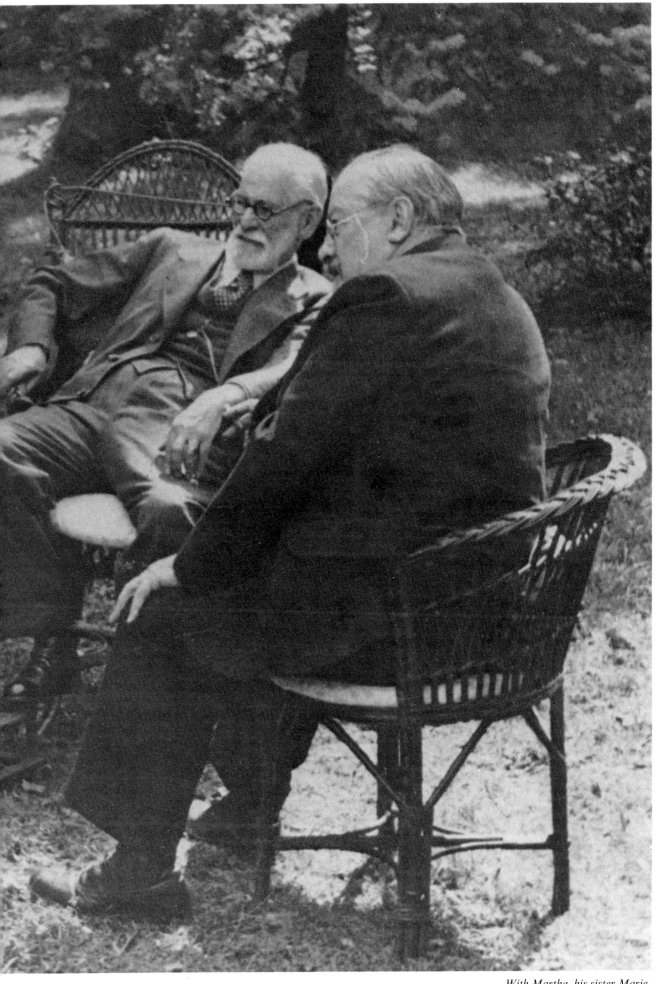

*With Martha, his sister Marie
and his brother Alexander*

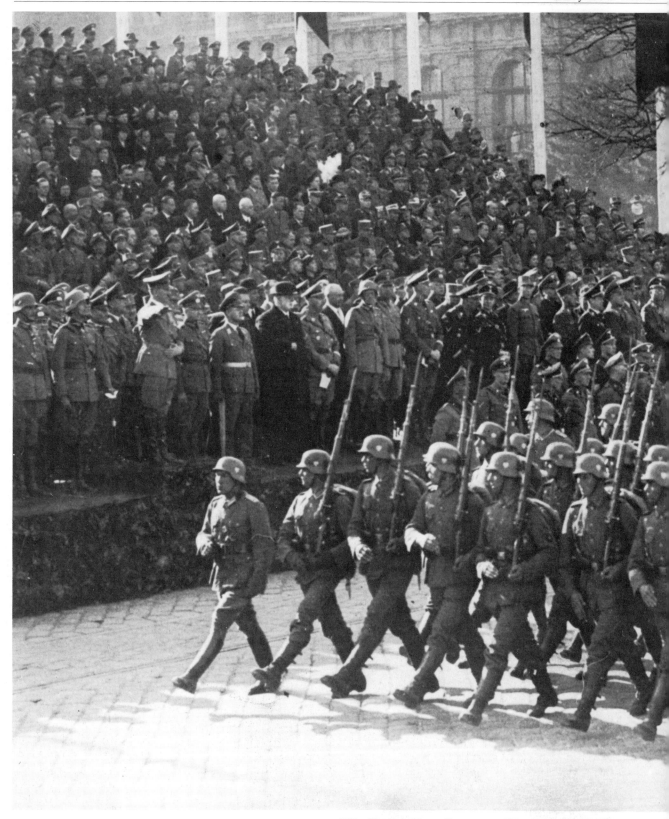

**322    The Anschluss: German infantry in Vienna, 1938**
Austria seems bent on becoming National Socialist. Fate seems to be conspiring with that gang. With ever less regret do I wait for the curtain to fall for me.
*Letter to Arnold Zweig, June 22, 1936*

**323    Entries in Freud's abbreviated diary for March, 1938**
*Translation in the Notes*

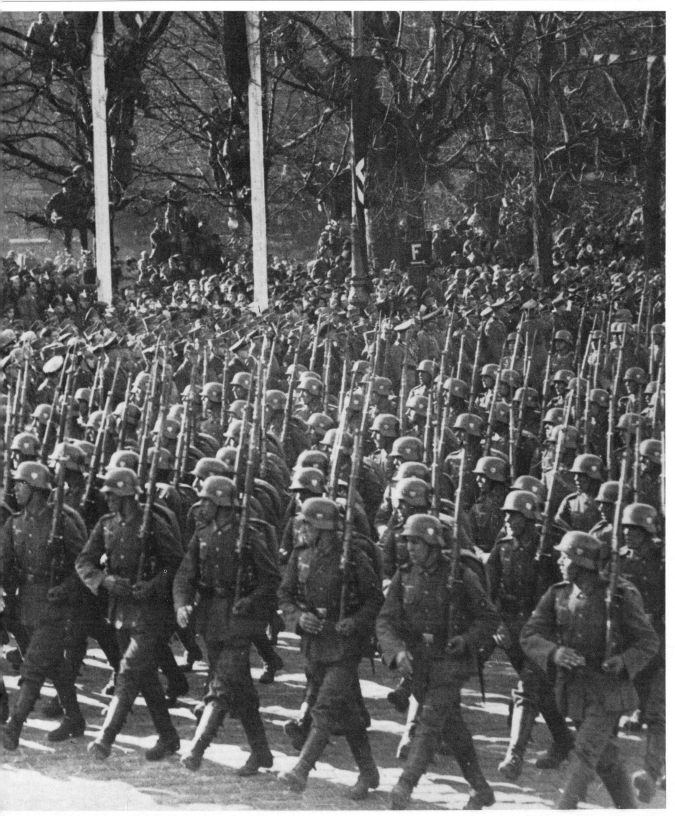

So 13/3, Anschluss an Deutschland
Mo 14/3 Hitler in Wien
Di 15/3 Kontrolle in Verlag + Haus
Mi 16/3 Jones
Do 17/3 Prinzessin
Di 22/3 Anna bei Gestapo

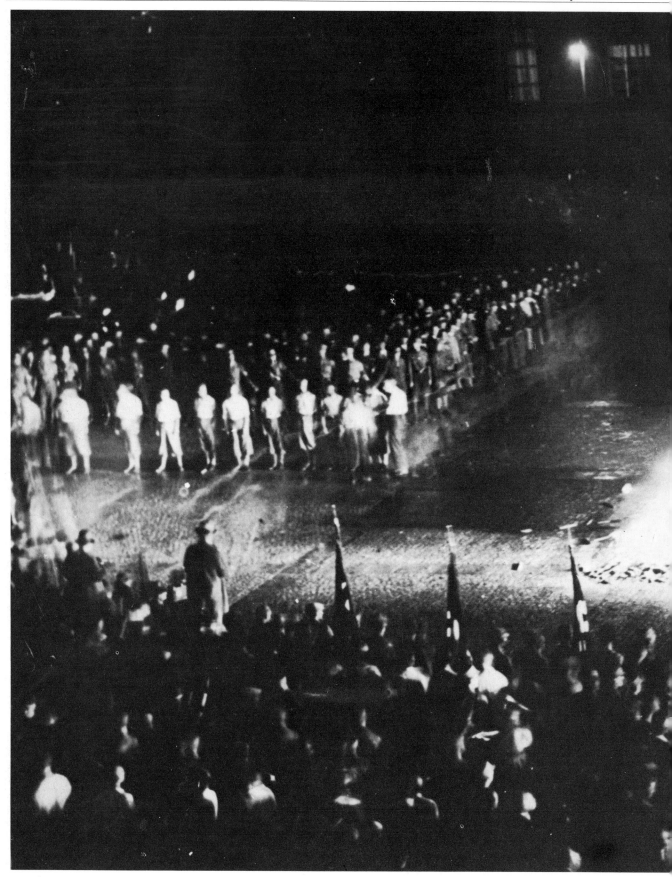

**324  Book burning**
Against the soul-destroying
glorification of the instinctual
life, for the nobility of the
human soul! I consign to the
flames the writings of the
school of Sigmund Freud.
*Declamation at the burning of
Freud's works*

What progress we are making.
In the Middle Ages they would
have burnt me; nowadays they
are content with burning my
books.
*Freud's comment*

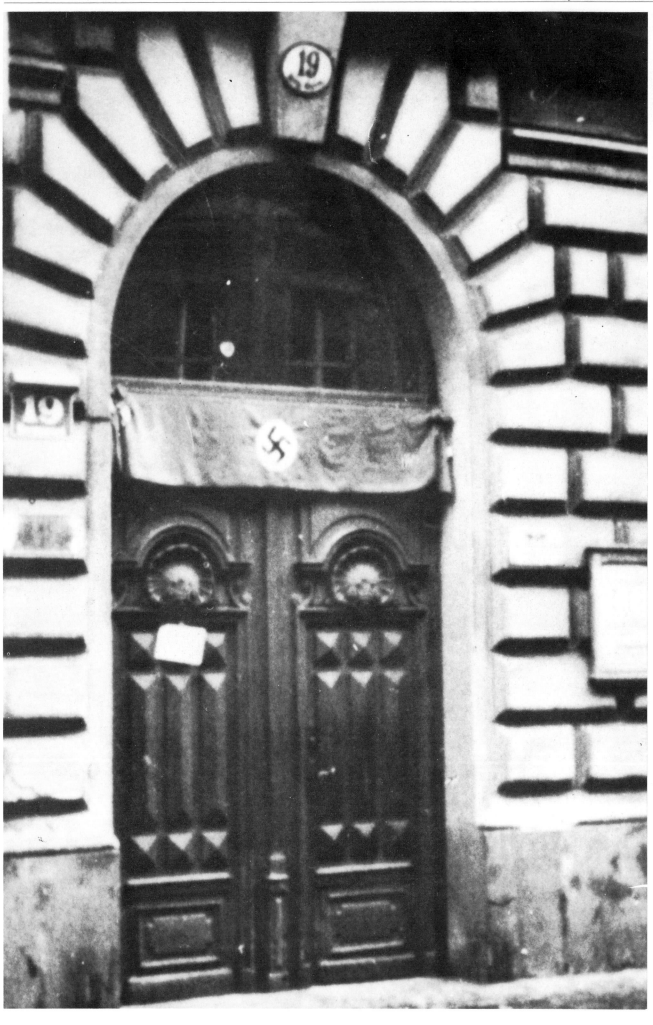

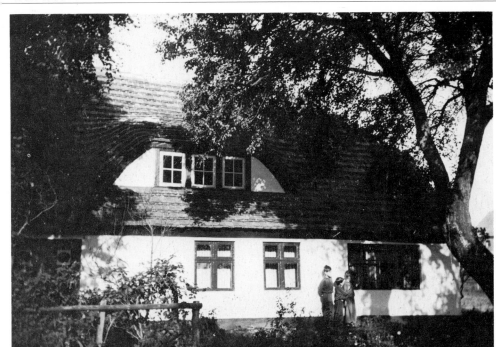

*Holiday house on the island of Hiddensee*

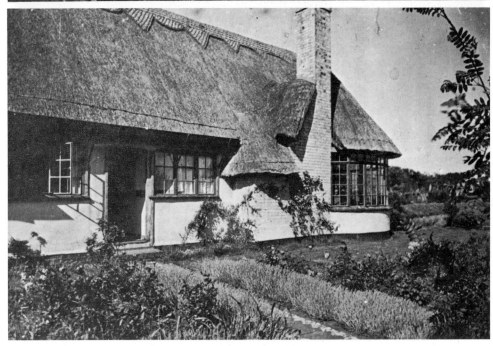

*"Hidden House," holiday house in Suffolk*

**325   Berggasse 19 with the swastika, March 1938**

I came to Vienna as a child of 4 years from a small town in Moravia. After 78 years of assiduous work I had to leave my home, saw the scientific society I had founded, dissolved, our institutions destroyed, our printing press ("Verlag") taken over by the invaders, the books I had published confiscated or reduced to pulp, my children expelled from their professions.
*Letter to* Time and Tide, *November 16, 1938*

**326   Hiddensee and "Hidden House"**

My best wishes for the opening of Hidden House! It is typically Jewish not to renounce anything and to replace what has been lost. Moses,[1] who in my opinion left a lasting imprint on the Jewish character, was the first to set an example.
*Letter to Ernst Freud, January 17, 1938*

*Freud's good wishes were for the decision of his children, who had already emigrated to England, to replace their lost German holiday house by an English one.*

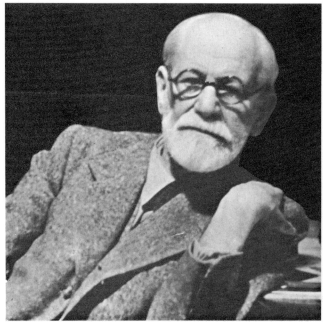

### 327  Waiting for the permit to leave

I have just come through some particularly unpleasant weeks. Four months ago I had one of my normal operations, followed by unusually violent pain, so that I had to cancel my work for 12 days, and I lay with pain and hot-water bottles on the couch which is meant for others. Scarcely had I resumed work when these events occurred, world history in a teacup, which have changed our lives. On the wireless I was able to listen first to our challenge and then to our surrender, to the rejoicing and the counter-rejoicing. In the course of this "eventful week" the last of my few patients have left me. I am not yet quite free from pain, so I cannot work and therefore I do absolutely nothing. Our house is certainly very unsettled; friends come to enquire how we are [ . . . ].
*Letter to Arnold Zweig, March 21, 1938*

I am writing to you for no particular reason because here I am sitting inactive and helpless while Anna runs here and there, coping with all the authorities, attending to all the business details. One can "already see the journey." [1] All we are waiting for is the Inland Revenue's "all clear," which is supposed to arrive within a week. Two prospects keep me going in these grim times: to rejoin you all and—to die in freedom. I sometimes compare myself with the old Jacob who, when a very old man, was taken by his children to Egypt [ . . . ]. Let us hope that it won't also be followed by an exodus from Egypt. It is high time that Ahasuerus came to rest somewhere.
*Letter to Ernst Freud, May 12, 1938*

In a certain sense everything is unreal, we are no longer here and not yet there; our thoughts are fluttering to and fro between Berggasse and Elsworthy Road. [2]
*Letter to Minna Bernays, May 26, 1938*

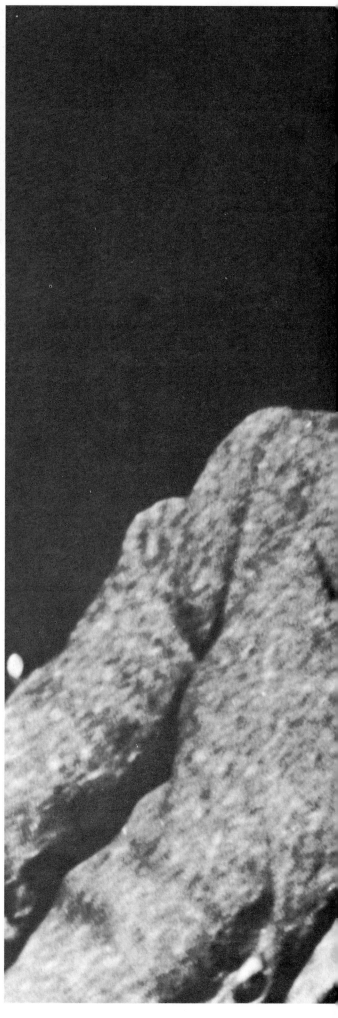

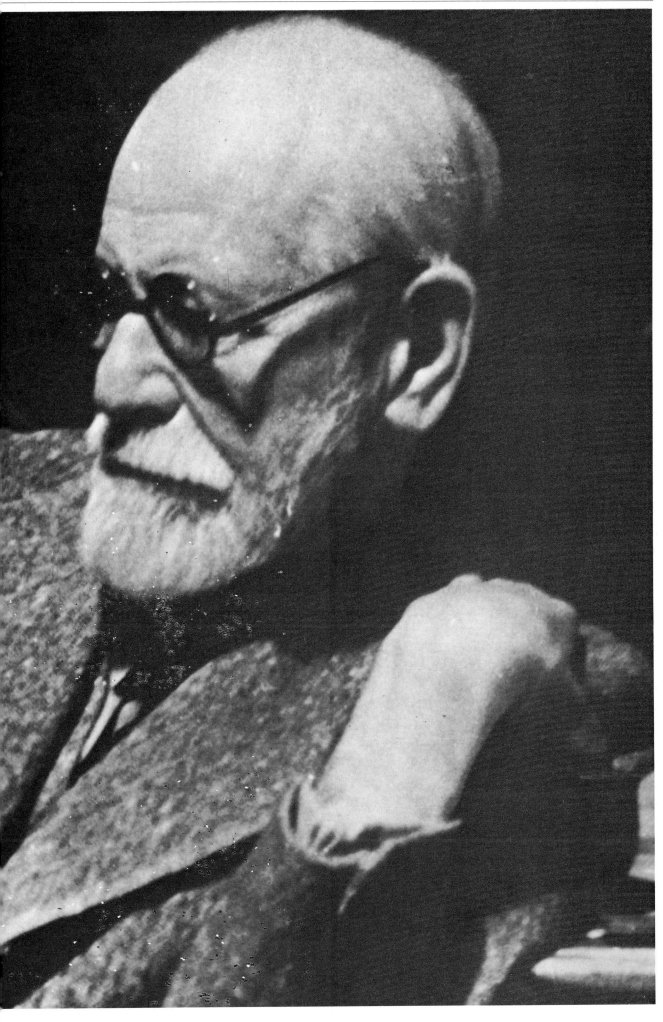

No. 28 ... Aufnahme in England gesichert —
— Ernstl in Paris — Ausreise scheint ermöglicht

**April**

Zwei Artikel in London

Fr 1/4    Ernst hier
Mi 6/4    Joseys Übersetzung bewirkt
Sa 9/4
So 10/4   Abstimmung —
Di 12/4   Minna aus Sanatos zurück
So 17/4   Ostersonntag ... Paris ...
Mo 18/4   ...
Di 26/4   Anfall von Taubheit
Fr 29/4   ...

**Mai**

Beer-Hofmann mit Prinzess
So 1/5    Minna ausgereist — ... mit Gestapo.
Do 5/5    82 Jahre —
Fr 6/5    ... im ... 14 Tagen?
Di 10/5   Ausreise bekommen
Do 12/5   ... abgereist
Sa 14/5   Martin abgereist — Spaltung der Sammlung
Sa 21/5   Mathilde u Robert abgereist.
Di 24/5
Mo 30/5   † Emilie Kassowitz

**Juni**

Do 2/6    Unbedenklichkeits Erklärung
Sa 3/6    Abreise 3^25 Orient Express — ...
          ... Paris London Marie Ernst ...
So 4/6    ... nach ...
          ... Dover London ...
Mo 5/6    ... Minna ... krank ...
          ... Zeitungen ... Manchester
Do 9/6    Sam aus Manchester
Fr 10/6   Besuch Yahuda
Sa 11/6   Minna z. Geburtstag ...
Sa 17/6
So 19/6   G. H. Wells
Di 21/6   Moses III neu begonnen
Do 23/6   Prinzess — Cyprischer Kopf
          Besuch der ... — Filme
Sa 25/6   Mrs Gunn mit aegypt. ...

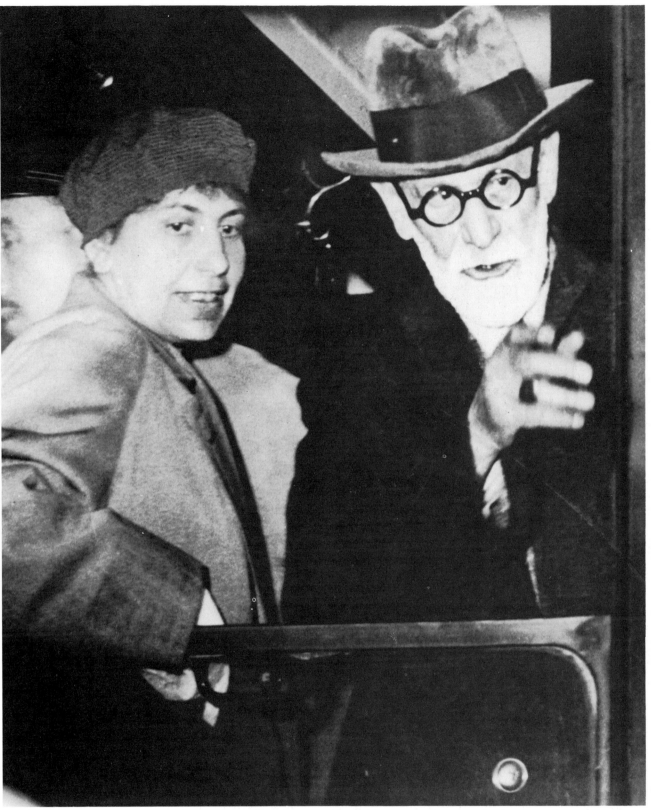

**328   Extract from Freud's abbreviated diary at the time of the emigration, 1938**

*Translation in the Notes*

**329   On the way into exile**
[ . . . ] we didn't all leave at the same time. Dorothy[1] was the first, Minna[2] on May 5, Martin[3] on the 14th, Mathilde and Robert[4] on the 24th, ourselves incidentally not until the Saturday before Whitsun, June 3. With us came Paula[5] and Lün,[6] the latter as far as Dover, where she was taken into quarantine by a friendly vet. Dr. Schur, our family

doctor, was to have accompanied us with his family, but at the eleventh hour he was unfortunate enough to require an appendix operation, with the result that we had to content ourselves with the protection of the lady pediatrician[7] whom Anna brought along. She looked after me very well, and in fact the difficulties of the journey did manifest themselves in

my case with painful heart fatigue [ . . . ].
*Letter to Max Eitingon, June 6, 1938*

*With Anna at the compartment window*

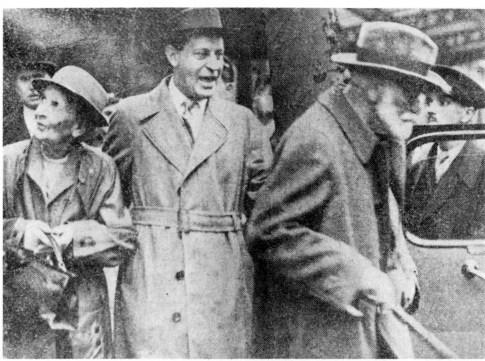

### 330   On the way[1]

Over the Rhine bridge and we were free! The reception in Paris at the Gare de l'Est was friendly, somewhat noisy with journalists and photographers. We spent from 10 A.M. to 10 P.M. in Marie's[2] house. [ . . . ] We crossed the Channel by the ferry boat and caught sight of the sea for the first time at Dover. And soon we were in Victoria Station where the immigration officers gave us priority. Our reception in London was a very cordial one. The more serious papers have been printing brief and friendly lines of welcome.
*Letter to Max Eitingon, June 6, 1938*

*With Martha and Ernst[3]*

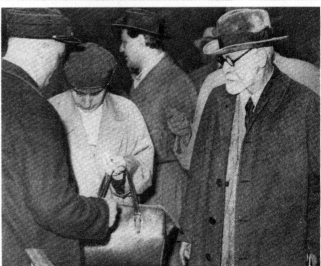

PROFESSOR SIGMUND FREUD, the famous Austrian psychologist, who is coming to live in London, photographed on arrival in Paris from Vienna. On the left is his daughter and in centre background his son, Herr Ernst Freud.

*With Anna and Ernst (in the background, center)*

# FREUD ARRIVES IN PARIS ON HIS WAY TO LONDON

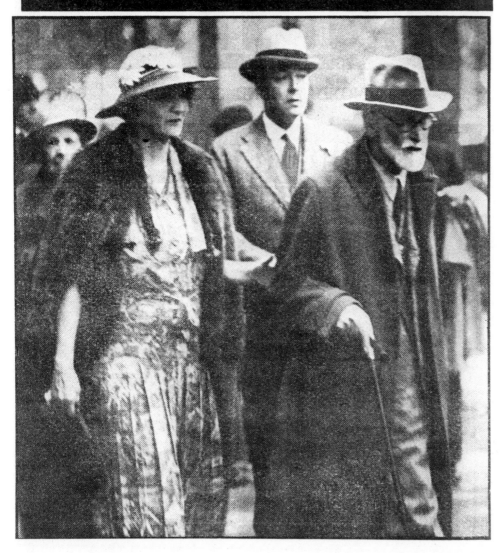

Professor **Sigmund Freud** (right) the famous psycho-analyst, photographed after arriving in Paris from Vienna yesterday. With him in the picture are **Princess George** of Greece and Mr. **William Bullitt**, the U.S. Ambassador.

*With Marie Bonaparte and*
*William C. Bullitt, the*
*American ambassador in Paris*

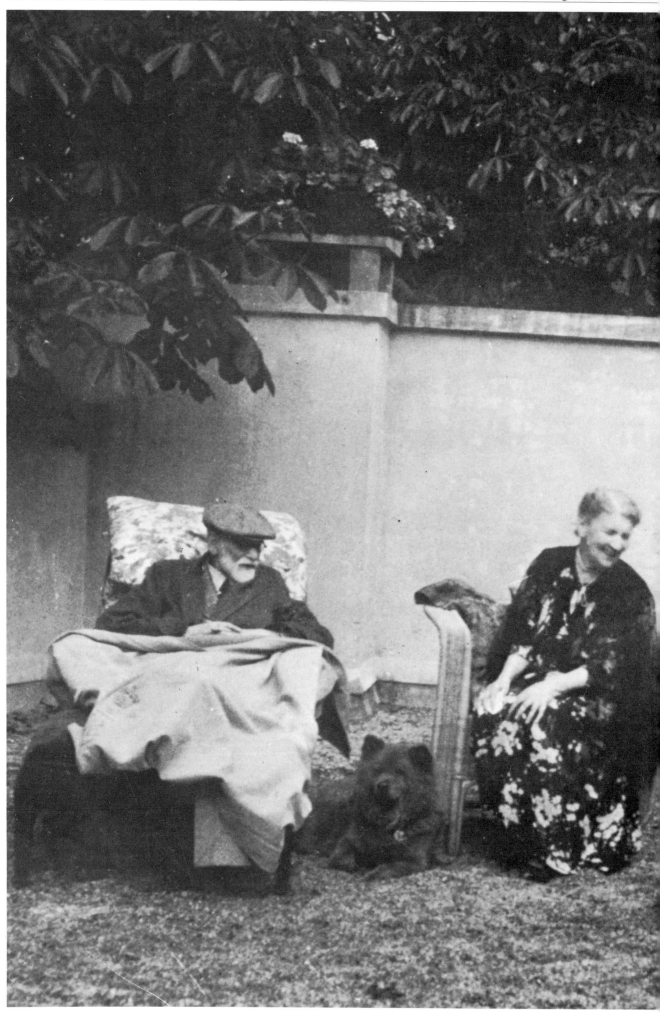

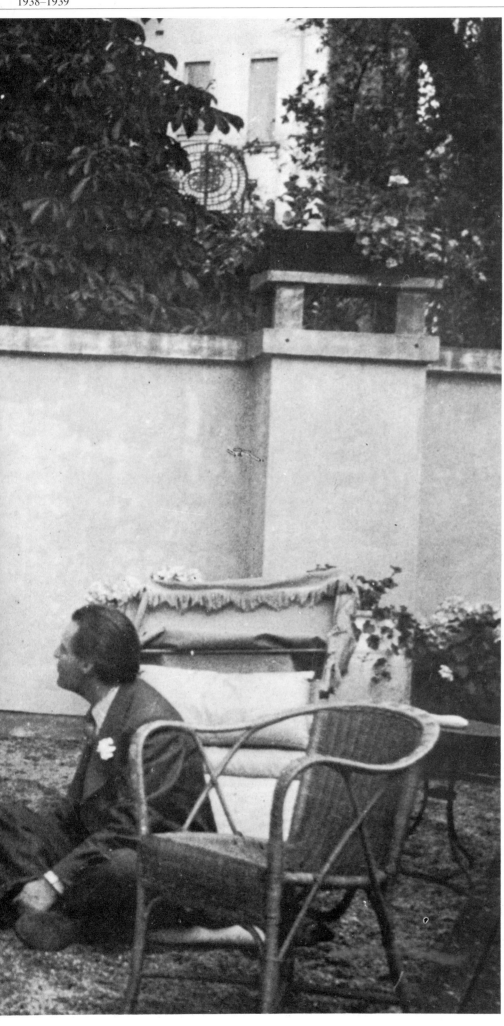

**331   The stay in Paris**
The one day in your house in Paris restored our good mood and sense of dignity; after being surrounded by love for twelve hours we left proud and rich under the protection of Athene.[1]
*Letter to Marie Bonaparte, June 8, 1938*

*With Martha, Ernst and the chow Lün*

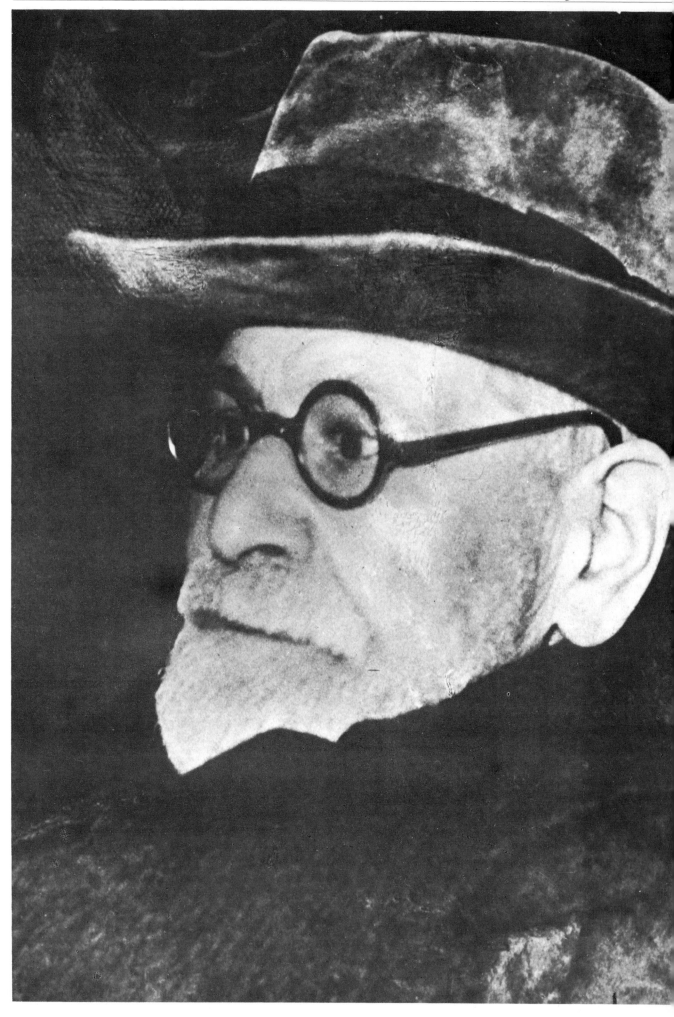

**332 In the car, immediately after arriving in London**
The emotional climate of these days is hard to grasp, almost indescribable. The feeling of triumph on being liberated is too strongly mixed with sorrow, for in spite of everything I still greatly loved the prison from which I have been released. The enchantment of the new surroundings (which make one want to shout "Heil Hitler!") is blended with discontent caused by little peculiarities of the strange environment; the happy anticipations of a new life are dampened by the question: how long will a fatigued heart be able to accomplish any work? [ . . . ] We have become popular in London overnight. "We know all about you," says the bank manager; and the chauffeur who drives Anna remarks: "Oh, it's Dr. Freud's place." We are indundated with flowers.
*Letter to Max Eitingon, June 6, 1938*

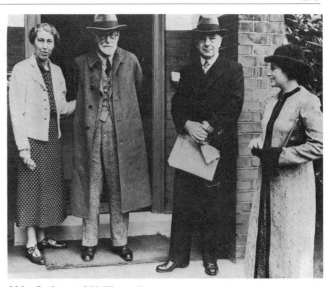

**333 In front of 39 Elsworthy Road**
Jones met us at Victoria and drove us back through the beautiful city of London to our new house, [ . . . ] it is quite far north, beyond Regents Park at the foot of Primrose Hill. From my window I see nothing but greenery which begins with a charming little garden surrounded by trees. So it is as though we were living in Grinzing where Gauleiter Bürckel has just moved into the house opposite.
*Letter to Max Eitingon, June 6, 1938*

*With Mathilde Holitscher, his eldest daughter, Ernest Jones and Lucie Freud, his daughter-in-law*

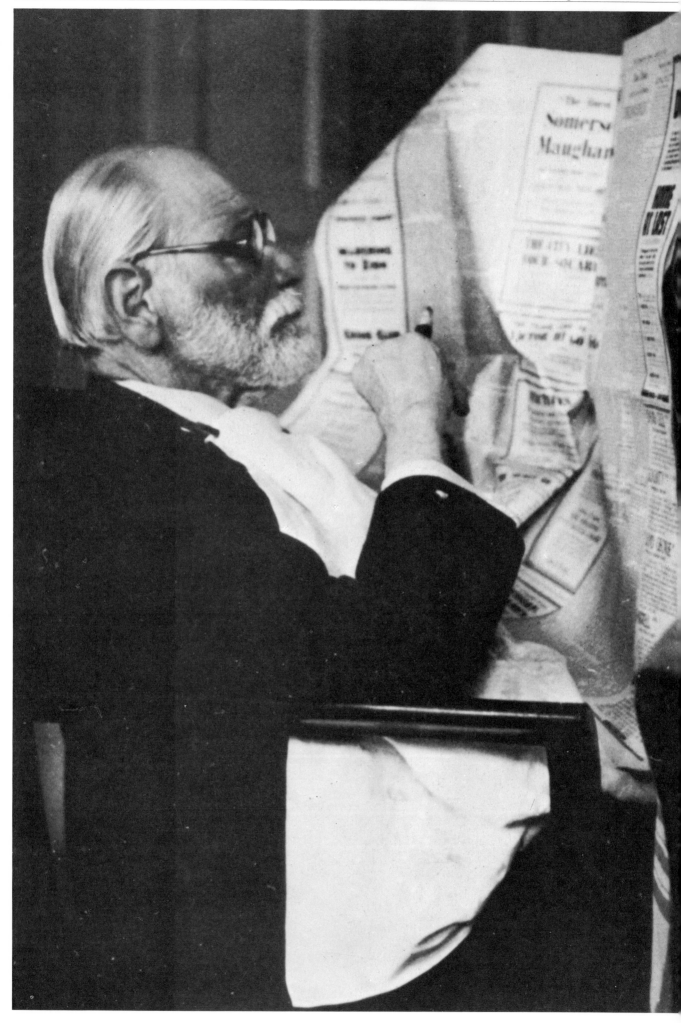

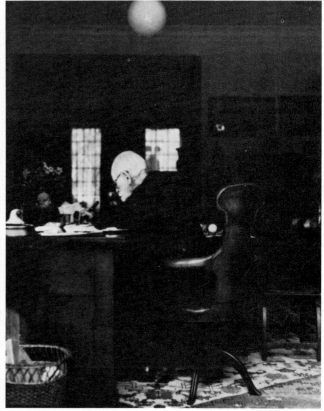

**334  In the new home**

Everything is going on very well with us, or would be, if the distressing news from Vienna and the continuous appeals for help, which only serve to remind one of one's own helplessness, did not stifle every feeling of well-being.

*Letter to Arnold Zweig,*
*June 28, 1938*

I am enjoying writing the third part of *Moses*. Just half an hour ago the post brought me a letter from a young American Jew[1] imploring me not to deprive our poor unhappy people of the one consolation remaining to them in their misery. The letter was friendly and well intentioned but what an overestimation! Can one really believe that my arid treatise would destroy the belief of a single person brought up by heredity and training in the faith, even if it were to come his way?

*Letter to Arnold Zweig,*
*June 28, 1938*

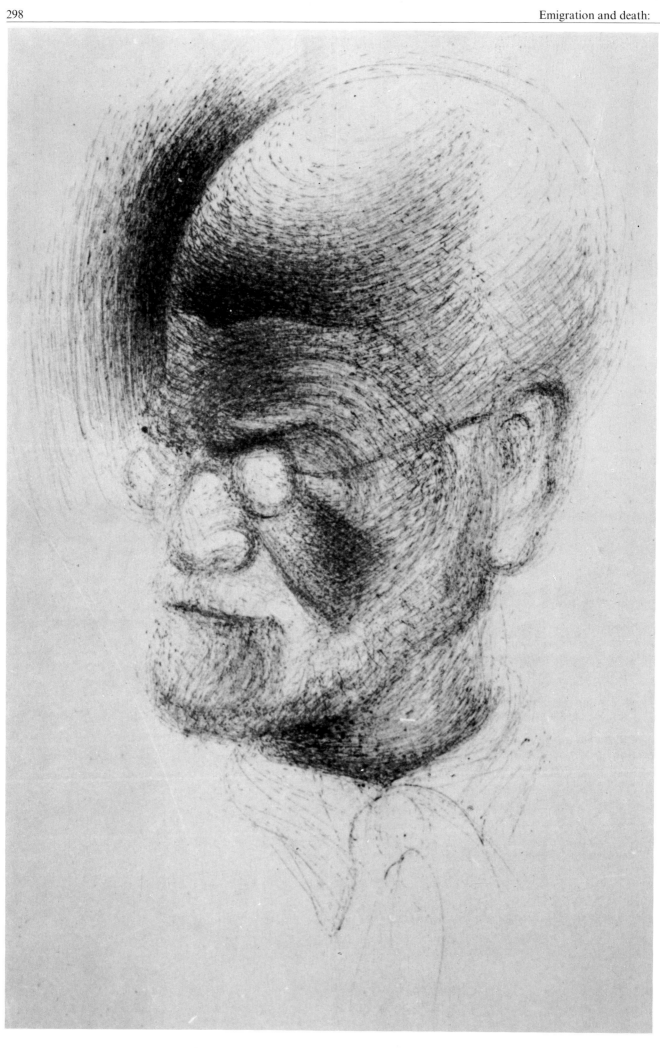

**335   Sketch of Freud by Salvador Dali**

I have at last met Freud in London. I was accompanied by Stefan Zweig [ . . . ]. Before leaving I tried to hand him a journal in which there was an article by me on paranoia. Freud never stopped staring at me and paid not the slightest attention to what I was showing him. Watching me constantly, as though trying to penetrate my psychological reality with his whole being, he exclaimed, turning to Stefan Zweig: "I have never seen such a prototype of the Spaniard. What a fanatic!"
*Dali on his meeting with Freud*

[ . . . ] I was inclined to look upon surrealists, who have apparently chosen me for their patron saint, as absolute (let us say 95 per cent, like alcohol) cranks. The young Spaniard, however, with his candid fanatical eyes and his un-deniable technical mastery, has made me reconsider my opinion. It would in fact be very interesting to investigate analytically how a picture like this one came to be painted.
*Letter to Stefan Zweig, July 20, 1938*

*Stefan Zweig brought Salvador Dali to visit Freud in July, 1938. That was when Dali drew this sketch in ink on blotting paper.*

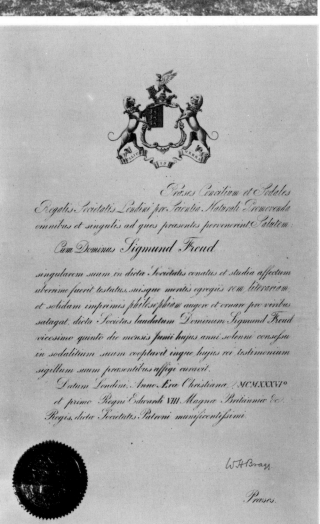

**336   With a secretary of the Royal Society**[1]

What pleased me most was the visit of the two secretaries from the Royal Society who brought the sacred book of the Society for me to sign [ . . . ]. They left a facsimile of the book with me and if you were here I could show you the signatures from I. Newton to Charles Darwin. Good company!
*Letter to Arnold Zweig, June 28, 1938*

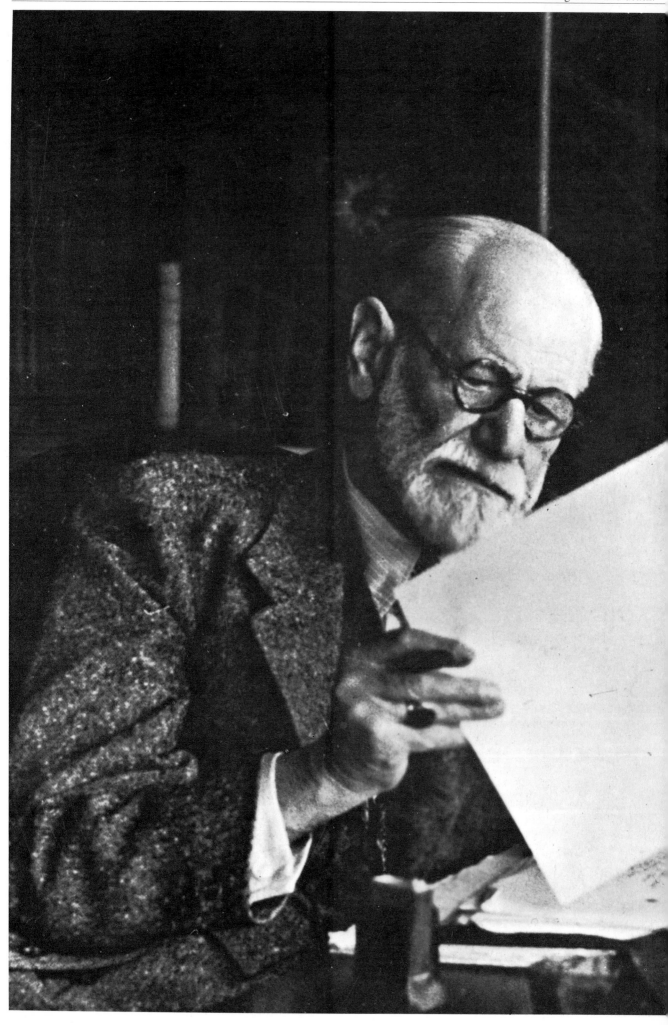

### 337   At his desk

There were letters from friends, a surprising number from complete strangers who simply wanted to express their delight at our having escaped to safety and who expect nothing in return. In addition of course hordes of autograph hunters, cranks, lunatics and pious men who send tracts and texts from the Gospels which promise salvation, attempts to convert the unbeliever and shed light on the future of Israel. Not to mention the learned societies of which I am already a member, and the endless number of Jewish associations wanting to make me an honorary member. In short, for the first time and late in life I have experienced what it is to be famous.
*Letter to Alexander Freud, June 22, 1938*

22/7

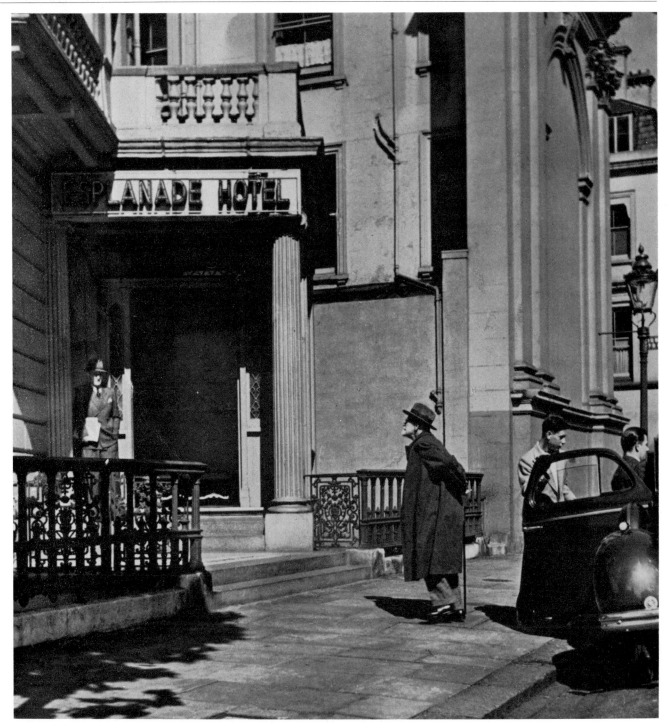

**338  First manuscript page of**
*An Outline of Psycho-Analysis,*
**1938**
I do not share the almost
fetishistic respect for MSS.[1]
I don't care anything for mine
and only keep them because I
have been told of the
possibility that they might
some time bring in some
pocket money for my
grandchildren.
*Letter to Max Eitingon,*
*November 13, 1934*

**339  In front of the Esplanade**
**Hotel, London, 1938**
In the meantime, somehow, we
have to take the uncomfortable
temporary measure [ . . . ] of
staying for weeks in a hotel
[ . . . ] as we have to be out of
the house[1] by 5th Sept[ember].
*Letter to Jeanne Lampl-de*
*Groot, August 22, 1938*

*Freud himself, however, only*
*spent a few days in the*
*Esplanade Hotel, as he had to*
*enter a London clinic. Prof.*
*Pichler had come from Vienna*
*to perform the last operation on*
*Freud's jaw.*

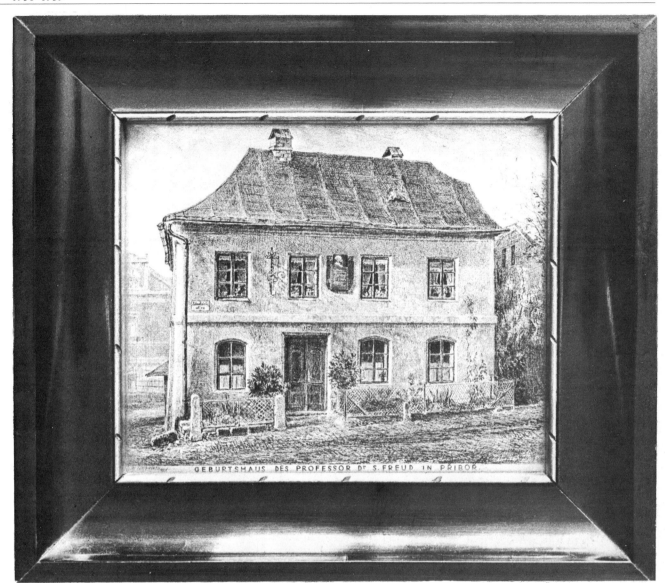

GEBURTSHAUS DES PROFESSOR Dr S. FREUD IN PRIBOR.

**340   Entrance to Freud's last house, in Maresfield Gardens**
The house is very beautiful. It suits me that you have postponed your visit for a while; by that time it will be ready for you to see.
*Letter to Marie Bonaparte, October 4, 1938*

*Freud lived here, at 20 Maresfield Gardens, Hampstead, until his death; Anna Freud still lives here.*

**341   Picture of Freud's first house**
*This picture of the house where he was born hangs in Freud's study in Maresfield Gardens.*

**342   View from the garden** *The door on the left leads into Freud's study.*

343   The couch

**344   The desk** [1]

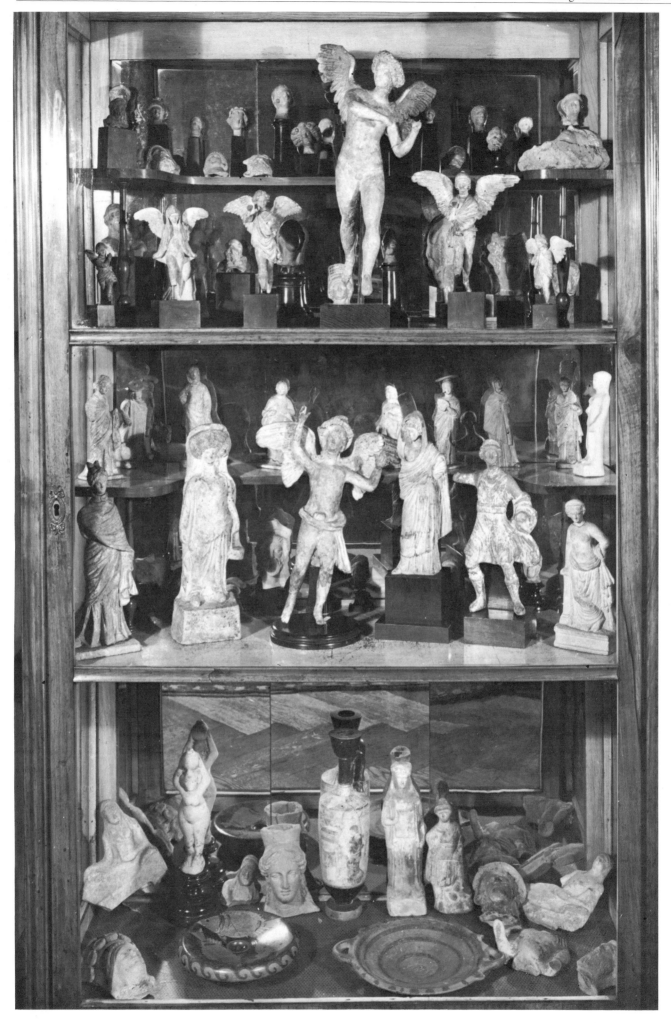

**345  Showcase with antiques**
All the Egyptians, Chinese and
Greeks have arrived, have
stood up to the journey with
very little damage, and look
more impressive here than in
Berggasse. There is just one
thing: a collection to which
there are no new additions is
really dead.
*Letter to Jeanne Lampl-de
Groot, October 8, 1938*

**346  In the garden at
Maresfield Gardens, 1939**
I am not well; my illness and
the aftermath of the treatment
are responsible for this
condition, but in what
proportion I don't know.
People are trying to lull me
into an atmosphere of
optimism by saying that the
carcinoma is shrinking and the
symptoms of reaction to the
treatment are temporary. I
don't believe it and don't like
being deceived. [ . . . ] Some
kind of intervention that
would cut short this cruel
process would be very
welcome.
*Letter to Marie Bonaparte,
April 28, 1939*

**349  H. G. Wells**
Indeed, you cannot have
known that since I first came
over to England as a boy of
eighteen years, it became an
intense wish phantasy
of mine to settle in
this country and become an
Englishman. Two of my half-
brothers had done so fifteen
years before.
*Letter to H. G. Wells, July 16,
1939*

*Herbert George Wells, 1866-
1946. The English writer, who
had known Freud since 1931,
often visited him in his exile in
London, and tried to help him
to become naturalized at once,
without success. Freud had the
status of "enemy alien" until his
death.*

**347  A page from the
correspondence register
(November/December 1938)**

*It was Freud's custom to note
all the letters he received
and wrote in a register of
correspondence. The only pages
extant, however, are those with
entries made in London.*

**348  Yvette Guilbert**
The warmth of your letter gave
me great pleasure and the
confidence with which you
promise a visit in May 1939
has moved me greatly. At my
age, however, every
postponement has a sad
connotation. It was privation
enough during these last years
not to have been granted an
hour's rejuvenation by the
magic spell of Yvette.
*Letter to Yvette Guilbert,
October 24, 1938*

*Yvette Guilbert, 1866-1943, the
celebrated French diseuse, was
friendly with Freud for many
years. On the photograph she
gave him, she wrote: "De tout
mon coeur au grand Freud!
Yvette Guilbert, 6 Mai 1939."*

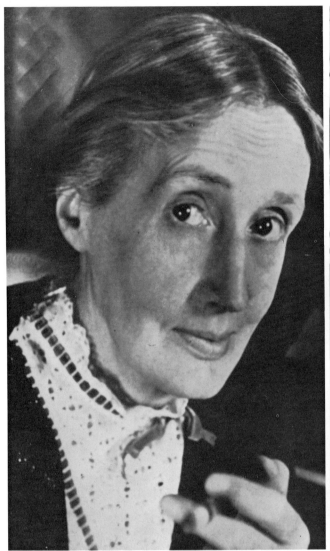
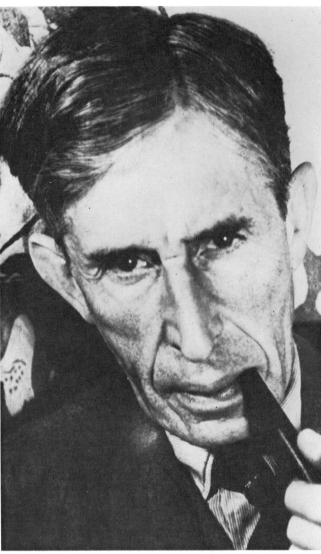

**350   Virginia and Leonard Woolf**

I only once met Freud in person [ . . . ] in the afternoon of Saturday, January 28, 1939, we went and had tea with him. I feel no call to praise the famous men whom I have known. Nearly all famous men are disappointing or bores, or both. Freud was neither; he had an aura, not of fame, but of greatness.
Leonard Woolf, *Downhill All the Way*

*Leonard Woolf, 1880-1969, and his wife, the writer Virginia Woolf, 1882-1941, founded The Hogarth Press in 1917. Beginning in 1924, this press published the English editions of Freud's works, and brought out, from 1953 onwards, the* Standard Edition of the Complete Psychological Works of Sigmund Freud *(24 vols.), edited by James Strachey.*

**351   First manuscript page of "A Comment on Anti-Semitism," 1938**[1]

Ein Wort zum Antisemitismus.

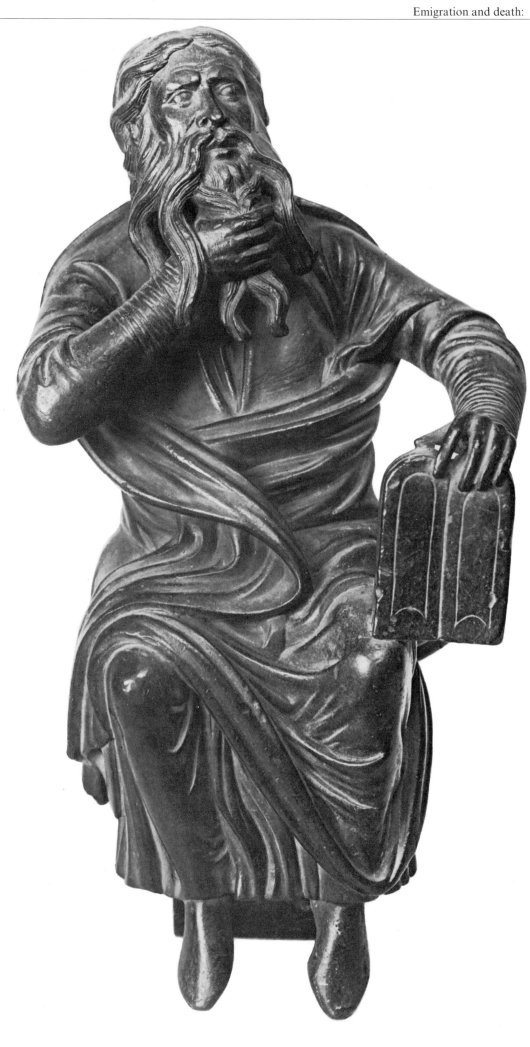

SIGMUND FREUD

# DER MANN MOSES
## UND DIE
## MONOTHEISTISCHE RELIGION

*DREI ABHANDLUNGEN*

1 9 3 9

VERLAG ALLERT DE LANGE
AMSTERDAM

Internationale Zeitschrift
für Psychoanalyse
und Imago

Herausgegeben von Sigm. Freud

XXIV. BAND      1939      Heft 1/2

Vorbemerkung

Der Jahrgang 1938 der „Internationalen Zeitschrift für Psychoanalyse"
und der „Imago" konnte wegen der politischen Ereignisse in Oester-
reich nicht erscheinen. Nach mehr als einjähriger Unterbrechung
erscheinen die beiden Zeitschriften jetzt wieder, nun zu einem
Band vereinigt und unter dem gemeinsamen Titel „Internationale
Zeitschrift für Psychoanalyse und Imago".

Der vorliegende Band dieser neuen Zeitschrift schliesst als XXIV.
Jahrgang (1939) an die Bände XXIII (1937) beider Zeitschriften un-
mittelbar an. Die e i n e Zeitschrift wird die Traditionen b e i d e r
unverändert fortsetzen.

Der Herausgeber

**352  Statuette of Moses by Nicolas of Verdun**[1]
The man (Moses) and what I wanted to make of him pursue me everywhere.
*Letter to Arnold Zweig, December 16, 1934*

**353  First edition of *Moses and Monotheism*, 1939**[1]
Several years ago I started asking myself how the Jews acquired their particular character, and following my usual custom I went back to the earliest beginnings. I did not get far. I was astounded to find that already the first so to speak embryonic experience of the race, the influence of the man Moses and the exodus from Egypt, conditioned the entire further development up to the present day—like a regular trauma of early childhood in the case history of a neurotic individual. To begin with, there is the temporal conquest of magic thought, the rejection of mysticism, both of which can be traced back to Moses himself [ . . . ].
*To Anon, December 14, 1937*

To deprive a people of the man whom they take pride in as the greatest of their sons is not a thing to be gladly or carelessly undertaken, least of all by someone who is himself one of them. [ . . . ] Moses was an Egyptian—probably an aristocrat—whom the legend was designed to turn into a Jew. [ . . . ] The deviation of the legend of Moses from all the others of its kind can be traced back to a special feature of his history. Whereas normally a hero, in the course of his life, rises above his humble beginnings, the heroic life of the man Moses began with his stepping down from his exalted position and descending to the level of the Children of Israel.
*Moses and Monotheism*

**354  *Internationale Zeitschrift für Psychoanalyse und Imago*, London, 1939**
The 1938 issue of the "Internationale Zeitschrift für Psychoanalyse und Imago", owing to political events in Austria, could not be published. After an interruption of more than one year, the two journals are now reappearing again, joined in one volume and with the combined title "International Journal for Psycho-Analysis and Imago."

The present volume of this new journal, volume XXIV (1939) is the immediate sequel to volume XXIII (1937) of both journals. The *one* journal will continue unchanged the traditions of both.
The editor

*Translation*

*As a continuation of the two German-language psychoanalytical journals, there appeared in London, from 1939 onwards, a combined journal,* Internationale Zeitschrift für Psychoanalyse und Imago; *it had to stop publication, however, as early as 1941.*

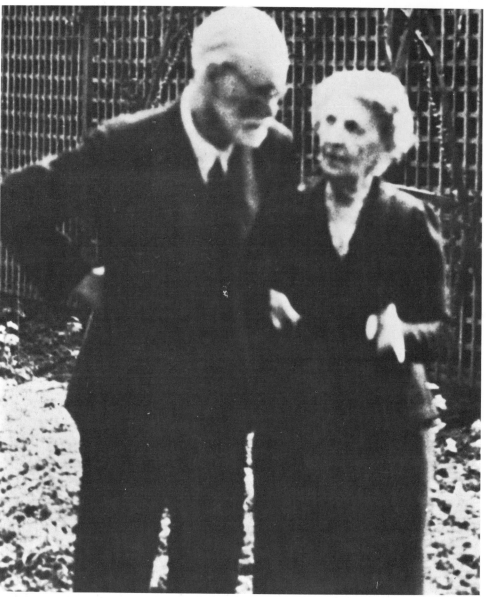

**355  With Martha, September 1939**

The beloved has a magic that only shifts ground, but is never exhausted. A good noble human being is an unfailing source of joy, sympathy and admiration. Stay healthy, strong, brave and steadfast for me, and I shall never be afraid of our becoming wearisome to each other.
*Letter to Martha Bernays, August 18, 1883*

*In the garden of the house at Maresfield Gardens.*

**356  In the year of his death**

Since the operation in September I have been suffering from pain in the jaw, and this has increased slowly but steadily, so that without hot-water bottles and large doses of aspirin I would not get through my daily tasks or my nights. On an earlier occasion a fairly large sequestrum of bone was discharged; it was expected that this process would be repeated and settle the affair, but so far this has not happened. They are uncertain as to what is taking place and do not know whether the delay is basically innocuous or whether it is a further step in the mysterious process we have been combating for sixteen years. [. . .] Meanwhile I have this paralyzing pain.
*Letter to Arnold Zweig, February 20, 1939*

*Freud died on September 23, 1939.*

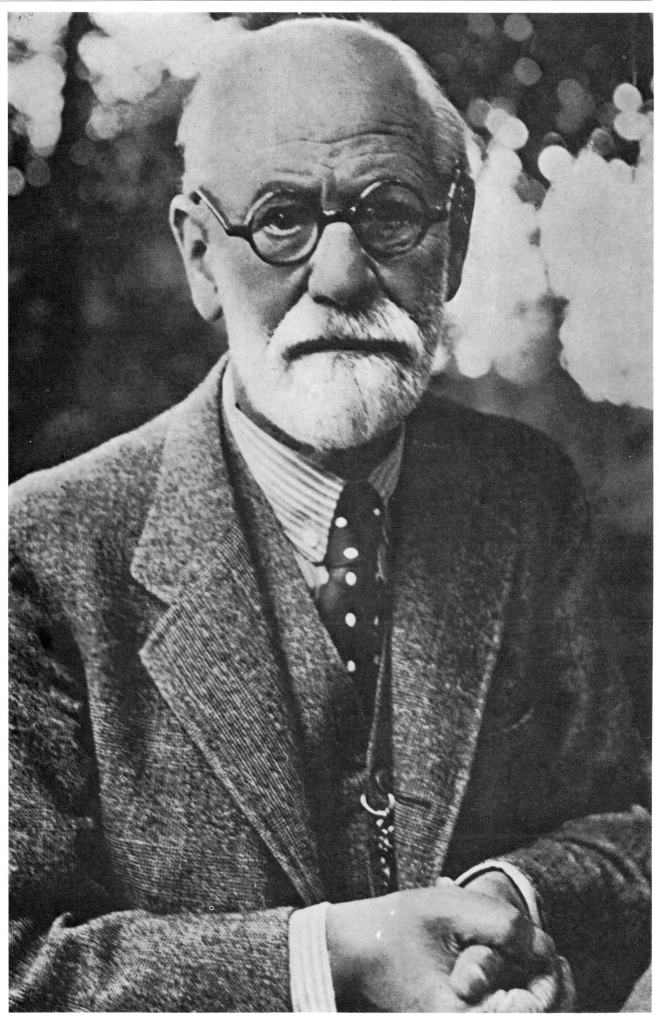

**357 Greek vase from Freud's collection; his funerary urn**
But no one is under the illusion that nature has already been vanquished. [ . . . ] There are the elements, which seem to mock at all human control: the earth, which quakes and is torn apart and buries all human life and its works; water, which deluges and drowns everything in a turmoil; storms, which blow everything before them; there are diseases, which we have only recently recognized as attacks by other organisms; and finally there is the painful riddle of death, against which no medicine has yet been found, nor probably will be. With these forces nature rises up against us, majestic, cruel and inexorable; she brings to our mind once more our weakness and helplessness, which we thought to escape through the work of civilization.
*The Future of an Illusion*

My two brothers already rest in English soil; perhaps I shall also find room there.
*Letter to Max Eitingon,*
*October 12, 1919*

*The urn, which also contains the ashes of Martha Freud, is in the Crematorium at Golders Green, London.*

# Appendix

**Notes on the Picture Section**

**1**

1. The map was published by Artaria, Vienna, in 1855. The regions of Trieste, Goritzia, Gradisca, Istria, Carinthia and Carniola are still called Illyria, after the Provinces of Illyria founded by Napoleon, which came back to Austria in 1814. The Kingdom of Illyria, formed by Austria in 1816, had already been broken up in 1849 into the Crown Lands of Carinthia, Carniola and the Coast Lands. The Kingdom of Lombardy and Venice, which went to Italy in the years after Freud's birth, in 1859 or 1866, is still shown. Bosnia and Herzegovina (the latter not marked on the map) are still part of the state of Turkey. They did not come under Austrian rule until 1878.

**3**

1. The photograph dates back to about 1930; in any case it was taken before the first commemorative plaque on Freud's birthplace was unveiled in 1931 (*cf.* illustration 294). Since 1918 the Schlossergasse has been called, in Czech, Zámečnická ulice; the name can be seen in the picture.

**4**

1. Entry in Hebrew by Freud's father. The German translation written in the margin of the page is, as Dr. Karl Erich Grözinger of the Seminar for Jewish Studies at the University of Frankfurt am Main informed us, incomplete. The translator has omitted passages which were unreadable or which he did not understand. On the other hand he has added a few explanatory phrases. In the second paragraph of the Hebrew text there are two points at which German words are written in Hebrew letters: *Uhr Nachmittag* (hour afternoon) and *Pathen* (godparents).

2. The Hebrew text here reads: "on the 16th Adar Rischon." Adar Rischon is a Jewish month in Leap Year, in which there are two months called Adar: Adar Rischon and Adar Scheni.

3. Literally: "And came to rest in his resting-place." In the Hebrew text this is followed by the sentence: "May he rest in his resting-place . . . (illegible)

until the time of the end, until the day when it shall be said to those who sleep in the dust: 'Awake in peace, Amen.'"

4. Place in the Austrian province of Galizia.

5. The Mohel performs the circumcision.

6. The Hebrew text here reads: "The Sandak was Herr . . .". The Sandak holds the child during the circumcision. There follows another illegible line with the date "4 . . . ber 1856."

**6**

1. Freud repeatedly pointed out the important part played by this children's nurse, Monica Zajícova, a Czech woman and a devout Catholic, of whom no portrait is extant. He does so not only in his letters to Fliess, but also in *The Interpretation of Dreams*: "Now these other dreams were based on a recollection of a nurse in whose charge I had been from some date during my earliest infancy till I was two and a half. I even retain an obscure conscious memory of her. According to what I was told not long ago by my mother, she was old and ugly, but very sharp and efficient. From what I can infer from my own dreams her treatment of me was not always excessive in its amiability and her words could be harsh if I failed to reach the required standard of cleanliness. [ . . . ] It is reasonable to suppose that the child loved the old woman who taught him these lessons, in spite of her rough treatment of him." (*S. E.*, **4**, p. 247 f) Freud mentions how he lost this nurse in a letter of October 15, 1897, to Wilhelm Fliess. In this letter he quotes something his mother said when he asked her, in 1897, why the old woman had disappeared: "During my confinement when Anna was born" (she is two and a half years my junior) "it was discovered that she was a thief, and all the shiny new kreuzers and zehners and all the toys that had been given to you were found in her possession. Your brother Philipp [*cf.* note on illustration 12] himself went for the policeman and she was given ten months in prison." (*S. E.*,**1**, p. 263 f)

**7**

The following notes on the pictures in the church were

provided by Prof. Renée Gicklhorn, who put these photographs at our disposal.

1. "I had the photographs published here taken in 1969 on the occasion of the unveiling of a monument to Freud in Freiberg. I was impelled to do this by repeated statements on the part of different biographers of Freud that the pictures in the Parish Church of Mariae Geburt had made a deep impression on Freud as a child. The votive picture of Saint Isidore is on one side of the presbytery. In a side chapel hangs a votive picture scarcely mentioned in older writings and never described in detail, showing a view of Příbor and scenes from its history at the time of the Swedish wars. I paid particular attention to this picture, and its photograph is published here for the first time; it is extremely possible that it was the one which, with its dramatic and action-packed scenes, made the greatest impression on the child.

2. Saint Isidore, 1772, painted by Anton Wolny of Chemnitz.

3. The *Schwedenbild* is by Ulrich and dates from 1843. In the center is Saint Joseph with the Christ Child, surrounded by smaller scenes identified by inscriptions in two languages.

**8**

1. *Cf.* illustration 154 and the accompanying text.

**10**

1. In connection with this disappointment with his father we may mention an event related by Martin Freud (in *Glory Reflected, Sigmund Freud—Man and Father*, London, 1957, p. 70 f). It happened in the year 1901 at the Thumsee, where the family was spending the holidays. During a walk Freud suddenly found himself confronted by a threatening mob shouting anti-Semitic slogans. Brandishing his alpenstock he advanced, glaring, upon the group, which scattered before him, obviously intimidated.

**11**

"Thou owest Nature a death." Obviously a reference to Shakespeare's *Henry IV*, Part I, Act V, Scene 1, ". . . thou owest God a death."

**12**

1. The letter is undoubtedly addressed to Freud's half-

brother Emanuel (1834-1915) who had been living in Manchester since 1859. Philipp (1838-1912) was the other half-brother from Jacob Freud's first marriage. Johann (John) was presumably Emanuel's son, born in 1855, and Pauline (1854-1943) his daughter.—Twice (in *Freude* and *Familie*) Freud uses the wrong capital letter. He signs his letter "Sigismund." In the annual reports of his school he is at first referred to as "Sigismund Freud"; as Dr. Eva Laible of Vienna has told us, "Sigmund Freud" does not appear there until 1870. However, we already find "Sigmund" on the page of the Bible on which his birth is noted (illustration 4), though only in the German translation; in the Hebrew it is clearly "Sigismund."

## 15

Translation of Freud's grades:

Deportment
  exemplary (1st term)
  exemplary (2nd term)
Application
  sustained
  sustained
Presentation of written work
  commendable
  most commendable!
Rated in class performance
  first; 4/60
  first with honor; 3/58
Religion
  excellent
  excellent
German
  excellent
  excellent
Latin
  excellent
  excellent
History
  commendable
  commendable
Mathematics
  commendable
  commendable
Natural History
  excellent
  excellent
Drawing
  passing
  satisfactory
Penmanship
  satisfactory
  commendable

## 16

Translation:
  Random Thoughts.
Gold inflates man like air a pig's bladder.

– . –

The worst egoist is the one to whom it has never occurred to think himself one.

– . –

Some men are like a rich mine that has never been thoroughly explored. Others write "debit and credit" over their thoughts as they do over their linen, and impale every little worm that gets lost in the wilderness of their brain.

– . –

Some men are iron ore, others fools' gold and fools' silver.

– . –

Every larger animal surpasses man in something, but he surpasses them all in everything.

S. Freud

This issue of the school magazine *Musarion*, consisting of eight pages—the first and last are shown in the illustration—is handwritten, but the writing is not Freud's. On this earliest literary effort—Freud was then fifteen—see K. R. Eissler's "Psycho-analytische Einfälle zu Freud's 'Zerstreute(n) Gedanken'" in K. R. Eissler, S. Freud, S. Goeppert, K. Schröter, *Aus Freuds Sprachwelt und andere Beiträge, Jahrbuch der Psycho-analyse*, supplement no. 2, Bern and Stuttgart, 1974, p. 103 ff.

## 17

1. From these annual reports of the Gymnasium (grammar school) we can also see the schedules then in use for the "compulsory subjects." Dr. Eva Laible will shortly publish a work about Freud's years at the Gymnasium.

## 19

1. Julie Braun-Vogelstein, Heinrich Braun's wife, who, after her husband's death, asked Freud to give her some reminiscences for Braun's biography about their young days together.

## 20

1. Samuel Hammerschlag several times gave Freud financial support for his studies, despite his own poverty.

## 21

1. It is not clear why, on the impression of the seal, which is shown here enlarged, the "C" (or, as it appears, the "E" of "Academia Espagnola") appears before the "A."
2. Freud and Eduard Silberstein, 1857-1925; it was not possible to obtain a

photograph of this boyhood friend.

## 25

1. Freud mentions this ideal of his boyhood in *The Interpretation of Dreams* (*S. E.*, **4**) in connection with his longing for Rome (*cf.* the texts to illustration 162), but most particularly in the context of his disappointment in his father. After describing the scene in which his father's cap is knocked into the mud by a Christian (*cf.* the text to illustration 10), Freud goes on: "I contrasted this situation with another which fitted my feelings better: the scene in which Hannibal's father, Hamilcar Barca, made his boy swear before the household altar to take vengeance on the Romans. Ever since that time Hannibal had had a place in my phantasies." (p. 197)
2. André Masséna, Duke of Rivoli, Prince of Essling, Marshall of France, 1758-1817. During the Revolution he rose rapidly. In 1814 he joined Louis XVIII. He left memoirs which were published posthumously.
3. Freud has repeatedly analyzed the crucial importance to his psychic development of this boy, of whom no picture has survived (he was the son of his half-brother Emanuel, and has already been mentioned in the note to illustration 12): "I have already shown how my warm friendships as well as my enmities with contemporaries went back to my relations in childhood with a nephew who was a year my senior; how he was my superior, how I early learned to defend myself against him, how we were inseparable friends, and how, according to the testimony of our elders, we sometimes fought with each other and—made complaints to them about each other. All my friends have in a certain sense been re-incarnations of this first figure who "long since appeared before my troubled gaze": they have been *revenants*. My nephew himself re-appeared in my boyhood, and at that time we acted that part of Caesar and Brutus together. My emotional life has always insisted that I should have an intimate friend and a hated enemy. I have always

been able to provide myself afresh with both, and it has not infrequently happened that the ideal situation of childhood has been so completely reproduced that friend and enemy have come together in a single individual—though not, of course, both at once or with constant oscillations, as may have been the case in my early childhood." (*S. E.*, **5**, p. 483)

## 26

1. The reference is to Oliver Freud (*cf.* illustration 159); Freud was nineteen when he first visited England.

## 27

1. A reference to the essay by Börne (1786-1837) written in 1823: "The art of becoming an original writer in three days," which Freud had read in his youth, but had forgotten again, and to which he later attributed a decisive influence upon the prehistory of his technique of free association and the concept of "dream censorship." See his work "A Note on the Prehistory of the Technique of Analysis" (1920), *S. E.*, **18**, p. 263 ff.—The illustration is a lithograph after the painting by Moritz Oppenheim.

## 29

Translation:
*Questions for the written Matura examination*
1. From the *German*: What considerations should guide us in the choice of a profession?—2. From the *Latin*: Virgil book IX, 176-223—Seyffert for Secunda (sixth and seventh years of grammar school) p. 283 no. XIII, to the words: "to call for the liberation of the Fatherland."—3. From the *Greek*: *Oed. R.* lines 14-57.—
From *mathematics*:
1. The area ($J = m^2$) and two sides ($h_a$ and $h_b$) of a triangle are given; draw the triangle.—2. What is the area of one side of a regular pyramid inscribed in a regular cylinder if the height of the cylinder is h and the radius of the base r? Calculate the area where r = 4, h = 8.—3. A shopkeeper sells a liquid in bottles of 5 fl. and 9 fl. How many bottles of each sort must he fill for the total amount to be 71 fl.?—4. What continued fraction is equal to the common fraction $\frac{406}{1109}$ what are its approximate values, and

what is the limit of the error made when the penultimate approximate fraction is substituted for the whole fraction?

**31**

1. The letter is addressed to Emil Fluss, a boyhood friend. The full text of this long letter, already quoted several times, of which only two pages are reproduced here, is to be found in *Letters of Sigmund Freud 1873-1939*, ed. by Ernst L. Freud, trans. by Tania and James Stern, London, 1961, p. 21 ff.
Translation:
Left-hand page:
*Night*
          Vienna, 16th June 1873
Dear Friend,
If I didn't shrink from making the silliest joke of our facetious century I would just say: The *Matura* is dead, long live the *Matura*. But I like this joke so little that I wish the second *Matura* [the oral part of the examination] were over too. Despite secret qualms of conscience and feelings of remorse, I wasted the week following the written exam, and ever since yesterday I have been trying to compensate for the loss by filling up thousands of old gaps. You never would listen when I accused myself of laziness, but I know better and feel there is something in it.

   Your curiosity over the *Matura* will have to be content with cold dishes, as it comes too late and after the meal is finished, and unfortunately I can no longer furnish an impressive description of all the hopes and doubts, the perplexity and hilarity, the light that suddenly dawned upon one, and the inexplicable windfalls that were discussed "among colleagues"; to do this, the written exam . . .
Right-hand page:
. . . you say, are safe. Safe from what? I ask. Surely not safe and secure from being mediocre? What does it matter whether we fear something or not? Isn't the main question whether what we fear exists? Admittedly more powerful intellects are also seized with doubts about themselves; does it therefore follow that anyone who doubts his virtues is of powerful intellect? In intellect he may be a weakling yet at the same time an honest man by

education, habit or even self-torment. I don't mean to suggest that if you find yourself in a doubtful situation, you should mercilessly dissect your feelings, but if you do you will see how little about yourself you're sure of. The magnificence of the world rests after all on this wealth of possibilities, except that it is unfortunately not a firm basis for self-knowledge.

**41**

1. Freud and Carl Koller later carried out their cocaine experiments here (Illustrations 83 to 86).

2. For data on Freud's university teachers, *cf.* Erna Lesky, *Die Wiener Medizinische Schule im 19. Jahrhundert*, Graz–Cologne, 1965; also Siegfried Bernfeld's illuminating essays on Freud's early years, soon to be published in German translation by the Suhrkamp Verlag. Dr. Eva Laible is also shortly to publish an article on Freud's student period, based on the most recent research.

**42**

1. In the letter to Julie Braun-Vogelstein already quoted (*cf.* Freud, *Letters 1873-1939, op. cit.*, p. 379 f), Freud says that his boyhood friend Heinrich Braun (illustration 19) had taken him in 1883 or 1884—hence long after the encounter described in the quotation accompanying this picture—to see his brother-in-law Victor Adler, who was then living at 19 Berggasse, in the apartment into which Freud moved in 1891, and where he lived until his emigration. The fact that Victor Adler had rented the Berggasse apartment before him is said to have played some part in his decision to move into it.

**43**

1. Brentano was ordained as a priest in 1864, but left the Church in 1873 because he rejected the doctrine of papal infallibility. When, as a former priest, he married, he lost his professorship at Vienna in 1880, and taught after that as a *Privatdozent*. His works had a great influence on the thinking of Edmund Husserl and Max Scheler.

**45**

1. Volume 12 of John Stuart Mill, *Gesammelte Werke*

(*Collected Works*), authorized translation under the editorship of Theodor Gomperz), Leipzig, 1880. Eduard Wessel, the translator of the volumes published earlier, had died suddenly. The last volume, which Freud translated into German in 1879, contains essays on women's emancipation, Plato, the labor question and socialism.

**46**

1. We owe this information to Dr. Franz Gall of Vienna University Archives, and also, yet again, to Dr. Eva Laible; information with reference to this is also to be found in Bernfeld (*cf.* note 2 to illustration 41, above).

**47**

1. Freud had hung a portrait of Helmholtz in his room.

2. Siegfried Bernfeld, in a detailed historical study, was able to show that traces of this way of thinking are still to be found in certain central psychoanalytical concepts; *cf.* especially the essay "Freud's Earliest Theories and the School of Helmholtz" in *Psychoanalytic Quarterly*, **3**, p. 341 ff (see, again, note 2 on illustration 41, above).

**49**

1. After gaining his doctorate (1881) Freud was a demonstrator at Brücke's Institute for three semesters.

**50**

1. *Cf.* K. R. Eissler's Biographical Sketch, p. 14.

**52**

Translation of Freud's examination grades:
   I examinations finished
          June 9, 1880  excellent
   II examinations finished
          July 22, 1880 acceptable
   III examinations finished
          March 30, 1881 excellent

**55**

1. Freud and Martha Bernays had become engaged on June 17, 1882, and on June 18 Martha travelled to Wandsbek. She returned to Vienna on September 2, 1882, but then, at her mother's wish, moved with her to Wandsbek on June 14, 1883. During the four years, approximately, until their wedding on September 14, 1886, Freud was able to visit his fiancée only six times, from Vienna, Paris and Berlin. Except for the one stay

in Wandsbek for about five weeks before going to Paris (*cf.* illustration 89) the meetings lasted only a few days each. During their separation Freud wrote to his fiancée almost every day. Extracts from this correspondence can be found in *Letters 1873-1939, op. cit.*

**60**

1. *Cf.* Freud's letter to Hugo Heller of November 1, 1906 in *Letters 1873-1939, op. cit.*, p. 278.

**62**

1. Hebrew for "sage," a Jewish academic title; in congregations of Spanish and oriental origin *Chacham* is the title of the Rabbi. Isaac Bernays was Chief Rabbi of the *Deutsch-Israelitischer Synagogenverband* at the Kohlhöfen Synagogue in Hamburg.

2. In the letter quoted, Freud tells Martha about a stay in Hamburg, where he had ordered some notepaper for her from an engraver. When he went to collect it he got into conversation with the jovial old gentleman, who turned out to be a pupil of Isaac Bernays and a friend of Martha's family.

3. Jacob Bernays, 1824-1881, Professor of Classical Philology at the University of Bonn, Martha's uncle.

4. Martha's father, Berman Bernays, 1826-1879, businessman; he moved with his family to Vienna in 1868 and became secretary to the economist and constitutional lawyer, Lorenz von Stein. It has not been possible to trace any picture of either Berman or Jacob Bernays.

**63**

1. *Cf.* the note to illustration 55.

**64**

1. Schönberg suffered from tuberculosis for years. When, in 1884, his condition was diagnosed as hopeless, he broke off the engagement.

2. By the remark "the house is secure" Freud means that his future mother-in-law had been told of the engagement, which had at first been kept secret.

3. Here Freud is alluding to his decision, in view of the precarious financial position of his family, to give up his academic career and prepare to set up in practice as a doctor. (*Cf.* illustration 73 and the accompanying texts.)

**67**

1. The picture in the Dresden gallery is not the original of the Holbein painting of the Madonna of Bürgermeister Meyer from Basel, but an old copy by Bartholomew Sarburgh (1590-c. 1637). The original is now in the Schlossmuseum in Darmstadt.

**72**

1. *Cf.* illustrations 122 to 124 with the accompanying texts.

**73**

1. Ernst Wilhelm von Brücke; *cf.* illustration 49.

**74**

1. When Freud first visited Nothnagel—the letter quoted is about this—the latter had just been called from Germany to take up the chair of internal medicine in Vienna.

2. It was for this manual that Freud later wrote his great contribution to child neurology, *Die infantile Cerebrallähmung*, Vienna, 1897 (*Infantile Cerebral Paralysis*, trans. by Lester A. Russin, Univ. of Miami Press, 1968).

**75**

1. Even later, when Freud no longer worked in the psychiatric clinic, he was able to use Meynert's laboratory for his research. However, after Freud had returned from Paris and was enthusiastically reporting on Charcot's doctrines in Vienna, Meynert gradually turned against him. This hostility increased when, in his book *On Aphasia* (1891; *cf.* illustration 120 with accompanying texts) Freud dissociated himself from localizing brain anatomy as represented by Meynert.

**76**

1. Josef Victor von Scheffel, 1826-1886, author of a famous historical novel *Ekkehard*. Translation (Ernest Jones, in the first volume of his biography *The Life and Work of Sigmund Freud*, London, 1953, p. 74, has attempted a more readable copy of the sketch): "The 'animal' part of this cavern which fits me as well as a snail-shell fits the snail, is fairly successful, the 'vegetative' part (i.e., the one intended for the ordinary functions of life in opposition to the higher 'animal' functions like writing, reading or thinking) rather less so. For instance, the table drawer can't be opened without the table

being pulled forward; but nevertheless my cleaning lady, who gave me sterling help in arranging the furniture, said she never would have believed that everything would fit together so well, and I wouldn't have believed it myself. Space is in the smallest hut for the lonely longing one." (First published in the German edition of this work *Sigmund Freud, Sein Leben in Bildern und Texten.*)

**77**

1. Freud gives in the letter a detailed psychological analysis of the motives which might have driven his friend to suicide. *Cf. Letters 1873-1939, op. cit.*, p. 73 ff.

**79**

Translation (a teaching program and Freud's publications up to that date were enclosed with the *curriculum vitae*): "I was born at Freiberg in Moravia on May 6, 1856. When I was 3 years old [,] my parents moved to Leipzig and then to Vienna, and I have lived permanently in this city up to the present time.—I received my first instruction at home, then attended a private primary school. In the autumn of 1865 I entered the *Real- und Obergymnasium* in Leopoldstadt. I took final examinations in July 1873, and in the following autumn I enrolled as an ordinary student in the Faculty of Medicine in Vienna, where, on March 31, 1881, I received the degree of Doctor of General Medicine. In the first years of my university life I attended lectures mainly in physics and natural history; I also worked for a year in the laboratory of Prof. *C. Claus*, and was twice sent on vacation courses to the zoological station at Trieste. In my third University year I was a pupil of the Physiological Institute, where I was engaged in histological work, especially the histology of the nervous system, under the guidance of Prof. *v. Brücke* and Assistant Professors *Sigm. Exner* and *E. v. Fleischl*. For one semester I had the opportunity to practice animal experiments in Prof. *Stricker's* laboratory of experimental pathology.

After obtaining my doctorate I held, for three semesters, the post of

demonstrator at the Physiological Institute, and, at the same time, benefited from the teaching of Prof. *E. Ludwig* in chemical work, especially gas analysis.

In July 1882 I entered the General Hospital and, to begin with, worked for six months as clinical assistant in Prof. *H. Nothnagel's* medical clinic.

On May 1, 1883, I was appointed Junior Resident at Prof. *Th. Meynert's* psychiatric clinic, where I spent five months. After a short period of duty in a ward for syphilis, I was transferred to Medical Ward 4 of the . . ."

The second page of the *curriculum vitae* reads as follows: "hospital, where particular attention has always been paid to nervous diseases. In Medical Ward 4 I had, for six weeks, the honor of deputizing for the Chief Physician Dr. *Scholz* as head of the ward, and acted as Associate Physician Class I for five months. I am at present working as Associate Class II in the same ward, and am engaged in observing the patients receiving treatment for nervous diseases there, and also working on brain anatomy in Prof. *Th. Meynert's* laboratory. Vienna, January 21, 1885 Dr. Sigm. Freud."

**80**

1. The testimonial is also signed by Theodor Meynert and Hermann Nothnagel. Translation: "Dr. Freud is a man of good general education and quiet serious character, an excellent worker in the field of neuroanatomy, finely skilled, clear sighted, with a wide knowledge of medical literature and a well-balanced capacity for logical deduction, together with a gift for elegant literary presentation. His findings enjoy recognition and confirmation. As a lecturer his manner is clear and confident. He combines the qualities of a scientific researcher with those of a competent teacher so well that the Committee unanimously proposes that the esteemed College should grant him admission to the further tests for appointment as university lecturer. Vienna, February 28, 1885."

**81**

Translation: "684 ministerial order of September 5, 1885 Z: 16040, by which Dr. Sigmund Freud is confirmed as *Privatdozent* for neuropathology. *Präs:* 11.9.1885 Z. 684 To Dr. Sigmund Freud! I am pleased to inform you that His Excellency the Minister for Culture and Education has, by order of 5th September 1885 Z: 16040 confirmed your appointment as *Privatdozent* in neuropathology in the Faculty of Medicine of the University of Vienna. Vienna, September 12, 1885. Dr. G. Braun Acting Vice-Dean. Nr. 684 R.P. 1884/5"

**83**

1. Ernst von Fleischl-Marxow (illustration 50); Fleischl-Marxow died as early as 1891.

**84**

1. *Cf.* illustration 316.

2. See the following illustration.

**86**

1. Between 1884 and 1887 Freud wrote, altogether, five articles on cocaine.

**90**

1. As the name indicates, the Salpêtrière was originally a gunpowder factory.

**98**

1. *Notre-Dame de Paris*, 1831

**104**

1. In the letter quoted, Freud tells of a visit to the former Royal Museum in Berlin "where I had a brief look at the antique fragments" including the Pergamon discoveries.

**105**

1. Freud gave his lecture "Über männliche Hysterie" on October 15, 1886. The original text is not extant; only reports on the occasion exist in various Viennese medical journals.

2. On November 26, 1886. Freud published this account on December 4, 1886, in the *Wiener Medizinische Wochenschrift*, **36**, p. 1633 ff., under the title: "Beobachtung einer hochgradigen Hemianästhesie bei einem hysterischen Manne" (Observations of a Severe Case of Hemi-Anaesthesia in an

Hysterical Male). (See                **108**                          reproduced in illustration
following illustration.)              1. Including the work             119

**111**
Translation:
Kk mähr: Landwehr Infanterie Bataillon Olmütz No. 15.
Res: 101
                              Qualifying Certificate
on the undermentioned Landwehr medical officer who served with the above unit during the period
from August 11 to September 9.

| | | |
|---|---|---|
| 1 | Name | Dr. Sigmund Freud |
| 2 | Rank | kk Oberarzt (lieutenant, medical corps) rank as from June 13, 1882 |
| 3 | Civilian circumstances | General practitioner and *Privatdozent* at the University of Vienna; no private means, finances in good order. |
| 4 | Decorations — Home | — |
| | Decorations — Abroad | — |
| 5 | Military Service | From August 11 to September 9, 1886, during the principal military exercise, Battalion Medical Officer, and during the concentration of the regiment from August 31 to September 6, Regimental Senior Medical Officer, according to the duty list of officers for the principal military exercise 1886. |
| 6 | Campaigns, successes and service in the field | — |
| 7 | Other service | — |
| 8 | Knowledge of languages | Written and spoken German perfect; French and English good, Italian and Spanish fairly good. |
| 9 | Skill in his profession and knowledge of the Public Health Service; trust accorded to him by military and civil authorities | Very skilled professionally; accurate knowledge of Public Health regulations and Public Health service; enjoys great trust on the part of military and civil authorities. |
| 10 | Special nonprofessional skills | — |
| 11 | Disposition and character | Honorable, steady character; cheerful disposition. |
| 12 | Keenness, order and reliability on duty | Very keen, from sense of duty, keeps good order and is very reliable on duty. |
| 13 | Whether in possession of the regulation uniform and first-aid kit | Possesses the regulation uniform and first-aid kit. |
| 14 | Conduct on duty — in the face of the enemy | No service at the front. |
| 15 | Conduct on duty — towards superiors | Obedient and frank, as well as modest. |
| 16 | Conduct on duty — towards equals | Friendly |
| 17 | Conduct on duty — towards inferiors | Benevolent, and a good influence. |
| 18 | Conduct on duty — towards patients | Very considerate and humane. |
| 19 | Conduct on duty — off duty | Very well-behaved and modest with good manners. |

**113**

1. For an explanation of the name see K. R. Eissler's biographical sketch, p. 16.

**117**

1. The English translation follows the German translation by Dr. Karl Erich Grözinger of the Seminar for Jewish Studies at the University of Frankfurt. We are also indebted to him for the following explanations and notes on the document: "Jacob Freud couches his dedication in words from the Old Testament. He uses a great deal of Old Testament terminology, but in the context of the dedication it acquires a completely new interpretation, in fact, more in terms of the European than of the old Jewish tradition. This is particularly evident in Ps. 18, 10, and Numbers 24, 4, 16. The first part of the dedication is intended as an appreciation of the spiritual development of Sigmund Freud, who finally has 'seen visions of the Almighty,' meaning insight; the second part is about the family Bible, which had at first been put away, but was now newly bound or covered so that it could be given as a birthday present.

2. Illegible. The reconstruction 'year,' which would make the best sense, is not borne out by the shape of the lettering.

3. The verb is in the wrong gender.

4. Jacob Freud is here recording a Talmudic tradition derived from Deuteronomy 10, 1-2, according to which the fragments of the first Tables of the Law broken by Moses (cf. Exodus 32) were also kept in the Ark of the Covenant (bab. Talmud Menachot 99a). The 'servant' must mean Moses rather than Jacob Freud.

5. The newly bound book."

**119**

1. In 1893 it was completed by the essay *An Account of the Cerebral Diplegias of Childhood (in Connection with Little's Disease)*, Neue Folge, III, *Beiträge zur Kinderheilkunde*, ed. Max Kassowitz. *Cf.* also "Über familiäre Formen von cerebralen Diplegien," *Neurologisches Centralblatt*, **12**, nos. 15 and 16 (1893), and the great work already mentioned, *Infantile Cerebral Paralysis (see* Note 74). By

virtue of these works on the neurology of childhood, Freud is today considered as the founder of the field of neuropediatrics which is at present in process of becoming established. (We are indebted for this information to Prof. Paul Vogel, Heidelberg.)

**120**

1. This little book, in which Freud criticizes the so-called localization theory—the theory of the structure of the brain which was generally accepted at that time—and declares his support for a functional conception of brain activity, is sometimes called the first true Freudian work because of its revolutionary content and the beauty of its style.

**122**

1. *Cf.* illustration 72 and the accompanying texts.

**123**

1. *Cf.* illustration 132 and the accompanying text.

**124**

1. The epoch-making work which was later adopted as the introductory chapter to the *Studies on Hysteria* (illustration 132) appeared on January 1 and 15 in the *Neurologisches Centralblatt*, **12**, p. 4 ff, and p. 43 ff.

2. Reference to a phrase in Goethe's *Faust*, II, 1.

**127**

1. This photograph was taken by Edmund Engelman in 1938 and is one of a series recently published by him in *Berggasse 19: Sigmund Freud's Home and Offices, Vienna 1938*, c. 1976 by Basic Books Inc., Publishers, New York. We are grateful for permission to reproduce this and the illustrations 128, 129 and 325, on pages 142-144 and 284, which were also taken by Edmund Engelman.

**130**

1. Freud published "The Neuro-Psychoses of Defence" on May 15 and June 1, 1894, in the *Neurologisches Centralblatt*, **13**, p. 362 ff and p. 402 ff (the illustration shows the conclusion). Here for the first time Freud discloses, partly in an indirect form, the central theoretical concepts of his psychology (e.g., the theory of cathexis and his understanding of the importance of sexuality). Principal terms such as "defense" or "conversion" appear in print for the first

time in this article.

2. *An Account of the Cerebral Diplegias of Childhood, loc. cit.* (*see* Note 119).

**135**

1. See illustration 159 and accompanying texts.

**141**

1. They were Hermann Nothnagel (illustration 74) and Richard Freiherr von Krafft-Ebing (illustration 142). At their suggestion a Committee was formed to confirm Freud's scientific status in a detailed report drawn up by Krafft-Ebing. On June 12, 1897, the Faculty approved the application for promotion by 22 votes to 10. The decision, together with the Committee's report, was forwarded on June 25, 1897, to the Ministry, which consequently called upon the government, as the responsible fiscal authority, to give a decision on the proposal.

Translation:

"Zl. 76. 711.

To the esteemed Ministry for Education and Culture!

Gentlemen,

With reference to the documents accompanying the order of 17 July 1897, Zl: 17. 657, regarding the appointment of Dr. Sigmund Freud as Professor Extra-ordinarius, the royal and imperial government office has the honor of reporting as follows: Dr. Sigmund Freud was born in 1856 in Freiberg in Moravia, Jewish, married, and has lived with his wife Martha, born in 1861, at IX Berggasse No. 19, since 1891. He has 5 children, the eldest of whom is at present aged 10 years. He lives in apparently very good circumstances, keeps three servants and possesses a lucrative if not very extensive practice.

From a moral and civic standpoint Dr. Freud is completely unimpeachable and enjoys a good reputation.

Regarding the question of *Bedeckung* [coverage], the royal and imperial government office has the honor, if Dr. Freud's *salary* should come under consideration, to refer to the present report of 4 October 1897, Zl. 76. 171.

Vienna, 4 October 1897. pp. Wolf."

The last paragraph means, as it appears from a supplement

to this testimonial, that a *Bedeckung* for a paid professorship could not be found, that is to say that sufficient financial means were not available. For the documents relating to this procedure, *cf.* Josef and Renée Gicklhorn, *Sigmund Freuds akademische Laufbahn im Lichte der Dokumente*, Vienna and Innsbruck, 1960, but see also K. R. Eissler's critical reply, *Sigmund Freud und die Wiener Universität*, Bern and Stuttgart, 1966.

**144**

1. "Hysteria in Relation to the Sexual Emotions," *The Alienist and Neurologist*, **19**, St. Louis, 1898, p. 599 ff.

**145**

1. *Cf. The Origins of Psycho-Analysis. Letters to Wilhelm Fliess, Drafts and Notes, 1887-1902*. Trans. by Eric Mosbacher and James Strachey, London, 1954, p. 249 and p. 298.

2. Freud's letters to Fliess contain many allusions to the painful drama of this inner process. For instance, a letter of October 27, 1897 (*op. cit.* p. 225) says: "It gets hold of me and hauls me through the past in rapid associations of ideas; and my mood changes like the landscape seen by a traveller from a train [ . . . ]. Some sad secrets of life are being traced back to their first roots, the humble origins of much pride and precedence are being laid bare. I am now experiencing myself all the things that as a third party I have witnessed going on in my patients—days when I slink about depressed because I have understood nothing of the day's dreams, phantasies or mood, and other days when a flash of lightning brings coherence into the picture, and what has gone before is revealed as prep-aration for the present. I am beginning to perceive big, general framework factors (I should like to call them) which determine development, and other minor factors which fill in the picture and vary according to individual experiences."

**146**

1. Included in *The Origins of Psycho-Analysis, op cit.*, p. 104. Obviously the diagram is comprehensible only when

related to the manuscript on melancholia which contains it. This manuscript bears no date, but was probably written on January 7, 1895, after a meeting with Fliess.

**147**

1. The reference is to Freud's own dream of Irma's injection which is described in detail in *The Interpretation of Dreams (loc. cit.)*.

**149**

1. In reality the book appeared as early as the beginning of November 1899. On the epigraph (*Flectere si nequeo superos, acheronta movebo*) Freud wrote to Werner Achelis on January 30, 1927: ". . . But it means to 'stir up the underworld.' I had borrowed the quotation from Lassalle, in whose case it was probably meant personally and relating to social—not psychological—classifications. In my case it was meant merely to emphasize the most important part in the dynamics of the dream. The wish rejected by the higher mental agencies (the repressed dream wish) stirs up the mental underworld (the unconscious) in order to get a hearing." (*Letters 1873-1939, op. cit.*, p. 376)

2. *Cf.* the letter to Wilhelm Fliess of March 23, 1900, in *The Origins of Psycho-Analysis, op. cit.*, p. 313.—In the first six years about 350 copies were sold. Nevertheless Freud held firmly to his belief that this was his most important book and his most significant discovery. "The interpretation of dreams is the royal road to a knowledge of the unconscious activities of the mind." (*S. E.*, **5**, p. 608) And even in 1931 he added in a preface to the revised third English edition: "Insight such as this falls to one's lot but once in a lifetime." (*S. E.*, **4**, p. xxxii)

**150**

1. In several of Freud's own dreams recounted in *The Interpretation of Dreams*, the father and Freud's ambivalent feelings towards him play a central part. In one of these dreams Freud identifies with a patient about whom he knew "that the root of his illness had been hostile impulses against his father, dating from his childhood and involving a sexual situation. In so far,

therefore, as I was identifying myself with him, I was seeking to confess to something analogous." (*S. E.*, **5**, p. 458) During his self-analysis Freud had also discovered in his own case the problem of the Oedipus conflict, which is discussed in detail for the first time in *The Interpretation of Dreams* (in particular on p. 260 ff.). (*Cf.* the second quotation to illustration 145.)

**152**

1. The complexity of Freud's interpretation of his own dreams, in which the theme of ambition and fantasies of greatness are very much to the fore, cannot be deduced from reading these fragmentary quotations, but only from reading the whole book.

**153**

1. "For the well-being of his country he lived not long, but wholly." In a note to the 1925 edition (*The Interpretation of Dreams, S. E.*, **5**, p. 423), Freud added: "The actual wording of the inscription is:
    Saluti *publicae* vixit
    Non diu sed totus.
The reason for my mistake in putting 'patriae' for 'publicae' has probably been rightly guessed by Wittels."
Fritz Wittels writes in his book *Sigmund Freud, His Personality, his Teaching, and his School* (trans. by Eden and Cedar Paul, Dodd, Mead & Company, London, 1924, p. 100): "For the sake of those of my readers whose Latinity is not of the best, I had better explain that 'publica' may signify 'publica puella,' a prostitute. One of the German terms for prostitute is 'Freudenmädchen,' the equivalent of the French 'fille de joie,' or of the Chaucerian-English 'gay girl.' Now, as early as 1896, *Josef* Breuer had begun to dissociate himself from Freud's researches because the stress Freud laid upon the sexual life was repugnant to him. The significance of the 'accidental' misquotation begins to dawn on us. We have also to consider the slip which led Freud to write 'patriae' instead of 'publicae' in the light of the fact that, as Freud himself tells us, his book *Die Traumdeutung* was the expression of his reaction to the death of his father (pater)."

**154**

1. *Cf.* illustration 8.

**155**

1. This work, "Fragment of an Analysis of a case of Hysteria," was written in January 1901, but not published until October and November 1905, in the *Monatsschrift für Psychiatrie und Neurologie*, **18**.

**156**

1. *The Psychopathology of Everyday Life* appeared first in two parts, in July and August 1901, in the *Monatsschrift für Psychiatrie und Neurologie*, **10**; the work was published in book form for the first time in 1904 in Berlin.

2. The early example of Freud's explanation of the reasons for forgetting names, described in this letter, was in fact not used later in the book.

**159**

1. The daughters' names were: Mathilde, named after Breuer's wife (illustration 72); Sophie, named after Sophie Schwab, niece of Hammerschlag (illustration 20); Anna, named after Hammerschlag's daughter.

**162**

1. The photograph was taken in about 1900, and thus dates from the time when Freud saw the Temple for the first time. The whole height of the building has now been excavated.

2. *Cf.* texts and notes to illustrations 10 and 25.

**163**

1. Freud describes in detail the steps he took, in the letter quoted.
Translation of the left-hand column of the document:
"I appoint the *Privatdozent* Dr. Arthur Schattenfroh as Professor Extraordinarius of Hygiene at the University of Vienna, with the appropriate emoluments, to enter into effect on 1 April 1902[,] and invest the *Privatdozente* at the same University, Dr. Sigmund Freud, Dr. Julius Mannaberg and Dr. Emil Fronz, with the title of Professor Extraordinarius in the University. Budapest, 5 March 1902. Franz Josef."

**165**

1. The subtlety of the interpretation of this feeling of alienation which overcame Freud on his visit to Greece in the year 1904, again only

becomes clear by reading the whole of the letter to Romain Rolland.

**166**

1. Freud summarizes this "enlarging of the concept of sexuality" in *An Auto-biographical Study* (*S. E.*, **20**, p. 38), as follows: "That extension is of a twofold kind. In the first place sexuality is divorced from its too close connection with the genitals and is regarded as a more comprehensive bodily function, having pleasure as its goal and only secondarily coming to serve the ends of reproduction. In the second place the sexual impulses are regarded as including all of those merely affectionate and friendly impulses to which usage applies the exceedingly ambiguous word "love." I do not, however, consider that these extensions are innovations but rather restorations; they signify the removal of inexpedient limitations of the concept into which we had allowed ourselves to be led. The detaching of sexuality from the genitals has the advantage of allowing us to bring the sexual activities of children and of perverts into the same scope as those of normal adults. The sexual activities of children have hitherto been entirely neglected, and though those of perverts have been recognized, it has been with moral indignation and without understanding."

**167**

1. *Cf.* K. R. Eissler's biographical sketch, pp. 21-22 When the group became too large, it met in rooms rented by the "Doktoren Kollegium." It was later called the Vienna Psycho-Analytical Society.

2. K. R. Eissler (pp. 21-22) gives some indication of the central themes of the work of Freud's individual pupils and collaborators. Comprehensive information on their publications is given in *Index of Psychoanalytic Writings*, edited by Alexander Grinstein, New York.

**168**

1. Ludwig Jekels, "Shakespeare's Macbeth," *Imago*, **5**, 1917, p. 170 ff.

**171**

1. For Freud's 60th birthday

**173**

1. The "Psychological Wednesday Society." Rank recorded the minutes of its meetings for years.

2. *Das Inzestmotiv in Dichtung und Sage*, Leipzig and Vienna, 1912.

**174**

1. In 1914 another volume appeared, edited by Freud alone, with the altered title *Jahrbuch der Psychoanalyse*. Jung also resigned as subeditor at the same time as Bleuler. The next volume was edited by Abraham and Hitschmann.

**175**

1. In *The Freud/Jung Letters* (edited by William McGuire, trans. by Ralph Manheim and R. F. C. Hull, The Hogarth Press and Routledge & Kegan Paul; Princeton University Press, 1974) the reader can follow the history of this stressful relationship.

**177**

1. He came to Vienna as the first foreign guest in 1907.

**178**

1. From 1904 onwards Abraham had been working at Burghölzli, the Psychiatric Clinic of the University of Zürich. In 1906 he became first assistant to Eugen Bleuler (see illustration 174) and came into contact with Freud's writings. However, he saw no further chances of promotion in Zürich, and opened a practice in Berlin in 1907. The passage quoted from the letter refers to his decision to leave Switzerland.

**180**

1. *Sigmund Freud, Life and Work*, 3 vols., London and New York, 1953, 1955, 1957. This series of photographs of Freud's early collaborators (illustrations 167-180) chosen by Ernst Freud, cannot of course be complete. In later years especially, women also played an important part, including, besides Anna Freud, Ruth Mack-Brunswick (1897-1946), Helene Deutsch (b. 1884) and Jeanne Lampl-de Groot (b. 1895).

**182**

1. The student to whom the authorization was issued was the psychoanalyst Eduard Hitschmann (illustration 171).

**183**

1. This refers to Wilhelm Fliess.

**184**

1. Preserved by Siegfried Bernfeld

**185**

1. Every April one of the family went in search of a suitable place in which to spend the summer holidays. Freud himself found Dietfeldhof.

**187**

1. Mathilde was married a year later.

**189**

1. Freud particularly enjoyed staying in the Eden Hotel; the brochure was among his papers.

**190**

1. *Delusions and Dreams in Jensen's "Gradiva"*, 1907, *S. E.*, **9**, p. 8.

**192**

1. The circle of his pupils and collaborators had commissioned the medallion from the Austrian sculptor Karl Maria Schwerdtner (1874-1916). On one side there is a picture of Oedipus standing before the Sphinx. The line from Sophocles' *Oedipus Rex* is, in translation: "Who divined the famed riddle and was a man most mighty." In his biography of Freud (*op. cit.*, **2**, p. 15) Ernest Jones says of this quotation: "At the presentation of the medallion there was a curious incident. When Freud read the inscription he became pale and agitated and in a strangled voice demanded to know who had thought of it. He behaved as if he had encountered a *revenant*, and so he had. After Federn told him it was he who had chosen the inscription Freud disclosed that as a young student at the University of Vienna he used to stroll around the great Court inspecting the busts of former famous professors of the institution. He then had the fantasy, not merely of seeing his own bust there in the future, which would not have been anything remarkable in an ambitious student, but of it actually being inscribed with the identical words he now saw on the medallion."

**194**

1. *Jahrbuch für psychoanalytische und psychopathologische Forschungen*, edited by Freud and Bleuler

**197**

1. Leipzig and Vienna, 1910; *cf.* "Five Lectures on Psycho-Analysis," *S. E.*, **11**, p. 9 ff.

**198**

1. The only honorary doctorate conferred on Freud

**199**

1. This refers once again to the *Jahrbuch für psychoanalytische und psychopathologische Forschungen*.

**200**

1. *Cf. James Jackson Putnam and Psychoanalysis*, ed. by Nathan G. Hale, Jr., Cambridge, Mass., 1971; this volume also contains the correspondence between Freud and Putnam.

**202**

1. The portrait was taken in Hamburg by the photographer Max Halberstadt, later Freud's son-in-law (*cf.* illustration 210). The portraits in illustrations 245 and 252, on pages 222 and 225, and on the jacket cover, are also by him, and all are reproduced here by kind agreement of W. E. Freud.

**203**

1. At the Congress, under pressure from the Viennese group, it was not Zürich that was decided upon as the seat of the "International Psycho-Analytical Association," but the place of residence of the President, who was each time elected for two years.

**205**

1. As President of the International Psycho-Analytical Association Translation:

ZENTRALBLATT FÜR PSYCHOANALYSE
Monthly Journal for Medical Psychology
EDITOR:
PROFESSOR Dr. SIGM. FREUD
Sub-editors
Dr. Alfred Adler, Vienna II, Praterstrasse 42
Dr. Wilhelm Stekel, Vienna I, Gonzagagasse 21
   Vienna, date of the postmark
Dear Colleagues,
   The great expansion of the psychoanalytic method and science and the ever-increasing importance of this procedure have made it urgently necessary to create a central journal in addition to Bleuler and Freud's "Jahrbuch für psychoanalytische und psychopathologischen Forschungen," sub-edited by

C. G. Jung. In autumn this year the first number of a Zentralblatt für Psychoanalyse (a monthly journal for medical psychology) will be published by J. F. Bergmann in Wiesbaden. Its editor is the founder of the science of psychoanalysis, Professor Sigmund Freud. The sub-editing is in the hands of the undersigned.

We invite you to take part in this venture as permanent collaborators. We would like short original articles, not more than one signature [16 printed pages] (at most!)— also information from your practice, single interesting observations, passages from literature, experiences of the psychopathology of everyday life, contributions to sexual pathology, references to folklore, fairy tales, sagas, myths and so on. In addition, reports of all relevant work of interest to us, and book reviews from the whole of the field under consideration.

It is only by rational division of labor that we can achieve our aim of making the Zentralblatt a quickly referred to, complete and reliable organ of the new science. We are counting on your keen cooperation, and ask you to let us know what original articles you can promise us for the near future.

We also ask you to give us continuing and regular references to some periodicals concerned with your immediate field of work and to inform us of the titles as soon as possible. The contributor's fee, both for original work and for reports and reviews, is 60 marks per signature [16 printed pages]. Independent works will be sent to you by the sub-editors. Unlike most current criticism, our reviews must present an essentially informative survey of the content of the work and its relationship to psychoanalysis.

Yours respectfully,
DR ALFRED ADLER.
DR. WILHELM STEKEL.

**207**

1. The Third International Psycho-Analytical Congress in Weimar, 1911

**208**

1. Freud was suffering at that time from intestinal trouble

which he had presumably contracted during his visit to America. In a letter to Ernest Jones dated June 25, 1911, (quoted in Jones, *Sigmund Freud, Life and Work*, 2, p. 101) he speaks of his "American colitis."

**210**

*Cf.* the text to illustration 244.

**214**

1. Adler called it "Verein für freie Psychoanalyse" (Society for Free Psycho-Analysis); in order to distinguish it from psychoanalysis he later described his doctrine as "individual psychology." The *Schriften des Vereins für freie psychoanalytische Forschung* were published by the Ernst Reinhardt Verlag, Munich. Translation:

Ernst Reinhardt, Munich, Publishers.

PAPERS OF THE SOCIETY FOR
FREE PSYCHOANALYTICAL
RESEARCH
EDITED BY DR. ALFRED ADLER
VOLUME I
Psychoanalysis and Ethics
A Preliminary Investigation
by Dr. Karl Furtmüller
48 pages Price 1 mark
To our Readers

The founding of the "Society for Free Psychoanalytical Research" was first suggested in June 1911 by certain members of Professor Sigmund Freud's "Vienna Psycho-Analytical Society," who felt that attempts were being made to commit the members of the old society to the whole of Freud's scientific doctrines and theories. Such a proceeding seemed to them not only difficult to reconcile with the basic tenets of scientific research, but especially dangerous in a science as young as psychoanalysis. In their opinion it also called in question the value of previous achievements if people were expected to commit themselves hastily to certain formulas and give up the possibility of attempting new solutions. Their conviction of the decisive importance of the psychoanalytical method of work and approach caused them to see that their scientific duty was to ensure a place for completely independent psychoanalytical research.

In October 1911 the Vienna Psycho-Analytical Society then declared it inadmissible to belong to both societies at the same time, upon which a number of members left the old society. There is thus no connection of any kind now between the "Society for Free Psychoanalytical Research" and the organizations affiliated to the "International Psycho-Analytical Association." We feel it our duty to state this explicitly here, because we would consider it an injustice if scientific critics were to place the responsibility for our work on men with whom we disagree in our conception of the fundamental conditions of free scientific work. Similarly, we should like on our side to request that we should be judged only on the basis of our own work.

The Committee of the "Society for Free Psychoanalytical Research."

**215**

1. In this letter, which was published in 1914 in the *Internationale Zeitschrift für ärztliche Psychoanalyse*, 2, No. 3, p. 297, Jung resigned from the presidency of the International Psycho-Analytical Association; personal relations with Freud had been broken off more than a year before. Translation:

The Central President of the "International Psycho-Analytical Association," Dr. C. G. Jung of Zürich, has addressed to the Presidents of the local groups the following communication dated April 20, 1914, which we bring herewith to the attention of the members of the Association:

"Dear President, I have been convinced by recent events that my views are in such sharp contrast to the ideas of the majority of members of our Association that I can no longer consider myself a suitable person to hold the office of President. I therefore beg to submit my resignation to the Obmännerkonferenz with cordial thanks for the confidence I have enjoyed up to the present.

Yours faithfully,
Dr. C. G. Jung.

The Trustee Meeting has agreed in writing to entrust the conduct of the Society's affairs provisionally, until the next Congress, to the Chairman of the Berlin Group, Dr. Karl Abraham (Berlin W., Rankestrasse 24).

**216**

1. *Cf.* K. R. Eissler's biographical sketch, p. 24.

**219**

1. This work had first appeared between 1912 and 1913, in several parts, in the periodical *Imago* under the title "Über einige Übereinstimmungen im Seelenleben der Wilden und der Neurotiker."

**220**

1. It hangs in the Louvre in Paris.

**221**

1. Actually earlier, in 1912.
2. The sculpture stands in S. Pietro in Vincoli, Rome.
3. "The Moses of Michelangelo" appeared in 1914, at first anonymously, signed simply "by ***" in the periodical *Imago*, **3**. It was not until 1924, when the article was included in Freud's *Gesammelte Schriften*, that he acknowledged its authorship.—Of course Freud's reasoning about the effect of the sculpture can be clearly followed only by reading the whole essay, at the beginning of which Freud describes in detail the fascination which it exerted over him: "For no piece of statuary has ever made a stronger impression on me than this. How often have I mounted the steep steps from the unlovely Corso Cavour to the lonely piazza where the deserted church stands, and have essayed to support the angry scorn of the hero's glance! Sometimes I have crept cautiously out of the half-gloom of the interior as though I myself belonged to the mob upon whom his eye is turned—the mob which can hold fast no conviction, which has neither faith nor patience, and which rejoices when it has regained its illusory idols." (*S. E.*, **13**, p. 213)

**222**

1. An allusion to Freud's work "The Theme of the Three Caskets," 1913, *S. E.*, **12**, p. 291 ff. In it, Freud first analyzes the choice of Portia's three suitors among three caskets in Shakespeare's *Merchant of Venice*. In the letter to Ferenczi quoted here he suggests that the "subjective condition" leading him to study the motif of the three caskets lay in the fact that he himself had three daughters. In *The Merchant of Venice*, as in the *Gesta Romanorum*, a collection of medieval tales which Shakespeare used as his source, it is each time the third metal, lead, which brings good fortune. In the course of his study Freud examines the motif of the choice out of three, one of his examples being *King Lear* and his three daughters: "Is not this once more the scene of a choice between three women, of whom the youngest is the best, the most excellent one?" (*loc. cit.* p. 293)

**223**

1. Letter dated February 11, 1914, in *A Psycho-Analytic Dialogue: The Letters of Sigmund Freud and Karl Abraham 1907-1926*, edited by Hilda C. Abraham and Ernst Freud, London, 1965, p. 164 f.

**224**

Translation:

*Notice*

By Imperial command, general mobilization, together with enlistment and draft of the home reserves, has been ordered.

Further details can be obtained from the mobilization information leaflets.

Official stamp Signature

**225**

1. In the first months after the outbreak of the First World War, Freud took an active, sometimes an enthusiastic interest in events (*cf.* especially Freud/Abraham, *A Psycho-Analytic Dialogue, op. cit.*). But he soon felt disillusioned and repelled by the "unleashed brutality" (letter dated September 22, 1914, *op. cit.*, p. 197).

**230**

1. Freud continued his lectures "Einführung in die Psychoanalyse" [Introductory Lectures on Psycho-Analysis] continuation: "Neurosenlehre" (Theory of Neuroses), in the following winter semester, 1916/17.

**232**

1. Sigmund Freud and Lou Andreas-Salomé, *Letters*, edited by Ernst Pfeiffer, London and New York, 1972. *Cf.* also her diary about her year of study in Vienna, *The*

*Freud Journal of Lou Andreas-Salomé*, ed. by Ernst Pfeiffer, London and New York, 1964.

**235**

1. For Schnitzler's 60th birthday.—As early as May 8, 1906, Freud had written to Schnitzler: "For many years I have been conscious of the far-reaching conformity existing between your opinion and mine on many psychological and erotic problems. [ . . . ] I have often asked myself in astonishment how you came by this or that piece of secret knowledge which I had acquired by a painstaking investigation of the subject, and I finally came to the point of envying the author whom hitherto I had admired." (*Letters 1873-1939, op. cit.* p. 261)

**238**

1. The enterprise, however, as long as it existed—that is, up to its enforced closure by the Nazis in 1938—was always in a more or less precarious financial situation. The main reason for this was the fact that for years the money from Budapest could not be transferred to Vienna; when this was finally accomplished, it had dwindled to a relatively small sum through devaluation.—On Anton von Freund, *cf.* also K. R. Eissler's remarks, p. 27.

**241**

1. Julius Wagner Ritter von Jauregg, 1857-1940, was, from 1902 onwards, Krafft-Ebing's successor at the Psychiatric Clinic of the General Hospital. It is perhaps typical of Wagner's ambivalent attitude that in the penultimate line he at first wrote "Extraordinarius." But Freud had already been appointed Professor Extraordinarius in 1902 (*cf.* illustration 163). A complete transcription of the document can be found on p. 128 of the book already mentioned, by Josef and Renée Gicklhorn, on Freud's academic career (see the end of the note on illustration 141).
Translation:
Freud has not, moreover, confined himself to the medico-psychological sphere, but has endeavored, from the starting point of his theories, to penetrate also into other spheres of the humanities,

partly in order to confirm his views, partly in order to explain phenomena in these unfamiliar spheres.

Though Freud's theories have met with violent opposition on many points, he has, on the other hand, found numerous supporters for his doctrines, and collaborators, both at home and abroad; and even if his teachings, as science progresses further, do not remain valid in their obsolete form, or have to be modified; if, in particular, the most violently opposed therapeutic trends, which Freud inaugurated on the basis of his theories, are dropped, there still appear, in the structure of his teachings, so many ingenious and valuable components, not merely hypotheses but also valuable observations and interpretations of contingencies that, even from a partly opposing standpoint, we cannot deny recognition to Freud's work.

Prof. Freud's work, as described, extends over a period of 24 years; Freud has already reached the age of 63.

It certainly cannot be considered premature, therefore, to propose that the Faculty's recognition of Freud's meritorious work should be expressed in an application to invest him with the title of Professor Ordinarius.

Prof. Wagner-Jauregg
Vienna, 6.VII.1919

**242**

1. Here Freud is making the distinction between a titular Professor Extraordinarius or Ordinarius and an actual salaried Professor Extraordinarius or Ordinarius.

**244**

1. As a result of the war there were still no train services to Germany. Freud and his family could not even travel to Hamburg for the funeral.
2. The younger, Heinerle (illustration 258), was given into the care of Freud's eldest daughter Mathilde.

**251**

1. Freud/Abraham, *A Psycho-Analytic Dialouge, op. cit.,* p. 384

**252**

1. For further details of Freud's illness, *cf.* K. R. Eissler's biographical sketch,

p. 29; also Max Schur, *Sigmund Freud: Living and Dying*, Int. Univ. Press, New York, 1972.

**258**

1. *Cf.* the texts to illustration 244.

**259**

1. After a painting by Conrad Westphal dating from 1924
2. *Internationale Zeitschrift für Psychoanalyse*, **12**, part 1, 1926; the obituary also appears in *S. E.*, **20**, p. 277. The quotation from Horace's *Odes* means: "The man of upright life unstained by guilt."
3. His fatal illness was caused by an injury from a fish bone. Abscesses formed as a result, leading ultimately to blood poisoning.

**261**

1. From 1923 to 1926, Freud had received most of his medical treatment from the internist Felix Deutsch (1884-1964). Deutsch was also a psychoanalyst and a specialist in psychosomatics.

**267**

1. This refers to the practice of the oral surgeon Prof. Pichler (illustration 260).

**270**

1. Until the end of the First World War, Freud took an active part and even gave occasional lectures in his own field at the regular meetings. Although later, first owing to pressure of work and then because of his illness, he could no longer attend the functions, he remained a member until the society was dissolved in 1938.

**273**

1. It had been founded in 1924.

**275**

1. In 1931 the "Comité permanent des lettres et des arts de la société des nations" asked the "International Institute of Intellectual Co-operation" to "arrange for exchanges of letters between representative intellectuals on subjects calculated to serve the common interests of the League of Nations and of intellectual life" (quoted in *S. E., 22*, p. 197). The correspondence was to be published periodically. At the very beginning the Institute approached Einstein who in his turn proposed Freud as a participant. At the end of July 1932 Einstein wrote to Freud

asking him, "Is there any way of delivering mankind from the menace of war?" Freud answered about a month later with a work written in letter form, "Why War?" (*S. E.*, **22**, p. 199 ff.)

**276**

1. Freud is referring here to Thomas Mann's lecture in celebration of his 80th birthday. *Cf.* note on illustration 308.
2. This refers to *Joseph in Ägypten* (Joseph in Egypt), Vienna, 1936.

**278**

1. In the letter quoted Freud comments on Stefan Zweig's biographical study on him in *Heilung durch den Geist* (Mesmer, Mary Baker Eddy, Freud), Leipzig, 1931.

**281**

1. For the relationship between Freud and Arnold Zweig, *cf.* their *Letters*, edited by Ernst Freud, London and New York, 1970.

**283**

1. Ferenczi had not only visited the United States with Freud, but had also accompanied him on several holidays, including visits to Florence, Rome and Siciliy.
2. This visit was followed by others in 1929 and 1930.

**284**

1. Paula Fichtl is still housekeeper in Freud's house in London, 20 Maresfield Gardens (*cf.* illustrations 340 to 345), where Anna Freud and Dorothy Burlingham now live. In celebration of Paula Fichtl's 40th year of service an analyst telegraphed to her from New York: "You have done more for analysis than most analysts."

**286**

1. The many levels at which Freud interprets Napoleon's Joseph fantasy can again be appreciated only by reading the whole letter to Thomas Mann.—The David painting hangs in the Louvre.

**287**

1. In Westminster Abbey, London. The monument by Maximilian Colt was erected in 1606.
2. Shakespeare was probably the author, next to Goethe, whom Freud rated most highly. He discussed his works over and over again, knew them thoroughly and quoted them many times. He was also

passionately interested for many decades in the controversy about Shakespeare's identity.

**289**

1. "Address delivered at the Goethe House at Frankfurt," *S. E.*, **21**, p. 208 ff.

2. The writer Alfons Paquet, 1881-1944, was a member of the board of trustees responsible for the award, and had strongly recommended that the Goethe Prize should be given to Freud.

Translation:

The

GOETHE PRIZE

endowed by the

CITY OF FRANKFURT

is awarded this year to the scholar recognized as the creator of fundamentally new perspectives

SIGMUND FREUD

of VIENNA

By strictly scientific methods, and at the same time boldly interpreting the parables coined by poets, Sigmund Freud has beaten a path to the driving forces of the mind, and thus created the possibility of recognizing the origin and structure of the forms of civilization and of curing many of their diseases. Psycho-analysis has revolutionized and enriched not only medical science, but also the inner world of the artist and the pastor, the historian and the educator. Sigmund Freud has gone beyond the dangers of self-dissection and beyond all the differences between intellectual trends, to lay the foundations of a new cooperation of the sciences and a better mutual understanding between nations. As the earliest beginnings of Freud's search into the mind go back to a reading of Goethe's essay "Nature," so in recent years as well, the Mephistophelian urge, encouraged by Freud's method of research, mercilessly to tear apart all veils, appears as the inseparable companion of Faust's insatiability and his reverence for the sculptural-creative forces slumbering in the unconscious. All outward marks of honor have up to now been denied to the great scholar, writer and warrior Sigmund Freud, although the revolutionary influence of his work was more in tune with the spirit of the times than that of any other living man. After carefully weighing everything for and against, the board of trustees wishes to show, with this honor, the value it sets upon Freud's ideas as a transition to a world of values cleansed of obsolete notions and strengthened anew.

THE OBERBÜRGERMEISTER, (Lord Mayor)

Frankfurt am Main, on Goethe's birthday, August 28, 1930

**291**

1. This refers to the Cottage Sanatorium in Vienna, in which Freud had been treated for acute cardiac and intestinal trouble before his journey to Berlin.

**292**

1. Romain Rolland

**293**

1. In 1931, on the insistence of his pupil and collaborator, Paul Federn, Freud had declared himself willing to sit for a bust to be made by the Yugoslavian sculptor Oscar Némon (born 1906). Later a statue too was made.—The photograph was taken in the garden of 6 Khevenhüller-strasse, in Pötzleinsdorf, a suburb of Vienna. The Freud family spent the summers of 1931 and 1932 here.

**294**

1. The plaque was by the Czech sculptor Franz Juran; the inscription reads in translation: "On May 6, 1856, Prof. Sigmund Freud, the world-famous psychoanalyst, was born in this house. Příbor 1931." After the German occupation the plaque was removed, and later replaced by another. Freud himself could not take part in the festivities in 1931. Anna and Martin Freud were there, also Freud's brother Alexander and many pupils and collaborators.

**296**

1. From the editors' preface to the number of the *Süddeutsche Monatshefte* illustrated here: ". . . even though such generalizations in psychiatry [the subject of this polemic article is the concept of the Oedipus complex], like every scientific theory carried to its logical conclusion, may lead to new discoveries, in their effect on the patients—on all mankind, in fact—they poison one of the few human relationships which mankind still holds sacred. They are in the trend of European nihilism, of the destruction of all accepted values, which we derive from Nietzsche. And here begins our fight against psychoanalysis." Among the authors mentioned on the cover, the psychiatrists Hoche, Friedländer and Aschaffen-burg had been for many years bitter opponents of psychoanalysis, who had already clamored for its boycott and denunciation in 1910. (*Cf.* Freud/Abraham, *A Psycho-Analytic Dialogue, op. cit.*, and *Freud/Jung Letters, op. cit.*)

**299**

1. *Cf.* the caption to illustration 319.

**300**

Translation:

*Appeal to the physicians of all countries*

We, the undersigned German physicians, welcome Henri Barbusse's call to fight against a new war. We physicians best know the horrors of war, because every day, even now, we see the irreparable damage that the last war has done to health.

The next war will make no distinction between the front and the rest of the country behind the lines. Poison gas, incendiary bombs and bacteria will annihilate all life. In the Great War almost 10 million men were killed on the battlefields, 17 million wounded and maimed. The standard of living of the working population has been lowered to an enormous extent by the war and the economic crisis that followed it. Mass unemployment has led to mass impoverishment. The reduction of the functions of social insurance, the means by which we fight disease, is leading to new and more serious damage to the health of individuals. Chronic malnutrition and bad housing allow the increase of mass plagues like tuberculosis. The number of nervous diseases is constantly growing, and with it the number of suicides.

Despite this progressive annihilation of civilized values by war and its aftermath, despite the horrifying scenes of the last war, not yet forgotten, forces are already at work again which see a new war as a way out of the economic crisis. The war that is raging now in the East cannot long remain localized. Soviet Russia is threatened in the first instance. An attack on this country, which wants to build its society in peace, means a new World War.

For this reason we, the undersigned, call upon the physicians of all countries to fight against war and to send representatives to the Geneva Anti-War Congress on July 28, 1932.

As guardians of the people's health we raise our voices in warning against a new international blood bath, into which nations are being systematically driven, the consequences of which are incalculable.

Sigm. Freud

**301**

1. Cantor in the synagogue

**307**

1. Among the honors paid to Freud in the last years of his life (including membership of the American Psychiatric Association and the New York Neurological Society), election to the Royal Society in 1936 was certainly the highest distinction. The intercession of this society later played a part in Freud's emigration. *Cf.* also illustration 336.

**308**

1. "Freud und die Zukunft," lecture in celebration of Freud's 80th birthday, given before the "Wiener academische Verein für medizinische Psychologie." Thomas Mann, *Gesammelte Werke*, 13 volumes, Frankfurt am Main, **9**, p. 478 ff. As Freud could not be present, Thomas Mann read the lecture again privately to him in the Berggasse a little later.

**309**

Translation:

Let Sigmund Freud's 80th birthday be a welcome opportunity for us to express, to the initiator of a new and deeper knowledge of humankind, our con-gratulations and our veneration. Important in every sphere of his work, as physician and psychologist, as philosopher and artist, this intrepid discoverer and healer has been, for two generations, a guide through hitherto uncharted regions of the

human mind. A completely independent spirit, a "man and knight with brazen glance," as Nietzsche says of Schopenhauer, a thinker and researcher who could stand alone, and yet drew many to him and with him, he went his way and forged ahead to truths which seemed dangerous because they uncovered what fear had hidden and shed light on dark places. Everywhere he exposed new problems and changed the old standards; in seeking and finding he made the scope of intellectual research many times wider, and even put his opponents in his debt by the impetus to creative thought which they gained from him. Though future years may shape and modify this or that result of his research, the questions Sigmund Freud asked mankind can never again be silenced, his discoveries cannot be denied or obscured for long. The concepts he fashions, the words he chooses for them, have already become self-evident constituents of the living language; in all fields of the humanities, in the study of literature and art, religious history and prehistory, mythology, folklore and pedagogy, and not least in poetry itself, we can discern the deep imprint of his influence, and if there ever was an unforgettable achievement of the human race, it is, we are certain, his discovery of the science of the mind.

We, who can no longer envisage our intellectual world without the bold concepts that have been Freud's life-work, are happy to know that this great untiring scholar is among us, and to see him at work with unimpaired vigor. May the man we honor, to whom we offer our gratitude, live among us for many years to come.
Thomas Mann    H. G. Wells
Romain Rolland Virginia Woolf
Jules Romains    Stefan Zweig

**311**
Translation:
*1936*
*June*
Fri 5/6   Visit to the new offices at Bergg, 7 [A flat had been rented in the house at Berggasse 7, used partly by the Internationale Psychoanalytische Verlag and partly by the Vienna

Psycho-Analytical Society for work sessions and as a library. It was the first home of their own that either the Press or the Society had had.]
Sun 14/6   Lecture by Thomas Mann at our house [*cf.* note to illustration 308]
Thurs 18/6   Minna [Bernays] 71 years old
Mon 29/6   Painter Krausz, Ella Braun
Tues 30/6   Foreign Member Royal Society [*cf.* note to illustration 307]
*July*
Sat 11/7   Agreement with Germany
Tues 14/7   Operation by Pichler
Sat 18/7   Sanatorium Operation
Sun 19/7   Back with eye bandaged
Thurs 23/7   Over the serious illness
Fri 31/7   Anna Marienbad, Congress [Anna Freud at the Congress in Marienbad on August 2]
*August*
Thurs 6/8   Anna back from Congress
Fri 14/8   Arn.[old] Zweig and H.[ermann] Struck [*cf.* illustration 227]
Tues 18/8   Moses with Arn. Zweig [Freud read to Zweig from his work on Moses.]
Thurs 20/8   Anna on Rax [Raxalpe, mountain group near Vienna. Anna Freud had come back from the Marienbad Congress with bronchitis and had gone to the Rax to recuperate.]— Plaquette by Willy Levy [Willy Levy, son of the psychoanalyst Katá Levy and the doctor Lajos Levy, had made a plaquette of Freud.]
Tues 25/8   Tandler† [Professor of Anatomy at the University of Vienna, Minister of Health in the Socialist government]— Bullitt [*cf.* illustration 330c] to Paris
Fri 28/8   Jones with family— Ernstl [son of Freud's daughter Sophie] to Russia
*Sept*
Sun 6/9   Kadimah [Jewish-Zionist association to which Freud's son Martin belonged]
Sat 12/9   Ernst and Lux [Ernst and Lucie Freud]— Wolf [Anna Freud's

Alsatian] once again
Mon 14/9   50 years married
*Oct*
Sat 17/10   Berggasse [return to the house in the Berggasse after the summer holidays]
Sun 18/10   Beer-Hofmann
Thurs 22/10   Arnold Zweig
Sat 24/10   Eitingon and date of Fliess's birthday
Tues 27/10   Nose-bleed.
Fri 30/10   New horse. [Chinese antique]
*Nov*
Sun 1/11   Meeting with Boehm [Boehm was working as an analyst in Berlin; he was a member of the Psychoanalytic Society there.]
Sun 15/11   Director v. Demel
Sat 21/11   Oliver [Oliver Freud]
Sun 22/11   †Etka Herzig [sister of Wilhelm Herzig; *cf.* illustration 317]
Thurs 26/11   Oli [Oliver] left
*December*
Thurs 3/12   Anna 41 years old.
Mon 7/12   Martin [Martin Freud] 47 years old.
Thurs 10/12   Edward VIII abdicated.
Sat 12/12   Operation by Pichler
Sun 20/12   Prof. Otto Loewi
Fri 24/12   Christmas in pain
Sun 27/12   Stefan Zweig

**312**
1. "Topsy" was Marie Bonaparte's dog; she had written a book about her: *Topsy; Chow Chow au poil d'or*, Paris, 1937. It was translated into German by Sigmund Freud and Anna Freud in 1938 while they were waiting for their exit permit.

**315**
1. *Cf.* illustrations 107, 108 and 119 with accompanying texts.

**316**
1. *Cf.* text to illustration 84.

**317**
1. *Cf.* illustration 69, also K. R. Eissler's biographical sketch, p. 34.

**318**
1. *Cf.* illustration 19.
2. It was also Ludwig Braun who made the laudatory speech in the B'nai B'rith lodge on the occasion of Freud's 70th birthday (*cf.* illustration 270 with text).

**323**
Translation:
Sun 13/3   Anschluss with Germany

Mon 14/3   Hitler in Vienna
Tues 15/3   Inspection [by the Gestapo] of printing press and house
Wed 16/3   Jones [Ernest Jones]
Thurs 17/3   Princess [Marie Bonaparte]
Tues 22/3   Anna with Gestapo

**326**
1. At that time Freud was still working intensively on his Moses book (*cf.* illustration 353).

**327**
1. A childhood expression of Sophie's, often quoted in the Freud family
2. The first London home of the Freud family. It was a furnished house with garden, which Ernst Freud had rented for his parents.

**328**
Translation:
Mon 28/3   Entry permit for England assured.—Ernstl [son of Freud's daughter Sophie] in Paris.— Emigration appears possible
*April*
Fri 1/4   Two Ernsts [Freud's son and grandson] in London
Wed 6/4   Ernst 46 years old.
Sat 9/4   Topsy's translation finished [*cf.* note to illustration 312]
Sun 10/4   Plebiscite [on the union of Austria with Germany]—
Tues 12/4   Minna [Bernays] back from Sanator[ium]
Sun 17/4   Easter Sunday 52 years in practice
Tues 19/4   Alex [Alexander Freud] 72 years old. Princess [Marie Bonaparte] left
Mon 18/4   Meal with newly-wed Radziwils [Marie Bonaparte's daughter and her bridegroom]
Tues 26/4   Attack of deafness
Fri 29/4   Princess returned.
*May*
Sun 1/5   Beer-Hofmann with Princess
Thurs 5/5   Minna left.— Negotiations with Gestapo
Fri 6/5   82 years old
Tuesday 10/5   Emigration within a fortnight?
Thurs 12/5   Received pass-ports
Sat 14/5   Martin [Freud] left
Sat 21/5   Valuation of collection [of antiques]
Tues 24/5   Mathilde and Robert [Freud's daughter and son-in-law] left.

Mon 30/5   †Emile Kassowitz [wife of Max Kassowitz, *cf.* illustration 107]

*June*

Thurs 2/6   Clearance

Sat 3/6   Departure 3:25. Orient Express—3 3/4 A.M. bridge of Kehl

Sun 4/6   Paris 10 o'clock, met by Marie, Ernst, Bullitt [*cf.* illustration 330]. Evening to London

Mon 5/6   9 in morning Dover–London. New house. Minna very ill. Columns in newspapers

Thurs 9/6   Sam [son of Freud's half-brother Emanuel] from Manchester

Fri 10/6   Visited Lün [After their arrival, Freud's chow had to spend six months in quarantine kennels in North Kensington. Freud saw her there several times.]

Sat 11/6   Visit of Jahuda [Professor of Jewish History]

Sat 18/6   Saw Minna for the first time on her birthday [Freud's sister-in-law had her sickroom on the second (British first) floor of the house. Owing to his weak condition, Freud could no longer go upstairs.]

Sun 19/6   H. G. Wells [*cf.* illustration 349]

Tues 21/6   Moses III begun again [resumption of work on the third part of the Moses book; *cf.* illustration 353].

Thurs 23/6   Princess— Cypriot head [sculpture which Marie Bonaparte had brought Freud] Visit of R. S. [Royal Society, see illustration 336]—Films [During the visit of the Secretaries photographs were taken.]

Sun 25/6   Mrs Gunn [English analyst whose husband was an Egyptologist] with Egyptian antique.

**329**

1. Dorothy Burlingham
2. Minna Bernays
3. Son Martin
4. Daughter Mathilde and husband
5. Paula Fichtl
6. Freud's chow
7. Dr. Josefine Stross, born 1901, still a colleague of Anna Freud's at the Hampstead clinic

**330**

1. These illustrations are cuttings from newspapers.
2. Marie Bonaparte (see the following illustration, 331).
3. He had travelled from

London to Paris to meet his parents.

**331**

1. "Athene" refers to a statuette from Freud's desk which Marie Bonaparte had already smuggled to Paris in order to hand it over to him there. At that time it was still uncertain whether the collection of antiques could be sent after him to London.

**334**

1. Charles Singer. Freud's reply is to be found in *Letters 1873-1939, op. cit.*, p. 448. *Cf.* illustrations 353 with accompanying texts.

**336**

1. *Cf.* illustration note to 307 and also the information in K. R. Eissler's biographical sketch, p. 35.

**338**

1. Manuscripts

**339**

1. 39 Elsworthy Road

**344**

1. Paula Fichtl's good memory enabled her to set out the various antiques on the desk in their accustomed order, so that Freud felt at home as soon as he sat down at it.

**351**

1. Freud wrote this paper in August, 1938. It appeared in

the German emigrant journal *Die Zukunft*, published in Paris and edited by Arthur Koestler (No. 7, November 25, 1938).

**352**

1. Freud had already dealt with this 12th-century statuette in his "Postscript to the Moses of Michelangelo" (*S. E.*, **13**, p. 237) and connected it with his interpretation of Michelangelo's sculpture (*cf.* illustration 221 with its accompanying texts).

**353**

1. The first two of the three essays had already appeared in 1937 in the periodical *Imago* (**23**, nos. 1 and 4). As early as the summer of 1934 Freud had written an outline of the book, still under the title *Der Mann Moses, ein historischer Roman* (The Man Moses, an Historical Novel). However, doubts about the validity of his arguments, as well as political considerations, prevented his publishing the book for a long time. It was not until after his emigration that he allowed the complete manuscript, many times revised, to be printed.

## Sources of Quotations

*A Note to the American Edition*
The publishers acknowledge gratefully permission to quote from Freud's published works and letters and from biographical sources. Deletions in the texts of quotations are indicated by three dots. Wherever, in brief quotations, strict adherence to such typographical distinctions in the originals as italicizing and paragraphing would have led to confusion, such distinctions are eliminated. Page numbers always refer to the English editions, from which the quotations were taken.

In this case we are particularly grateful to the Institute of Psycho-Analysis and The Hogarth Press Ltd., for permission to quote from *The Standard Edition of the Complete Psychological Works of Sigmund Freud*, translated and edited by James Strachey; Copyright under the Berne Convention and also © for the years 1957, 1958, 1959, 1960, 1962, 1964 by James Strachey, London: The Hogarth Press Ltd. and New York: W. W. Norton & Company, Inc. But thanks are also due to the American publishers in whose seperate American editions these quotations also appear, as listed below:
Basic Books, Inc., New York: *Collected Papers of Sigmund Freud*, edited by Ernest Jones, M.D., Volume 1, "Early Papers," "On the History of the Psycho-Analytic Movement," authorized translation under the supervision of Joan Riviere, Volume II, "Clinical Papers," "Papers on Technique," authorized translation under the supervision of Joan Riviere, Volume III, "Case Histories," authorized translation by Alix and James Strachey, Volume IV, "Papers on Metapsychology," "Papers on Applied Psycho-Analysis," authorized translation under the supervision of Joan Riviere, Volume V, "Miscellaneous Papers, 1888-1938," edited by James Strachey, all five volumes published by Basic Books, Inc., by arrangement with The Hogarth Press Ltd. and The Institute of Psycho-Analysis, London, first American edition 1959; *The Freud Journal of Lou Andreas-Salomé*, translated and with an introduction by Stanley A. Leavy, © 1964 by Basic Books, Inc., Publishers, New York; *The Interpretation of Dreams by Sigmund Freud*, translated from the German and edited by James Strachey, published in the United States by Basic Books, Inc., by arrangement with George Allen & Unwin Ltd. and The Hogarth Press, Ltd.; *Letters of Sigmund Freud*, selected and edited by Ernst L. Freud, translated by Tania and James Stern, © 1960 by Sigmund Freud Copyrights Ltd., London, Basic Books, Inc., Publishers, New York; *The Life and Work of Sigmund Freud*, Volumes I, II, III, by Ernest Jones M.D., Volume 1, "The Formative Years and the Great Discoveries, 1865-1900," © 1953 by Ernest Jones, Volume II, "Years of Maturity, 1901-1919," © 1955 by Ernest Jones, Volume III, "The Last Phase, 1919-1939," © 1957 by Ernest Jones, Basic Books, Inc., Publishers, New York; *The Origins of Psycho-Analysis: Letters to Wilhelm Fliess, Drafts and Notes; 1887-1902*, by Sigmund Freud, edited by Marie Bonaparte, Anna Freud, Ernst Kris, authorized translation by Eric Mosbacher and James Strachey, introduction by Ernest Kris, © 1954 by Basic Books, Inc., Publishers, New York; *Psychoanalysis and Faith: The Letters of Sigmund Freud and Oskar Pfister*, edited by Heinrich Meng and Ernst L. Freud, translated by Eric Mosbacher, © 1963 by Sigmund Freud Copyrights Ltd., Basic Books, Inc., Publishers, New York; *A Psycho-Analytic Dialogue: The Letters of Sigmund Freud and Karl Abraham, 1907-1926*, edited by Hilda C. Abraham and Ernst L. Freud, translated by Bernard Marsh and Hilda C. Abraham, © Hilda C. Abraham and Ernst L. Freud 1965, Basic Books, Inc., Publishers, New York; *Studies on Hysteria* by Josef Breuer and Sigmund Freud, translated from the German and edited by James Strachey in collaboration with Anna Freud, assisted by Alix Strachey and Alan Tyson, published in the United States by Basic Books, Inc., by arrangement with The Hogarth Press Ltd.; *Three Essays on the Theory of Sexuality* by Sigmund Freud, translated and newly edited by James Strachey, © 1962 Sigmund Freud Copyrights Ltd., Basic Books, Inc., Publishers, New York. Harcourt Brace Jovanovich, Inc., New York and London: Sigmund Freud and Lou Andreas-Salomé, *Letters*, Letters of Lou Andreas-Salomé copyright © 1966 by Ernst Pfeiffer, letters of Sigmund Freud copyright © 1966 by Sigmund Freud Copyrights Ltd. *The Letters of Sigmund Freud and Arnold Zweig*, copyright © by Sigmund Freud Copyrights Ltd. and the Executors of the Estate of Arnold Zweig. W. W. Norton & Company, Inc., New York: Sigmund Freud, *An Autobiographical Study; Beyond the Pleasure Principle; Civilization and Its Discontents; The Ego and the Id; The Future of an Illusion; Group Psychology and the Analysis of the Ego; Introductory Lectures on Psycho-Analysis; Leonardo da Vinci and a Memory of His Childhood; The Psychopathology of Everyday Life; The Question of Lay Analysis; Totem and Taboo*. Princeton University Press, Princeton, New Jersey: *The Freud/Jung Letters: The Correspondence between Sigmund Freud and C. G. Jung*, ed. William McGuire; trans. Ralph Manheim and R. F. C. Hull, Bollingen Series XCIV, © 1974 by Sigmund Freud Copyrights Ltd. and by Erbengemeinschaft Prof. C. G. Jung.

## Sources of Quotations

*A Note to the British Edition*
The publishers acknowledge gratefully permission to quote from Freud's published works and letters and from biographical sources, as listed below. Deletions in the texts of quotations are indicated by three dots. Wherever, in brief quotations, strict adherence to such typographical distinctions in the originals as italicizing and paragraphing would have led to confusion, such distinctions are eliminated.

The Institute of Psycho-Analysis and The Hogarth Press Ltd., for permission to quote from *The Standard Edition of The Complete Psychological Works of Sigmund Freud*, translated and edited by James Strachey; *Psycho-Analysis and Faith: The Letters of Sigmund Freud and Oskar Pfister; A Psycho-Analytic Dialogue: The Letters of Sigmund Freud and Karl Abraham; Sigmund Freud and Lou Andreas-Salomé: Letters; The Letters of Sigmund Freud and Arnold Zweig;* and *Studies on Hysteria* by Joseph Breuer and Sigmund Freud; The Hogarth Press Ltd., for permission to quote from *Letters of Sigmund Freud, 1873-1939*, edited by Ernst L. Freud; *The Origins of Psycho-Analysis; Sigmund Freud, Life and Work*, by Ernest Jones; *Downhill All the Way*, by Leonard Woolf; The Hogarth Press Ltd., and Routledge & Kegan Paul Ltd., for permission to quote from *The Freud/Jung Letters*; Routledge & Kegan Paul Ltd., for permission to quote from *Leonardo da Vinci and a Memory of his Childhood*; and *Totem and Taboo*; George Allen & Unwin Ltd., for permission to quote from *Delusions and Dreams in Jensen's "Gradiva"; The Interpretation of Dreams*; and *Introductory Lectures on Psycho-Analysis*; Ernest Benn Ltd., for permission to quote from *The Psychopathology of Everyday Life*.

**1**
*An Autobiographical Study,* 1925, S. E.,** **20**, p. 8.

**2**
1. Quotation: *Letters of Sigmund Freud 1873-1939,* edited by Ernst Freud, The Hogarth Press, London; Basic Books, New York, 1960, p. 406 f.
2. Quotation: *Screen Memories,* 1899, S. E., **3**, p. 312 f. In his work "An Unknown Autobiographical Fragment by Freud" (*American Imago,* **4**, 1946, p. 3 ff.) Siegfried Bernfeld has proven that this work is a disguised autobiography.

**3**
*The Interpretation of Dreams,* 1900, S. E., **4**, p. 192.

**6**
*The Origins of Psycho-Analysis; Letters to Wilhelm Fliess, Drafts and Notes: 1887-1902,* edited by Maria Bonaparte, Anna Freud, Ernst Kris, Imago Publishing Company, London, 1954, p. 221.

**8**
*An Autobiographical Study, op. cit.,* p. 8.

**9**
1. Quotation: *Screen Memories, op. cit.,* p. 312.
2. Quotation: *The Origins of Psycho-Analysis, op. cit.,* p. 298.

*Authors' names are only indicated in connection with quotations which do not, or not exclusively, come from works by Freud.
**S. E. = Standard Edition, 24 Vols., edited by James Strachey, published since 1953 by The Hogarth Press, London. Am. Ed. W. W. Norton, New York.
***First published in the German original, *Sigmund Freud, Sein Leben in Bildern und Texten,* edited by Ernst Freud, Lucie Freud, Ilse Grubrich-Simitis, Suhrkamp Verlag, Frankfurt am Main, 1976.
****The second, enlarged German edition of *Briefe 1873-1939,* edited by Ernst and Lucie Freud, S. Fischer Verlag, Frankfurt am Main, 1968, contains several letters which are not at present available in the English edition. These additional letters have therefore been translated where necessary.

**10**
*The Interpretation of Dreams, op. cit.,* p. 197.

**11**
*Ibid.* p. 205.

**14**
1. Quotation: translated from "Curriculum vitae," 1885, in *Selbstdarstellung; Schriften zur Geschichte der Psychoanalyse,* edited by Ilse Grubrich-Simitis, Fischer Taschenbuch Verlag, Frankfurt am Main, p. 125.
2. Quotation: "Some Reflections on Schoolboy Psychology," 1914, S. E., **13**, p. 241 f.

**15**
1. Quotation: *An Autobiographical Study, op. cit.,* p. 8.
2. Quotation: *Letters of Sigmund Freud, 1873-1939, op. cit.,* p. 215.

**17**
*The Interpretation of Dreams, op. cit.,* p. 423 f.

**18**
"Some Reflections on Schoolboy Psychology," *op. cit.,* p. 242, p. 244.

**19**
*Letters of Sigmund Freud, 1873-1939, op. cit.,* p. 379 f.

**20**
*Ibid,* p. 101 f.

**21**
*Ibid.,* p. 112.

**22**
*The Interpretation of Dreams, op. cit.,* p.192 f.

**23**
*Ibid.,* p.193.

**24**
"A Childhood Recollection from *Dichtung und Wahrheit,*" 1917, S. E., **14**, p. 156.

**25**
*The Interpretation of Dreams, op. cit.,* p.196 ff.

**26**
*Ibid.,* p. 447 f.

**27**
First published in the German edition of this work, p.73.***

**28**
1. Quotation: *International Journal of Psycho-Analysis,* 1969, **50**, p. 423.
2. Quotation: *The Interpretation of Dreams, op. cit.,* p. 262.

**29**
*Letters of Sigmund Freud, 1873-1939, op. cit.,* p. 21 f.

**32**
*Ibid.,* p. 22.

**33**
*An Autobiographical Study, op. cit.,* p. 8.

**34**
*Ibid.,* p. 9.

**37**
Translated from: "Curriculum vitae," *op. cit.,* p. 125.

**39**
*Abstracts of the Scientific writings of Dr. Sigm. Freud, 1877-1897,* 1897, S. E., **3**, p. 227.

**41**
Translated from: "Curriculum vitae," *op. cit.,* p. 125.

**42**
*The Interpretation of Dreams, op. cit.,* p. 212 f.

**44**
*Letters of Sigmund Freud, 1873-1939, op. cit.,* p. 310.

**45**
*Ibid.,* p. 90.

**47**
First published in the German edition of this work,*** p. 86, apart from "the man is one of my idols," published in Ernest Jones, *Sigmund Freud, Life and Work,* The Hogarth Press, London, 1972, **1**, p. 45.

**48**
*An Autobiographical Study, op. cit.,* p. 9 f.

**49**
*The Interpretation of Dreams, op. cit.,* p. 422.

**50**
1. Quotation: *Letters of Sigmund Freud, 1873-1939, op. cit.,* p. 29.
2. Quotation: Ernest Jones: *Sigmund Freud, Life and Work, op. cit.,* **1**, p. 99.

**51**
1. Quotation: *An Autobiographical Study, op. cit.,* p. 10.
2. Quotation: *The Interpretation of Dreams, op. cit.,* p. 172.

**52**
*Ibid.,* p. 450.

**54**
*An Autobiographical Study, op. cit.,* p. 10.

**55**
1. Quotation: First published in the German edition of this work,*** p. 93.
2. Quotation: *Letters of Sigmund Freud, 1873-1939, op. cit.,* p. 25.

**56**
1. Quotation: *Ibid.,* p. 27.
2. Quotation: Ernest Jones: *Sigmund Freud, Life and Work, op. cit.,* **1**, p. 125.

**57**
*Letters of Sigmund Freud, 1873-1939, op. cit.,* p. 128.

**58**
First published in the German edition of this work,*** p. 95.

**59**
*Letters of Sigmund Freud, 1873-1939, op. cit.,* p. 109.

**60**
First published in the German edition of this work,*** p. 96.

**61**
First published in the German edition of this work,*** p. 96.

**62**
*Letters of Sigmund Freud, 1873-1939, op. cit.,* p. 37. p. 38.

**63**
*Ibid.,* p. 53.

**64**
1. Quotation: First published in the German edition of this work,*** p. 99.
2. Quotation: First published in the German edition of this work,*** p. 99.

**65**
First published in the German edition of this work,*** p. 99.

**66**
*Letters of Sigmund Freud, 1873-1939, op. cit.,* p. 96.

**67**
*Ibid.,* p. 96 f.

**68**
*Ibid.,* p. 97 f.

**69**
*Letters of Sigmund Freud, 1873-1939, op. cit.,* p. 60 f.

**70**
Ernest Jones: *Sigmund Freud, Life and Work, op. cit.,* **1**, p. 191 f.

**71**
First published in the German edition of this work,*** p. 102.

**72**
First published in the German edition of this work,*** p.102.

**73**
1. Quotation: *An Autobiographical Study, op. cit.,* p. 10 f.
2. Quotation: First published in the German edition of this work, *op. cit.,* p. 103.

**74**
*Letters of Sigmund Freud, 1873-1939, op. cit.,* p. 48 f.

**75**
*Ibid.,* p. 114.

**76**
*Ibid.,* p. 82.

**77**
*Ibid.,* p. 73 f.

**78**
*Abstracts of the Scientific Writings of Dr. Sigm. Freud 1877-1897,* 1897, *op, cit.,* p. 231.

**79**
*Letters of Sigmund Freud, 1873-1939, op. cit.,* p. 118.

**81**
*An Autobiographical Study, op. cit.,* p. 12.

**82**
*Letters of Sigmund Freud,*
*1873-1939, op. cit.,* p. 211.
**83**
*The Interpretation of Dreams,*
*op. cit.,* p. 111.
**84**
*An Autobiographical Study, op.*
*cit.,* p. 14 f.
**86**
"On Coca," 1884, in *Cocaine*
*Papers,* edited by Robert Byck,
Stonehill, New York, 1974,
p. 58, p. 60.
**87**
*Letters of Sigmund Freud,*
*1873-1939, op. cit.,*
p. 161 f.
**88**
*Ibid.,* p. 166.
**89**
*Ibid.,* p. 170.
**90**
1. Quotation: Translated
from *Briefe 1873-1939,* edited
by Ernst and Lucie Freud, S.
Fischer Verlag, Frankfurt am
Main, 1968,**** p. 228.
2. Quotation: *Letters of*
*Sigmund Freud, 1873-1939, op.*
*cit.,* p. 196.
**91**
"Report on my Studies in Paris
and Berlin," 1956 (1886), *S. E.,*
**1**, p. 9.
**93**
1. Quotation: *Letters of*
*Sigmund Freud, 1873-1939, op.*
*cit.,* p. 187.
2. Quotation: "Charcot,"
1893, Obituary, *S. E.,* **3**,
p. 12.
**94**
"Report on my Studies in Paris
and Berlin," *op. cit.,* p. 14.
**96**
*Letters of Sigmund Freud,*
*1873-1939, op. cit.,*
p. 208 f.
**97**
First published in the German
edition of this work,***
p. 120.
**98**
*Letters of Sigmund Freud,*
*1873–1939, op. cit.,* p. 194.
**99**
*Ibid.,* p. 199 f.
**100**
*Ibid.,* p. 185.
**101**
*Ibid.,* p. 190 f.
**102**
*Ibid.,* p. 198.
**103**
*Ibid.,* p. 203.
**104**
*Ibid.,* p. 224.
**105**
*An Autobiographical Study, op.*
*cit.,* p. 15 f.

**107**
First published in the German
edition of this work,*** p. 126.
**108**
*Letters of Sigmund Freud,*
*1873-1939, op. cit.,* p. 222.
**109**
Translated from *Briefe 1873-*
*1939,**** op. cit.,* p. 228.
**110**
*Letters of Sigmund Freud,*
*1873-1939, op. cit.,* p. 214.
**111**
*Ibid.,* p. 231 f.
**112**
*Ibid.,* p. 214.
**113**
First published in the German
edition of this work,*** p. 131.
**114**
Translated from *Briefe 1873-*
*1939,**** op. cit.,* p. 228.
**115**
*The Origins of Psycho-*
*Analysis, op. cit.,* p. 56.
**116**
*An Autobiographical Study, op.*
*cit.,* p. 17.
**118**
*The Origins of Psycho-*
*Analysis, op. cit.,* p. 119.
**119**
*An Autobiographical Study, op.*
*cit.,* p. 18.
**120**
*The Origins of Psycho-*
*Analysis, op. cit.,* p. 61.
**121**
*Letters of Sigmund Freud,*
*1873-1939, op. cit.,* p. 239.
**122**
*An Autobiographical Study, op.*
*cit.,* p. 19.
**123**
1. Quotation: *Ibid.,* p. 19 f.
2. Quotation: Joseph Breuer
and Sigmund Freud, *Studies on*
*Hysteria,* 1895, *S. E.,* **2**, p. 30.
**124**
1. Quotation: *Abstracts of the*
*Scientific Writings of Dr. Sigm.*
*Freud 1877-1897, op. cit.,*
p. 244.
2. Quotation: *Letters of*
*Sigmund Freud, 1873-1939, op.*
*cit.,* p. 408 f.
**128**
*The Interpretation of Dreams,*
*op. cit.,* p. 238.
**129**
"On Beginning the
Treatment," 1913, *S. E.,* **12**,
p. 133 ff.
**130**
*The Origins of Psycho-*
*Analysis, op. cit.,* p. 83 f.
**131**
*Ibid.,* p. 81.
**132**
*An Autobiographical Study, op.*
*cit.,* p. 21 f.

**133**
*The Origins of Psycho-*
*Analysis, op. cit.,* p. 157.
**134**
First published in the German
edition of this work,*** p. 148.
**135**
*The Origins of Psycho-*
*Analysis, op. cit.,* p. 168.
**136**
"A Disturbance of Memory on
the Acropolis, 1936, *S. E.,* **22**,
p. 239 f.
**139**
1. Quotation: *The Origins of*
*Psycho-Analysis, op. cit.,*
p. 264
2. Quotation: *Ibid.,*
p. 329.
**140**
*Ibid.,* p. 133.
**141**
*The Interpretation of Dreams,*
*op. cit.,* p. 136 f.
**142**
Translated from Josef and
Renée Gicklhorn, *Sigmund*
*Freuds akademische Laufbahn*
*im Lichte der Dokumente,*
Urban & Schwarzenberg,
Wien-Innsbruck, 1960,
p. 96 f.
**143**
1. Quotation: *An Auto-*
*biographical Study, op. cit.,*
p. 33 f.
2. Quotation: *The Origins of*
*Psycho-Analysis, op. cit.,*
p. 215, p. 217 f.
**144**
*Ibid.,* p. 271 f.
**145**
1. Quotation: *ibid.,* p. 161 f.
2. Quotation: *ibid.,* p. 221,
p. 223.
**146**
*Ibid.,* p. 129.
**147**
*Ibid.,* p. 321 f.
**148**
*Ibid.,* p. 292.
**149**
1. Quotation: *The Inter-*
*pretation of Dreams, op. cit.,*
p. 100 f.
2. Quotation: *An Auto-*
*biographical Study, op. cit.,*
p. 47.
3. Quotation: *The Origins of*
*Psycho-Analysis, op. cit.,*
p. 313.
**150**
1. Quotation: *ibid.,* p. 170.
2. Quotation: *The Inter-*
*pretation of Dreams, op. cit.,*
p. xxvi.
**152**
1. Quotation: *ibid.,* p. xxiii f.
2. Quotation: *ibid.,* p. 469.
**153**
*Ibid.,* p. 422 f.

**154**
*Ibid.,* p. 583.
**155**
1. Quotation: *The Origins of*
*Psycho-Analysis, op. cit.,*
p. 326.
2. Quotation: "Fragment of
an Analysis of a Case of
Hysteria," 1905 (1901), *S. E.,* **7**, p. 9.
**156**
*The Origins of Psycho-*
*Analysis, op. cit.,* p. 261 f.
**157**
*Ibid.,* p. 334.
**158**
*The Interpretation of Dreams,*
*op. cit.,* p. 301.
**159**
*Ibid.,* p. 487.
**160**
*The Origins of Psycho-*
*Analysis, op. cit.,* p. 333.
**161**
*Moses and Monotheism: Three*
*Essays,* 1939, *S. E.,* **23**, p. 46,
footnote.
**162**
1. Quotation: *The Origins of*
*Psycho-Analysis, op. cit.,*
p. 335.
2. Quotation: *ibid.,* p. 236.
**163**
*Ibid.,* p. 342.
**164**
*Ibid.,* p. 344.
**165**
"A Disturbance of Memory on
the Acropolis," *op. cit.,* p. 240
f, p. 247.
**166**
1. Quotation: *Three Essays on*
*the Theory of Sexuality,* 1920,
*S. E.,* **7**, p. 133 f.
2. Quotation: *An*
*Autobiographical Study, op.*
*cit.,* p. 37.
**167**
The quotations placed before
the group of collaborators and
pupils:
1. Quotation: *Letters of*
*Sigmund Freud, 1873-1939, op.*
*cit.,* p. 359.
2. Quotation: *The Freud/Jung*
*Letters,* edited by William
McGuire, Princeton University
Press, Princeton, New Jersey;
The Hogarth Press and
Routledge & Kegan Paul,
London, 1974, p. 141.
1. Quotation: *Letters of*
*Sigmund Freud, 1873-1939, op.*
*cit.,* p. 352.
2. First published in the
German edition of this
work,*** p. 174.
**168**
1. Quotation: "Some
Character Types met with in
Psycho-Analytic Work," 1916,
*S. E.,* **14**, p. 33.

2. Quotation: "On the History of the Psycho-Analytic Movement," 1914, *S. E.*, **14**, p. 33.

**169**
Federn had applied for a lectureship. The quotation is an extract from Freud's letter of recommendation. First published in the German edition of this work,*** p. 174.

**170**
Freud/Pfister: *Psycho-Analysis and Faith: The Letters of Sigmund Freud and Oskar Pfister*, edited by Heinrich Meng and Ernst L. Freud, The Hogarth Press and the Institute of Psycho-Analysis, London, 1963, p. 47 f.

**171**
*Letters of Sigmund Freud, 1873-1939, op. cit.*, p. 318.

**172**
1. Quotation: *Introductory Lectures on Psycho-Analysis*, 1916-1917 (1915-1917), *S. E.*, **15**, p. 167 f.
2. Quotation: Preface to Reik's *Ritual: Psycho-Analytic Studies*, 1919, *S. E.*, **17**, p. 261.

**173**
1. Quotation: "On the History of the Psycho-Analytic Movement," *op. cit.*, p. 25.
2. Quotation: Preface to Reik's *Ritual: Psycho-Analytic Studies*, *op. cit.*, p. 261.

**174**
"On the History of the Psycho-Analytic Movement," *op. cit.*, p. 26.

**175**
1. Quotation: *The Freud/Jung Letters*, *op. cit.*, p. 196 f.
2. Quotation: "On the History of the Psycho-Analytic Movement," *op. cit.*, p. 66.

**176**
Freud/Pfister: *Psycho-Analysis and Faith*, *op. cit.*, p. 17.

**177**
1. Quotation: *Letters of Sigmund Freud, 1873-1939, op. cit.*, p. 306.
2. Quotation: *ibid.*, p. 431.

**178**
1. Quotation: Freud/Abraham: *A Psycho-Analytic Dialogue: The Letters of Sigmund Freud and Karl Abraham 1907-1926*, edited by Hilda C. Abraham and Ernst L. Freud, The Hogarth Press and the Institute of Psycho-Analysis, London, 1965; Basic Books, New York, p. 9.
2. Quotation: *ibid.*, p. 111.

**179**
1. Quotation: "On the History of the Psycho-Analytic

Movement," *op. cit.*, p. 33.
2. Quotation: *Letters of Sigmund Freud, 1873-1939, op. cit.*, p. 329 f.

**180**
*Letters of Sigmund Freud, 1873-1939, ibid.*, p. 385.

**181**
*The Freud/Jung Letters, op. cit.*, p. 88.

**182**
*Introductory Lectures on Psycho-Analysis, op. cit.*, p. 19 ff.

**183**
1. Quotation: *The Origins of Psycho-Analysis, op. cit.*, p. 211.
2. Quotation: *An Autobiographical Study, op. cit.*, p. 65 f.

**185**
*Letters of Sigmund Freud, 1873-1939, op. cit.*, p. 283 f.

**187**
*Ibid.*, p. 281.

**188**
*Ibid.*, p. 276.

**189**
*Ibid.*, p. 402.

**190**
1. Quotation: *ibid.*, p. 276.
2. Quotation: *Delusions and Dreams in Jensen's "Gradiva,"* 1907 (1906), *S. E.*, **9**, p. 10.

**191**
*Letters of Sigmund Freud, 1873-1939, op. cit.*, p. 269.

**192**
*The Freud/Jung Letters, op. cit.*, p. 88.

**193**
*Ibid.*, p. 82.

**194**
*An Autobiographical Study, op. cit.*, p. 48.

**195**
*The Freud/Jung Letters, op. cit.*, p. 131.

**196**
Freud/Abraham: *A Psycho-Analytical Dialogue, op cit.*, p. 33.

**197**
"On the History of the Psycho-Analytic Movement," *op. cit.*, p. 30 f.

**198**
1. Quotation: *ibid.*, p. 31.
2. Quotation: *An Autobiographical Study, op. cit.*, p. 52.

**199**
Freud/Pfister: *Psycho-Analysis and Faith, op. cit.*, p. 29 f.

**200**
"On the History of the Psycho-Analytic Movement," *op. cit.*, p. 31 f.

**201**
*Ibid.*, p. 32.

**202**
*Letters of Sigmund Freud, 1873-1939, op. cit.*, p. 314.

**203**
"On the History of the Psycho-Analytic Movement," p. 42 ff.

**204**
*Ibid.*, p. 44.

**205**
*Ibid.*, p. 44 f.

**206**
Translated from the German edition of this work,*** p. 192.

**207**
Freud/Abraham: *A Psycho-Analytic Dialogue, op. cit.*, p. 107.

**208**
First published in the German edition of this work,*** p. 193.

**209**
Freud/Andreas-Salomé: *Letters*, edited by Ernst Pfeiffer, The Hogarth Press and the Institute of Psycho-Analysis, London, 1972; Harcourt Brace Jovanovich, New York, p. 230 in the notes.

**210**
*Letters of Sigmund Freud, 1873-1939, op. cit.*, p. 296.

**212**
Freud/Abraham: *A Psycho-Analytic Dialogue, op. cit.*, p. 109 f.

**213**
*The Freud/Jung Letters, op. cit.*, p. 12.

**214**
"On the History of the Psycho-Analytic Movement," *op. cit.*, p. 51 f.

**216**
1. Quotation: First published in the German edition of this work,*** p. 200, apart from the last sentence which is published in Ernest Jones: *Sigmund Freud, Life and Work, op. cit.*, **2**, p. 174.
2. Quotation: *Letters of Sigmund Freud, 1873-1939, op. cit.*, p. 383.

**217**
Freud/Andreas-Salomé: *Letters, op. cit.*, p. 33.

**218**
Freud/Abraham: *A Psycho-Analytic Dialogue, op. cit.*, p. 170.

**219**
*Totem and Taboo*, 1912-1913, *S. E.*, **13**, p. xiii f.

**220**
*Leonardo da Vinci and a Memory of his Childhood*, 1910, *S. E.*, **11**, p. 113.

**221**
1. Quotation: *Letters of Sigmund Freud, 1873-1939, op. cit.*, p. 412.

**202**
2. Quotation: "The Moses of Michelangelo," 1914, *S. E.*, **13**, p. 229, p. 233.
3. Quotation: *ibid.*, p. 228.

**222**
*Letters of Sigmund Freud, 1873-1939, op. cit.*, p. 307.

**223**
First published in the German edition of this work,*** p. 207, apart from the last two sentences which are published in Ernest Jones: *Sigmund Freud, Life and Work, op. cit.*, **2**, p. 118.

**224**
Freud/Andreas-Salomé: *Letters, op. cit.*, p. 21.

**225**
1. Quotation: Freud/Abraham: *A Psycho-Analytic Dialogue, op. cit.*, p. 186.
2. Quotation: *ibid.*, p. 187.

**227**
*Letters of Sigmund Freud, 1873-1939, op. cit.*, p. 312.

**228**
First published in the German edition of this work,*** p. 211.

**229**
Freud/Abraham: *A Psycho-Analytic Dialogue, op. cit.*, p. 225.

**231**
1. Quotation: *Letters of Sigmund Freud, 1873-1939, op. cit.*, p. 321.
2. Quotation: "My Contact with Joseph Popper-Lynkeus," 1932, *S. E.*, **22**, p. 224.

**232**
Freud/Andreas-Salomé: *Letters, op. cit.*, p. 45.

**233**
1. Quotation: First published in the German edition of this work,*** p. 215.
2. Quotation: Freud/Andreas-Salomé: *Letters, op. cit.*, p. 51.

**234**
First published in the German edition of this work,*** p. 215.

**235**
*Letters of Sigmund Freud, 1873-1939, op. cit.*, p. 344 f.

**236**
First published in the German edition of this work,*** p. 216.

**238**
Freud/Abraham: *A Psycho-Analytic Dialogue, op. cit.*, p. 278

**240**
1. Quotation: Translated from Ludwig Binswanger, *Erinnerungen an Sigmund Freud*, Francke Verlag, Bern, 1956, p. 103.
2. Quotation: *Letters of Sigmund Freud, 1873-1939, op. cit.*, p. 427.

242
Freud/Pfister: *Psycho-Analysis and Faith*, op. cit., p. 95.
243
Freud/Abraham: *A Psycho-Analytic Dialogue*, op. cit., p. 291.
244
Translated from *Briefe 1873-1939*,\*\*\*\* op. cit., p. 343.
245
Ernest Jones: *Sigmund Freud, Life and Work*, op. cit., **3**, p. 88.
246
1. Quotation: Freud/Andreas-Salomé: *Letters*, op. cit., p. 99.
2. Quotation: *Beyond the Pleasure Principle*, 1920, S. E., **18**, p. 49.
247
*An Autobiographical Study*, op. cit., p. 54.
249
*Group Psychology and the Analysis of the Ego*, 1921, S. E., **18**, p. 70.
250
*The Ego and the Id*, 1923, S. E., **19**, p. 55 f.
251
First published in the German edition of this work,\*\*\* p. 224.
252
*Letters of Sigmund Freud, 1873-1939*, op. cit., p. 348 f.
253
First published in the German edition of this work,\*\*\* p. 226.
258
*Letters of Sigmund Freud, 1873-1939*, op. cit., p. 349.
259
*Ibid.*, p. 364.
260
Freud/Andreas-Salomé: *Letters*, op. cit., p. 124.
261
*Letters of Sigmund Freud, 1873-1939*, op. cit., p. 396.
262
*Ibid.*, p. 391.
263
1. Quotation: *The Psychopathology of Everyday Life*, S. E., **6**, p. 110.
2. Quotation: *Letters of Sigmund Freud, 1873-1939*, op. cit., p. 402.
264
First published in the German edition of this work,\*\*\* p. 234.
265
*The Interpretation of Dreams*, op. cit., p. 172 ff.
266
Freud/Andreas-Salomé: *Letters*, op. cit., p. 154.
267
Freud/Abraham: *A Psycho-Analytic Dialogue*, op. cit., p. 363 ff.

269
Freud/Pfister: *Psycho-Analysis and Faith*, op. cit., p. 102.
270
"Address to the Society of B'nai B'rith," 1941 (1926), S. E., **20**, p. 273 ff.
271
*Ibid.*
272
*The Question of Lay Analysis*, 1926, S. E., **20**, p. 246.
273
1. Quotation: *ibid.*, p. 228.
2. Quotation: "Psycho-Analysis," 1926, article in the *Encyclopaedia Britannica*, S. E., **20**, p. 265.
275
1. Quotation: First published in the German edition of this work,\*\*\* p. 242.
2. Quotation: First published in the German edition of this work,\*\*\* p. 242.
276
1. Quotation: *Letters of Sigmund Freud, 1873-1939*, op. cit., p. 422.
2. Quotation: *ibid.*, p. 428.
277
First published in the German edition of this work,\*\*\* p. 243.
278
*Letters of Sigmund Freud, 1873-1939*, op. cit., p. 401 ff.
279
*Ibid.*, p. 365.
280
Translated from *Briefe 1873-1939*,\*\*\*\* op. cit., p. 399.
281
Freud/Zweig: *The Letters of Sigmund Freud and Arnold Zweig*, edited by Ernst L. Freud, The Hogarth Press and the Institute of Psycho-Analysis, London, 1970, p. 127; Harcourt, Brace & World, New York, 1970.
282
*Letters of Sigmund Freud, 1873-1939*, op. cit., p. 432.
283
*Ibid.*, p. 382.
285
1. Quotation: *ibid.*, p. 338 ff.
2. Quotation: "Dostoevsky and Parricide," 1928 (1927), S. E., **21**, p. 188.
286
*Letters of Sigmund Freud, 1873-1939*, op. cit., p. 428 ff.
287
Translated from *Briefe 1873-1939*,\*\*\*\* op. cit., p. 400.
289
1. Quotation: Postscript to *An Autobiographical Study*, op. cit., p. 73.
2. Quotation: *Letters of*

*Sigmund Freud, 1873-1939*, op. cit., p. 397.
290
*Civilization and its Discontents*, 1930 (1929), S. E., **21**, p. 145.
291
Freud/Andreas-Salomé: *Letters*, op. cit., p. 187.
292
"Some Psychical Consequences of the Anatomical Distinctions between the Sexes," 1925, S. E., **19**, p. 248 ff.
293
Freud/Zweig: *The Letters of Sigmund Freud and Arnold Zweig*, op. cit., p. 27 ff.
294
*Letters of Sigmund Freud, 1873-1939*, op. cit., p. 406.
296
*An Autobiographical Study*, op. cit., p. 49.
298
Freud/Zweig: *The Letters of Sigmund Freud and Arnold Zweig*, op. cit., p. 39.
299
First published in the German edition of this work,\*\*\* p. 261.
301
Freud/Zweig: *The Letters of Sigmund Freud and Arnold Zweig*, op. cit., p. 54.
302
*Ibid.*, p. 65.
303
Ernest Jones: *Sigmund Freud, Life and Work*, op. cit., **3**, p. 486.
305
Freud/Andreas-Salomé: *Letters*, op. cit., p. 208.
306
*Ibid.*, p. 208 ff.
307
Freud/Zweig: *The Letters of Sigmund Freud and Arnold Zweig*, op. cit., p. 108.
308
*Letters of Sigmund Freud, 1873-1939*, op. cit., p. 425.
312
*Ibid.*, p. 430.
313
*Ibid.*, p. 432.
314
*The Origins of Psycho-Analysis*, op. cit., p. 229.
315
*Letters of Sigmund Freud, 1873-1939*, op. cit., p. 341.
316
*The Interpretation of Dreams*, op. cit., p. 174.
317
*Letters of Sigmund Freud, 1873-1939*, op. cit., p. 57.
318
Translated from "Zum

Ableben Professor Brauns," in *Mitteilungsblatt der Vereinigung jüdischer Ärzte*, No. 29, May 1936, Vienna, p. 6.
319
Freud/Zweig: *The Letters of Sigmund Freud and Arnold Zweig*, op. cit., p. 66.
320
*Letters of Sigmund Freud, 1873-1939*, op. cit., p. 440.
322
Freud/Zweig: *The Letters of Sigmund Freud and Arnold Zweig*, op. cit., p. 133.
324
Ernest Jones: *Sigmund Freud, Life and Work*, op. cit., **3**, p. 194 ff.
325
*Letters of Sigmund Freud, 1873-1939*, op. cit., p. 452.
326
*Ibid.*, p. 436.
327
1. Quotation: Freud/Zweig: *The Letters of Sigmund Freud and Arnold Zweig*, op. cit., p. 158.
2. Quotation: *Letters of Sigmund Freud, 1873-1939*, op. cit., p. 438.
3. Quotation: First published in the German edition of this work,\*\*\* p. 286.
329
*Letters of Sigmund Freud, 1873-1939*, op. cit., p. 440 f.
330
*Ibid.*, p. 441
331
Ernest Jones: *Sigmund Freud, Life and Work*, op. cit., **3**, p. 243.
332
*Letters of Sigmund Freud, 1873-1939*, op. cit., p. 441 f.
333
*Ibid.*, p. 441.
334
1. Quotation: Freud/Zweig: *The Letters of Sigmund Freud and Arnold Zweig*, op. cit., p. 163.
2. Quotation: *ibid.*
335
1. Quotation: Translated from *Dali; Gemälde, Zeichnungen, Objekte, Schmuck* (Ausstellungskatalog der Staatlichen Kunsthalle Baden-Baden, 1971), p. 229.
2. Quotation: *Letters of Sigmund Freud, 1873-1939*, op. cit., p. 444.
336
Freud/Zweig: *The Letters of Sigmund Freud and Arnold Zweig*, op. cit., p. 164.

**337**
*Letters of Sigmund Freud,
1873-1939, op. cit.*, p. 443.
**338**
First published in the German
edition of this work,*** p. 303.
**339**
First published in the German
edition of this work,*** p. 303.
**340**
*Letters of Sigmund Freud,
1873-1939, op. cit.*, p. 447.

**345**
First published in the German
edition of this work,*** p. 313.
**346**
*Letters of Sigmund Freud,
1873-1939, op. cit.*, p. 454.
**348**
*Ibid.*, p. 447 f.
**349**
*Ibid.*, p. 454 f.
**350**
Leonard Woolf, *Downhill All
the Way*, The Hogarth Press,
London, 1967, p. 168.
**352**
Freud/Zweig: *The Letters of
Sigmund Freud and Arnold
Zweig, op. cit.*, p. 98.
**353**
1. Quotation: *Letters of
Sigmund Freud, 1873-1939, op.
cit.*, p. 435.
2. Quotation: *Moses and
Monotheism, op. cit., S. E.*, **23**,
p. 7, p. 15.

**355**
First published in the German
edition of this work,*** p. 320.
**356**
Freud/Zweig: *The Letters of
Sigmund Freud and Arnold
Zweig, op. cit.*, p. 175 f.
**357**
1. Quotation: *The Future of an
Illusion, S. E.*, **21**, p. 15.
2. Quotation: Ernest Jones:
*Sigmund Freud, Life and Work,
op. cit.*, **3**, p. 5.

**Sources of Pictures**
The source of some of the illustrations selected by Ernst Freud could no longer be traced after his death. Where such uncertainties occur the picture numbers have not been included in this list.

We thank the following persons and institutions for permission to reprint.

**1**
Österreichisches Staatsarchiv, Kriegsarchiv, Vienna; courtesy of Fritz Molden, publishers. This map is printed in their book *K. u. K. Familien-album*, Vienna, 1971, edited by Franz Hubmann.
**2**
*a* Lee Miller, Philadelphia
*b* Sigmund Freud Copyrights Ltd., London (abbreviated to SFC from now on)
**3, 4**
SFC
**5, 6**
Lee Miller, Philadelphia
**7**
Prof. Dr. Renée Gicklhorn, Vienna
**9**
Kartensammlung der Österreichischen Nationalbibliothek, Vienna. The picture is a color lithograph by F. X. Sandmann from a drawing by Jacob Alt.
**10**
SFC
**11**
Omri David Marlé, London
**12, 13**
SFC. The original of number 13 is lost.
**14**
*a* Bildarchiv der Österreichischen Nationalbibliothek, Vienna (abbreviated to BON from now on)
*b* From the *Erster Jahresbericht des Leopoldstädter Communal-Realgymnasiums*, 1865
**15**
Prof. Dr. Renée Gicklhorn, Vienna
**16**
SFC
**17**
Bundesministerium für Unterricht, Vienna
**18**
BON
**19, 20**
SFC
**21**
Sigmund Freud Archives

(Sigmund Freud Collection, Manuscript Division, Library of Congress, Washington, D.C. (abbreviated to SFA from now on)
**22**
BON
**23**
Printed in *Album-Fortuna; Erholung nach der Arbeit*, Familienbuch zur Belehrung und Unterhaltung für Geist und Herz, August Walther, Publisher, new edition III and IV, Vienna
**24**
SFC
**25**
*a* Alinari, Florence—antique bust, Museo Nazionale, Naples
*b* Printed in *Konsulat und Kaiserreich*, Adolphe Thiers, Mannheim, 1845-47
**26**
Archiv für Kunst und Geschichte, Berlin; copperplate engraving by Wenzel Hollar, *ca.* 1650
**28**
The Ny Carlsberg Sculpture Collection, Copenhagen
**29**
Bundesministerium für Unterricht, Vienna
**30**
Wiener Presse-Bilddienst Votava
**31**
SFC
**32**
Wiener Presse-Bilddienst Votava
**33-36**
SFC
**37**
Greti Mainx; the photograph was taken after 1900; however, the laboratory has remained unchanged since the time when Freud worked there.
**38**
SFC
**39**
Printed in *Sitzungsber. d. k. Akad. d. Wissensch. Wien* (Math.-Naturwiss. Kl.), **75**, I. Abt., 1877
**40, 41**
Bildarchiv des Instituts für Geschichte der Medizin, Vienna (abbreviated to BIGM from now on). Number 40 is a drawing by Moritz Ledeli, *ca.* 1885.
**42**
Printed in *Victor Adlers Aufsätze, Reden und Briefe*, Verlag der Wiener Volksbuchhandlung, Vienna, 1929. Photograph of 1886; we

thank Dr. Rudolf Ekstein, Los Angeles, for drawing attention to this photograph.
**45**
National Portrait Gallery, London; painting by G. F. Watts
**46**
BIGM; Lithograph by Adolf Dauthage, 1882
**47**
Verlag F. A. Brockhaus, Wiesbaden; photograph of 1893
**48**
BIGM; the photograph shows the "Alte Gewehrfabrik" before its demolition in 1910.
**49**
BIGM
**50**
SFC
**51**
Printed in *Sitzungsber. d. k. Akad. d. Wissensch. Wien* (Math.-Naturwiss. Kl.), **78**, III. Abt., 1878
**52**
Archiv der Universität Wien, Vienna
**53**
BON
**54**
Archiv der Universität Wien, Vienna
**55-59**
SFC
**60**
National Portrait Gallery London; painting by an unknown artist, 1629
**61**
Staatliche Bildstelle, Hamburg
**62-65**
SFC
**66**
Deutsche Fotothek, Dresden; view from the tower of the Zwinger and the Picture Gallery during construction, *ca.* 1850
**67**
Deutsche Fotothek, Dresden; based on a work by Hans Holbein the younger, "Die Madonna des Bürger-meisters Meyer"; copy by Bartholomaeus Sarburgh; Dresden Gemäldegalerie, no. 1892
**68**
Staatliche Kunstsammlungen, Dresden, Photographic Division
**69**
Frank Herrmann
**71, 72**
SFC
**76**
SFA
**77**
BIGM

**78**
Printed in *Arch. Anat. Physiol.*, Leipzig, Anat. Abt., 1884
**79, 80**
Archiv der Universität Wien, Vienna
**82**
SFA
**83**
The Scriptorium, Buyers, Sellers, Appraisers of Original Letters, Documents & Manuscripts of Famous People, Beverly Hills
**84**
Archives of the firm of Merck, Darmstadt
**85**
SFC
**87**
Printed in *Die Privatheilanstalt für Gemüths- und Nervenkranke in Oberdöbling bei Wien*, Vienna, 1876
**88, 89, 91**
SFC
**92**
Bibliothèque Nationale, Paris
**93**
SFC
**96, 98, 99**
Bibliothèque Nationale, Paris
**100**
Service de documentation photographique de la réunion des musées nationaux, Paris
**101**
Mme J. Colomb-Gérard, Paris
**102**
Printed in *Fritz Kreisler*, Louis P. Lochner, Bergland Verlag, Vienna, 1957
**104**
BON
**105**
BIGM; photograph of 1972; the hall has remained unchanged since the time when Freud gave his lecture there.
**107-109**
BON
**110**
SFC
**111**
Österreichisches Staatsarchiv, Kriegsarchiv, Vienna
**112**
SFC
**113**
BON
**114, 115, 117, 118**
SFC
**125**
Lee Miller, Philadelphia
**126**
SFC
**127**
Basic Books, Inc., New York
**128**
*a* Lee Miller, Philadelphia
*b* Basic Books, Inc., New York